STATE OF THE ART

Ideas & Images in the 1980s

Sandy Nairne *in collaboration with*
Geoff Dunlop and John Wyver

Photographs by Geoff Dunlop

CHATTO & WINDUS, LONDON *in collaboration with*
Channel Four Television Company Limited

Published in 1987 by Chatto & Windus Ltd
40 William IV Street, London WC2N 4DF

British Library Cataloguing in Publication Data
Nairne, Sandy
 State of the Art: ideas and images in
 the 1980s.
 1. Art
 I. Title II. Dunlop, Geoff III. Wyver, John
 700 N7425

 ISBN 0-7011-3086-5
 ISBN 0-7011-3087-3 Pbk

Photoset by Rowland Phototypesetting Ltd
Bury St Edmunds, Suffolk
Colour origination by Waterden Reproductions
Printed in Great Britain by
Butler & Tanner Ltd, Frome and London

Contents

Acknowledgements

First thanks go to the artists, critics, curators and gallery owners who have collaborated with us in the making of the television programmes, and who form part of the subject of this book. They have been endlessly supportive and helpful throughout the long process.

I would like to acknowledge the close support of Diane Large, associate producer on the series, Gina Hobson our production manager and Linda Zuck who worked as a research assistant on both the programmes and the book. Together with our enthusiastic Channel Four trainee, Surrinder Singh Juttla, they made up the office team. The programmes were realised through the skills of Jeremy Stavenhagen as lighting cameraman, with Chris Renty recording sound, and Lawrence Dodds as assistant cameraman. Their commitment to the quality of the work was constant through more than a dozen exhausting weeks of filming, where schedules were held together by the unflappability of Gina Hobson. That commitment was matched in the cutting rooms by the editors Stuart Davidson and John Keenan, and the assistant editors Steve Fletcher, Melanie Gilbert and Imogen Pollard.

Those who helped us on translations were Gisela Hossmann and WDR in Germany and Linda Zuck, Ruth Baumgarten, Ian Brunskill and the Institute for Aboriginal Development in Alice Springs. We were fortunate in having the able assistance of Ambra Sancin and Gary Sangster in Sydney, and we gratefully acknowledge the financial support of the Visual Arts Board of the Australia Council in making this possible. We were also assisted in Australia by the Aboriginal Arts Board, Richard Dunn, Max Hensser, Tim and Vivien Johnson, Chris McGuigan, Jan Meek, Bernice Murphy, Leon Paroissien, Nick Waterlow, Daphne Williams and Ross Wolfe. The special role of the commissioning editors, Michael Kustow at Channel Four and Wibke von Bonin at WDR in Cologne, must be acknowledged; their trust and support were often greatly appreciated.

James Lingwood has curated the exhibition which opens at the Institute of Contemporary Arts, London, in January 1987, continuing the initial enthusiasm of Declan McGonagle. I am also grateful for the dedicated hard work on this book by the staff of Chatto & Windus and, in particular, by Andrew Motion, Ron Costley and Allegra Huston. I need to emphasise the particular relationship with Geoff Dunlop (producer/director) and John Wyver (series producer) without which the series, and this book, would not have existed.

I would like to thank all those who gave advice and support at different stages of the project; they include Heiner Bastian, Suzanne Davies, Bruce Ferguson, Richard Francis, Kate Linker, Lucy Lippard, Donald Kuspit, Irving Sandler, Nicholas Serota and especially Lisa Tickner.

The museums, public galleries and institutions that have helped us are the Artangel Trust, Independent Television News, the Institute of Contemporary Arts, London Docklands Development Corporation, Midland Bank Group Treasury, Polytechnic of Central London, The Roundhouse, the Royal Academy of Arts, the Tate Gallery (curatorial staff, Conservation Department and Library), the Slade School of Fine Art, the Unilever Collection, the Victoria and Albert Museum, the Whitechapel Art Gallery, *Woman's Journal* and the Yaa Asantewa Arts Centre in London; the Fruitmarket Gallery, Edinburgh; the City Art Gallery, Southampton; Stoke-on-Trent Garden Festival; University of Leeds; *Artforum*, the Battery Park City Authority and the Broida Museum, New York; the Museum of Fine Arts, Boston; the Museum of Contemporary Art, Los Angeles; the Minneapolis Institute of Art and the Walker Art Center, Minneapolis; the Hirshhorn Museum, Washington DC;

Artspace, the Aboriginal Arts Board and the Visual Arts Board of the Australia Council, the Aboriginal Artists Agency, the Biennale of Sydney and the Art Gallery of New South Wales in Sydney; the Papunya Tula Company, Alice Springs; the Staatliche Kunsthalle, Baden-Baden; the Neue Nationalgalerie and the Olympic Stadium, Berlin; the Cologne Art Fair and Museum Ludwig, Cologne; the Hessisches Landesmuseum, Darmstadt; the Deutsche Bank, Düsseldorf and Frankfurt; the Kunsthalle and Revolution 71, Düsseldorf; Parc de la Villette, Paris; *Brutus*, Tokyo. We are also indebted to the following private collections: the Saatchi Collection, London; the Dr E. and D. Stoffel Collection, Cologne; the Douglas S. Cramer Collection and the Broad Collection, Los Angeles.

The galleries that have assisted are Blond Fine Art, Anthony d'Offay Gallery, The Elbow Room, Gimpel Fils, Nigel Greenwood Gallery, Interim Art and Edward Totah Gallery in London; Salvatore Ala, Mary Boone Gallery, Leo Castelli Gallery, Paula Cooper Gallery, Bess Cutler Gallery, Barbara Gladstone Gallery, Pat Hearn Gallery, Metro Pictures, Annina Nosei Gallery, Tony Shafrazi Gallery, Sperone Westwater and John Weber Gallery in New York; Galerie Stampa, Basel; Galerie Paul Maenz and Galerie Michael Werner, Cologne; Galerie Liliane and Michel Durand-Dessert, Paris; Yuill/Crowley Gallery, Sydney.

All photographs are by Geoff Dunlop, copyright © *Illuminations (Television) Ltd* 1987 except for those otherwise indicated in the list of illustrations.

All quotations are taken from interviews made for the television series except those otherwise indicated. Grateful acknowledgement is made to copyright holders for permission to reprint material including the following:

Susan Sontag, *On Photography*, Allen Lane, London, 1978, pp. 178–179. Copyright © Susan Sontag 1973, 1974, 1977. Reproduced by permission of Penguin Books Ltd.

'Big Science', words and music by Laurie Anderson. Copyright © Difficult Music 1982. Reproduced by kind permission of Warner Bros. Music Ltd.

Terry Smith, 'The Provincialism Problem'; Annelie Pohlen, 'Review: Anselm Kiefer'; Rosetta Brooks, 'From the Night of Consumerism, to the Dawn of Simulation'; Patricia C. Phillips, 'Forum: Something There Is that Doesn't Love a Wall'; Ingrid Sischy, 'On Location'; Thomas Lawson, 'Towards Another Laocoon or, The Snake Pit'. Copyright © Artforum International Magazine, Inc. 1974, 1984, 1985, 1986. Reprinted by permission.

Kay Larson, 'Selling Yourself Yourself'; Kim Levin, 'Power/The East Village'; Lucy R. Lippard, 'Power/Control'; Roberta Smith, 'Power/The Art World'; C. Carr, 'The Hot Bottom'; Gary Indiana, 'Art Objects'; Ellen Lubell, 'New Kid on the (Auction) Block'; Lucy R. Lippard, 'Battle Cries'. Copyright © the authors and the Village Voice Publishing Corporation 1980, 1983, 1984, 1985. Reprinted by permission.

John Russell, 'Contemporary Showcase with a Difference'. Copyright © The New York Times Company 1985. Reprinted by permission.

Dillon Ripley, *The Sacred Grove: Essays on Museums*. Copyright © Dillon Ripley. First edition: Simon & Schuster, New York, 1969. Paperback edition: Smithsonian Institution Press, Washington, 1978. Reprinted 1982. Reproduced by permission of Smithsonian Institution Press.

The Standard Edition of the Complete Psychological Works of Sigmund Freud, Volume 17, translated and edited by James Strachey. Reproduced by permission of Sigmund Freud Copyrights Ltd, the Institute of Psycho-Analysis and the Hogarth Press.

Preface

State of the Art was written to accompany a series of six television films for Channel Four, London, and WDR in Cologne. It was planned as an important element in the project, incorporating more extensive interviews and commentary than the programmes themselves could include. The book has the same title as the series; the chapters follow the themes of the individual programmes; the layout, illustrations and use of quotation are designed in a manner parallel to the television format.

What I had proposed was a series of television films that would take a broad view of the visual arts, discussing them not in isolation but in the context of the contemporary thought and culture of which they form a part. This approach is not usual in television presentations of art (though John Berger's *Ways of Seeing* and the Open University's *Modern Art and Modernism* series have been important exceptions in Britain). I proposed that the divisions of the programmes would not be based on national schools, particular styles or chronological change, but on issues current both in art and in society as a whole. Secondly, the films would not be about the lives of the artists, their eating or sleeping habits, nor indeed about artists at all. What we have produced is a discussion of art itself, seen through the work of particularly interesting artists and through extensive interviews with them, focusing on the ideas that have helped form their art and the circumstances in which it is viewed and interpreted. It was clear that there could be no objective position, that many of my ideas had been formed by what I had read and those I had listened to. Nor could our project be independent from the circulation of ideas and assessments in the art world.

Close collaboration was needed to make these programmes. We had to recognise the very different positions of writer, producer and director, and the very different work required of each, but there was still considerable cross-over. There was no automatic hierarchy. Ideas were debated at length in order to reach agreement, and as far as time allowed the form and style of the films were discussed simultaneously with their content. As a curator who spends time working directly with art objects, I am strongly aware of the qualities of those objects that can never be seen on television. The texture and material of paintings and sculptures, and of more unconventional art, cannot be adequately *re*-presented in an electronic medium. But television's special contribution is to focus attention on particular works and details of them, to convey ideas, represent views, provide information and create metaphors, all at considerable speed. When transmitted through a large network, the ability of television to reach a massive audience distinguishes it from the other forms of secondary discourse – exhibitions, catalogues, books and museum displays – with which it is otherwise associated.

This book, like the television series, has no intention of being comprehensive. It is not a survey, nor an assessment of the art scene in particular

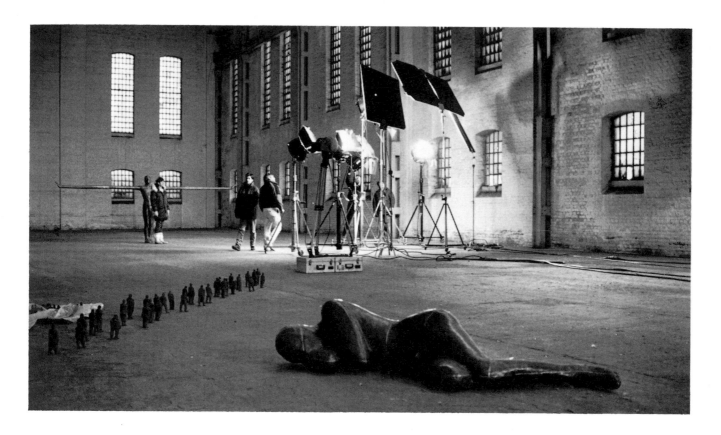

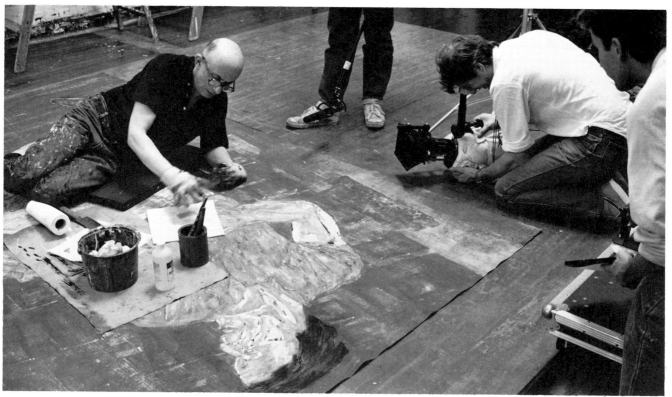

1 Filming sculpture by Antony Gormley for *State of the Art*, London, 1986.

2 *State of the Art* cameraman Jeremy Stavenhagen filming Leon Golub, New York, 1985.

PREFACE

countries at a particular time: it takes a selection of works from the last ten years with which to discuss issues in contemporary art. The selection, though thematic, is not arbitrary. Inevitably it is sometimes based on subjective choices. There are many important artists who might have been included, and many more whose work did not seem pertinent to the ideas we wished to discuss here and could only have been included in an extended series and book.

The juxtaposition of art from different countries and by artists with different reputations is integral to this book. Despite the contrasting styles and techniques, there are unifying threads in both the production and reception of Western art. The artists emerging in any one year from colleges in Europe, North America and Australia will have more shared assumptions to unite them than divergent opinions to divide them. Even so Chapter Six – and the last of the programmes – examines different cultural identities in the Western world, recognises different histories and experiences and concludes that it is false to see contemporary Western art as the result of a single, European, tradition.

The works discussed here belong in the field of Fine Art – that is, the practices of painting, sculpture, drawing, photography, installation, performance, video and other mixed media that are currently exhibited in galleries and museums. These media are employed by various *kinds* of artists, each of whom would define the term artist in a different way. Much of the work examined is made in traditional ways, but the influence on the art world as a whole of the new media – performance and video for instance – should not be underestimated. Our purpose is to explore the meanings and associations of works that pass commonly through the public and private sectors of the art world. That is not to say that their criteria are adequate.

The text of the book is made up of passages of description and analysis of works of art, quotations from the artists interviewed for the series and from other commentators, contextual descriptions and discussions of relevant ideas. These are intended both to give a sense of how ideas were handled in the programmes, and to draw out, not the 'ambience' of the artist's studio or neighbourhood, but the circumstances in which their work is produced: what makes it particular or special. I hope that this combination of written texts, together with the variety of photographic illustrations, will speak more adequately than a single voice.

I think it's important for viewers to understand the rhetoric of realism – how it is a depiction of what is real, and that it is not real. That this rhetoric permeates the pictures that we see whether they are still photographs, whether they are filmic, or whether they are broadcast for television. And just to say as a reminder that in fact what you are seeing is not me but a representation of me, which is being framed and photographed and edited and inserted within a larger linear, narrative form of which I have very little control. BARBARA KRUGER

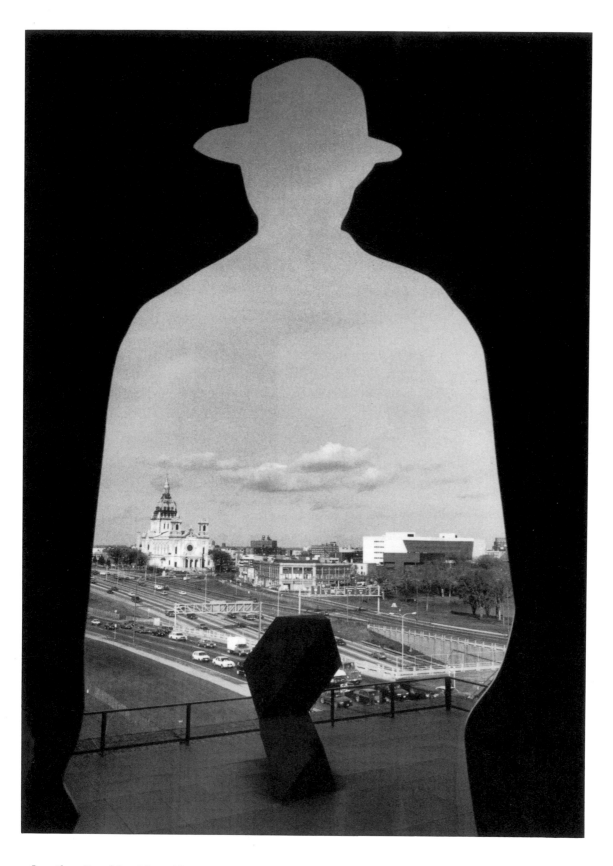

3 Jonathan Borofsky, *Man with
Briefcase*, 1979, at the Walker Art
Center, Minneapolis, 1985.

Introduction

Art is not isolated from everyday life. The common perception of art as a matter of painstaking imitation or as a product of fantasy and imagination, a sphere of interest both different and separate from economics or politics, has been elevated into what makes it important: important because it is *not* the stuff of business or political argument, because it is not *reducible* to these things. This separation is both true and untrue. It is evidently untrue in so far as the work of artists is part of the fabric of the whole economy: materials are transformed and finished works are bought and sold. Equally the production, exhibition and interpretation of art are not without a political framework, not beyond ideology. Yet its place in society is not as obviously utilitarian as the production of washing machines or the curing of illness.

Most artists are unsuccessful in commercial terms (in being unable to make a living from their work), but this is not their primary measure of success. Fulfilment lies in personal expression, intellectual engagement or therapeutic effect. Many artists resignedly sustain their work through a second job, endorsing the uneconomic status of their 'vocation'. Only a minority of artists (though in this book they are the majority) may reach the level of success that involves regular private gallery and museum exhibitions and coverage in the international art magazines; yet the majority have some professional training, and would not regard the possible prominence of their work as merely a matter of luck. But whatever the degree of professional reputation or economic dependence, works of art are not built from the ether, but on ideas and emotions experienced in our present culture. Our understanding of these works cannot be tied only to causative or descriptive links with the world, but those links must not be ignored.

Art remains a high status activity. Patronage, whether state, corporate or individual, indicates the importance of art to controlling groups, for whom it has the possibility of moral as well as aesthetic quality, intelligent enquiry, freedom and goodness as well as beauty. The patron's view often differs from that of the artist; while it is commonplace for artists to provide literal depictions of their times, many others regard themselves as engaged critically with *ideas* and their visual representation. Part of the 'outsider' tradition is to see the artist as the natural critic of society. But whether unconsciously or intentionally critical, art is part of our perception of the world. Art is one of the elements in our culture that is an indication of what is new and significant – thus it has a deep and pervasive influence.

The question remains whether art has the forms that can cope with the questions that history has put on the agenda. STUART HALL, *Voices*, Channel Four Television, London, 11 June 1985.

Looking at and discussing art does not usually require intellectual justification. That art is worthwhile may be a matter of assumption for many, but it is

a matter of indifference for others. Why examine art rather than the more accessible and widely distributed sections of popular culture? If art has a more limited public than the material of advertisements, television and popular journals, can it be as significant? If artists are still regarded as idiosyncratic figures in our society, why are they of interest as more than eccentric? There are a number of kinds of answers to these questions. Art may be a minority interest (so are theatre, literature and dance) but its influence extends more widely than merely to those who have direct contact with paintings or sculpture. Art provides one of the 'languages' of our culture – a language in which the philosophical, the moral, the political and the aesthetic are mixed together, a language which may principally demand contemplation, but can also incorporate the polemical. Contemporary art is part of the continual exchange of images in our society, images that become part of an understanding of the world. Art, in varying circumstances, provides either reinforcing or critical elements in that understanding. Art is an intervention, not a reflection. However immediate its message and method it is generally intended to last over time, and it will be exhibited and discussed at other times and in other places.

If art contributes to, among other things, the way we view the world and shape social relations then it does matter whose image of the world it promotes and whose interests it serves. HANS HAACKE, in *Fifth Biennale of Sydney*, Sydney, 1984.

The market system works to make art 'rare' (more original, more authentic) and to keep prices at the highest level. Maximum return is generally produced in a field of low technology (all individual hand work is in this category) by controlling the supply and working to create an excess of demand. The art market trades on exciting a desire for the 'touch' of the original hand. The glamorous aspects of the art world, the auctions featured in fashion magazines, the siting of art galleries among prestigious shops, the exclusivity of the opening or 'private view' are features of the system. In mixed economies paradoxes abound. While some 'spectacular' prices (especially prevalent since a growth in the market for contemporary art in the USA, West Germany, North Italy, Switzerland and Belgium after 1980) add to the glamour, the majority of art changes hands at considerably lower price levels. These prices may still be higher than those which wider distribution would allow. But with galleries taking up to 50 per cent of the purchase price to cover their own expenses, there may not be enough to make a complete income for an artist year by year. There is a fairly unbridgeable gap between the price in the gallery and what a moderately well-informed spectator will *think* is reasonable to pay, between what the artist (and gallery) needs to make and display the work and what that spectator might allocate to spend on buying art. Yet it is the market, sometimes in parallel with independent and artist-organised galleries, that takes chances in bringing forward new work to wider public attention; much of that work is selected later by public museums and galleries.

An example of these contradictions in the market system can be seen in New York's East Village. This development comes twenty years after the

previous move by many galleries from uptown Manhattan to downtown SoHo (and here the shops have followed the galleries). On one hand stylish young professionals are involved in restoring buildings, contributing to the process of gentrification, making galleries in which objects are sold at prices which seem obscene when set against the destitution and poverty on the same streets. On the other hand some galleries, a few run on a cooperative basis, provide store-front outlets for much more reasonably priced works of art. The galleries exhibit the work of a wider range of artists than in SoHo or uptown, and they increase the street life and trade in a depressed neighbourhood. Both SoHo and the East Village promote a level of visibility for contemporary art that has few parallels elsewhere. New York's position is exceptional but symptomatic. Its public did not always exist; it seems that only a few hundred people made up the New York art scene in the early 1950s, and now Steve Rubell, owner of the Palladium Club, declares that artists are the rock stars of the 1980s. New York has set the pace, the style and the market and public interest for contemporary art worldwide.

There is nothing like a 100-foot painting on a ceiling: there is no painting on canvas that is going to be like that. There is something about it, It envelops you, it takes you over, and it's real and it's there in a different way from a movable, portable canvas. So I've made many of these almost to fight the system, and yet I'm not against the system. I'm part of the system. I just have this dual feeling about it, $2,000 for a scribble – that is the going price for a Borofsky scribble you know . . . It's part of the game. By playing the game I've got myself into an arena where at least I have the chance to speak about more serious things. JONATHAN BOROFSKY

In the 1970s artists and critics mounted the most sustained attack on the institutions of the art world. Investigative art practices sought to expose the layers of 'framing' around the spectator's perception of a work of art, emphasising that there is no unmediated, isolated and uninfluenced view. This coincided with new approaches to art history that located changes in art in a historical perspective, separate from unfolding stylistic change and connoisseur-like appreciation. Artists made works that attempted to circumvent the marketplace, producing art that was temporary, specific to a location, or larger than the domestic scale. Artists put new effort into running their own non-profit galleries and studios. They argued that only through independent institutions did it seem possible to make truly experimental or critical work. Many of these initiatives, taking varying forms in Europe, North America and Australia, needed funding from local or regional governments or their agencies, and these funding bodies in turn favoured the independent initiatives of artists. Other artists left the art world entirely to work as artists in the community, responding closely to local needs and initiatives. A frequent pattern of government cuts in arts funding has, in the 1980s, undermined the potential of such organisations. The more conservative climate of the last seven years, with cautious attitudes to public spending, has concentrated funds towards more prestigious public galleries and museums. The encouragement of sponsorship of the

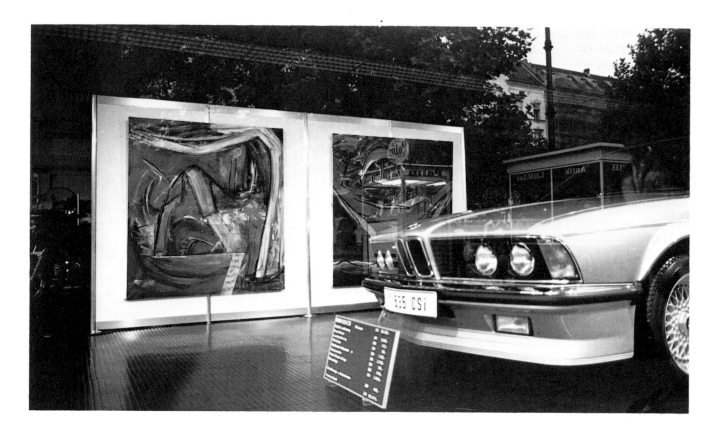

4 Exhibition of young artists' paintings in the BMW showroom, Kurfürstendamm, Berlin.

arts by the business and corporate sector has reinforced this pattern.

What we see reflected, then, in supposedly 'revivalist' painting is the widespread antimodernist sentiment that everywhere seems to have gripped the contemporary imagination . . . Antimodernism is primarily a disaffection with the terms and conditions of *social* modernity, specifically with the modernist belief in science and technology as the key to the liberation of humankind from necessity. CRAIG OWENS, 'Honor, Power and the Love of Women', *Art in America*, New York, January 1983, p. 11.

In the same period many artists and critics attacked the mainstream of modern art which seemed locked into abstract and formal mannerisms favouring the 'look' of a work over its content. Changes in the fashions and styles of art itself only became evident towards the end of the decade. One dramatic shift was the end of the twenty-year American dominance of the international art world (through magazines, art fairs, international Biennales and survey exhibitions). If the 1964 success of Robert Rauschenberg at the Venice Biennale had confirmed the establishment of the American position, then the works of Georg Baselitz and Anselm Kiefer exhibited in the German pavilion in 1980 marked its end. A younger generation of Europeans began to steal the limelight. Italian artists (Francesco Clemente, Sandro Chia and Enzo Cucchi) and German artists (Baselitz and Kiefer, together with Markus Lüpertz, Jörg Immendorff and A. R. Penck) were favourably, though not uncontroversially, received by New York galleries

and collectors. The shift extended to include 'new waves' of work from France (Gérard Garouste, Robert Combas and Jean-Charles Blais), from Britain (the new sculpture of Bill Woodrow, Richard Deacon, Anish Kapoor and others) and from Switzerland, Holland, Austria and Spain. The 'new' artists and their work were variously irreverent, brash, expressive, exuberant and serious, declared the locality of their origins, and happily incorporated myth, history and narrative, associations previously outlawed in modern art. This European, and predominantly painterly, upsurge was marked by various international exhibitions: the historical exhibition *Westkunst* in Cologne in 1981, *A New Spirit in Painting* at the Royal Academy in London in the same year, *Zeitgeist* in Berlin and *Documenta VII* in Kassel in 1982.

The increased attention being given to a new generation of European artists had a counterpart in critical reassessments in America. The 'Decor' painters associated with Holly Solomon's Gallery, the recognition of feminist artists like Judy Chicago and Miriam Shapiro, the controversy around 'Bad Painting' and 'Narrative Art', the general revitalisation of painting as a practice, were all part of a changed climate in New York, Los Angeles and other parts of America (this was not news to cities like Chicago where the figurative painterly tradition had remained strong). The 'new spirit' in art – subjective, intuitive, painterly, romantic, historical and bombastic – gradually began to dominate the art world in America and Europe. This new sense of direction among artists, the regrouping of ideas, the change of taste in the market, the revival of what had seemed to be old-fashioned painting (and dubious associated ideas, like the re-identification of the male heroic painter), the reassessment of art historical interests, the renewed interest in the work of major European figures like Giorgio de' Chirico, Max Beckmann and Francis Picabia, who seemed to have been pushed to one side by the modernist mainstream, all appeared to signify the end of one period and the start of another. It was not only in the art world that the last years of the 1970s and the early years of the 1980s were a period of considerable upheaval.

The loosening of rigid formal rules in the mainstream of art meant among other things that artists dealing with social and political issues could be less selfconscious about their material. Issues that had been treated constantly in literature, the theatre and the cinema were in the 1980s able to be reconsidered in art. The breaking of the mould of a formalist modern art also broke the mould of a single type of 'political art'. One of the key points that feminist artists and critics had already asserted in the 1970s was that all art has a political dimension, and that for women (as for many others) politics cannot be neatly defined as just the issues of parliamentary debate. Much feminist art stressed the relations between the personal and the political to explore issues of identity and experience, and women artists led the way in the exploration of the poetic and the subjective and in the demand for a 'content' to art. Equally, a number of black artists were exposing discrimination and Eurocentric attitudes in Western society and discovering a personal identification with Afro-Caribbean or Asian traditions. New work of dissent

often broke convention and productively used a blurring of the boundaries of 'high' and 'low' art, the fine arts and mass culture. Such work was, and is, carried out in performance (which has a vigorous recent tradition from the Fluxus artists of the late 1950s to figures like Vito Acconci, Stuart Brisley and Laurie Anderson), in installations, in video, in painting, but most of all in the use of photographic images. There was a strong feeling (perhaps too optimistic) that the art world might become more open to different voices, more eclectic, more plural. Different voices might be understood as powerful and distinct, and not be subject to a single set of criteria of what is good, acceptable or saleable.

Equally discernible in the early 1980s were new cross-overs between music and art (through the conscious exploitation of the social status of rock music), between art and writing, art and television, and art and architecture. *The Times Square Show* in New York in 1981, an installation organised by Colab in an old house on Times Square on the themes of sex and commerce, and a magazine like *ZG*, published in London and New York, aimed in their different ways to keep boundaries indistinct, to keep political comment present but undogmatic, and to keep style and stylishness in the foreground. The art world, like the fashion world, was subject to the exuberant post-punk ethos of individual, anarchic but street-wise creativity.

These various strands of art, and these different ideas of the role of artists, have had a considerable impact on the contemporary art world. But despite the divergence of positions and the attention being given in New York to Neo-Abstract and Neo-Conceptual art, exuberant figurative painting has become the new orthodoxy. The exhibition which reopened New York's Museum of Modern Art in 1984, *An International Survey of Recent Painting and Sculpture*, included art from an unusually broad range of countries, but also suggested the possibility of a new international conformity. The degree to which different kinds of art co-exist in the art world may have increased over the last twenty years, but different kinds of art are visible, and available for debate, in quite unequal degrees. Some views of what is aesthetically or commercially valuable prevail over others. *State of the Art* strives to counter this imbalance. It is primarily concerned not with reputation or fashion, but with ideas that illuminate the artists' works, and with works that illuminate our understanding of the modern world.

1 History, the Modern and Postmodern

This is how one pictures the angel of history. His face is turned toward the past. Where we perceive a chain of events, he sees one single catastrophe which keeps piling wreckage upon wreckage and hurls it in front of his feet. The angel would like to stay, awaken the dead, and make whole what has been smashed. But a storm is blowing from Paradise; it has got caught in his wings with such violence that the angel can no longer close them. This storm irresistibly propels him into the future to which his back is turned, while the pile of debris before him grows skyward. This storm is what we call progress. WALTER BENJAMIN, *Illuminations*, Fontana, London, 1973, pp. 259–60.

. . . he let the entire world press upon him. For instance? Well, for instance, what it means to be a man. In a city. In a century. In transition. In a mass. Transformed by science. Under organised power. Subject to tremendous controls. In a condition caused by mechanisation. After the late failure of radical hopes. In a society that was no community and devalued the person. Owing to the multiplied power of numbers that made the self negligible. SAUL BELLOW, *Herzog* (1964), Penguin, London, 1985, p. 201.

The modern world is chaotic and contradictory. Modernity, in the minds of early twentieth-century visionaries, was expected to lead to an emancipated society, but the great technical and scientific advances, and the 'progress in knowledge', have failed to rid the world of 'poverty, despotism and ignorance'.* Every aspect of life reveals a gap between the optimistic *idea* of modernisation and the modernised reality. Men and women fly in space and artificial skin is made in the laboratory, yet national and religious wars remain insoluble. Some of the worst aspects of poverty have been reduced in the West, but, internationally, the gap between the rich and poor grows ever wider. As work, transport, communications and consumption have been transformed, so too have class relations, education, the family, sexuality and the arts. Every activity, every part of life, is now subject to the market, and can be packaged, bought and sold.

Jean-François Lyotard, interview in *Flash Art*, Milan, March 1985, p. 33.

Cameras define reality in the two ways essential to the workings of an advanced industrial society: as a spectacle (for masses) and as an object of surveillance (for rulers) . . . Social change is replaced by a change in images. The freedom to consume a plurality of images and goods is equated with freedom itself . . . As we make images and consume them, we need still more images; and still more. SUSAN SONTAG, *On Photography*, Allen Lane, London, 1978, pp. 178–9.

The ubiquity and power of public images is one of the most significant aspects of the changing world. They surround us – images with messages, images with information, images as ideas. The reproduction of images from person to person, institution to institution and country to country is now taken for granted. With the speed of travel and communications, this saturation of images reinforces the impression that we live in one world. As

we recognise the control of the technological resources that produce them and the control of their distribution through news, fashion, advertisements, architecture, art and entertainment, so we recognise images as one of the binding forces in a 'global culture'.

Images are not free, even outside a totalitarian state. What can be depicted, represented or expressed is limited not so much by law but by social convention and expectation. One of the important cultural functions of the modern media is the selective construction of our understanding of society. Through media images we perceive, as Stuart Hall writes, 'the "lived realities" of others, and imaginarily reconstruct their lives and ours into some intelligible "world-of-the-whole", some "lived totality"'.*

If some images help construct a 'global culture' in a restrictive manner, others can help to counter this. The use of stereotypes is one of the powerful mechanisms for assimilation in mass circulation imagery, but there is an eventual fatigue inherent in all stereotypic images. Artists may deliberately accelerate or retard this fatigue. Images change us as we change them; they are part of the contest that is social change, the contest of differing histories and ideas.

'Culture, the Media and the "Ideological Effect"', in Curran, Gurevitch and Woollacott (eds.), *Mass Communication and Society*, Edward Arnold, London, 1977, p. 341.

* * * * *

History is always in practice a reading of the past. We make a narrative out of the available 'documents', the written texts (and maps and buildings and suits of armour) we interpret in order to produce a knowledge of the world which is no longer present. And yet it is always from the present that we produce this knowledge: from the present in the sense that it is only from what is still extant, still available, that we make it; and from the present in the sense that we make it out of an understanding formed by the present. CATHERINE BELSEY, *The Subject of Tragedy*, Methuen & Co., London, 1985, p. 1.

We know the past, and the present, through histories that are far from neutral, histories constructed from particular viewpoints. There is no single history: only the combination of many, the views of individuals, groups, classes and countries. Yet 'history' is in constant use, as sets of images from the past employed in the present. Politically conservative thinkers often present the future as a version of the past: modernised and revitalised, with all the awkward parts effaced. Conversely, some socialists use the past as a resistance to the bureaucratic and authoritarian aspects of the present, as the repository of elements of life untouched by market relations. The languages of consumerism, tourism, and even welfarism attempt to find a solidity, an undefined *value*, in images from the past. Old subjects, old buildings and old associations are used to counter the widespread feelings of dislocation and displacement in present society.

At some point following World War II a new kind of society began to emerge (variously described as post-industrial society, multinational capitalism, consumer society, media society and so forth). New types of consumption; planned obsolescence; an ever more rapid rhythm of fashion and styling changes; the penetration of advertising, television and media generally to a hitherto unparalleled degree

HISTORY

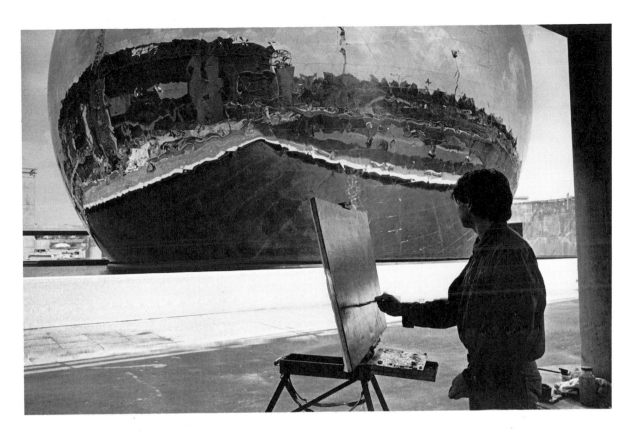

5 Outside La Géode, Parc de la
Villette, Paris.
6 Freeway, Los Angeles.

throughout society; the replacement of the old tension between city and country, centre and province, by the suburb and by universal standardisation; the growth of the great networks of superhighways and the arrival of automobile culture – these are some of the features which would seem to mark a radical break with that older prewar society . . . FREDRIC JAMESON, 'Postmodernism and Consumer Society', *The Anti-Aesthetic*, ed. Hal Foster, Bay Press, Port Townsend, 1983, pp. 124–5.

The term postmodern is increasingly used to refer to several different, but inter-related, concepts. It suggests the possibility of a new era in society to succeed the modern – one characterised by the unprecedented acceleration of change, in which the old certainties of politics, religion, ethics and philosophy become confused and paradox abounds. Secondly, it refers to a resistance to 'modernisation', an anti-modern position that no longer presumes the benefits of the modern world, combining cynicism and detachment with a renewed commitment to 'fundamental' values. A third usage denotes a *stylistic* break by which the consciously modernist aspects of Western culture are contested and overtaken. This change is uneven, and in architecture, art, literature and music the term postmodern is a fiercely debated critical concept.

From the stream of conferences, seminars and publications in which the concepts of modernism and postmodernism have been discussed, a variety of descriptions has emerged.* At an extreme, the postmodern world is seen as totally commodified; culture is flattened out, with little remaining difference between 'high' and 'low' culture, little argument between fine art and kitsch, or between the 'avant-garde' and the academic. The world is reduced to a series of simulacra: there is a new depthlessness, appearance is everything. Nothing is original or authentic because the world is experienced second-hand. There is a new nostalgia as we lose a secure sense of our place in history; all culture becomes a parody of past forms.

Such pessimistic descriptions point to the collapse of a sense of identity, and to the impossibility of individual expression under the bombardment of images and within the fragmentation of culture. (On the one hand there is this fragmentation, and on the other, economic and social forces are producing a homogeneous 'global culture' which is an apparent continuation of modern values and goals.) But this may still be a productive moment. Released from the critical constraints of a single and supposedly universal value system, the artist is free to explore and expose contradiction itself, to heighten the ironies, to work from the chaos and to address specific issues. Alternatively, the artist may feel freer to dream, to fantasise new worlds out of the old, to play with past images and associations.

* * * * *

I said, Hey pal, how do I get to town from here . . . and he said, well just take a right where they're going to build that new shopping mall; go straight past where they're going to put in the freeway, and take a left at what's going to be the new sports centre . . . and keep going until you hit the place where they're thinking of building that drive-in bank . . . You can't miss it. And I said . . . this must be the place . . . Golden City . . . Golden Town. LAURIE ANDERSON, *Big Science*, Warner Brothers, New York, 1982.

See also Fredric Jameson, 'Postmodernism, or The Cultural Logic of Late Capitalism', *New Left Review* 146, London, July/August 1984; Jean-François Lyotard, *The Postmodern Condition: A Report on Knowledge*, trans. Geoff Bennington and Brian Massumi, Manchester University Press, 1984; Jean Baudrillard, *In the Shadow of the Silent Majorities*, Semiotexte, New York, 1983.

7 Skyline, downtown Los Angeles.

The failure of the modern movement in architecture to provide the brave new world which its architects and advocates had envisaged is an example of the licensing of postmodern stylistic experiment. Through a critique of under-financed, poorly constructed environments – identical, sterile and dehumanising – postmodern writers and architects have been able to turn to the vernacular and the historical to find new inspiration. Postmodern architecture has established an area of eclectic 'play' in which decoration, ornamentation of surface and fittings, sculptural embellishment and traditional materials are combined with essentially modern construction methods. Critics such as Charles Jencks argue for the use of classical motifs and insignia, the system of classical orders and ornament, as the basis for the re-establishment of 'meaning' and 'metaphor' in contemporary architecture. The related stress on a sense of 'place', the sympathetic combination of new with old, and the strength of the conservation movement have not, however, halted the spread of the late-modern glass-curtain-walled office block and the glazed-in shopping mall.

The recent work of Ricardo Bofill spans several types of postmodern architecture. The huge scheme at Val-sur-Marne on the outskirts of Paris, entitled 'Les Espaces d'Abraxas', redeploys a classical surface on modern blocks of subsidised public housing. Concrete abounds, but instead of being grey and flat, it is coloured, moulded and scored, producing half-capitals, architraves, podiums, machiolations and rustications. A spectacular play on classical motifs is in operation, but the rules are outrageously flouted. A set

8 Les Espaces d'Abraxas by Ricardo Bofill, Val-sur-Marne, near Paris.

In *Ricardo Bofill and Leon Krier*, Museum of Modern Art, New York, 1985, p. 5.

of 'columns', for example, is constructed from the glass bay windows of the apartments. 'This building,' Ricardo Bofill has written, 'was conceived as a landmark, a point of reference, a habitable monument in an amorphous suburban context . . . In the 1980s the *raison d'être* of architecture itself appears again: the building of symbols, monuments and archetypes capable of generating pleasure about living in a space.'* But the very scale and grandeur of the project seems as dwarfing to the inhabitants as the plain concrete ramps and walkways of post-war modernist housing. Bofill's eclectic historicism is impressive, yet it is hard not to view the buildings as something created in part for the glossy pages of the international architectural magazines. Postmodern building has nevertheless revived a concern with the *human* element and provided a new richness and complexity in the language of architecture.

The producers of culture have nowhere to turn but to the past: the imitation of dead styles, speech through all the masks and voices stored up in the imaginary museum of a new global culture . . . The situation evidently determines what architecture historians call 'historicism', namely the random cannibalisation of all the styles of the past . . . the increasing primacy of the 'neo'. FREDRIC JAMESON, 'Postmodernism, or The Cultural Logic of Late Capitalism', *New Left Review* 146, London, July/August 1984.

* * * * *

After the development in the 1970s of many strands of contemporary art which were not painting, the re-establishment of painting as a central concern of the art world has been the target of attacks from many artists and critics, who see the conflation of the interests of painters with those of the market as excluding from critical attention performance, video, installation and more overtly progressive work. The 'new painting' of the past decade, signalled by the exhibitions *A New Spirit in Painting* and *Zeitgeist*, has been characterised by an eclecticism of style which draws on both the pre-modern and the modern.* Those exhibitions contained an enormous variety of work, consistent only in a predominantly large scale, and in expressive types of brushwork. The work was united, however, by a common antipathy to the late-modern abstract painting championed by the American critic Clement Greenberg in the 1960s and 1970s. Greenberg's modern art was obsessed with the specificity of painting, with its flatness, its saturation, its colour composition, its emotional depth corresponding to the presumed emotions of the painter. By contrast, the work of Mario Merz or Bruce McLean exemplifies the determination to establish painting in relation either to an aspect of everyday life or to a conceptualised framework of thinking, questioning the modernist presuppositions of the primacy of the individual artist and his or her spontaneous creative impulses.

Conceptual art was a term applied from the mid-1960s describing work which no longer relied on the particular physical qualities of painting or sculpture and tried to resist the pressure of the market to make every work of

9 Georg Baselitz, *Strassenbild*, 1980, at the *Nouvelle Biennale de Paris*, 1985.

'New Painting', like 'Neo-Expressionism', is one of several terms used to denote the exuberant figurative painting that gained prominence in the late 1970s and early 1980s.

art another commodity for sale. It self-consciously questioned the meaning of 'direct' or 'authentic' expression, and was often made from text, drawings or diagrams which stressed the *idea* in art above all else. Although the 'new painting' is a reaction to the aridity of many conceptual approaches, it often itself depends on certain 'conceptual' features and is contrived in ways that involve a conceptualised strategy. The recent paintings of Georg Baselitz have all their subject motifs depicted upside-down, Julian Schnabel often paints on the fractured surface of broken crockery, precluding a coherent image, and Francesco Clemente paints himself at the centre of every metaphor and dream. Their work is expressive while questioning the possibility of 'true expression'; they have formal interests, but they are not formalists. They incorporate fantasy, the 'psychic' and the 'real' as elements to juggle with, and not as subject or object to be experienced and then defined. The desire to speak to an audience, to break with the perceived coldness of much late-modernist, Minimal and Conceptual art, encouraged the desire to make less hermetic works and to attempt the grand statement. But this attempt also has its dangers: at times the grand has become grandiose, and the expressive has approached the bombastic.

By the end of the 1970s it was a common but exaggerated complaint that Fine Art courses in art schools taught more about the wiring of neon lights than about drawing from life or about the properties of oil paints. Much has changed; there is a revival of interest in materials, techniques and subjects that had previously remained in use only in the most academic practices. In Britain, while sculptors like Anish Kapoor, Tony Cragg, Bill Woodrow and Edward Allington extend their range of unconventional materials and techniques, others like Barry Flanagan and Stephen Cox explore the carving of stones and marbles. Flanagan also uses bronze-casting, traditional patinas and gilding; Francesco Clemente and other Italian painters have experimented with fresco techniques; the Germans Georg Baselitz, Anselm Kiefer and Jörg Immendorff work at times with wood-block graphics; Enzo Cucchi, Julian Schnabel and Gérard Garouste create notably dense, painterly canvases, sometimes with sculptural attachments. Throughout this range of styles there has been a new emphasis on drawing as a medium for sketching, for creative planning and for the traditional 'study' before the larger work.

* * * * *

In American sensibility, the past is in museums, or in Europe; the past is largely a fable, something with application to the present, but not really contiguous to it. In most of the rest of the world, however, and especially in Italy, the past is not only contiguous to the present but is congruent with it. HOWARD FOX, 'A New Romanticism in Italian Art', *A New Romanticism*, Hirshhorn Museum and Sculpture Garden, Washington, 1985, p. 12.

A painter sits in front of his easel. Leaning forward, he makes deft strokes with a pencil, reinforcing in one direction, and then cross-hatching to increase the tone in the other. The angle of the pencil changes, switching to

outline and then back to tone, shaping, moulding the face he is drawing. The accessories of drawing and oil painting are stacked around the artist: trolleys on each side of his chair hold charcoal sticks, pencils, brushes, oil tubes, cloths, tins, thinners and a paint-covered palette. The pencil drawing is on cartoon paper pinned over stretched canvas. Canvases of the same size are stacked against the wall behind the easel. The chair and easel occupy the centre of the small square room. Faint pattern lines with foliate corners cover the high ceiling. Bookcases fill the corners; a table and chair are cluttered with books, correspondence and papers. A classical bust of a female head sits among the books, and a skull sits among the paints on the trolley.

Carlo Maria Mariani works in a studio which is part of his apartment in Rome. The canvases are a set of portraits of contemporary artists and art world figures, each portrayed in a particular costume. Francesco Clemente wears an Indian turban and holds a small bird, Paul Maenz wears Goethe's famous wide-brimmed hat, Jannis Kounellis holds a dagger and Greek mask, and Sandro Chia, Mimmo Paladino, Roy Lichtenstein and Mario Merz are all dressed appropriately. On the easel Andy Warhol stares out imperiously from under his shock of white hair; he wears the costume and cloak that Napoleon wore at his coronation as Emperor.

Two figures look out from a canvas. One again wears Goethe's hat, the other wears the hat that was associated throughout his life with Joseph Beuys. They are depicted in a neo-classical style, a kind of formal realism where every fold, drape, shadow and even leaf is in place; not naturalistic but composed. Behind the figures in *Deutschland, Deutschland*, 1985, is the pyramidal monument from the English Cemetery in Rome, a place where Mariani often goes to draw.

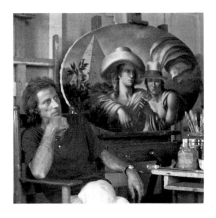

10 Carlo Maria Mariani with *Deutschland, Deutschland*, 1985.

The only means of becoming great and, if possible, inimitable is by imitating the ancients . . . For me the opposite of independent thought is the copy, not the imitation: by the former I mean servile servitude; by means of the latter, what is imitated, if it is done with understanding, may assume almost another nature and become original. J. J. WINCKELMANN, quoted in Italo Mussa, *Carlo Maria Mariani*, De Luca Editore, Rome, 1980, p. 113.

In a larger painting, *It is Forbidden to Awaken the Gods*, 1984, two muses, or artists, are asleep. Each has a brush in his hand. They lie with putti at their side among some vast antique sculptures: a veiled head and a massive stone hand. The scene is like a stage setting with evanescent, luminous lighting. A third painting shows a seated artist with laurels adorning his head. With his right hand he holds a baby upside down. In his left hand he holds a brush and is putting the last touches to the image of the baby. The unfinished baby looks startled. A soft glow surrounds the illusion of *Il Pittore Mancino* (*The Left-Handed Painter*), 1983.

If we look at the American artists in the sixties, the exponents of Pop Art, they were taking advertising, this saturation of images, and making an artistic statement out of them. But, as far as I am concerned, personally, it is something I want to go beyond – I don't want to be involved in the chaos. I want to try and recover the precious

CARLO MARIA MARIANI

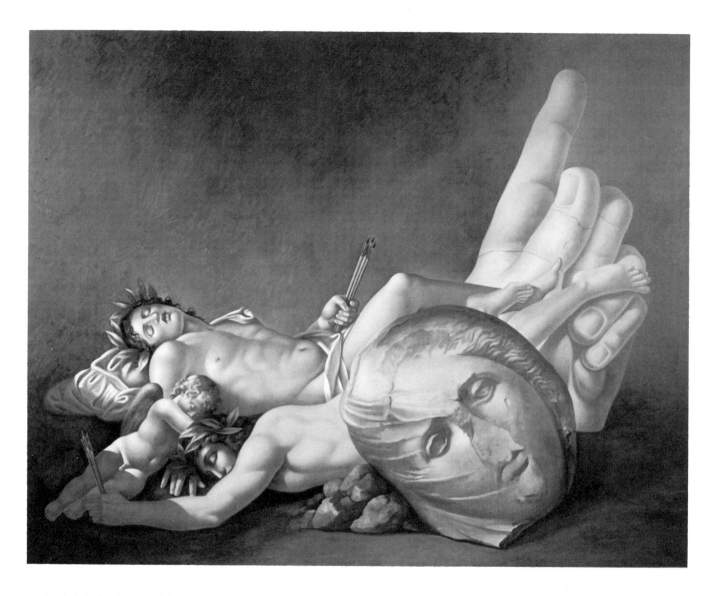

11 Carlo Maria Mariani, *It is Forbidden to Awaken the Gods*, 1984.

individuality of us poor mortals in order to conquer, rediscover, the world outside us.

My work reflects my interest in a particular historical period, that is, the last decade of the eighteenth century and the early years of the nineteenth. My interest in this period isn't purely artistic, but also social and political, and it is something very private and specific to me, this great admiration, this great love I have for this time.

This is a period I have always felt immensely drawn to. Above all, the artistic production that came out of this period: the retrieval, the recovery of beauty, the sense of nostalgia for a past which could be reclaimed, and the melancholic nature of this nostalgia – the great poetry, shall we say, the great style and elegance of this period. I am aware of this also being the time of the birth of modern artistic thought.

Does Carlo Maria Mariani really want to *be* an early nineteenth-century painter? Can his allegorical and classical references be understood by a contemporary audience? Why should an artist living in the 1980s want to make such work, whether defined as neo-classical or mannerist? These questions have been raised not only in relation to Mariani's work and that of the other artists in the *Pittura Colta* group whose spokesman is critic Italo Mussa, as well as that of the artists in the *Anachronisti* led by critic Maurizio Calvesi, but also in relation to work made by Stephen McKenna in Germany, Christopher LeBrun in Britain and Gérard Garouste in France.

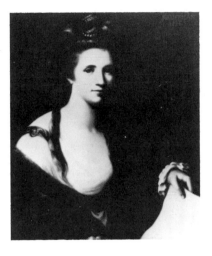

One answer is that for all of them painting is both a vehicle for developing ideas about painting and a vehicle for ideas in visual form. The traditions of painting are such that emulation and reworking have long and distinguished histories. Indeed the continuity of painting as a practice partly arises from the fact that certain subjects and ideas recur. The neo-classical period in European culture was an attempt to comprehend the culture of ancient Greece and Rome, and to use certain strands of its thought and images in current painting, sculpture, poetry, architecture and even clothing. It was a massive cultural project, in which the ancient civilisations were re-erected as the epitome of what civilised life might become. For a Roman in the early nineteenth century, of a certain class and status, it was a matter of discernment and distinction, and a matter of values.

In the 1970s Mariani developed an interest in Angelica Kauffman, an English painter who studied under Sir Joshua Reynolds and spent many years in Rome. She and Mary Moser were the first women members of the newly founded Royal Academy of Arts in London. The interest stemmed from a series of conceptually orientated works in which Mariani 'completed' unfinished portraits and paintings. Mariani postulated that Kauffman might herself have liked to have completed an unfinished picture of St Jerome by Leonardo da Vinci that she owned. Mariani completed this work for her. In a letter he wrote:

12 Carlo Maria Mariani, *Imaginary Self-Portrait of Angelica Kauffman*, 1976.

Unfortunately, I was born too late, and it is a bitter disappointment not to have known you personally. And not having you near, I couldn't have you tell me why you never carried out your plan.

Thinking along these lines, I decided to carry out your hypothetical project, and I give you proof of it here, hoping it will please you and dedicating it to your memory.

Finally, I would like to express again my admiration and my thanks for the things

you have taught me to understand by looking at your drawings and your works, and for the joy I have had by immersing myself in the memory of that delightful and tasteful woman you were on earth.

I greet you warmly, yours, Carlo Maria Mariani

Rome, February 16, 1976*

In Italo Mussa, *Carlo Maria Mariani*, p. 104.

CARLO MARIA MARIANI

I found fascinating the way in which she was held in such great esteem, which was extraordinary for a woman living in those times, and she seemed to have such an important role socially as well. I felt that she was not only a very nice person, but that she had made a masterpiece of her whole life, and so I was led to look at her way of working, her way of painting, and all the time I admired the fact that she was a woman artist – it has always been so difficult for women to succeed – and so at the same time I hoped that my interest in her would revive her memory so that she was not forgotten.

I feel that it was a time more than any other when certain qualities, certain virtues – aesthetic sense, beauty, humility, nobility – were exalted, and to me it was a very positive time, a period of great enlightenment. I don't think it is unusual for artists to turn back to a period which they find fascinating and which they take as a model. For example, look at Delacroix's great love for Rubens.

It isn't unusual to feel discontent with the times you live in, and I'm not the only one to feel this way, but in my case I have always felt drawn to the past, it has always had a strong attraction. Maybe it is because we seem to have lost our sense of values, and that somehow by going backwards, if only mentally, I think I can regain them. I suppose it is an escape. But I am not running away from a determinate time, but from any time – I am trying to be as timeless as anyone could possibly be.

My discourse is extremely serious, but of course there is undeniably a subtle unconscious irony in the works, which indeed the critics have pointed out, and this irony is probably something to do with wishing, dreaming for something which you know could never be possible.

I could be accused of using rhetoric, which I don't think is in my work. I certainly don't mean this to be the case. In one of my paintings I have painted the victorious athlete, but I did not mean to exalt him.

I haven't any heroes. I don't really believe in them. I must cite Brecht who said, 'Blessed are those who have no need for heroes.' They can be dangerous, can't they?

I can see that the use of the classical, and particularly the idea of heroism, can run the risk of becoming nationalistic polemic, rhetoric, but in my case this has never entered my thoughts, and has never been my intention.

It was Goethe who said, 'Every good idea has already been thought: suffice it only to think it again.' Mariani's work proposes exactly this kind of continuity between the past and the present. But in doing so there is a sense of loss, of frustration and disappointment. The past becomes a form of archaeological resuscitation. Mariani's ideals are personal and particular, and he incorporates irony into his relation with his works. It is less certain that a gallery or museum audience will read the irony he intends, and the work is always in danger of being perceived as no more than a bizarre 'reproduction' of the neo-classical values of the late eighteenth century.

* * * * *

HISTORY

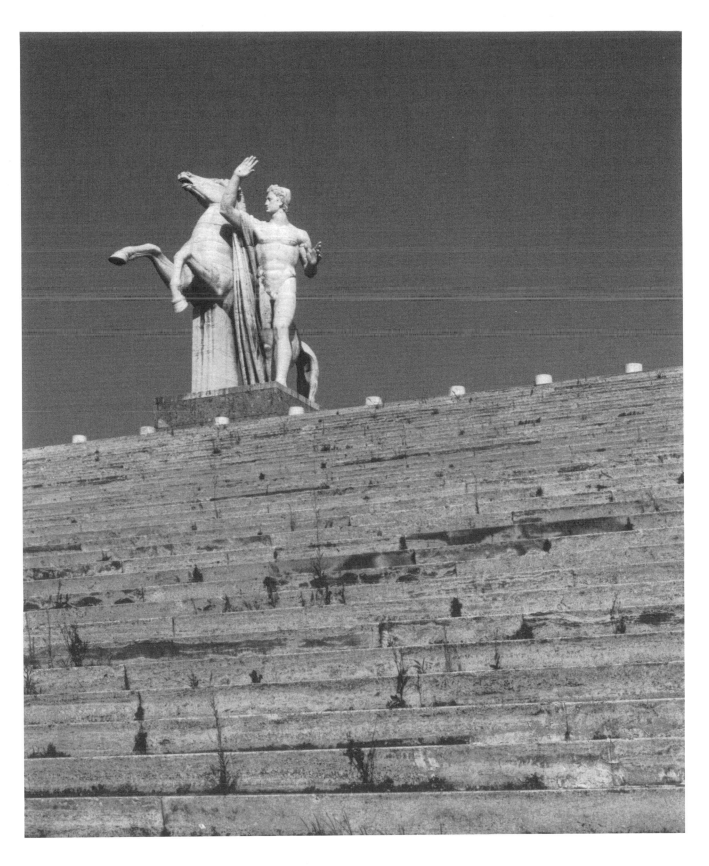

13 EUR, one of Mussolini's building
projects in Rome.

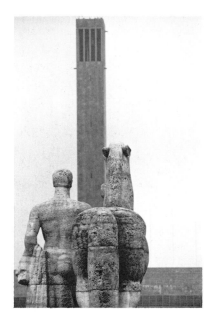

14 Sculpture and belltower at the Maifeld, West Berlin.
15 Stadium for the 1936 Olympics, West Berlin.

The rhetoric which accompanies this resurrection of painting is almost exclusively reactionary: it reacts specifically against all those art practices of the sixties and seventies which abandoned painting and coherently placed in question the ideological supports of painting, and the ideology which painting, in turn, supports. DOUGLAS CRIMP, 'The End of Painting', *October* 16, New York, 1982, p. 74.

For almost all fascisms – precisely because they were so nationalistic – looked back to the past and desired both to revive some bygone age of glory and to prove their movements to be the culmination of their country's history . . .
 In Western Europe, this desire for a return to a pre-industrialised and pre-French Revolution society, where hierarchy was respected and social stability assured, offers yet one more contradiction in movements which claimed to embody the true future. STUART WOOLF, *Fascism in Europe*, ed. S. J. Woolf, Methuen & Co., London, 1981, pp. 9–10.

The search for the past is double-edged. On one hand the revival of traditions, the revitalisation of myths and the retention of cultural knowledge have been basic to the freeing of any society from oppressive control. The recognition of the worth of any specific history helps establish independence, and the deeper comprehension of a culture provides the basis for a critique of current actions and policies. On the other hand the past can be grossly distorted for repressive ends. Art can play a role in both of these processes.
 In the 1920s and 1930s the revival of classical forms and styles affected architecture and art across Europe and America. However, in Italy and Germany, classical style was combined with the insistence of an extreme hierarchical order to produce massive building projects, and to help formulate the restrictive physical ideals of the citizen of a totalitarian state. The paintings and buildings, and by association the *styles*, became branded as the objects in which fascism was felt to reside; they seemed contaminated and debased. The current restaging of academic and neo-classical styles of painting, and the suspicion of an implied 'call to order', has caused clashes inside and outside the art world. The prominence and popularity of the new and historicist painting make its ambiguities more significant, and necessitate a critical engagement with its various ironies.

We are living in an age of skepticism and as a result the practice of art is inevitably crippled by the suspension of belief. The artist can continue as though this were not true, in the naive hope that it will all work out in the end. But given the situation, a more considered position implies the adoption of an ironic mode. THOMAS LAWSON, 'Last Exit: Painting' (1981), reprinted in *Art After Modernism: Rethinking Representation*, ed. Brian Wallis, New Museum of Contemporary Art, New York, 1984, p. 164.

Karl Marx's statement that the 'tradition of all the dead generations weighs like a nightmare on the brain of the living' is a telling premonition of much of the twentieth century. Two world wars have involved mass conscription, and brought the bombardment of civilian populations and the extermination of millions. In every country, the post-war period of regeneration involved convolutions of historical construction. In West Germany writers, artists

HISTORY

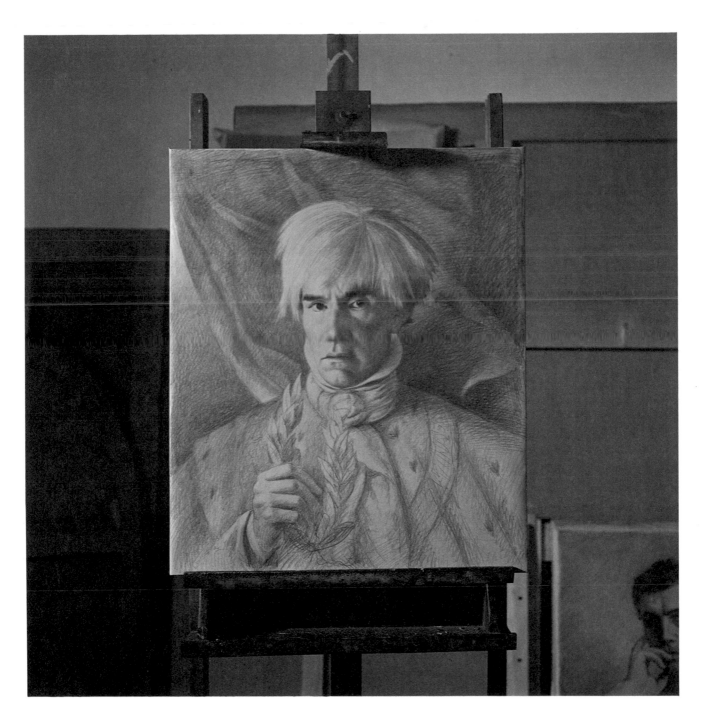

16 Carlo Maria Mariani, *Andy Warhol*, 1985. Warhol wears the coronation robes of the Emperor Napoleon.

and filmmakers turned away from 'Germanic' or 'Teutonic' associations, and as in most of Western Europe, American cultural influence was paramount. From the 1950s on American styles swept through the art world: Abstract Expressionism, Post-Painterly Abstraction, Pop Art, Minimal Art and Super-Realism. It was probably not until the 1960s that the ascendancy of national socialism and Hitler's rise to power, the elements of an 'unacceptable' past, could reasonably be assimilated within education and schooling.

One of the greatest values of Joseph Beuys's work in Germany was that it countered the ascendancy of American models and drew attention to regional, national and European sources. Beuys's work was about himself, but the myths that he incorporated or regenerated, the narratives that he implied, made clear reference to his existence as a German citizen with a particular history, living in European and Celtic traditions. His own struggles against the rigidity of the educational system and his promotion of ideas of direct democracy were explicitly formed in reaction to the post-war West German state. Anselm Kiefer, a student of Beuys, is an artist of a younger generation who, together with Georg Baselitz and Markus Lüpertz, was first perceived primarily as a provocateur in his associations with the repressed national past. Kiefer's work was seen only in terms of his references to Wagnerian heroes or fascist architecture; Baselitz's in terms of the ambiguity of his rebel-heroic figures; and Lüpertz's in terms of his stylised helmets and war machinery. As Sylvere Lotringer wrote, 'There's a feeling, especially among the young generation, that they have to deal with something that they don't quite feel responsible for but they don't quite know how to get rid of.'*

In *Semiotexte, The German Issue*, New York, 1982, p. 72.

The unanimous condemnation of Kiefer's exhibition at the 1980 Venice Biennale by the German art critics says more about their own fear of involvement than it says about the paintings. They believed that in Kiefer's images they were looking at history, yet the light from these images is refracted by his insight that the course of history can be perverted by ideology. They thought they perceived 'an overdose of Teutonic zeal' when in fact it was they who were introducing the Teutonic spirit.
GÜNTHER GERCKEN, 'Figurative Painting after 1960', *German Art in the 20th Century*, Royal Academy of Arts, London, 1985, p. 476.

The painting depicts a large courtyard. The courtyard is formed by a colonnade. The columns are square, built from large blocks of stone with flat unadorned fronts; the effect is strict and severe. In the middle of the courtyard an artist's palette appears to be mounted on a stand. The courtyard scene is painted in thick impasto paint, predominantly black and white, the columns yellowy-ochre and the sky black and grey with fragments of yellow straw pushing through the surface of the paint. Varnish is partially applied making some parts more liquid and other parts more solid. The palette seems to be floating, a central focus of the painting, a reference back to its production and a fragile monument to artistic freedom in the face of an authoritarian system. This painting and its studies make reference to the *Kyffhauserbund*, the German Imperial veterans' league. The depicted architecture was constructed by Anselm Kiefer, who drew on neo-classical

HISTORY

work by Boullée and Ledoux, work that the Nazi architect Albert Speer himself drew on. It was Speer who designed the German Pavilion for the Venice Biennale, the building in which Kiefer's paintings first reached international attention.

Kiefer's painting *Sulamith*, 1983, contains a more specific architectural reference. There are flames in the fireplace at the end of a dark, cavernous hall, but black painted papers cover the flames that might appear in torches between the massive vaults. The word 'Sulamith' is written across the painting. The architectural source is Wilhelm Kriess's massive crypt-like memorial building, the Soldatenhalle in Berlin, and Kiefer points out that Kriess was much influenced by Gilly, the teacher of Schinkel, who himself drew on much Egyptian material.* The name Sulamith appears in several other paintings, in combination with the name Margarete; the Jewish and the Teutonic side by side. This is not a generalised association but a close link with Paul Celan's poem 'Death Fugue' written in 1945. The poem is a metaphoric depiction of Auschwitz. Celan, from a Romanian Jewish family, had managed to escape while his parents were taken to an extermination camp. The second half of the poem runs:

Information from conversations with Anselm Kiefer, August and November 1985.

Black milk of daybreak we drink you at night
we drink you at noon in the morning we drink you at sundown
we drink and we drink you
a man lives in the house your golden hair Margarete
your ashen hair Shulamith he plays with the serpents

He calls out more sweetly play death death is a master from Germany
he calls out more darkly now stroke your strings then as smoke you will rise into air
then a grave you will have in the clouds there one lies unconfined

Black milk of daybreak we drink you at night
we drink you at noon death is a master from Germany
we drink you at sundown and in the morning we drink and we drink you
death is a master from Germany his eyes are blue
he strikes you with leaden bullets his aim is true
a man lives in the house your golden hair Margarete
he sets his pack on to us he grants us a grave in the air
he plays with the serpents and daydreams death is a master from Germany

your golden hair Margarete
your ashen hair Shulamith*

In *Mohn und Gedächtnis* (1952) and *Paul Celan: Poems*, trans. Michael Hamburger, Carcanet New Press, Manchester, 1980, pp. 51–3.

To name or picture something, even a taboo subject, is not to endorse it. Kiefer's references are to historical figures, to places, to literature, to architecture, to landscapes and to myths. They are references and not celebrations. In conversation he explains that he hopes that he knows what is good or bad, but that his works do not *say* what is good or bad. He sees himself as 'bringing to the light things that are covered, that are forgotten'. He regards this as part of a painter's job, but refuses to moralise himself. His earlier woodcuts and paintings of 'famous heads', his overlaying of names and places across ploughed and burned landscapes, his earliest performances, his references to old songs and refrains were found difficult and

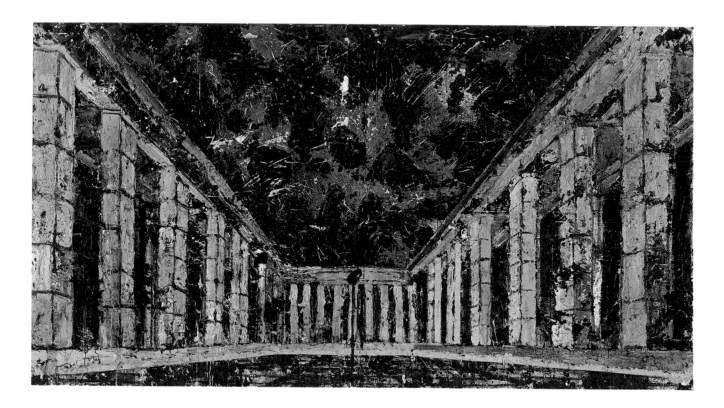

17 Anselm Kiefer, *To the unknown painter*, 1983.

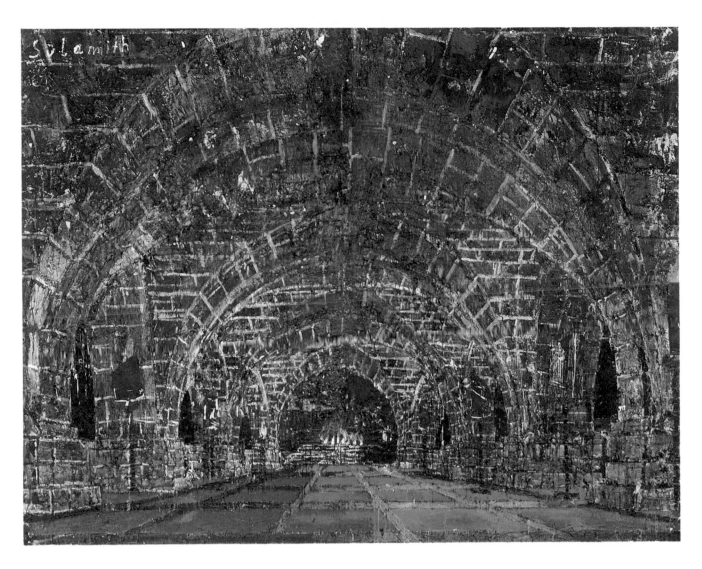

18 Anselm Kiefer, *Sulamith*, 1983.

disturbing by some of the German art world even before he made reference to Nazi architecture or to Hitler's military campaigns.

Two ideas are essential to an understanding of Kiefer: that of painting as painting, as a kind of ritual activity, and that of painting as conveyor of the content of tradition and the national cultural heritage. Every fibre, every particle of material in Kiefer's works is simultaneously a painterly medium and a vehicle loaded with personal, mythic and historical meaning: straw is the relic of earth and harvest, threatened by fire, and, when cast as Margarete's hair, the stuff of Teutonic myth; sand is the sand of the Brandenburg Marches, where the writer Theodor Fontane once wandered and where Kiefer now seeks the spirit of the earlier artist; birds' wings are wounded nature, or emblems of the free flight that is also boldly symbolised in these heavily ballasted paintings by an airborne palette . . . Kiefer's paintings definitively open up the hornet's nest of German repression of history, and this achievement must be stressed. Yet to reduce the work to such a 'politicum' will not do. ANNELIE POHLEN, review in *Artforum*, New York, October 1984, p. 99.

Some of Kiefer's most famous paintings are landscapes. One series started in the 1970s refers to the Brandenburg Marches, with names written on the canvas – the places visited by the German writer and critic Theodor Fontane and recorded in *Walking Tours through the Brandenburg March*. The views depicted are not from Brandenburg, which Kiefer has never visited, but from the undulating land of the Odenwald, south of Frankfurt, where Kiefer lives and works. These paintings start from photographs (as do many of Kiefer's works, most obviously the photographic books, bound by the artist, which follow sequences in the landscape or record special installations made in the studio) and in some the photograph is retained on the surface of the canvas. Brandenburg is significant because, as the central area of Prussia, it was the base of the Bismarck regime and the powerhouse in the unification and militarisation of Germany. The landscape paintings incorporate sand and straw with the paint and shellac; the burning of the stubble becomes associated with cyclical renewal, and with 'scorched earth' as a military strategy.

'Scorched earth' is a technical term used by the army. Troops in retreat burn the area they are leaving behind so that the enemy will not be able to produce on this land anymore. When applied to painting, this does not mean that I want to illustrate a regular military operation, but that I wish to portray the present-day problems in the art of painting. If you wish, you can view it as the new beginning which each painting must make again, every time. Each artwork destroys the one that precedes it. The earlier artworks still exist, but no longer for the artist. They live on in the museum and take on a different character. ANSELM KIEFER, interview with Jörg Zutter (1978) reprinted in *Carnegie International*, Carnegie Institute, Pittsburgh, 1985, p. 160.

Kiefer's home landscape, part open, part forest, straddles the Limes Line, the ancient demarcation between Hunnish territory and the Roman Empire. The woods are dotted with the tidied and signposted remnants of forts and lookout posts. Driving out from a nearby village one finds an abandoned tank. It sits in the snow at the edge of the field, not more than twenty years old, abandoned perhaps from a military exercise, its gun pointing absurdly

19 Abandoned tank near Buchen in the Odenwald.

20 First World War memorial, near Buchen.

towards the sky. After a cold night the tank is covered in hoar frost, white lines etched across the surfaces of the rusting metal. As you stand in this landscape you become aware of a regular drone. Every nine minutes a faint but persistent engine noise passes overhead; NATO reconnaissance planes circling at high altitude. In this militarised landscape the church bells ring out across the snow. Next to each church is a memorial to those killed in the First War. There are no memorials for the Second War.

The large exhibition of Kiefer's work at the Kunsthalle, Düsseldorf, in 1984 (which travelled to Paris and Jerusalem) prompted further debate about his work. His success in the American market, despite the fact that he has no fixed arrangement with a dealer and keeps as much control over the sale of his work as possible, was followed by his sharing the medal at the prestigious Carnegie International in 1985. If the reception of his work in Germany has been ambivalent, in America it has ranged from adulation to sharp criticism. Donald Kuspit refers to Kiefer's use of paint as 'like the use of fire to cremate the bodies of the dead, however dubious, heroes, in the expectation of their Phoenix-like resurrection in another form' and goes on to refer to the new German painters as performing 'an extraordinary service for the German people. They lay to rest the ghosts . . . of German style, culture and history . . .'* Meanwhile the art historian Benjamin Buchloch, referring to the American critics who 'celebrate the "Germanness" of German *angst* in painting', regrets that 'seldom do they (or, of course, the paintings in question) reflect upon the *real* fears (and practices of protest) brought on by

'The American Case Against Current German Painting', *Expressions*, St Louis Art Museum/Prestel Verlag, 1983, p. 46.

21, 22 Anselm Kiefer, *Wayland's
Song (with wing)* and detail, 1982.
The painting is composed of oil,
emulsion and straw on
photographic paper and canvas,
with attached lead wing.
23 The Odenwald, winter 1985.

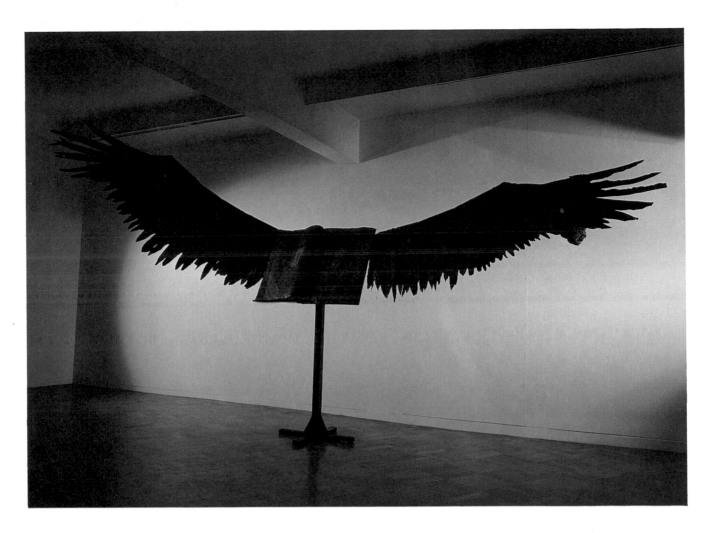

24 Anselm Kiefer, *Das Buch*, 1985.
The width is almost five and a half
metres.

Postscript to 'Figures of Authority, Ciphers of Regression', *Art After Modernism: Rethinking Representation*, p. 132.

the aggressive policies of the Reagan administration and by the deployment of missiles on the territory likely to be the first "war theatre".* Kiefer plays no direct part in such debates; he refuses all interviews (including the request to speak in *State of the Art*), and equally refuses all photographs of himself and prevents any photographs being taken of his studio other than his own.

Kiefer himself cites as intelligent the debate that surrounded the exhibition of his work at the Israel Museum in Jerusalem. He was the first contemporary German artist to be accorded a one-person exhibition in this museum. In the *Jerusalem Morning Post Magazine* Meir Ronnen wrote: 'In murdering the Jews, we Germans, thus Kiefer might be translated, have murdered a part of ourselves . . . But mourning might be the key to the psyche of Kiefer. It is not a mourning comparable to the mourning of the Jews of our times. Kiefer seems to be mourning the indigestibility of his heritage by battling with it in an ongoing series of waking dreams.'* Significantly Kiefer has returned to Israel several times since the exhibition, and his recent works have developed his interests in the Jewish mythology of the Kaballah, cosmology and alchemy.

Jerusalem Morning Post Magazine, 27 July 1984.

When I cite Richard Wagner, then I do not mean the composer of this or that opera. For me, it is more important that Wagner changed, if you will, from a revolutionary into a reactionary. I also mean the phenomenon – Wagner. The way in which he was used in the Third Reich and the problems in connection with this. Why, in fact, was it possible to use him then and to offer him to the people in such a primitive way? You must assume that a part of what they made of him was present in his work. In the person Wagner, extreme possibilities are unified; also the phenomenon of [the] use and misuse [of these possibilities] . . . ANSELM KIEFER, interview with Jörg Zutter, 1978.

The visual power of the paintings, their scale and use of different materials, is matched by Kiefer's lead sculptures: a winged lectern with book and a winged palette. The wing is a symbol used in a number of paintings, most notably in *Wayland's Song (with wing)* which has an actual lead attachment. Kiefer works on paintings and sculptures for several years, keeping full a huge studio space (a far from romantic disused factory on the edge of a small industrial estate). Against the walls, and on the easels, are partially worked canvases. Gas apparatus for melting lead, and soldering and welding equipment, stand about. The floor is littered with large-scale wood-block prints, the tables are covered with photographic prints; from the ceiling hang bunches of herbs and grasses. The art world builds myths about such an isolated figure, and can view Kiefer as a kind of 'History' painter;* as he says, history is a material to be used like colour, as part of a complex mix of materials, references and associations that fill his paintings as he works and reworks them. He does not think of history as a line, nor so pessimistically as a circle repeating itself; but he believes that the world is better off without a united Germany.

History painting was traditionally the most prestigious and public genre with subjects taken from mythology, ancient history and Christian iconography.

* * * * *

HISTORY

Around the studio are several large canvases; some completed, some being worked on. Between the large canvases there are smaller works, tables covered with watercolours and drawings, others with small sculptures and notes, and a desk cluttered with correspondence, notes, photographs, invitations and information. Above the desk is a pinboard with photographs, of Jörg Immendorff with his former tutor Joseph Beuys, with A. R. Penck and with his dealer Michael Werner, next to an image of Chairman Mao stitched on cloth, an anti-nuclear sticker, notes, galley proofs, and a business card from Immendorff's own Café Dora in Hamburg. In the middle of the studio is a large palette on wheels in the shape of an imperial eagle, an oversize set of wooden steps from which to paint with a monkey holding a paintbrush painted on the side, a set of aluminium café chairs next to the desk and several cats which appear, then disappear to the artist's apartment above.

On one of the largest canvases a demonic ghost figure in blue is holding luminous paintbrushes; behind him a lecturer is being pelted with tomatoes by his audience; behind the lecturer an eagle has been crucified with paintbrushes. On a table to one side of the ghost figure is a naked girl, and on the other side the suited figure of Immendorff (all the male figures seem to be portraits of Immendorff); an ape's head appears in the upper left corner. Another canvas shows Immendorff working with an ape on his back, painting over his shoulder.

Electric Painting, 1985, shows a studio space filled with 'electrified' Roman standards, each displaying one of the motifs that Immendorff has made his own: his version of the Brandenburg Gate, a watchtower, and a tank poised on the legs of a combined set of compasses and thumbscrew (a reworking of East Germany's emblem); each 'standard' is glowing neon bright. Within the canvas the artist can be seen on one side of the depicted studio kneeling down to finish a picture of Hitler. Behind him is the Moulinex food cutter that Immendorff uses to carve polystyrene for his sculptures. Another large painting shows Hitler crucified, paintbrushes through his palms. Behind, a cauldron is bubbling, with a small Brandenburg Gate sinking into the boiling liquid.

While a student at the Düsseldorf Academy of Art in the late 1960s, Immendorff set up his own academy, the LIDL academy, merging his painting with anarchist politics, performances and events. Throughout the 1970s he worked as a secondary school teacher and until the mid-1970s remained committed to a Maoist viewpoint, painting canvases closely related to his view of political struggle. An encounter with the work of the Italian artist Renato Guttuso in 1976 crystallised his changing views. He shifted the emphasis in his own work to a more personal view of history and started the *Café Deutschland* series.

25 Jörg Immendorff in the Revolution 71 discotheque, Düsseldorf, the original setting for *Café Deutschland*.

26 Jörg Immendorff, *Electric Painting*, 1985.

27 Jörg Immendorff, *Café Deutschland IV*, 1978.

I do want to rake things up. I want to communicate something of the unease, the critique within me. In that sense I suppose I'm one of those people unable to deny their background in the events of 1968. When I think of the demonstrations, the confrontations with the police, the strength of feeling at big events, where I even made speeches, it seems to me that there was always a sensual dimension to it. It was not just cold political conviction; I always saw things as an artist. For me it was always a matter of defining the place where we were as a place of sensual experience, and that is why I chose, for instance, this discotheque or that café: because it was an authentic place.

The project Café Deutschland *was prepared some years ago. When you consider that in my pictures in the sixties I dealt with German emblems, with state symbols, in a – let's say – somewhat anarchistic, anti-authoritarian way, in a rebellious manner, then the preparation time was lengthy. However, my perception became more acute in considering the work of Guttuso at a biennial in 1976 in Venice, where we had adjoining spaces. The picture* Café Greco *on which the series is directly based was not included; I saw the original of that later.*

In the seventies I felt I belonged to a certain political line of thought, that is, one which laid down a certain role for art in the service of certain political beliefs. Guttuso, too, thought this, as a member of the Communist Party of Italy, and is, up to this day, a Communist Senator, I think, in Rome. I was in a different political position and both times I gave a counter-presentation, so to speak, and I set my café against Café Greco *in a conceptual manner. As I'm German I didn't call my café* Café Düsseldorf *or anything like that but* Café Deutschland *and filled it with those things which I was concerned about and with which I was involved.*

The international success of Jörg Immendorff's *Café Deutschland* series of paintings, like many recent successes in the art world, seems to satisfy the criterion of both left and right. A tradition-rooted nationalism is combined with a sense of opposition (something perhaps felt lacking in the angst-free German expressionism). ROSETTA BROOKS, 'I'd Like to Buy the World a Coke . . .', ZG 13, London/New York, Spring 1985, p. 6.

28 Renato Guttuso, *Café Greco*, 1976.

The series of paintings starts with the story of his meeting with A. R. Penck (one of several artistic pseudonyms used by the East German Ralf Winkler). Whereas Renato Guttuso's famous *Café Greco* painting (now owned by the collector Peter Ludwig and for several years on loan to the Altes Museum in East Berlin) shows a number of key historical figures seated together, Immendorff's work brings famous people together with his more personal and symbolic scenario. In each painting several scenes are combined so that a *single* narrative structure is hard to follow. In *Café Deutschland – Winter*, 1977, Immendorff and Penck are reaching through the stones of the Berlin Wall which is covered in ice and snow: on separate sides are the signs 'BrrD' and 'DDrrr'. In *Café Deutschland I*, 1977–78, the original architectural setting of the discotheque (the 'Revolution 71' in Düsseldorf, where Immendorff used to spend time) is most evident. The artist sits at the bar; he also has a hand stretching through the Wall at the front of the scene; Penck is mirrored in the central column. Behind them is ecstatic dancing, with a huge eagle and swastika next to the dance floor. In *Café Deutschland IV*, 1978, the two artists are seated at a table, both painting. They are painting a trap door. Green-

coated figures stalk through the café carrying boulders. A wolf–demagogue is speaking from a pedestal; at some tables listening equipment is being monitored, at another, a telephone. Someone is reaching for a book by Heinrich Böll from a shelf; next to it is a volume by Brecht. The right-hand side of the café is cut off with barbed wire, binoculars stare through. Overhead, coated figures walk, some holding rocks.

*I can remember our first meeting. It wasn't possible to have a rational discussion but we communicated with drawings. There were the symbols, one of us came from the East, one from the West, but it works, there is a point to it, it can arouse new energies. Then later, of course, came the personal friendship. The symbol now is dead because Penck is now in the West, but our friendship has remained.**

JÖRG IMMENDORFF

A. R. Penck emigrated from East Berlin in 1980. He lives in London.

I think he was under just as much pressure as I was, even if there were more police over there and it's more liberal here. Here I can go, say, to Spain. The external, the shell is the difference, but the individual pressure, that is, whether I am pressurised by Stalinism or bureaucracy over there or over here by overstimulation, by excess supply which paralyses the brain, was equally tormenting in its intensity. Because it was so tormenting, because the pressure was so great, it also had a strong counter-pressure, a strong creative impulse, like a volcano, an eruption. If you are held back and you still have some remains of what should make up a person, a will to resist and the yearning for freedom, then this yearning will become particularly strong and then it's only a matter of finding a specific medium, which for the two of us was painting.

When the pictures are hanging on the wall I no longer consider it to be important for people to know who is portrayed in them. Is it Robert Havemann who, let's say, is running through a barbed wire fence or is it Bert Brecht? They are rather representatives for other positions, because the positions of the special figures express themselves in the pictures also by way of stance, by way of colour, how they stand in relation to other figures.*

A distinguished East German academic and advocate of free speech.

There is no exposé, no unmasking in Café Deutschland. Café Deutschland is an expansion, an acknowledgement of the motifs and commonplaces presented by the media, the popular ideologies, the current historical and political debates. DIEDRICH DIEDERICHSEN, 'On Immendorff', *Café Deutschland Gut*, Wolfgang Wittrock, Düsseldorf, 1983.

Immendorff emphasises that close narrative readings of the paintings are not intended. It is work generated from his own experience, containing personally 'authentic' information about contemporary social and political life. It is symbolic, and active, but not didactic.

I mean painting is not only form, or rather is not only content, but is also form, and who knows where the dividing line is.

JÖRG IMMENDORFF

In 1982 Immendorff completed a massive bronze sculpture entitled *Brandenburg Gate*, which was exhibited at *Documenta VII.** Four 'columns' are set in a base depicting a flattened eagle and an ice drift. The first column is the tank with the compass and thumbscrew. The second column is a watchtower with figures on top. The third column is made of the four horses of the

A quadrennial international exhibition of contemporary art held in Kassel, West Germany.

29 Jonathan Borofsky, *Running Man*, 1982. Painted on the Berlin Wall at the time of the *Zeitgeist* exhibition.

30 The Berlin Wall.

HISTORY

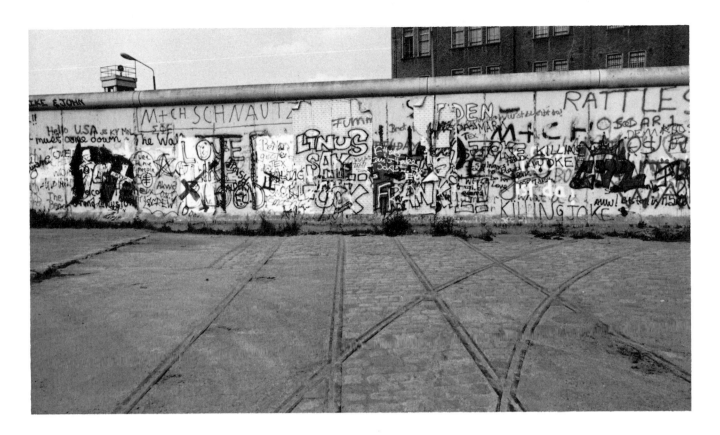

31 The Berlin Wall.
32 Jörg Immendorff, *Brandenburg Gate*, 1982–83, in the yard of the transport firm Hasenkamp, Cologne.

original Quadriga falling down; Rosa Luxemburg's face appears on one side. The fourth column is an eagle with a paintbrush round its neck. On top the ice melts over the snow; two pairs of cymbals (Penck is a free-jazz musician who often plays drums) squash an eagle and another pair of compasses.

JÖRG IMMENDORFF

The Brandenburg Gate *appeared many years before it was realised in bronze – in pictures, in the most diverse variations. It was for me like something concentrated, something compressed, and it was meaningful to me because it is the central symbol for partition, as everyone knows who knows Berlin or has read the newspapers about this. Seeing that the Brandenburg Gate can no longer be used for its intended function, that is, that one can no longer pass through it, it was more a symbol of opening and also a symbol of connection between West and East. I said that the old one doesn't work any longer so I'll make a new one, a new one corresponding to the situation, a bit evil and somewhat desolate. One sees that the pillars have been shaped differently, that they are no longer exalted and neo-classical, but every pillar contains something special. The roof, for example, is an ice floe. On one pillar, the Quadriga horses have crashed from the roof, and Rosa Luxemburg is portrayed above the chariot.*

I insist that with present-day involvements which cannot be cut off, the solitary German question does not exist. And I have always attached importance to the fact that I've taken up this so-called German problem – that is, the partition, the schizophrenia, the division – as a symbol, not as a regional artist getting on everyone's nerves, always on about the Berlin Wall and the two Germanys, but as a symbol. I tell everyone who can take it and who can face up to it, 'You are schizophrenic, I am schizophrenic.' But I want to use that as a constructive element. I want to have the struggle of the two worlds within me, or within Germany, or on a global scale, to be understood as a constructive struggle.

33 Brandenburg Gate from the west, Berlin.

Immendorff is now an internationally successful artist who devotes himself to painting and sculpture, and only occasionally does guest-professor work in an art school. He sees the past as a component in the present which has to be struggled with. History is a series of questions within present political dilemmas, ultimately a number of moral questions. He distrusts political parties of the left or right, follows no party line, but is committed to holding these moral questions of personal freedom and collective responsibility at the forefront of his work.

JÖRG IMMENDORFF

I haven't become more rational in my work, it's still about rights, about pleas, about symbols. Except that I say nowadays that I'm perhaps much more political in the sense that – what many people don't understand – I have returned to my self much more honestly in order to behave more openly, more intimately towards other people. That's what's different.

I can't simply ignore history. I look to it in order to find the causes of all the things I find difficult, mysterious and unresolved today. Of course, I am also interested in questions concerning the future and, as the present doesn't seem to offer any solutions, a more intensive study is necessary, which means I must go back to history.

* * * * *

HISTORY

Berlin is not only Berlin, but is also the symbol of the division of the world, and something even more: a 'point in the universe', the place in which the question of a unity which is both necessary and impossible confronts every individual who resides there . . . The problem of division – of fracture – as Berlin poses it not only to Berliners, not only to Germans but, I believe, to every thinking human being – and it does so in an impelling, I mean painful, way – is a problem which we are not capable of formulating adequately, in a *complete* reality; the most we can do is to formulate it in a *fragmentary* way . . . MAURICE BLANCHOT, 'The Word Berlin', *Semiotexte, The German Issue*, New York, 1982, pp. 60–1.

The Brandenburg Gate stands inside East Berlin. The Berlin Wall passes around it, coming from the river and the back of the Reichstag on one side and then across the wilderness of Potsdamer Platz, one of the busiest city centres in Europe before World War II, turning behind the Martin Gropius Bau and on to Checkpoint Charlie. On the western side of the Brandenburg Gate is the Russian War Memorial. The British duty officers escort Russian sentries across one of the checkpoints each day to provide the guard. Big wooden boards block the view out of the woods, a precaution against attempts by Berliners to shoot the sentry while on duty.

The Wall has had various physical incarnations since August 1961 when a barrier was put up overnight by the East German authorities. In its present form it stands about five metres high with a plain rounded top, painted white on each side, with lights and sentry posts at every turn and a mine-filled 'corridor' on the eastern side. It stands entirely on East German land, but this has never prevented graffitists adding comments, slogans or drawings on the western side. During the last three years it has been densely covered with a mixture of different styles and types of statement: from the absurd to the serious, the emotive and the clichéd.* It was less crowded in 1982 when the large international exhibition *Zeitgeist* took place in the Martin Gropius Bau, which is located within metres of the Wall itself. The American artist Jonathan Borofsky was invited by the organisers, Christos Joachimides and Norman Rosenthal, to make works specially for this exhibition.

The Wall is occasionally repainted white by the East German authorities.

When I first went to the site of the Zeitgeist show to propose a piece, I kept in mind that I would use the Wall. Here I am painting on walls my whole life, inside museums, and here was the ultimate wall – the division in all of us, symbolic in a country of the division of two Germanys. It's also just by the site of the Gestapo torture chambers, which I read a lot about as a child, being a Jew, and was very touched by.

JONATHAN BOROFSKY

My first choice was to blow a hole in the Wall, and I'm telling this publicly for the first time. I consulted some people who knew explosives there in Germany. I thought that the most important thing I could do was to blow a hole in the Wall and I didn't even have to take credit for it; it didn't have to be an artistic performance, but it was something that would be in the paper the next day. But on further consultation it seemed also potentially dangerous to somebody who would be walking by the Wall; there were enough negative things, it was a little frightening, a kind of violent act for me. But it just seemed like I was angry enough there to want to.

The exhibition was organised by the Philadelphia Museum of Art and the Whitney Museum in New York, and curated by Mark Rosenthal and Richard Marshall.

34 Jonathan Borofsky in his studio in Venice, California, 1985.

So I started putting an image on the wall. The Running Man *is that, it's a way of trying to put the hole in the Wall but symbolically. The image itself is one of ambiguous fear, running, tension and anxiety.*

The *Running Man* also appeared as a cut-out figure in Borofsky's large exhibition of 1984, which was on show at the Walker Art Center, Minneapolis in November 1985.* It had first been made for an installation at the University Art Museum, Berkeley in 1978, and had joined the repertoire of images which Borofsky re-uses and adds to. Every new image and every reappearance is given a new number according to Borofsky's counting system; a continual counting of numbers that he has written down in sequence since 1969. Sheets of paper are covered in the numbers, now at more than 2,500,000, and are added to at intervals by Borofsky. In Minneapolis the two galleries, the entrance hall, side passages and even a tree in the street were filled with sculptures and images. Some works had sound tracks attached (the *Chattering Men* who chatter and the *Dancing Clown* with an endless repetition of Borofsky's version of 'My Way') and across the whole space a collection of noises and sounds played as a separate work. The cloistered quiet of the museum was transformed into a carnival atmosphere.

Many of Borofsky's images are drawn or painted directly onto the wall, a process that Borofsky has perfected by keeping his images on acetate sheets and projecting them through an overhead projector so that he can make an exact transfer. The acetate sheets are kept stacked together and carried by Borofsky from one exhibition to the next, each image ready to be used again if Borofsky requires it, if it suits the location and occasion. A number of themes recur in the images: the male–female dichotomy, the split between inner self and outer world, between the two halves of the brain, different kinds and qualities of communication, and a critical assessment of modern life and its accoutrements.

JONATHAN BOROFSKY

The character with the ears is 'the animal', part of me, the part of me that when I'm up in the mountains listens very carefully to the sounds, it moves my ears very carefully from side to side, to pick up the ever so slightest sound, like a dog might. That's the animal in me. The other characters are all part of the human species, part of my vocabulary as I perceive it around me. They might have a specific meaning for me now, I might give you the definition of the animal with the ears as that definition I gave you, but tomorrow I might give you a different one, although it will be close. The origins of it are the attempt to hook onto a collective unconscious of images in everyone and to pick them out of the air, to pick them out of the newspaper, out of the movies, out of my dreams, out of my inner world, out of my outer world, looking for images that help to reflect an understanding of ourselves.

The man with the briefcase came from seeing probably my tenth man with a briefcase advertisement in the newspaper, for advertisements for suits – but in reality he was a model – and thinking how archetypal this image was: seeing people standing on street corners, seeing businessmen going to work, and beginning to relate to that image. It's also a very personal image to myself, since I also have a briefcase and carry

HISTORY

35, 36 Jonathan Borofsky, *Dancing Clown at 2,845,325*, 1982–83; and *Chattering Man*, 1983, with Chris Renty, *State of the Art* sound recordist, at the Walker Art Center, Minneapolis, 1985.

JONATHAN BOROFSKY

37, 38 Jonathan Borofsky,
notebook page with first sketches
for *Hammering Man* and *Running
People, c.* 1978; and drawing at
2,712,809, *c.* 1980–81.

*all my thoughts and images when I go to a show, in that briefcase. So the briefcase
slowly became a metaphor for my brain, my thoughts.*

*I would like to think that my shows are a metaphor for life and that part of it is just
fun and part of it is to be taken extremely seriously, and that part of it is sad and part of
it is happy. I think I'm good at what I do, but that's not enough. I started small and
started exposing an inner self in a smaller way and got a good response – people would
come up and say 'Well, we really appreciate that you're so open in your work.' All I
needed was a few people to tell me that I wasn't embarrassing myself. I said yes, I'm on
the right track here.*

*I'm on the telephone and things just come out on paper that I don't plan. My hand
just moves and I doodle. Out of some of those doodles come ideas and then those ideas
get expanded on, get blown up into larger paintings or sculptures. Grand ideas
sometimes start with a very small intuitive spark.*

Borofsky's success in the art world has allowed him to extend the kind of
work he can make. During 1985 he used his own funds to make a
documentary, *Prisoners* (in collaboration with Gary Glassman), that looked
at the lives and backgrounds of a number of prison inmates in Southern
Californian institutions near where he lives and works. This was a compli-
cated work requiring research, extended interviews and careful editing.

*Their bodies are locked up in little six-foot by eight-foot boxes for the rest of their lives
and it's quite a symbol for me, of a lack of freedom, and so I wanted to know about these
people. I feel for these people in one sense. In another sense they make me afraid. I have
to worry about my own safety. I have to put locks on my doors, and I don't like that. So
there's a good reason to find out how to have less of this fear around. It's a good reason
to try and understand why a prisoner exists, why do we have people like this, is there
any way to have less of them; why do people kill, is there any way to have less killers on
the streets? As a sociologist I want to find out about this, I want to understand, so I
can be less fearful when I walk the streets. Secondly, I want to find out what this lack of
freedom means to a human being, what is it like in there, what does it feel like to be
locked up in a box for twenty years and allowed to go out into a tiny yard for some air
twice a week? What does that do to a human being, do they still have their spirit and
their soul?*

*Of the thirty-two prisoners we interviewed, twenty-eight were mistreated in
different degrees as children and either locked in closets for punishment or whipped, or
hit with the hands real hard over and over again, and it seems clear to me and probably
to you if you thought about it for a short period of time that anybody who's mistreated
as a youngster is going to grow up and probably end up mistreating those people he
deals with or she deals with.*

*There are a lot of drugs that seem to relate to the prison experience, either somebody
has been on drugs when they committed the crime or they were committing the crime
to get enough money for drugs. Most of all, I felt that these were human beings that,
through circumstances partly out of their control as younger people, have ended up
living almost worthless lives, by our standards.*

HISTORY

But this society which we live, struggle, create, think, suffer and enjoy, is merely one moment in eternity. This is our world. There was a man once upon a time because we made him our contemporary. In the future, 'there will be a world.' In uttering this sentence we make it *our* world. AGNES HELLER, *A Theory of History*, Routledge & Kegan Paul, London, 1982, p. 40.

Borofsky emphasises that the sources of his art are both the 'outer' world of daily experience and information and the 'inner' world of thoughts, emotions, dreams and meditations. His art and life are a way of searching for a settled state of mind to combat the chaos of the world as he perceives it around him. That perception involves both conscious and subconscious processes. Borofsky's art speaks both of an uncertainty in his personal expression, a refusal to make definitive statements, and an understanding of the individuality of history, the multiple accounts of individual experience that make up the 'daily life' of the world. It is an art of fragments with recurring themes, such as personal freedom set against social constraints, and recurring images and symbols.

The Hammering Man *can be perceived in one way, given the context. If it's stood up in Poland, given the workers' situation there, it could be perceived one way. If it's stood up in South Africa, and it happens to be a black silhouette anyhow (and I chose the black silhouette not necessarily because it represented a black man, but because it looked very good sculpturally as a silhouette), now in the context of South Africa you*

39 Jonathan Borofsky with Gary Glassman, editing the video *Prisoners* made in 1985 with the inmates of Southern Californian penal institutions.

JONATHAN BOROFSKY

40 Jonathan Borofsky, *Hammering Man*, 1981. Installed at the Minneapolis Institute of Art.

have the possibility of reading it as a miner in black South Africa. I guess I'm a very political person, I'm always thinking about how life can work better and why it isn't working better, and disturbed by situations that get in the way.

The Hammering Man, *it's a shoemaker, a carpenter, it stands to honour the worker in general, not just the worker in me, but the worker in general.*

Borofsky's *Hammering Man* is installed at the Minneapolis Institute of Art. It is over 24 feet high; one huge arm silently rises and falls across the other. Several *Hammering Men* were combined in the Walker Art Center, some in a gallery which you entered past a sloping coal truck, giving the impression of a cavernous space – focusing not on a coal mine as such but on the apartheid issue of South Africa. Biko, Mandela and other names were chalked up, an open letter from Bishop Desmond Tutu lay in printed copies to be picked up off the floor. In referring to the struggle against apartheid, Bishop Tutu says, 'It is no more a political issue for men and women of conscience than support of Nazism is a political issue. It is a moral issue.'

Jonathan Borofsky's work exemplifies a kind of history in the making: the compiling of notes, images and ideas makes up his version of the world. As a 'contemporary' in the thick of the postmodern world, Borofsky shares his exploration of the central issues in history, of morality and freedom, so that we as viewers will identify with his experience. His art invites response. Each image is differently juxtaposed in each exhibition, so there is no definitive relationship between the parts and the whole. This is a poignant metaphor for the world as we find it: multiple and fragmented, but capable of supplying positive as well as negative images, and capable of change.

Mariani works through the recreation of historical style, Kiefer reorganises and re-presents taboo images and archetypes in order to force the facts of the past into our consciousness, and Immendorff restages historical incident and symbol to strengthen our understanding of the present. In his scattered but repetitive images, the clichés and stereotypes emphasised, Borofsky provides insight into the everyday process of the growth of histories around us; connecting personal narratives to the larger narratives of our time, he gives us common experience as historical experience.

Your letters contain *nothing but nothing* except for *The Worker's Cause . . .* When I open your letters and see six sheets covered with debates about the Polish Socialist Party, and not a single word about . . . ordinary life, I feel faint. ROSA LUXEMBURG, letter to Jogisches, quoted by Angela McRobbie, 'Fear of Fascism', ZG, 'Breakdown' issue, 1983.

It was only in the 1970s that the historical limits of modernism, modernity and modernisation came into sharp focus. The growing sense that we are not bound to *complete* the project of modernity . . . and still do not necessarily have to lapse into irrationality or into apocalyptic frenzy . . . all of this has opened up a host of possibilities for creative endeavours today. ANDREAS HUYSSEN, 'Mapping the Postmodern', *After the Great Divide: Modernism, Mass Culture, Postmodernism*, Indiana University Press, Bloomington, 1986.

2 Value, Commodity and Criticism

Artists have an unprecedented kind of control over their own production, but must lose it immediately in the post-production process. They lose control not only of the object, but of its objective. When a work of art is out of the artist's hands it gets out of hand in several senses . . . the work is abandoned to an independent existence in a world which may transform it beyond recognition – framing it wrong, hanging it in a bad light, mystifying or deideologising it. At this point the artist surrenders the power of the object to the dealer, museum, new owner, turning back to the studio, to new work over which s/he still has the illusion of control. LUCY R. LIPPARD, 'Power/Control', *Village Voice*, New York, 18 October 1983, p. 82.

Who has the power to say what is good or bad, to discriminate, to approve or endorse? Where is it agreed that one work of art will be worth a fortune and another much less? When is one work praised and another dismissed? Who are the opinion-makers? Among many opinions, whose opinion counts most? And how much effect does this have on the system? Is change led by the needs of the market, does the market follow the interests of key collectors and curators, or do artists themselves decide what the most important art shall be?

This chapter considers five places in which validation and valuation occur: the private gallery, the private collection, the public museum, the art magazine and the public site. In each place decisions are made: qualities are assessed and judgements are acted upon. The single example of each does not stand for all the others, but serves as a means of investigating the processes of aesthetic and commercial valuation in practice. Clearly these five places do not encompass all the processes of valuation in the art world. The teaching institutions, art schools and colleges, local and state subsidies to the arts, artist-run galleries and arts centres, art history books, international public exhibitions, *Documenta* and the biennales, all affect the current assessment of qualities and ideas about art. Less immediate are the roles of popular criticism in the newspapers, fashion magazine articles, television documentaries (like *State of the Art*) and even the constant flow of stories, jokes and their stereotypical representations of contemporary art.

The art world of this book does not encompass all art worlds. This is the world of artists who aim for national and international recognition, who respond to contemporary critical writing, who are close to the processes of teaching, and who may exhibit in private and public galleries in countries other than their own. It is a world of many shared assumptions. The other art worlds of traditional portrait painters, sculptors of monuments or landscape painters have their own societies, places of exhibition, journals and social positions. Most importantly they have different criteria for judgement.*

An artist's fame accrues in a long conversation involving many voices; an observer's taste grows and changes, so that any act of judgement is necessarily the record of a

See Andrew Brighton and Nicholas Pearson, *The Economic Situation of the Visual Artist*, Calouste Gulbenkian Foundation, London, 1985.

41 International Contemporary Art Fair, Cologne, 1985. 165 galleries participated; 52,000 people visited in seven days.

moment. There is a different point of view, similarly, for every curator and dealer, conservative to radical. The system that appears to be such a monolith from a distance is at close range more a honeycomb of buzzing opinions. KAY LARSON, 'Selling Yourself Yourself', *Village Voice*, 15–21 October 1980, p. 71.

The object of 'artistic' or aesthetic value is subject to prevailing criteria (preferences in form, ideas, techniques, styles and subjects of art) which are constantly shifting and contested, not through any formal agreements or disagreements, but through gradual and constant changes of opinion and precedent. Nor are criteria imposed by any institutional authority such as the Royal Academy or the Museum of Modern Art, New York. Rather, they emerge through the example of all the 'institutions': museums, galleries, art magazines, critical writings, and private and corporate collections. It is a system that is multiple and plural, where many criteria are in play at the same time; it is incomplete, in that many people disagree with the assumptions that come to prevail; and despite attempts at fixing critical standards, it is inherently unstable. Evaluation is not impossible, but it must be specific.

The commercial or market value of a work, or a type of work, is the price that someone will pay for it at a particular moment. The price will depend on the level of demand for that type of work and the available supply. (Here is the appeal of the auction room. However arbitrary the moment and however particular the interests of the participants, because of its public nature it *appears* to be 'fair'.) But commercial value and aesthetic value, though they are in constant correspondence, are not simply dependent upon each other. Those who sell works of art will stress the aesthetic value (assumed to be timeless) and will underplay the interest of the object as a 'business' investment. Those critics and historians whose job it is to assess the aesthetic may avoid discussing the commercial value at all. In the art market it is not uncommon to find artists who sell works for very high prices having mixed or low critical reputations, and others who sell for lower prices with large critical followings.

* * * * *

The late Dr Willi Bongard, editor and publisher of the Cologne-based market newsletter *Art Actuel*, attempted to assess commercial value against an artist's reputation in the art world. For 100 artists he worked out a points system based on where they had exhibited, how many feature articles had been published on their work, which important private and museum collections had acquired their work, and which international survey exhibitions had included them. Each gallery, museum or magazine would be worth a certain number of points depending on the rating Dr Bongard gave: a one-person exhibition at the Museum of Modern Art, New York, for instance, was worth considerably more than an exhibition at the Scottish National Gallery of Modern Art in Edinburgh. A one-person exhibition, however, was in itself worth more points than participation in a group exhibition. Against the accumulated points scored (for some years Joseph Beuys came first with Jasper Johns close behind), Dr Bongard would

42, 43 The Deutsche Bank, Frankfurt; and section diagram with names of the artists in the Deutsche Bank Collection indicating on which floor their works are displayed.

research the price of a 'standard' work for each artist, and on the basis of the price/point ratio would make comments as to whether each artist's work was inexpensive or overpriced, good value or bad. Bongard's newsletter provided important information and analysis for private and corporate collectors.

Changing patterns of investment, the availability of·'risk' capital and of course the general financial climate are all factors in the buoyancy of the art world. In recent years an increasing number of banks and corporations have established their own collections of contemporary art. Philip Morris, Chase Manhattan Bank, the Prudential Insurance Company, Unilever and the Deutsche Bank all have impressive collections which they justify as a useful patronage of the contemporary arts and a benefit to their employees and visitors. The same institutions, and many others, are also involved in the sponsorship of exhibitions, concerts and theatre productions. They endorse and support the arts, while those arts endorse the name of the bank or corporation. The artist Hans Haacke explores this process further in Chapter Five.

Among the several high towers in the financial district of Frankfurt, the twin towers of the Deutsche Bank (known locally as 'credit' and 'debit') stand as gleaming symbols of modern financial management. On twenty-two floors of Tower A and thirty-five floors of Tower B an extensive collection of contemporary German art has been assembled. With the general support of Deutsche Bank chairman Hermann J. Abs, a purchasing

Peter Beye, Klaus Gallwitz, Herbert Zapp and Wolfgang Wittrock.

committee was established by one of the directors, Dr Herbert Zapp. The committee* have concentrated on one artist for each floor (their names are engraved next to the buttons in the lifts), buying works on paper to keep within the 2 million DM limit, with a few oil paintings for the larger open spaces of the lower floors. Dr Zapp says of the collection:

DR HERBERT ZAPP

For the bank, art is important because the bank has never, in its 120-year history, seen itself as a purely financial institution, but as an institution connected politically, socially and culturally to the world outside. That is why this field is important to us. In my case and in the case of the others who are working on this topic it is a kind of leaning which we have, impulses which one has got; the favourable circumstances allow one to make something of this.

It is simply something which we want to have for our surroundings and for our employees. Investment considerations play no part at all. No one has ever asked me if the pictures we have bought in the last five or eight years are worth more today, or how much more they are worth.

The collection is being catalogued by the curator Marie-Theres Suermann, who spends part of her time talking with the staff of the bank about the work. 'Twenty per cent of the staff think that having contemporary art is a good thing,' she explains, 'twenty per cent are aggressively against the idea. Sixty per cent don't know what to think. I am working with the sixty per cent.' The selection of some young, relatively unproven artists will have an effect less on the price of their works directly, but more on the establishment of their reputation. It will enhance the degree to which their work, even when its content or style implies values of life totally at odds with the priorities of the bank, is seen as valuable by other potential buyers. In turn it helps the bank to soften its image with both clients and employees.

* * * * *

The Private Gallery

Art dealers are not just another kind of businessman. No one who was good at business would go into art dealing unless he really wanted to – the variables and the undependables are too numerous. And when you are working with living artists you have to keep up an imaginative pressure – the good dealer makes his artists feel important all the year round. Above all there has to be a feeling for timing . . .
ANTHONY FAWCETT and JANE WITHERS, 'Commercial Art', *The Face*, London, December 1983, p. 75.

Each year the Galerie Michael Werner takes a stand at the Cologne Art Fair. The Fair is organised by the Association of German Art Dealers and is one of five such major international events each year. In 1985, 165 galleries took part, mostly from Europe, and over seven days the fair was visited by 52,000 people. To put this in some perspective, the International Art Guide for 1986 lists 716 galleries dealing in contemporary art: 57 are in Cologne, 88 in Milan, 99 in London, 192 in Paris and 280 in New York.* Another perspective: each

Art Diary 86/87, Giancarlo Politi Distribution, Perugia.

44 Michael Werner at his stand in the International Contemporary Art Fair, Cologne.

year there are 1900 graduates from fine art courses in Germany, 1400 in Britain, 850 in France and approximately 35,000 from visual arts courses in the United States.*

Figures courtesy of Council for National Academic Awards, the German and French ministries of education, and quoted in Robert Hughes, 'On Art and Money', *Art Monthly* 82, London, December/January 1984/85.

Michael Werner started his gallery in West Berlin in 1963, moving to Cologne in 1969. His gallery sells the work of Georg Baselitz, Jörg Immendorff, Markus Lüpertz, Per Kirkeby, James Lee Byars and A. R. Penck, some of whom have been with the gallery since the 1960s. Werner has been closely involved with the success of his artists in the last decade. They, and he, have gained prominence in Germany, in Europe and subsequently in America. In 1983 Werner established a transatlantic partnership with the gallery of Mary Boone in New York.

Cologne is my city and I am involved in it, and Europe is interesting. That's certain. A kind of regionalism has arisen in Europe. This is very strong in Germany, for instance, and this can't only be termed provincial. I still remember the time fifteen years ago when I had difficulties with German artists because they were German and nowadays you've got the situation in Germany where you have difficulties with American artists because they're American.

Dealing in art is absolutely uninteresting. Of course, there must be such a thing. All this takes place. I myself have a business. All these things exist but it's not worth talking about them. That's uninteresting because it's an exchange of goods. I have a picture and I get money for it, or someone comes to me with a picture and I give him money.

MICHAEL WERNER

The whole of what an artist does is his 'position'. I am interested in his position. I'm not interested in whether he paints a picture I like or dislike. It doesn't make me nervous if he paints a picture which I don't like. I'm not interested in this. I know that this is a living person and I'm only interested in his position. Position is what I discuss with him, what we talk about. By this I mean the sum of what he himself represents and of what comes from him – and to do this over a long period. It is not difficult to paint pictures for thirty years. That's not difficult at all. There are many people who can do that. But to maintain a position which is closely related to 'reality' – whatever that may be, let's put it in inverted commas – is very, very difficult; it's very hard work. 'Position' has nothing to do with economic or social position.

Michael Werner's insistence on an interest in the 'position' of the artist rather than the 'quality' of particular works stems from his presumption that everything made by his artists is valuable and saleable, and reflects the widespread assumption of the art market that once an artist is established, whatever he or she produces must be promoted and sold. The mythology of the artist as creative genius encourages dealers to promote the whole of the artist: work, personality and attitudes. And rather than promote directly, they will encourage seemingly unbiased 'promotion' through art magazines, museums, public exhibitions and art-world notoriety. This reinforces the mythology itself: the artist as inspired visionary, eccentric 'outsider' or more recently, like Jean-Michel Basquiat, as streetwise kid. Conversely it gives greater weight to the moment when taste and critical opinion select a talented artist from the crowd of hopefuls.

The number of corporate and private collectors has increased tremendously and, if nothing else, it has become apparent that investment in art, if well managed, can generate interest and revenue exceeding most other small-time investment gambles of the affluent . . . As in the case of all luxury goods . . . the desire to possess artworks and the need to use them for the constitution of individuality and social identity not only grows constantly, but can be massively propagated as well. With the rising number of speculators in this gamble, the number of certified artists and products participating in the race has to be dramatically increased. Not only can the original artists not produce quickly enough, but also products they do produce move very quickly out of the price range of the many newcomers to this (new) stock exchange. High Culture has after all merged its enterprise with the conditions of the culture industry. BENJAMIN H. D. BUCHLOCH, Postscript to 'Figures of Authority, Ciphers of Regression', *Art After Modernism: Rethinking Representation*, p. 134.

As galleries establish a particular group of artists whose work they promote and sell, so they succeed in the 'industry' by attempting to retain a stable clientele of individuals and institutions that will buy those works. Werner claims to sell a proportion of work to other dealers, predominantly outside Germany, but he also sells to a number of private collectors. The attendance of the public at exhibitions in the gallery in Cologne may appear to be of little direct consequence, but this, together with the participation of the gallery in art fairs, the promotion of exhibitions through the art magazines and reviews by critics, is important in supporting each artist's and the gallery's general reputation and position.

I don't arrange exhibitions for the public. That isn't my task. I arrange exhibitions for the artists and for myself. My direct answer was: for myself. I'm very egoistic. I arrange exhibitions. I have a gallery in which I exhibit art. Anybody can come in. It's not non-public. The public has no claim on me. I'm a private individual. You know what I mean? They have no claims on me. I have a task for myself, and maybe I have a task for the artists I work with.

Collectors are important for me. There are collectors with whom I am in very close contact, whose 'performance' – whatever that may be, again in inverted commas – I have a very high opinion of. When a person has a fantastic instinct for what he himself and also I myself consider to be important, then he's a very important collector for me.

People in Europe are used to putting on all kinds of intellectual masks in order to talk about art and to acquire art, whereas in America this isn't necessary. That is a significant difference. They can express their interest directly in figures. That isn't possible in Europe. It isn't done. In Europe people who are involved in art love – let's say – the moral attitude. It is an attitude which stems from a time when the nobility ruled and that's what they did. They didn't buy a picture because of its surplus value. They bought a picture because it was usual to do so and because it was part of interior decoration.

In 1986 Michael Werner and Mary Boone were married. The collaboration with her has meant a working and domestic life split between the two cities for Werner. Whatever the fashionable interests between European and American art, the commercial backgrounds create differing amounts of pressure. Werner says that the order of rental costs for the galleries is $2000 per month in Cologne and $50,000 per month in New York. In the New York art world people talk of the 'European Invasion', meaning the so-called German Neo-Expressionists, the Italian painters Chia, Clemente and Cucchi, and other European artists with regular gallery arrangements. This has been a considerable benefit to the New York art market, and it has raised interest and prices in Europe as well.

Twenty or thirty years ago, dealers in New York used to struggle against dealers in Paris or London, each affirming the national superiority of their artists. These transatlantic squabbles are now extinct. What you have instead, on the multinational model, is associations of galleries selling the one product in New York, London, Düsseldorf, Paris, Milan. The tensions of national schools are dissolved. But this means that the successful artist must work on an industrial scale. ROBERT HUGHES, 'On Art and Money', reprinted in *Art Monthly* 82, London, December/January 1984/85, p. 11.

It almost looks as if nobody wants to be an artist anymore; everyone wants to be an art dealer as a shortcut to success. After all, Mary Boone is more famous than most of her artists. KIM LEVIN, 'Power/The East Village', *Village Voice*, 18 October 1983, p. 78.

The name of Mary Boone is almost synonymous with the fashionable art market of New York in the early 1980s. After working at the Bykert Gallery on Madison Avenue, she began dealing privately in 1975, and in 1977 opened her own gallery at 420 West Broadway in SoHo. From these premises she started to organise joint exhibitions with the most famous of

45 Mary Boone on the cover of *New York*, 19 April 1982.
46 Page from *Artforum*, November 1985.

47 Mary Boone in her gallery, New York.

contemporary art dealers, Leo Castelli. The principal object of their collaboration was the young American painter Julian Schnabel. He rose to fame in the late 1970s and early 1980s (fame through the market and not at this stage with public galleries or museums) with large-scale semi-figurative, highly wrought and eclectic images. His early success signalled changed ideas in art (from minimal to neo-expressionist), the presence of an ebullient new generation, a renewed vitality in sales and a closer relation to the world of fashion: not just discreet pieces in art journals, but feature articles in *House and Garden* and *Vogue*. In 1982 Mary Boone moved to her spacious and specially designed gallery at 417 West Broadway.

Julian Schnabel left Mary Boone in 1984 to join the Pace Gallery run by Arnold Glimcher, with a figure of $1 million as an inducement mentioned in the press. The other artists in the Boone gallery include Ross Bleckner, Troy Brauntuch, Michael McClard, David Salle, Michael Tracey, Eric Fischl and Jean-Michel Basquiat. Like Werner's Cologne gallery, the stable is entirely male, and like him she stresses the 'position' of the artist.

MARY BOONE *Extremists, that's what interests me is extremists; people that take a radical position, but not radicality as a fashion. The following group of artists will present a similar challenge and even attack on this generation, and this generation will be scrutinised and there will be a distillation of the most important figures. It's a process that to me has nothing to do with fashion, it has to do with culture, it has to do with cultural concerns, the kind of work that – you know, people use the terminology, this artist is*

not right for the times. I mean, a perfect example is someone like Philip Guston. It wasn't that his paintings changed considerably, it was that the public had the interest and the cultural temperature was right to look at these paintings at that time.

A few years ago it felt very strange when younger artists suddenly started having sell-out shows. People worried that aesthetic value was becoming synonymous with economic value. Now there's less chance of misconstruing the 'value' it attaches to art. A sell-out show is simply a sign that a number of people like an artist's work and want to take it home with them – it is once more a sign of what is popular and chic, not what's good. ROBERTA SMITH, 'Power/The Art World', *Village Voice*, 18 October 1983, p. 75.

Mary Boone stresses how much of the running of the gallery is a service operation for the artists whose work it promotes and sells. Like Werner, she emphasises the closeness of the relationship: 'It's a collaboration – it's not a parental relationship, and it's not an agent relationship; it's a collaboration.' The servicing involves producing exhibition catalogues, keeping detailed records on the location of works, helping with the loan of works to public exhibitions, collecting other catalogues and critical commentaries, and ensuring that photographs of works are available for reproduction. The gallery, like most, takes about 50 per cent of the sale price of works to pay for the operation.

Since Mary Boone's collaboration with Michael Werner, Werner's artists have been exhibited in her New York gallery. A number of more 'historical' exhibitions have also been arranged there, including work by Marcel Brood-thaers, Francis Picabia and Joseph Beuys.

I'm showing younger artists in order to support doing historical shows that I think are important to be seen.

Many of these shows are extremely expensive to do. I think it's the gallery's responsibility to give this information to people. When I did the Broodthaers show I knew that there was at least one museum in New York that would have liked to have done that exhibition but couldn't afford to.

Why has Michael been important? For a lot of reasons. Because I think he shows important artists. I've always been involved in the notion of internationalism. From the very early days of the gallery I tried to exhibit artists in as broad a scope as possible.

The gallery is about the dissemination of ideas because really most of our time is spent with that. Objectivity is a very important position that a museum always has, but a gallery never can obtain; even if a gallery shows the work of an artist, of a dead artist for the first time, there is always a mercantile or covert message that's linked to the exhibition. With a museum people never have these questions; this is something that I'm trying to shift, but I don't know if it's going to be possible.

MARY BOONE

Whatever confusions it suits Mary Boone to maintain between the private and public interests of the gallery, her policy affects the processes of valuation through the artists she and Werner choose for the gallery and the ways in which the work, once selected, is promoted and sold. Both of them claim a passionate interest in searching for new art of quality, but their

gallery lists appear to be fairly fixed. Large numbers of visitors may go through the gallery in New York, but the physical volume of sales is not huge. Boone estimates that less than 300 works are sold each year, but then in 1986 a painting by A. R. Penck cost upwards of $15,000 and a David Salle around $75,000. Part of Boone's fame has been her ability not only to exploit 'creative pricing' but, like other dealers with an excess of demand for the works of their artists, to be very selective about who may buy the work. There are the 'right' collections, both public and private (which would have been high on Dr Bongard's list), where taste and reputation combine to form a priority for any dealer and artist.

Money and status are the elephants wandering through the art world we're supposed to pretend we don't see. An unspoken etiquette attends to the clumsy things. One day, I witnessed a beastly blunder at the old Mary Boone gallery, when a plain, unfashionably dressed woman approached Boone and bellowed, 'How much is that painting?' Boone handled it well, murmuring something like 'It's sold.' She sells selectively, of course, to the Right People. C. CARR, 'The Hot Bottom', *Village Voice*, 3 April 1984, p. 38.

* * * * *

The Private Collection

The purchase of a contemporary work of art by a private collector differs from that made by a corporation, museum or 'ordinary' buyer in a number of ways. The work is generally deemed more significant for having been bought by someone who makes a speciality of buying art. The work leaves the artist's control but may be more easily available for loan to exhibitions than it would be in a museum. The work joins a specific group of other works, which may be known only indirectly through magazine articles or other loans, but the understanding of which may be tinged by knowledge of the owner's tastes, interests or reputation. A private collection is a particular and sometimes very influential place for an artist's work to be. In extreme cases a collector's influence is exercised not just through the purchase of particular works but across the whole market, when they pay an exaggerated price to obtain a desired work, or sell a group of works, causing prices to fall. Influential collectors on the grand scale (examples are Charles and Doris Saatchi in London and Peter and Irene Ludwig in Aachen) are closely linked with an international network of taste and fashion that helps determine the demand for, and interest in, new works of art.

Douglas S. Cramer is a Hollywood producer, vice-president of Aaron Spelling Productions, the company that produces television series which include *Dynasty*, *Love Boat* and *The Colbys*. He has collected modern and contemporary art since the 1950s when he worked in New York, and has now assembled a collection that fills a house in Bel Air and a ranch outside Los Angeles. The collection is concentrated first around an older generation of American artists, with works by Frank Stella, Elsworth Kelly, Roy Lichtenstein, Jim Dine (an old school friend) and Robert Motherwell. The younger generation of Americans in the collection includes Susan Rothenberg,

Julian Schnabel (a portrait of Cramer with his son), David Salle, Joel Shapiro, Jonathan Borofsky, Eric Fischl and Jean-Michel Basquiat. In 1985 Cramer bought a painting by Anselm Kiefer from the *Märkischer Sand* series.

Mary Boone needs courting, Arnold Glimcher needs courting, Irving Blum needs courting. I think the major dealers around the world, like the major producers, or the major writers, or the major businessmen need a certain amount of courting. There are so many collectors – there is so much demand for the works of the best and the most recognised artist that they have. I recognise – it took me a while to do that, but I recognise that they have a responsibility to the artists, and to the collectors that have been with them for a period of time. When a new hot shot collector comes in and says, 'I want the best of everything you have,' you know, you've got to prove yourself to them and I don't resent that. Some of my confrères in the collecting world detest it.

I look at four or five hours a day of unedited and rough film as a rule, and to get home and see something that's permanent and that is there is wonderful. I mean they're not going to take that away from me and run it off or change the way it is. It's a relief, that's what it is. By the same token, sometimes negotiating a deal with Arnold or Mary, trying to get a look at a painting, will give me the relief from dealing with fifteen local agents who were trying to get more money or better dressing rooms or more time off for their stars on our shows.

The art world was there first but certainly what we do in Dynasty, *the kind of glamour and excitement and romance that's inherent in the show, you can see any day you walk up and down West Broadway in SoHo.*

DOUGLAS CRAMER

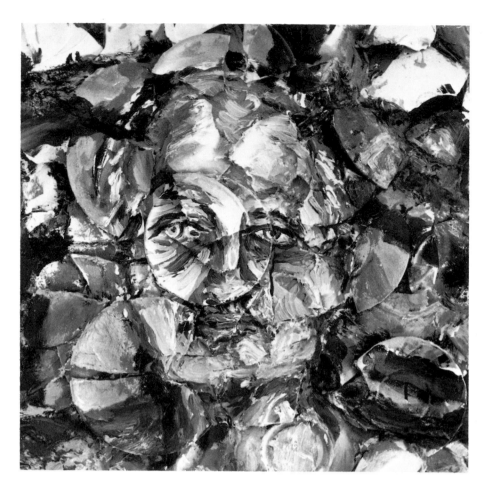

49 Julian Schnabel, *Douglas Cramer and Son* (detail), 1982. Painted on broken crockery.

50 Living room in Douglas Cramer's house, Los Angeles, with work by Roy Lichtenstein and Joel Shapiro.

High art is patently exclusionary in its appeal, culturally relative in its concerns, and indissolubly wedded to big money and 'upper class' life in general . . . What is obscured is the *acquired* nature of the attitudes necessary for partaking in that culture, the *complexity* of the conditions under which one may acquire them, and the *restrictedness* of access to the means for doing so. MARTHA ROSLER, 'Lookers, Buyers, Dealers, and Makers: Thoughts on Audience', *Art After Modernism: Rethinking Representation*, p. 312.

Cramer's position might be seen as pivotal between money earned from 'low' culture and money spent on 'high' culture. However pressed by his commitments as a producer, he finds time to put in bids at auctions and to spend time at galleries in New York and Los Angeles. He socialises as much in the art world as in the film and television world. He claims to take them seriously only when he needs to. 'If I don't take either one of them seriously I'd be in a lot of trouble. It's easier to laugh at one than the other, but fortunately I can laugh at both in different ways at different times and keep my sanity.'

In *The Colbys*, the spin-off series from *Dynasty*, the Colby family have a collection, and scenes in galleries and auction rooms are integral to the scripts. There is little doubt that modern and contemporary art are on the agenda in fashionable life in America, and not just in New York.

Some parts of Europe – West Germany, Belgium, Switzerland – have sections of society that compare with this phenomenon of glamour. The blending of reality and fantasy in the film world and the art world, the idea of art as the domain of the wealthy (and a part of show business) that *The Colbys* promotes is sold to ever increasing numbers of countries in the wake of *Dynasty* and *Dallas*.

51 Andy Warhol, *Douglas Cramer*, 1985.

The most profound enchantment for the collector is the locking of individual items within a magic circle in which they are fixed as the final thrill, the thrill of acquisition, passes over them. Everything remembered and thought, everything conscious, becomes the pedestal, the frame, the base, the lock of his property. WALTER BENJAMIN, 'Unpacking My Library', *Illuminations*, p. 60.

DOUGLAS CRAMER

There are some artists perceived as the best, that I have no feeling for, no emotional response to, and that's not to say that I don't think their work should be shown. I don't collect them myself, but that goes back to the nature of what you collect. I essentially collect works that emotionally draw me to them.

Every collector, anyone that's involved with the arts, has a larger responsibility than just to his own collection but to, let's say, the museum or museums of your choice. I support four or five museums; I'm actively behind MOCA which I've bled for and will in the future because I believe in it and I believe in the goals and aspirations of the museum and the people that are behind it.*

I hate to admit it and I hate to think of it but any collector that tells you that there isn't some profit in terms of collecting art is not telling you the truth. I don't play art the way I play the stock market or gold. I consider it something to buy and keep for the time that it's allotted to me. I've been fortunate, we all have a few dogs or a few mistakes, but I think I've come out well.

I've been obsessed with success, I've been obsessed with art, I'm obsessive about

Museum of Contemporary Art, Los Angeles.

owning, it's very hard to see something and not want it. I don't keep what I have like some Swiss millionaires, the art locked up in a house that no one can see. All the houses are open to museum groups by appointment or arrangement. I think at the moment I have fourteen or fifteen works in shows all over the world, so that I lend and I know that in a given period of time the art will – because I also give frequently to museums – all end up in one museum or in one public form or the other. And if I'm eventually giving it to the world, is it that obsessive, or that wrong, for me to want to have it ten, fifteen, twenty years of my own?

<p align="center">* * * * *</p>

The Public Museum

Traditionally, that is to say during the last 200 years, museums have not collected contemporary or avant-garde art . . . Patrons supported artists, commissioned works, and on their death bequeathed them to museums. There was a time lapse of some sort. A time lapse helped create a consensus . . . By creating museums of modern art, we have abandoned the traditional approach of art museums to art. A museum of this sort is more like a trade fair, exhibiting works made for the moment, but not given any collective value, except insofar as fashion decrees that they are 'in'. DILLON RIPLEY, *The Sacred Grove*, Smithsonian Institution Press, Washington, 1978, p. 135.

When Picasso told Gertrude Stein that he was to have a show at the Museum of Modern Art, she replied, 'No museum can be modern.' MARY BOONE in *The Art Dealers*, ed. Laura de Coppet and Alan Jones, Clarkson N. Potter, New York, 1984, p. 280.

The new Museum of Contemporary Art opened in November 1983 in temporary premises in downtown Los Angeles, near Little Tokyo, with an exhibition of work from major private collections. Entitled simply *The First Show*, it featured work from, among others, the collections of Dominique de Menil, Giuseppe and Giovanna Panza di Biumo, Charles and Doris Saatchi, and the Weisman family. It was a predictable but clever choice as the museum, like many American museums, relies heavily on the private sector for its funding and on private collections for loans of works for exhibitions. Douglas Cramer is a trustee, one of a group of powerful business people, artists, lawyers and other collectors. Pontus Hulten, the first director of the Pompidou Centre in Paris, was appointed director. He worked with the first chairman, Eli Broad, to establish the basic organisation on the foundations laid by artists such as Robert Irwin, Sam Francis and DeWain Valentine who had been determined to have their own contemporary art institution in Los Angeles. As well as running the programme at the Temporary Contemporary, the staff and trustees have seen through the building of a brand-new permanent museum building on Bunker Hill. Designed by Arata Isozaki, it opened to the public in early 1987. The Temporary Contemporary, a warehouse conversion by architect Frank Gehry, is being kept on for exhibitions as well. The present director is Richard Koshalek.

THE FIRST SHOW

Painting and Sculpture from Eight Collections

1 9 4 0 – 1 9 8 0

DOMINIQUE DE MENIL

HOWARD AND JEAN LIPMAN

DRS PETER AND IRENE LUDWIG

GIUSEPPE AND GIOVANNA PANZA DI BIUMO

ROBERT A ROWAN

CHARLES AND DORIS SAATCHI

TAFT AND RITA SCHREIBER

THE WEISMAN FAMILY

The Museum of Contemporary Art, Los Angeles

52 Cover of the catalogue for *The First Show*, Museum of Contemporary Art, Los Angeles, 1985.
53 Richard Koshalek, director of the Museum of Contemporary Art, Los Angeles.

The artists actually decided that the city should have a museum of contemporary art, RICHARD KOSHALEK
and they formed a group called the artists' advisory council. They met on a monthly
basis. They met in artists' studios, they talked about the idea, and slowly as the idea
grew in their minds of what kind of institution this city should have, they would bring
along different segments of the community. So they would bring along collectors, and
people who had been involved in art, such as Marcia Weisman and Eli Broad, for
example. They'd bring along the political sector, Mayor Tom Bradley, who's very
interested in developing the arts as a major aspect of the city of Los Angeles. They
would deal with the corporate sector and bring along corporate executives and
philanthropists, such as Robert O. Anderson and William F. Kieschnick.

Above all, MOCA has a constituency. More than 250,000 people have visited the
Temporary Contemporary. There are 16,000 people who pay $35 a head for annual
membership. The endowment is pushing the $15 million mark. William F. Kiesch-
nick, president of Arco and chairman of MOCA, has in more senses than one the touch
of gold when it comes to the museum's affairs. Nor did it hurt that the J. Paul Getty
Trust not long ago gave MOCA an unrestricted grant of $3 million. The museum's
director, Richard Koshalek, is so buoyant that he will one day have to be tethered to
earth like a captive balloon. JOHN RUSSELL, 'Contemporary Showcase With a
Difference', *New York Times*, 3 March 1985.

Since the corporate blanket is so warm, glaring examples of direct interference are
rare, and the increasing dominance of the museums' development offices hard to
trace; the change of climate is hardly perceived, or taken as a threat. That it might
have consequences beyond the confines of the institution and that it affects the type
of art that is and will be produced, must therefore sound like over-dramatisation.
Through naiveté, need or addiction to corporate financing, museums are now on the
slippery road to becoming public relations agents for the interests of big business and
its ideological allies . . . Rather than sponsoring intelligent, critical awareness,
museums tend to manage appeasement. HANS HAACKE, 'Museums, Managers of
Consciousness', *Hans Haacke*, Tate Gallery, London, 1984, p. 108.

In 1985 MOCA presented major exhibitions of the work of Manny Farber,
James Turrell, Red Grooms, Jonathan Borofsky, W. Eugene Smith and
William Brice, as well as a Japanese exhibition, several installations and
video programmes, a series of dance, theatre, music and performance art
works produced with the California Institute of the Arts, and regular
information and education programmes. With both buildings running, and
some semi-permanent display of the collection (which includes eighty
works of Abstract Expressionism and Pop Art purchased from the collection
of trustees Giuseppe Panza di Biumo, and sixty-seven contemporary Amer-
ican works bequeathed by Hollywood producer Barry Lowen), the activities
will be ever more extensive. As with most museums, these will be selected
and organised by the curatorial staff.

The trustees do have a programme committee for MOCA and we do discuss the ideas RICHARD KOSHALEK
that we, the curatorial staff, would like to present in the future, in terms of exhibitions
and performing arts programmes, but that committee has no vote, that committee has
no right of approval, and the decision of the director and the curatorial staff are their
decisions and so far we've had absolutely no interference in that sense. We have a

54 Museum tour at the *Manny Farber* exhibition, Temporary Contemporary, MOCA, Los Angeles, November 1985.

55 A group of Trustees looking over Arata Isozaki's new Museum of Contemporary Art, Los Angeles, 1985.

curatorial staff and they do extensive research, they're constantly talking to artists for example about what artists are doing important work right now, what work looks interesting in downtown Los Angeles, what work looks interesting on the West Side of Los Angeles, what work have you seen in New York City, that this museum should be involved in. We're constantly talking to critics and historians of contemporary art, asking questions about the museum and what the museum should be doing; we're constantly talking to collectors.

We do find critics in the newspapers will say, that was a wonderful exhibition to do but how about doing this exhibition, how about looking at this artist's work; or how about doing an exhibition that deals with the transit problems in downtown Los Angeles, from an architectural critic. We're constantly alert to taking in enough information so we don't just have this sort of very small circle of people with limited information making decisions that affect the history of art.

Whether museums contend with governments, power-trips of individuals or the corporate steamroller, they are in the business of moulding and channelling consciousness. Even though they may not agree with the system of beliefs dominant at the time, their options not to subscribe to them and instead promote an alternative consciousness are limited. The survival of the institution and personal careers are often at stake. HANS HAACKE, 'Museums, Managers of Consciousness', *Hans Haacke*, p. 109.

More Americans go to museums than go to football games. Last year almost 4.5 million people went to the Metropolitan Museum of Art in New York . . . The museum has very largely supplanted the church as the emblematic focus of the American city. It has become a low-rating mass medium in its own right. In doing so it has adopted, partly by osmosis and partly by design, the strategies of other mass media: the emphasis on spectacle, cult of celebrity, the whole masterpiece-and-treasure syndrome . . . In the meantime, that public – conditioned by its museums, by the art market, and by the pervasive journalistic attitude that only finds works of art interesting if they are fabulously expensive or forgeries, or ideally, both – has willed the glamour of big money onto art in a way that is, I believe, historically unique. ROBERT HUGHES, 'On Art and Money', *Art Monthly* 82, p. 6.

It is not just the 'masterpieces' and 'treasures' that draw a large public to museums and public exhibitions. At the Pompidou Centre 840,000 people saw the work of Salvador Dali, and 250,000 went to Jean-François Lyotard's exhibition *Les Immateriaux*. The Tate Gallery in London has had a steadily increasing audience from 500,000 visitors per year in the mid-1950s to 1,300,000 in 1985, and visitors to the Whitney Biennial, a survey exhibition of contemporary American art, have trebled over the last ten years. It may be that the barriers against understanding or appreciating modern and contemporary art have considerably lowered for younger generations; this may come both from the incorporation of modern art into the ethos of fashionable consumerism, and from the effects of wider art education in Europe and America since the 1960s. It may even be a by-product of the masterpiece-and-treasure exhibitions (though there is little evidence that visitors to Tutankhamen feel immediately like tackling Cindy Sherman or even Picasso), or it may be from reforms in the museums and galleries themselves, with better education programmes, eating facilities, advertising, and more

stylish promotion. Whatever those reforms may have done to get more people looking at art, they have generally done little to foster a critical dialogue with the art and with the idea of the institution.

RICHARD KOSHALEK *There's no limit to the audience for* MOCA. *If the institution has the ability to provide equal information to all segments of this community, we will find that interest is not only in the West Side of Los Angeles, where you'd expect it to be, in Pasadena, for example, but we'll find it in Little Tokyo. We do the labels at the Temporary Contemporary, which is located in Little Tokyo, in Japanese and also in Spanish. We get more mail on the fact that we do that, from different people who write to us in Japanese and write to us in Spanish and say thank you very much for making this gesture to us and to our language.*

The curators' decisions in a contemporary art museum may well be 'independent' in the technical sense, but the museum will be linked to other museums, nationally and internationally, through similar ideals, policies and programmes. Museums organise exhibitions that tour to different cities in order to share the costs, though they sometimes compete to exhibit the work of a particular artist or to purchase particular works of art. Individual museums will differ in policy in relation to local or regional interests. At MOCA there is a strong commitment to the art being made on the West Coast and in Los Angeles. The museum is self-consciously trying to gather the limelight for West Coast artists, not only in their own city, but in the international art world. In effect this means acceptance through the magazines and galleries in New York. Its trustees and staff depend, like other museums, on the wider social view of the museum as central to ideas of culture, as an independent determinant of value, something stable, critical but unshakeable. In practice a museum influences value judgements as much as it accepts the value judgements established by others.

National prestige and the needs of international diplomacy are important factors behind certain kinds of state support for art. The National Gallery, Tate Gallery, Hayward Gallery and other similar major institutions symbolise and represent the cultural (and political) power and importance of the nation. Meanwhile cultural exchanges (the lending and mounting of exhibitions abroad, as well as foreign tours by major performing companies) are used between friendly nations as expressions of their continued friendship, and between less friendly nations as part of the softening up process for, and as part of the cementing of, the hard politics of international economic relations and military bargaining. NICHOLAS PEARSON, *The State and the Visual Arts*, The Open University Press, Milton Keynes, 1982, pp. 107–8.

* * * * *

The Art Magazine

It seems to a great many of us now that the one style, one critic, one wave formula that recently held sway has broken down, perhaps for good. We are greeted with the spectacle of many styles, many critics. My own feeling is that this is a healthy state of affairs. It may be confusing for the art dealers, the art collectors, the art speculators, the art curators, and even for many artists and some art critics. But it reflects our society and the possibility of egalitarian pluralism. JOHN PERREAULT, 'Pluralism in Art and Criticism', *Art Journal*, New York, Fall/Winter 1980, p. 377.

The magazine *Artforum* was started in San Francisco in 1962, moved to Los Angeles, then moved again to New York in 1967. It now has offices in a Louis Sullivan building on Bleecker Street to the east of SoHo, and the publishers, editorial, advertising and design staff all work in the same space as a team. There are four 'publishers', Amy Baker Sandback, Anne Dayton, Anthony Korner and an investor in California who takes no direct part in the running of the magazine. The editor of *Artforum* is Ingrid Sischy.

The majority of the art public (those hundreds of thousands in the museum attendance figures), will read art criticism in newspapers or books. But in the art world this writing more often confirms existing ideas or reputations than propagates new ones. The newspapers may seem to have more direct power and influence on commercial value (though there is no equivalent to the ability of some theatre critics to bring down a new theatrical production), but it is the art magazines that influence curators and artists and help set new trends. Criteria and aesthetic assumptions can be questioned, and the terms of a debate can be altered. While private dealers frequently claim that they never read art magazines or criticism, it is they who support the magazines through advertising. *Artforum* takes 50 to 60 per cent of its income from advertising; the majority of this comes from private galleries. Knight Landesman, the national advertising director of *Artforum*, says, 'The amount of advertising is about the topicality of *Artforum*, the quality of the editorial content, the excitement that's in the magazine, the quality of the association of other advertisers. So that the success of *Artforum* is visible in the ad pages because the ad pages are strong and exciting and important.' But does this mean that the magazine can never stray too far from the interests (and valuations) of its advertisers? Publishers and editor may be close now, but this hasn't always been the case; in the 1970s a strong critical line and a much larger inclusion of photographic work resulted in the eventual removal of the editor.

Artforum is in competition with other art magazines. *Art in America* has sales of 55,000 copies per issue against *Artforum*'s 40,000, though the latter, like magazines in Europe, claims a readership about four times the size of its sales figure. In Britain, *Art Monthly* sells 4,000 copies, and *Artscribe* about 9,000. In Europe, the Italian edition of *Flash Art* sells 22,000 and the international edition 25,000 copies.* *Artforum* changed its contents in 1985 to include a new set of regular columns that would complement the main articles and the review section.

Figures courtesy of each magazine.

It's not an opposition to journalism, it's just that we think somewhere in the world it is necessary that there is a magazine which is dedicated to the analysis of works of art. That is what criticism is. We believe that this is not necessarily something for a tiny tiny audience, we also don't believe it's something for a huge, huge audience.

The body of the editorial features is like the mouth of the magazine, the part that either introduces new contemporary artists, or that examines and analyses certain theoretical issues, the part that approaches certain revisionist historical issues, the place where artists or theoretical subjects are investigated in depth. Then the back part of the magazine, which for me is the critical part of the magazine, is a type of record of critical responses within a given history, and as far as I'm concerned the reviewing function of the magazine is one of the most important parts of it, because it shows critical consciousness.

The very endeavour of art criticism is to try and get close to this thing of what art is, that's what it's about. It's not judgement. It is a record of a certain perception at a given time, of a certain thing. I think that to even approach criticism as final judgement, I think is to misunderstand what it is.

There is an analytical approach, a theoretical approach, there is a historical approach, there's a philosophical approach, there's a psychoanalytical approach, there's a critical approach, perhaps one could even say a descriptive approach. I mean the entire question, and I think the project of what art criticism is in itself, in a way is a very new project. It's a project in the way that we now know it, that's only been going on for a hundred years.

The word quality is a dangerous word, it's an insidious word, it's a word as far as I'm concerned with a negative history. It's never as simple to say, 'Well, all the works of art in Artforum *are of high quality,' because I realise the pit of what that word means. The issue for me is consciousness, more than quality. The old excuse for why there weren't women artists in the galleries was, 'Hey! we don't want to deal with tokenism, it's all a question of quality.' That's an insidious thing, who's looking for what where?*

I accept that what a good work of criticism does is that it provides information, and thinking, and discourse, around art. If that information affects the system, my answer to that is great, I'd rather that affected the system, rather than it being who knew who, and who was figuring out what package.

Critical overview takes the form of perpetual stance-taking and professional possessiveness . . . Within the exchange of volleys from predictable positions, the artists' work is held up as a stereotype of itself, like a heraldic shield in a costume drama battle . . . Critical labels incise lines of power and artists take their places in the art-historical queue, waiting for the omnipotent zeitgeist machine to endorse their stylistic variation. ROSETTA BROOKS, 'From the Night of Consumerism, to the Dawn of Simulation', *Artforum*, February 1985, p. 76.

Artforum has a number of regular writers, some of whom write exhibition reviews, others who write feature articles, regular 'topic' columns, or both. The mould of the magazine is slightly broken, with special issues where a thematic group of articles on Technology, High and Low Art, or Photography are brought together. Ingrid Sischy has made a point of trying to pay writers well, but Thomas McEvilley, who is both a writer and reviewer for

56 Ingrid Sischy, editor of *Artforum*.

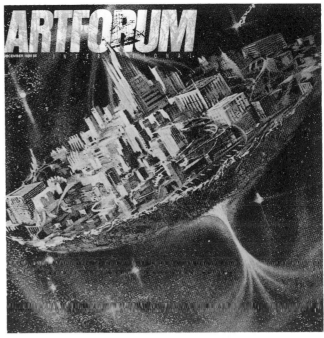

FORUM

REMOTE
CONTROL

A well-oiled beep fills the screen and flexes to the strains of the already-ancient "People Run." It's sort of an orange color and, in this extreme close-up viewing, totally unrecognizable as a swatch of human anatomy. It mobs the viewing aperture and looks like a cross between a slab of fatty bacon and keystone approaching its melting point. It is then quickly replaced by a talking roll of toilet tissue which pleads with members of a family to "touch" it. The rotund glob of needy, animated paper gives way to an "an-

chorman," a somber talking head who reports a catastrophic plane crash. We look at images of emergency medical teams packaging the dead in yellow body bags. The runway is littered with blood and spare body parts. This segment is immediately followed by a shot of a kitten in sunglasses propped under a beach umbrella.

As this clashing litany suggests, television is the most relentless purveyor of the messages that constitute and perpetuate our severely fragmented public consciousness. It slices our attention span into increments too intimate/usual to get up and measure. Spending a large part of our lives planted in front of a piece of talking furniture we are held hostage by the pleasure of the cutting and the repetition, by a kind of interrupt fascination which is facilitated by the relief we feel

in audiences, and has the feel of the erratically riveted wonderment experienced by infants. That television's parade of segments follow one another but do not "go together" does not seem strange or problematic to its viewers. Seen cinematically these disjunctions might appear as affronts to narrative, as some kind of "kooky" avant-garde collage.

Television tells us not of a vision but of visions. It evades singularity and loiters amid the serial, the continual, the flow. Its interest in storytelling is peripheral yet promiscuous. For although a large portion of broadcast time is given over to Hollywood-style filmic drama and the familiar closure of storytelling, television, perching in our living rooms like a babbling, overcontrolling guest, is deeply embedded in the authoritative declarations and confes-

sionals of "direct address." The cinema frames and brackets particular incidents and in doing so reveals its connection to painting and photography, while television seems to emerge via the coupling of new picture and computer technology with the chattering of radio. As television anecdotal accountings necessarily speak of the past, television's direct address inhabits the present. The "nonfiction" genres (news, sports, talk shows) that use direct address also appropriate the stuff of events almost instantaneously and play them back with the relentlessness of an avenging mirror. And because all this combined with ads, sit-coms, soaps, game shows, and docudramas looks like what we've come to think of as life, its simulation grants it perpetual license. Blurring the distinction between the thought and the

act, between imagination and experience, TV's constant broadcast alleviates the truth of its special sanctity and sprinkles it on everything that moves.

Direct address dominates and lets the viewer think they know when doing the talking and to whom. We know when Dan Rather is going to break the bad news and we're not supposed to be contradicted by a talking tub of margarine or seduced by a roll of toilet paper. We know TV means what is said when it's announced. "You Are There." We know that we have received orders not to move and that we're learning to walk in place at the speed of light.
—BARBARA KRUGER

Barbara Kruger's four-panel intervention film-still series on television and other matters regularly in Artforum.

Images from television, September 18 and 29, 1985. Photos: Charles Hagen

57 Detail of Bridget Riley's painting *Crest* on the cover of *Artforum*, November 1985.
58 Cover of *Artforum*, December 1985.
59 Page of *Artforum* with column by Barbara Kruger, November 1985.

60 Ingrid Sischy with publisher Amy Baker Sandback and *Artforum* staff working on layouts.

Artforum, has, like many critics, an academic teaching post as well. He is listed as being a contributing editor, and he explains that 'the contributing editors are independent, and yet they have a special link with the magazine . . . there's a sort of edgemanship involved. The contributing editor is not fully a staff member; I conceive that part of my responsibility is to criticise the magazine itself.'

The editorial tone of an art magazine may in general be determined by the publishers and editor, but in practice the editor's choice of writers and the choices that the writers propose will have a stronger influence. Thomas McEvilley regularly visits galleries in the smarter parts of Manhattan, SoHo and the East Village. It is in the East Village that many young artists organise exhibitions away from the tighter constraints of the market in the hope of being noticed by curator or critic.

THOMAS MCEVILLEY *Every month there are many shows that a critic might review, often there are a number of shows that he or she feels would deserve to be reviewed and all matter of criteria might enter to make the decision. It might seem that there is a worthy gallery that hasn't been receiving attention in the press, it might be that one is influenced because one of the artists is a woman who has previously not received attention in the press. (I feel very concerned with the fact that in the last three or four years the representation of women has plummeted in the major shows and the major galleries, so there is a place for that kind of decision.)*

A critic of thirty years ago walking into a major international show feels that he or she is only concerned with the quality of individual art works. Today a critic walking into a major international show like the last Documenta, *in addition to being very concerned with the individual works, he's got to also be concerned with questions like, why were so few women artists represented, what social and political attitudes seem prevalent in the work and why, at this moment, are those being selected out in a major international show?*

One praises art that one admires. One is focusing attention on art that one thinks is of high quality, so the role of quality controller is still present. It's really one's responsibility to elucidate very keenly one's reasons for liking it, not where one defines one's tastes or relies on claims of quality with a capital Q, as just self-evidently present in a kind of transcendental way, but to teach an approach to the question of quality which is constantly critical, constantly analytical.

Criticism clearly has its role as negative criticism. Criticism means really to criticise everything. One is not timorous, let's say, in denouncing work that one feels either lacks quality or lacks appropriateness. One can be extremely bold and assertive in making one's criticisms and still sanely acknowledge that one is coming from a certain position and state what that position is.

When one walks through the Castelli Gallery, especially at a really major opening, like the Keith Haring opening, one walks through to sense the teeth of the gearbox of the big machine grinding around one, to feel how sharp the bite is going to be this season. There's a great deal of professional tension, careerist tension, in the huge galleries that makes them very exciting. But at the same time it can almost be unfair to the work and one might try to excise the context from one's consciousness.

I do not conceive what's going on as some ethical struggle between critics and

dealers. To a large extent it's adventurous and creative dealers that have brought us contemporary art in the last ten or twenty years. At the same time, I feel that as a critic I have to maintain independence of that system of marketing; I don't write for commercial galleries. I don't accept gifts from artists whose shows I have reviewed, and so forth. I try not to get into a situation where I have a vested interest in becoming, let's say, an entrepreneurial advocate for a certain type of art. As soon as criticism becomes involved in the rest of the system in that way I think it's not criticism any more.

There is a strong interplay between certain types of critical discourse and the activity of actual art making. Many artists feel this also. I feel that an honest and healthy and strong and truly critical writing is one of the most productive elements in an art-making situation.

Not all critics or historians would agree with McEvilley when he says that 'nowadays many critics feel that what we'd like to do is not so much be critical for other people as induce other people to be more critical.' Other critics still see themselves as 'guiding lights', whose role is not only to evaluate, but to establish what values are, or – to use a moral connotation – should be. A critic has a place in the system; there is no external position from which to look at art in an 'objective' or disinterested way. To admit that judgement is relative does not prevent discrimination, and certainly presupposes critical dialogue.

* * * * *

The Public Site

It has turned into a hulk of rusty steel
and clearly, at least to us, doesn't have any appeal.
It might have artistic value but just not here,
so put it some other place where it should appear
and for those of us at the plaza I would like to say,
please do us a favour and take it away.
HANK PERVESLIN, quoted in *Artforum*, Summer 1985, p. 98.

The 1985 summer issues of *Art in America* and *Artforum* carried extensive coverage of American sculptor Richard Serra's *Tilted Arc*. In May of that year Dwight Ink, the chief administrator of the General Services Administration in Washington, had declared that the massive steel sculpture, installed in 1981 at Federal Plaza in New York outside the Jacob K. Javits building, under the GSA's own Art-in-Architecture programme, should be relocated. This decision came from a panel of enquiry headed by William Diamond, regional administrator of the GSA, which had held three days of public hearings in March 1985. Richard Serra made clear that if the GSA decided to remove or relocate *Tilted Arc* he would seek a court injunction for violation of contract. He also, ineffectually, let it be known that if it was moved he would consider leaving America. The sculpture has remained in place.* As at October 1986.

The controversy that has swelled around the slash of Cor-Ten steel that Serra installed four years ago in Federal Plaza is a vivid example of how the complex interrelations of art, site, architecture and the public can come to an ugly conflict and create a profound breach between members of the art world and the public. While *Tilted Arc* may be in a public place, it is not public art . . . Few can argue that Serra's work is not site-specific. But the significant issue is the degree of sensitivity with which the condition of site as a public place and psychological region was interpreted. PATRICIA C. PHILLIPS, 'Forum: Something There Is that Doesn't Love a Wall', *Artforum*, Summer 1985, p. 101.

What makes me feel manipulated is that I am forced to argue for art against some other social function. I am asked to line up on the side of sculpture against those who are on the side of concerts or maybe picnic tables. But of course all these things have social functions . . . It is a measure of the meagre nature of our public social life that the public is asked to fight out a travesty of the democratic procedure over the crumbs of social experience. DOUGLAS CRIMP, evidence at hearing quoted in Robert Storr, '"Tilted Arc": Enemy of the People', *Art in America*, New York, September 1985, p. 94.

The dispute over *Tilted Arc* may be an extreme example of a clash of opinions. Richard Serra is an artist making minimalist and environmentalist sculptures who came to prominence in the late sixties and has a firmly established international reputation. Yet whatever the commercial value of his works in the art world, his art does not have a wide popular following. Indeed while seemingly aware of the implications of museum and gallery endorsement, Serra said in 1976, 'I've never felt, and I don't feel now, that art needs any justification outside of itself.'

Other artists feel not so much that art needs justification, but that placing it in public spaces, outside the specialised (and sanctified) spaces of the gallery and museum, requires special care and attention. It needs, wherever possible, collaboration between artist, architect and environmental planner, to create sympathetic reinforcement of different visual elements: trees or plants, buildings and art. Collaboration is the aim of many schemes around the world, including the GSA's own programmes, which aim to improve public spaces and use the proper consultative processes, with both specialist advisers and community representatives.

Battery Park City is a 92-acre area of land at the south-western tip of the island of Manhattan, created from land infill. Its development includes the new World Financial Center opposite the present World Trade Center, new housing and office space, a riverside esplanade and open park spaces. The Fine Arts programme was initiated by Amanda M. Burden, Vice President Planning and Design of Battery Park City Authority, with the enthusiastic support of the former chairman, Richard A. Kahan. In the spring of 1982 a Fine Art advisory committee of 'art historians, writers, teachers and collectors' was formed. The chair of the committee is collector Victor Ganz.

VICTOR GANZ *We have made every effort to avoid confrontational art, and have succeeded. At the same time we have not, in our desire to get along with people, tried to accept things that are clichés, or are so conventional that they really have no edge to them.*

A great many people are very concerned when art is discussed that is going to be in a

61 Richard Serra, *Tilted Arc*, 1981,
in Federal Plaza, New York. The
sculpture is 3.7 metres high by 36.6
metres long. It is 6.4cm thick.

public situation, because it isn't like art in a museum. Everybody agrees that in art in a museum, the people go into a museum or can not go if they don't want to, but if they work near where art stands they have every right, I think, to feel they want to be certain one way or another that they are not going to be confronted every day by something which they just can't stand.

Meyer S. Frucher, President and Chief Executive Officer of the Authority, has helped the progress of the arts programme, which fits in with the 'Master Plan' prepared by architects Cooper Eckstut Associates. This plan extended the Authority's policies by laying down in detail the type and scale of the developments, materials and finishes to be used for different sorts of buildings, and the nature of the linking elements such as the esplanade along the Hudson River.

MEYER S. FRUCHER

The developers have begun to realise what we have done by having this arts programme, by having these guidelines, which I consider an extension of the arts programme and vice versa. They have now begun to look at it, and they have said to us, 'You have added enormous value to this project, so that the additional cost has in fact a pay-off at the end, because you have created a wonderful environment, and we urge you . . . not to alter this in future stages.'

A particular characteristic of the arts programme, organised by Nancy Rosen, has been to bring artists and architects into partnership. Cesar Pelli, the architect of the World Financial Center, a $1.5 billion project being built by the Canadian real estate company Olympia & York, was asked, together with the landscape architect M. Paul Friedberg, to work with the artists Scott Burton and Siah Armajani on the design of the Plaza. Both these artists were used to working in architectural settings, but Pelli was only gradually converted to working with artists. He is now convinced, Scott Burton says; his own opinion is that 'what office workers do in their lunch hour is more important than pushing the limits of self-expression. The main moral value in modernism for 100 years was the freedom of the self, but that's a trivial issue now. There are more important things than personal autonomy. Social and communal values are more important.'*

Quoted in Douglas C. McGill, 'Architect and Artists Collaborate on Battery Park City Plaza', *New York Times*, 31 January 1985.

Artists making works as part of the programme are Nancy Graves, Ned Smyth, Richard Artschwager and Mary Miss. The architect Stan Eckstut of Cooper Eckstut was asked to collaborate with Mary Miss on a work for the South Cove shorefront, with Susan Child assisting as landscape designer. Mary Miss, like Burton and Armajani, is used to working in public sites, and her sculptures of wood, wire mesh and other simple materials are often so extensive that they become part of the environment. People can walk over them and through them. As Stan Eckstut puts it, 'The problem was obviously having two designers on a project, no matter whether it was two architects or two artists, it's two designers . . . a lot of times Mary and I became very confused about who was the architect and who was the artist.'

MARY MISS

It's better for me if somebody doesn't know when they've come to the art. The art

PROPOSED WESTWAY PARK

NORTH RESIDENTIAL NEIGHBORHOOD
Utilities & Streets (Spring 1989)

MURRAY STREET LOOP

WORLD FINANCIAL CENTER
Building A (1985)
B (1987)
C (1985)
D (1986)
W.F.C. Plaza (Fall 1988)

ESPLANADE & GATEWAY PLAZA
Completed

RECTOR PLACE RESIDENTIAL NEIGHBORHOOD
Esplanade & Rector Park Completed
Parcels A thru L Under Construction

BATTERY PLACE RESIDENTIAL NEIGHBORHOOD
Utilities & Streets (Spring 1986)
Esplanade & South Cove Park (Spring 1987)

SOUTH PARK
(Spring 1989)

63 Battery Park development next to the World Trade Center, New York, 1985.
64 Mary Miss and Stan Eckstut, model of proposal for the South Cove, Battery Park City, 1985.

62 Site plan of Battery Park City, 1985.

should be so tied to the place that there's no space around it removing it, or setting it aside. I think that's the way art has functioned almost always, it's just within a fairly short historical period that it's become so objectified, and so separated, made into something precious, to be moved from one spot, or bought, or sold, or involved in that kind of exchange.

Once Stan kind of realised that I was very much involved in some of the issues that he was involved in, he felt more comfortable. Those attitudes are things that I have taken as part of my work over the years, you know, the way the viewer is going to come to the site, the experiences that one has in approaching the site, how to integrate the site into the city, make it part of an urban context, are things that are very much of interest to me.

Even if we're icing on the cake, at least there's some icing there, and also I don't think we're icing on the cake, I think if we'd been brought in as artists at the end of the process . . . that's when it's like icing. But I'm as tied into this place as an artist as the man who's designing the plumbing at this point.

If you look at the way public art has been treated, by any artist, first of all it hasn't been taken seriously by anybody for a long time. And then when it was, it was treated the same way as though something was in a gallery, and the important thing in the gallery, or in the museum, was to establish your identity, mark your place on the map, so to speak. So you find these pieces, these things that really are like signatures standing on the corners of city blocks, or in front of office buildings, but they are so lost . . . they're so without a reason for being there.

I've chosen to step out of the art market. I found that to be much too constricting to me physically, mentally and in every other way. I wanted to be able to function as an artist, even if somebody wasn't going to sell my work in a gallery, and I think that's the thing I love most about this area that I've ended up in: that I can keep working, no matter what is in fashion tomorrow, or next week, or whatever.

The question (overt or implied) now asked . . . is no longer 'Is it true?' but 'What use is it?' In the context of the mercantilisation of knowledge, more often than not this question is equivalent to: 'Is it saleable?' JEAN-FRANÇOIS LYOTARD, *The Postmodern Condition: A Report on Knowledge*, trans. Geoff Bennington and Brian Massumi, Manchester University Press, 1984, p. 51.

Working to a commission on a public site reverses many of the characteristics of studio-based art; the work is neither made nor directed by a single artist, it cannot be bought or sold, and it is available without the surrounding 'frame' of the gallery or museum. It may have been initially selected by art-world or community representatives, but public opinion is the final test. But as the work's surroundings may have been made more 'valuable', more attractive to the visitor, the owner or developer will have gained. In a place that can be commercially developed, the 'qualities' attached to a work of art will reflect the values the developer is promoting. Unless there is public or art-world intervention, this will most likely fall back into the most conservative and traditional of choices.

Public and private are terms in constant use in this chapter, and works of art oscillate constantly between the two spheres of interest. Decisions are often made with both in mind, but private interest – even when this does not

directly, as for critics and curators, signify commercial interest – will generally be the final concern. Many who work in the art world mask their private and personal interests behind a 'public' front. Artists are expected to have private concerns uppermost when they make their works, but are then expected to operate entirely in the public interest in allowing their work to be exhibited, sold and controlled by others.

Artists are not the only participants in the art world who can be caricatured as 'obsessive'. The ambitions of curators, critics, gallery owners and collectors frequently match the determination of the artists they deal with. The desire for fame and fortune, which would probably be satisfied more quickly in other fields, is not likely to be the principal motivation, but cannot be discounted. A peculiarly rich mix of intellectual debate, the excitement of innovation, the buzz of information and gossip is offered by the art world, together with a fashionable ambience and the possibility, for a few, of considerable financial gain.

Of these five places where commercial and aesthetic value are in debate, no single one leads the others. Some critics are more adventurous than others in writing about new artists, some curators will risk more in organising an exhibition of unproven work, and some galleries and collectors are more prepared to step out of line to establish value where it has not already been perceived by others. At the beginning of an artist's career the opinions of other artists can be particularly influential. For 'value', like meaning, is not simply there in the work of art waiting to be perceived, but exists through these processes of debate between those who write about it, sell it, own it, exhibit it or want to move it permanently into the public domain. The criteria are constantly stretched and modified as new agreements are reached, new talents are discovered and new ideas displace the old.

3 Imagination, Creativity and Work

It's not just the work. Somebody built the pyramids . . . Pyramids, Empire State Building, these things don't just happen. There's hard work behind it. I would like to see a building, say the Empire State, I would like to see on one side of it a foot-wide strip from top to bottom with the name of every bricklayer, the name of every electrician, with all the names. So when a guy walked by, he could take his son and say, 'See that's me over there on the forty-fifth floor. I put the steel beam in.' Picasso can point to a painting. What can I point to? A writer can point to a book. Everybody should have something to point to. MIKE LEFEVRE, quoted in Studs Terkel, *Working*, Pantheon, New York, 1972, p. 16.

Work, and the massive experience of it, is right at the centre of our living culture. Work is a living and active area of human involvement – it makes, and is made by, us. It affects the general social nature of our lives in the most profound ways. PAUL WILLIS, 'Shopfloor culture, masculinity and the wage form', *Working Class Culture*, ed. Clarke, Critcher and Johnson, Hutchinson, London, 1979, p. 186.

In the previous chapter two kinds of value – aesthetic or artistic value, and commercial value – were considered. The role of the work of art as 'art', as an object of contemplation, provocation and enjoyment – very roughly its 'use value' – was examined alongside its role as a commodity, tradeable in the market, an object with an 'exchange value'. In this chapter art is discussed as part of a process; the result of work. What is it that artists do? Is it just skilled labour or pure inspiration? Do artists have a special kind of creativity? What is the work in art, and in what ways do we find art in work?

Different kinds of artists appear to do different kinds of work. Making a video is an activity distinct from egg tempera painting or sculpting in wood. Yet for all those that consider themselves to be 'artists' there are two intertwined processes: physical and technical skills in combination with imaginative skills. These skills are in flux; the initial 'conception' of a work is subject to constant and continuous change as the object itself is being made, while at the same time the physical work may have to be altered or adapted as the idea develops. Whether working to commission or autonomously in the studio, artists' work requires the highest degree of *control* over its production. The work of art, whether painting, sculpture or performance, cannot be almost right, but must be exactly as the artist determines.

With the disintegration of traditional ties between producer and consumer . . . of the arts . . . the artist actually is, in certain ways, a free-floating, unattached individual not bound by patron or commission. In this way, the conditions of work are even more sharply contrasted with those of other types of work. It is easy to see, in this context, how the artist comes to be idealised as representative of non-forced and truly expressive activity (overlooking where necessary, the virtual impossibility in very many cases of actually making a living wage out of such work). JANET WOLFF, *The Social Production of Art*, Macmillan, London, 1981, p. 18.

65 National Museum of Science
and Industry, Parc de la Villette,
Paris.

66, 67 Midland Bank Group
Treasury, London.

IMAGINATION

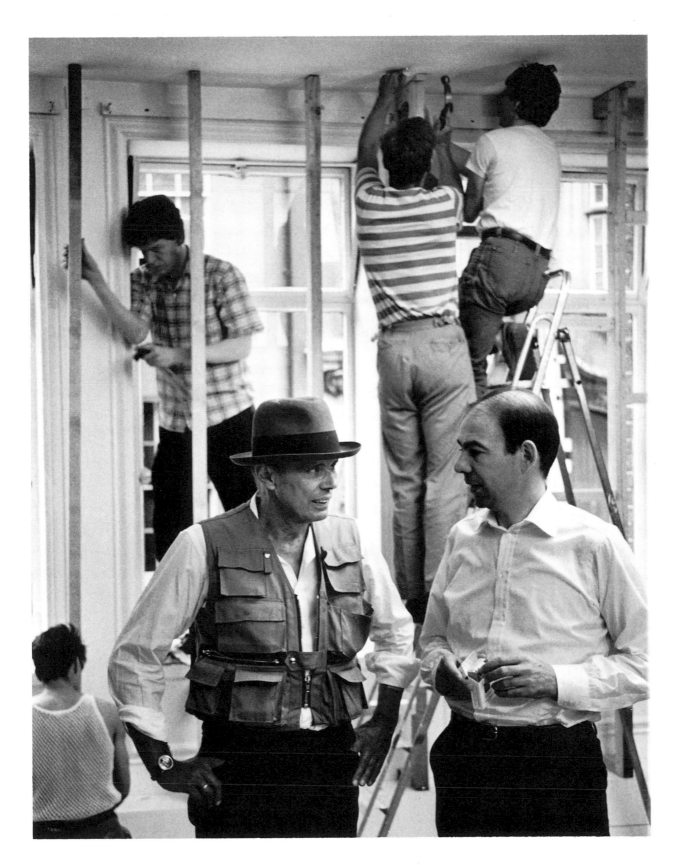

68 Joseph Beuys with Anthony d'Offay, during installation of *Plight* in the Anthony d'Offay Gallery, London, October 1985.

The tendency of media commentators to poke fun at the idea of anything and everything the modern artist does being 'art' reinforces the idea of the artist as a lone visionary whose technical skills are negligible when set against his or her 'inspiration'. We see an individual figure, highly self-motivated, working neither to commission nor to satisfy a market demand but to fulfil an inner need or desire. Studio assistants or technicians may help, but their functions will be clearly subsidiary. The expectations of young artists leaving college are all too often focused on this model – the popular stereotype, propagated in film and television, of the (male) artist nobly slaving in a garret.

Ironically, in order to become this 'independent' artist – in order to continue as an artist at all – most will have to take other work: teaching, decorating, accounting or whatever they find will pay the bills. And there are many artists for whom such notional independence is anyway imposs-ible or undesirable: they work to commission, painting portraits or land-scapes, making works for public sites or installations for museums; they work in teams because their medium – film or performance, for example – demands it. Artists have long since discovered that a mix of skills is essential to survival.

Waged work . . . may cease to be a central occupation by the end of the century. We therefore urgently need to prepare ourselves to be active and self-employed in tasks which will be defined not by the boss, the state, the Führer or the electronic brain, but by ourselves. We have to relearn how to devote ourselves to what we do, not because we are paid for it, but for the pleasure of creating, giving, learning, establishing with others non-market, non-hierarchic, practical and affective relationships. ANDRÉ GORZ, *Paths to Paradise, On The Liberation From Work*, Pluto Press, London, 1984, p. 107.

Patterns of work are subject to the shifting forces of demand and supply, technological change, warfare, family tradition and education. As the types of work available have altered over the past thirty years, so have expecta-tions and ideas; rates of pay, job satisfaction, benefits, employment guaran-tees, pensions and possibilities of flexible and part-time hours are all part of contractual negotiations. There is the question both of whether enough work exists in the post-industrial age, and of what forms the work there is will take. Will the new work be more or less fulfilling than the old? Will unpaid domestic labour have a new position against full-time employment? Artists may appear peripheral to these questions, but it is their creativity and self-motivation that correspond with many of the solutions, offered from left and right, to the problems of the new technological age.

The artist has become the embodiment of the creative ideal. As physical labour is given over to machines, as much responsible mental work is handed over to computers, it may be more useful to employers, and society in general, to limit further the number of people who regard themselves as creative. This number will tend to be limited if the artist is viewed as *innately* creative, born rather than trained.

This notion of the creative, without denying the different physical abilities

IMAGINATION

with which we are born, is restrictive and insubstantial. It is as narrow and limiting as the notion which confines women's creativity to motherhood and domesticity. The artist becomes a special kind of person, rather than a person with special skills. He or she is no longer a picture-maker or sculptor, trained in certain techniques and intellectual knowledge, but set apart, revered and marginalised simultaneously. Many artists, at a subconscious level, may fulfil this role, live out the stereotype. Others may incorporate in their work a critique of the 'idea of the artist', proposing other and more extensive possibilities.

Not only do we have to grasp that art is a part of social production, but we also have to realise that it is itself productive, that is, it actively produces meanings. Art is constitutive of ideology; it is not merely an illustration of it. It is one of the social practices through which particular views of the world, definitions and identities for us to live are constructed, reproduced and even redefined. GRISELDA POLLOCK, 'Vision, Voice and Power: Feminist Art History and Marxism', *Block* 6, London, 1982, p. 9.

#

'Great Art' would have us believe that only 'Great Artists', as it defines them, produce 'Art'. The rest of us, lacking the inspiration, remain passive, watching, listening, accepting, admiring, consuming. This myth even defines spectatorship as passive, which it need not be. If we are going to get beyond this we have to question such definitions of the 'Artist'. We have to look at ourselves as producers in relation to our world and our ways of living . . . KATHY HENDERSON, *The Great Divide*, The Open University Press, Milton Keynes, 1976, p. 34.

Every human being is an artist. In my work man appears as an artist, a creator. By artists I don't just mean people who produce paintings or sculpture or play the piano, or are composers or writers. For me a nurse is also an artist, or, of course, a doctor or a teacher. A student, too, a young person responsible for his own development. The essence of man is captured in the description 'artist'. All other definitions of this term 'art' end up by saying that there are artists and there are non-artists – people who can do something, and people who can't do anything.

JOSEPH BEUYS

In early October 1985 Joseph Beuys built a large installation work at the Anthony d'Offay Gallery in London. During the same days he supervised the positioning of a number of his sculptures, including the recently cast bronze, *Lightning* (*Blitzschlag*), in the central rotunda of the Royal Academy of Arts, as part of the exhibition *German Art in the 20th Century*.

Entitled *Plight*, the installation at d'Offay's involved lining the walls of the gallery with large rolls of felt, two rolls high, in specially manufactured groups of five. The two rooms of the gallery were thus padded, insulated and isolated. In the centre of the larger room a grand piano was positioned, with a blackboard and a thermometer on top of its closed case. Beuys, and his associate Heiner Bastian, directed the technicians. As the felt rolls were lifted, positioned against the walls and fixed in place, the temperature in the room began to rise. The walls and windows were gradually covered in,

69 Joseph Beuys, October 1985.

IMAGINATION

and the felt, a mixture of rabbit's hair and sheep's hair, dominated, creating a dull, grey, womb-like, but also tomb-like, space.

Now, plight is a term or an English word which has two sides. One very negative, a great dilemma, a terrible need, a bad situation. The other, an expression of trust, an expression of loyalty and also a great promise. And these two poles of the term interested me for this felt-room. This felt-room, too, has a negative as well as a positive aspect. It expresses on the one hand total isolation. Everything is taken away which is genuinely communicative, for instance language. This room contains elements similar to those in Beckett's plays: everything is isolated, and knocking on the wall has no resonance. Communication is no longer possible.

The other aspect is that it is a room which relates to the temperature–concept of sculpture. Warmth as an element of sculpture ['Plastik'] is expressed. The positive aspect is thus protection against a negative influence from the outside. It is an experiment, insofar as I am conscious that it represents a product of a special kind of laboratory. A laboratory which is interested in extending the concept of art and starts with experiments in the field of sculpture.

'Everyone an artist' is the clearest formulation of Joseph Beuys's intention. It means a widened concept of art in which the whole *process of living* itself is the creative act. On one level it means farewell to narrow definitions and to the restriction of art to the products of a specialised group of professionals. More importantly, it implies an intensified feeling for life, for the processes of living, and for the structures of society . . . For Beuys this process of personally understanding and discovering the world began with sculpture, or more precisely, with material. Material is substance, both carrier and conveyor of meaning. Beuys's sculpture throughout the years has been extended as a vehicle of meaning and most particularly of his own understanding of the energies that give direction and meaning to life. These energies are not always visible, tangible, or accessible to analysis. CAROLINE TISDALL, *Joseph Beuys*, Solomon R. Guggenheim Museum, New York/Thames and Hudson, London, 1979, p. 7.

23 January 1986.

When Joseph Beuys died* he was still a controversial figure. Despite his widely acknowledged position as the leading artist in Europe, his work continued to provoke and to confound expectations, as it had for thirty years. Its consistency, however, came in part through his use of certain significant materials: fat, felt, copper, honey, blood and certain woods and stones, and in part through his determination to unite his works of art with a wider philosophy and ambition. Beuys as an artist was not just a sculptor, but also a draughtsman, a performer, a politician, an environmentalist and a teacher. He was determined to redefine radically the role of the artist and was uninterested in carrying out didactic commissions, decorating interiors or making works for collectors. He was also determined to expound his ideas about creativity in any arena to which he could gain access, to undercut some of the assumptions that surround ideas of work, to force concepts of work to be reconsidered by each of us as employers and employees, as producers and consumers. He sought a dialogue with intellectuals of all persuasions, but especially with those in the natural sciences, whom he found at times more sympathetic than colleagues in the arts.

If it were the task of art to understand something intellectually, I would express it better in logical sequences of sentences and not produce colours or forms. Man, in this manner, in speaking about such terms, experiences the force fields which constitute him: not only visual perception, but also the element of hearing, the sense of equilibrium, the sense of temperature, the sense of smelling, the sense of tasting, etc.

Only now the professional term is used correctly if one says: of course there will be human beings who are creative in the domain of electricity. But there are also human beings who are creative in the domain of painting. And through the disposition of colours they can express something which points above that which an electrician can, perhaps, express. The artist points towards the totality of the relationship between the physical incarnation of humanity and its total spirituality. He breaks through the barrier of the distorted perception of the world as relationships of specific matter, relationships such as those formed by the so-called exact, natural sciences. Man, tout court, is a creative being. Art or creativity is the occupation most worthy of man. Now man is in a position where his labour can be freed of all alienation, because he can learn in this way to recognise his own nature, to recognise what he is capable of. The concept of ability becomes central and with this comes the recognition that it is here, not in money, that society's true capital lies. The state today runs the institutions of the mind, almost everywhere. It is the dominant element. That is to say, the enterprises of the mind are state enterprises. But the enterprises of the mind are the most important production sites in the whole sphere of production because there true human capital is being developed, man's ability.

If today a firm obtains a loan from a bank, the only thing which comes into it is whether the firm can give back the loan as quickly as possible – whether in the short or long term – so that the bank can make a large profit. The whole thing is built on a system of profit. When human creativity is recognised as society's true capital, then the old injustices of the profit system will vanish.

From now on this creativity is within man and is not something invested in him by some ineffable, all-powerful higher being, like a god or several gods or whatever some religion says about the spiritual world. From now on the spiritual world is to be brought down to earth by man; the planet has to be created by man alone and not simply given to him as a gift. The old principles have invested certain things, but from now on man is the deciding factor; everything depends on him and on the power of self-determination, which is also the power of freedom and the concept of creativity.

We must continually voice these weighty relations which are contained in the concept of creativity, in a so-called permanent conference, one could say, about humanity itself. And that will be the future workplace of man, full occupation in his own spiritualisation. Because in physical employment, with the necessity to rationalise, immanent in economics and technology, men and women will increasingly be brought out of factories. Everything will be much more automated in the future, and the struggle for work, as it is now, as it was twenty years ago, is a regressive one which won't lead to the solution of today's problems. Because it would be very unreasonable to run a business irrationally and reconstruct very primitive set-ups again so that people could somehow scrape around again, at some conveyor belt, or in a Taylorised system, or do work which they don't really need to do any more.

Of course, enough physical work will remain. Or let us say, it will only then become possible to really do the work of the hand, by combining it with the mind and

70 Joseph Beuys, *Plight* (detail), 1958–85, at the Anthony d'Offay Gallery, London, 1985.

71 Joseph Beuys, *Fat Chair*, 1966.

IMAGINATION

72 Joseph Beuys, *The End of the 20th Century*, 1983. Installed at the Workcomplex, Hessisches Landesmuseum, Darmstadt.

73 Joseph Beuys, *Felt Suit*, 1970.

for instance cure dying forests. Until today no system, whether in the East or in the West, can achieve this. Because to cure a forest is something which won't make a profit, in the short term. Of course there will be a profit, including a material profit, but in 300 years.

The most consistent expression of Joseph Beuys's ideas came through his teaching as a professor at the Academy of Art in Düsseldorf (prior to his dismissal in October 1972 following disagreements over the selection of students), as founder of the Organisation for Direct Democracy through Referendum, and as co-founder of the Free International University, which organised conferences and seminars including the notable participation at *Documenta VI* in 1977. He also argued his point of view in innumerable talks and seminars organised alongside his performances or exhibitions of his works. Beuys's sculptures, drawings and certainly his performances were in themselves a provocation to debate in both art and politics. 'I do not want to carry art into politics,' he said, 'but make politics into art.'

His position as a controversial artist, wearing his famous hat and sleeveless hunting jacket, was exploited by Beuys wherever possible. In June 1979 he stood for election to the European Community parliament. He was not elected. At *Documenta VII* in 1982 he more successfully organised a work entitled *7000 Eichen* in which cities worldwide extended their tree-planting programmes and marked each new oak tree with one of 7000 mountain stones.

The largest collection of Beuys's sculpture is the *Workcomplex* at the Hessisches Landesmuseum at Darmstadt. The galleries were installed and arranged by Beuys, and the collection is based around a large group of sculptures and objects from performances, originally acquired by the collector Karl Ströher. The first gallery is filled with twenty-one stones which initially appear to be in the course of arrangement. Some are balanced on wooden pallets, others held up on small wooden blocks, and one is raised up on a trolley. Each stone has been drilled, and the hole plugged with a conically shaped stone covered in felt. The plug seems to be leaking a chemical solution. The stones are uncut boulders, each unnervingly human in shape, reminiscent of a shrouded corpse. The gallery also contains a sculpture, *Trans-Siberian Railway*, 1961, with a wooden 'buffer' and 'train' and a line drawn in sulphur connecting these to one of two brown-painted canvases which face into the wall.

In the general conception . . . the Poet, the Artist, is by nature indifferent to the crude worldliness and materialism of politics and social affairs; he is devoted, rather, to the more substantial sphere of natural beauty and personal feeling . . . [but] in the work of the Romantic poets . . . a conclusion about personal feeling became a conclusion about society, and an observation of natural beauty carried a necessary moral reference to the whole and unified life of man . . . Wordsworth wrote political pamphlets . . . Blake was a friend of Tom Paine and was tried for sedition . . . Byron spoke on the frame-riots and died as a volunteer in a political war . . . RAYMOND WILLIAMS, *Culture and Society, 1780–1950*, Penguin, London, 1963, p. 48.

The other galleries at Darmstadt house major sculptures, including the huge and battery-like *Fond III* of 1968 made of nine piles of felt topped with copper. In the smaller galleries there are a variety of smaller objects meticulously arranged in glass cases in the style of an ethnographic collection. Here images and objects that are the detritus of particular performances (the boxing gloves from the *Boxing Match for Direct Democracy* of October 1972) are mixed with created and found objects of all kinds. Some have the strongest historical references, like the collection of objects entitled *Auschwitz*, which includes a printed plan and photographs of the buildings, while others refer to Beuys's thoughts about energy, warmth and social organisation (the dead bees, the hare's fur, the blocks of fat, the preserved sausage meat, the scratched carvings on slate). Fat and felt are the materials he used most consistently. In 1943, when his fighter plane crashed in the Crimea, he was rescued by members of a nomadic Tartar tribe who 'covered my body in fat to help it regenerate warmth, and wrapped it in felt as an insulator to keep the warmth in'. In his work there is often a strong reference to the healing properties of materials, and many of the sculptures and performances have a paramedical appearance. They endorse the healing, caring and intuitive human actions which Beuys valued over rationalistic scientific procedures. But Beuys has often stressed that his sculptures question, rather than answer.

These experiments intend, through sculpture, to produce a starting point, to provoke – that the social function, the social problems, which aren't yet solved, shall be solved by human beings. And through which part of man? Through man's free creativity and self-expression. That is my main intention, to make human beings conscious of their creativity. To help them in that. . . . It sounds as though I could help people. As though I could tell them how to do it right. That means I would be a know-all. This is not the case.

Self-determination and self-government will be.the most important thing. All the future social changes which have to be wrought, of course I mean improvements, can only be based on the definition of humanity as creative, or able. Because only that contains the definition of human freedom.

* * * * *

The landscape looks bleak, scarred by the remains of past and present industrial labour. The long low sheds of a steel mill, partly demolished, and the winding gear at pit heads are interspersed with factory buildings and rows of small brick houses. Occasional cone-shaped pottery-kiln chimneys stick up through the roofs. The entire landscape is sliced through with motorway link roads and dual carriageways. This panoramic view is overlooked by a silent male figure, hands to each side, holes as eyes, staring out to the horizon. The lead sculpture stands on a small hillock, recreated from a slag heap, bulldozed and resurfaced to be part of the new garden festival at Stoke-on-Trent, Staffordshire.

The sculpture is by Antony Gormley and is hollow. The space inside it is where Gormley's own body stood in the studio as the work was being made. The outer lead casing has been beaten into place and soldered together over a layer of glass fibre. The glass fibre was itself built up to reinforce the plaster and scrim that had been moulded over Gormley's body. 'To use the analogy of the photograph, [it] is simply that you are recording; you end up with a still image of something that is taken from the continuum of life. You are taking a time and making it into a place.' In 1981 Gormley gave up making sculptures with lead covering other objects in order to concentrate on works based on his own body.

74 Antony Gormley, *A View: A Place* (detail), 1985–86.

I felt that humanity existed, and that it existed without clothes. How can I possibly explain this? It was naked, humanity seemed naked, and all the tubes and buttons and machineries, neither came into the world with us, nor will they follow us out, nor do they matter supremely while we are here. E. M. FORSTER, 'The Machine Stops', *The Eternal Moment and other Stories*, Sidgwick and Jackson, London, 1928, pp. 30–1.

Making these sculptures requires many collaborations. The first collaboration is with Vicken Parsons, his wife, who makes the plaster and scrim mould over his body; the second is with a glass-fibre technician who strengthens the new 'body'; the last is with skilled plumbers and artist assistants who work on shaping and fixing the lead skins. All but the first process Gormley can do on his own, but for greater efficiency, and when he

75 Antony Gormley, *A View: A Place*, 1985–86, Stoke-on-Trent Garden Festival, 1986.

has the money, he employs others. At all stages he adjusts, alters and reworks the sculptures. The first stage is the most crucial, as the shape and pose of his body determine the look of the figure. Since the facial features, toes and fingers have been generalised, this 'look' carries much of the meaning.

ANTONY GORMLEY

The most usual way is that every month or two I'll look back over maybe two or three sketch works, sketchbooks of drawings, and select out of those maybe two or three things that I feel are strong enough to be made into work, and then it goes into the studio and I start making up direct, life size.

It's my closest experience of matter. It's a very simple thing to say but in fact that's the truth. I regard my body as the vehicle through which all my impressions of the world come, and equally I want to use my body as the vehicle through which anything that I have to communicate with the world can be carried.

My body is the location of my being. If I started manipulating other people, I would use them as actors and I want to use the actual substance of my being as the material of my work. The inconvenience of it is really beside the point. It is actually very convenient; I'm not lost in the kind of virtuosity that might result from having to make a body from scratch out of clay.

I know what the thing looks like from the inside. I don't know what it looks like from the outside. I am that object and that seems to me to be an enormous advantage. You cannot ever be inside another substance as you are inside your own body. When I'm standing or in a particular position for a pose, I am attempting to unite my physical and mental self into a total form.

There are times of great intimacy in the working process where there is only room for you and it's right that it should be so. There is also an aspect of making sculpture that I am particularly interested in which could be called tribal, which is simply the way in which people by working together generate a certain kind of energy and have collectively the power that is not available to a man on his own. That power is something I want to use. Hopefully the work in its manufacturing process is a balance between quiet things that are only accessible to me because they happen within the chemistry of my own mental and physical being, and the very active physical jobs that need to be done in the manifestation of sculpture. You end up with something that has the power of both areas of human experience.

I'm unearthing a kind of language that existed almost before language, before the kind of thinking that we use – where deep within our cellular kind of wisdom there is such a close bond between us and the really powerful things of the world, the elements, the planets, and the space that connects them all. I want to tap into that energy. I'm always saying the work is not symbolic, it is not standing for something else, there's my weakness and there's my strength. In the world today we're absolutely information-bonkers. We're so keen to find out what the artist intended that we don't actually discover what the work really means.

76 Antony Gormley, drawings, 1986.

The strength of . . . artists and [their] possession of a technical skill enables [them] to rise above the merely personal, and to relate [their] personal deprivations to the discontents implicit in being human. We are all deprived; we are all disappointed; and therefore we are all, in some sense, idealists. The need to link the real and the

IMAGINATION

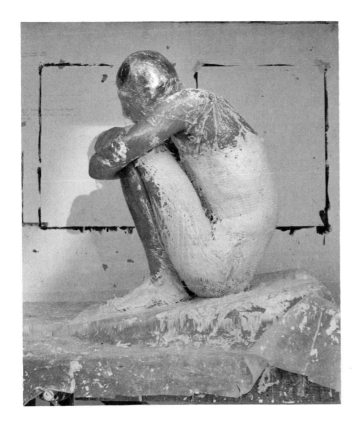

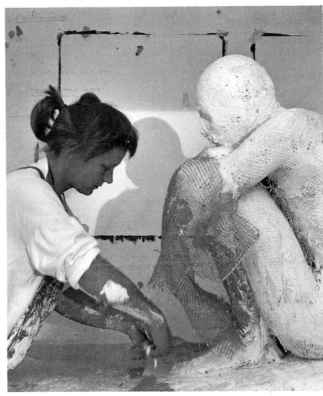

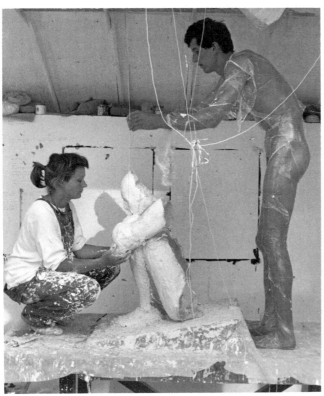

77, 78, 79 Antony Gormley and Vicken Parsons making a plaster mould from his body, London, 1985.

80 Antony Gormley fitting the lead casing in the final stages of a sculpture.

81 Antony Gormley, work in
progress, 1985.

82 Antony Gormley, *Man Asleep*,
1985.

ideal is a perpetual tension, never resolved so long as life persists, but always productive of new, attempted solutions. ANTHONY STORR, *The Dynamics of Creation*, Pelican, London, 1976, p. 290.

Gormley's sculptures imply physical experiences and feelings, and through a process of identification we may feel similar sensations to those felt by the artist. He stresses that in his view physical experiences can be commonly understood in ways that override social and sexual differences.

As well as physical identifications, emotional and psychological states are indicated by the posture of the figures. In *Field*, outstretched arms give a feeling of extension and also of vulnerability, or aloneness. The viewer's eye flicks back and forth between hand and shoulder, trying to unify, or make normal, the limbs that have been so absurdly stretched.

Man Asleep refers to dreaming. Dreaming is commonly thought of as a subconscious process that is parallel to creativity and the imagination, a place for the expression of fantasy and desire, of ambition and frustration. The dream of the sculpture might suggest a mass of people, a consciousness of unity, or a moment of collective determination. The clay figures seem both resolute and exhausted; both individuals and a throng.

The touch, the mark, of the artist's hands is the usual identification of labour, the manual result of mental processes both conscious and subconscious. While the clay has the immediacy and responsiveness of this touch, the deathly, beaten surfaces of the lead figure seem to deny the artist's hand. Yet he has been more completely present in the creation of the figure, using not just his hands but his whole body. In both clay and lead Gormley has more or less total control over his work, and he will produce as many or as few sculptures as he likes. He knows the dangers of overproducing in a stylised fashion which might stifle his inventiveness.

ANTONY GORMLEY

The balance between me as witness to my own sensations and feelings and the final sculpture has to be witnessed not only by the world, but also by space. That sounds like a 'cosmic' concept but it's very important for me.

Quoted in *Antony Gormley*, Städtische Galerie, Regensburg, 1985, p. 52.

For Gormley, making art is an expression of his humanness, of the particular feelings and reactions he has in and to the world, a form of work that is for him almost religious. Emotions such as 'tentativeness, or generosity, or meanness, or fear, or love'* which he hopes to represent are highly abstract and, as with Beuys, his work requires a process of imaginative identification from the viewer. But whereas Beuys concentrated chiefly on the *conception* of his works of art, through his drawings and his frequent incorporation of found objects, Gormley concentrates on an idea that is brought to fruition through the material transformations. As we become gradually aware of the direct, cast-like relationship between the sculpture and Gormley's own body, the physical work in Gormley's sculptures, the succession of creative processes, becomes more evident in the final object.

* * * * *

IMAGINATION

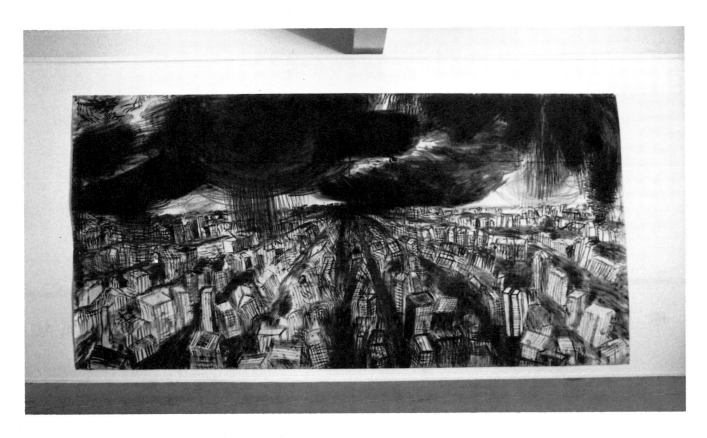

Three large drawings by Miriam Cahn fill the gallery. Each one is nearly three metres high, and each is made with black chalk on white paper. Each shows a landscape. Rain pours down from heavy clouds in each scene, one a town, one a hilly landscape and one a mountain range. The perspective places us as if in the sky looking down on each dark and glowering panorama. Seen more closely, the marks of the buildings and ridges are interspersed with occasional fingerprints, handprints and footprints. The marks, the dark shadows and outlines, are built up with layer after layer of the black chalk, pushed and rubbed into the paper by hand.

When I stand in front of these landscapes, when there are three of them together and they create a closed space, it's very important to get the feeling of flying over them. Whether it's like being in a dream or in an aeroplane doesn't matter. This feeling of flying or floating over the pictures is very important, because there is something dream-like and, at the same time, something real. When I create these landscapes I stand right in the middle of them, I lie around in them, I'm not actually in control. The breaking of perspective and playing with perspective and removal of perspective are extremely important because it's spatial work which makes people standing in front of it start to hover themselves.

The procedure – I always call it a process (just as in chemistry, or in law, or something of the sort). I have certain materials. I put myself, as a whole person, as a whole woman, into certain moods and I work on the floor, at the table with my whole body with these materials. I often have certain structures – that's clear. I know

83 Miriam Cahn, *Strategic Places (menstrual work) town 2.10.85*, one of a group of three drawings.

MIRIAM CAHN

84 Miriam Cahn scrapes black
chalk from large blocks,
accumulating a pile of chalk dust
with which to draw.

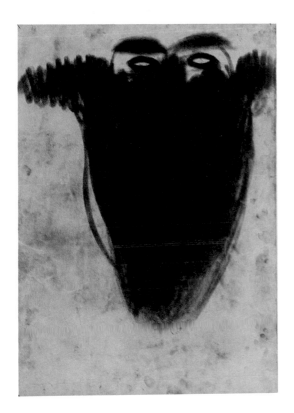

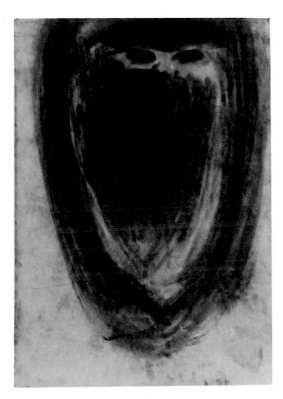

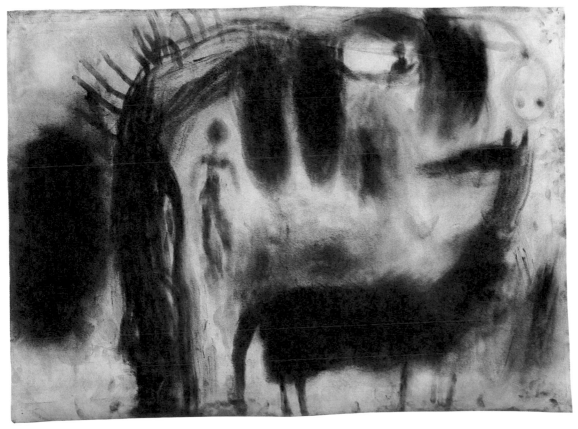

85 Miriam Cahn, *My ancestors,*
L.I.S. 2 sides (of my being) 13.4.85,
two of a group of five drawings.
86 Miriam Cahn, *L.I.S. with children*
and animals (menstrual work)
17–20.4.85, one of a group of five
drawings.

whether I intend to create a sphere, or a landscape, whether I intend to create figures. But I don't know how many and this always takes the form of a series. These are not individual pictures. It is a process which is already given, determined by the dust arising from the chalk. I spread the dust onto the paper and that is really an old-fashioned, a lost process which maybe wise women used in bygone days. Let's say it's similar to reading tea leaves. The process is called 'reading in the dust'. When you see 'L.I.S.' in works of mine that always stands for 'Lesen in Staub' – 'reading in the dust'.

Conscious, subconscious – that's an expression which characterises Freud's work. I've nothing against Mr Freud. I think he was an artist, but these are simply expressions which are too limiting. I've got a motto: that is, 'complete subjectivity'. This is concerned with such terms as subconscious and conscious. But it isn't this division, it doesn't include this, but it is everything together. It is more of a kind of flowing process, whereas this subdivision between conscious and subconscious is again a part of our system of dividing up things which can't be divided up in this way. I am working as a complete person, and that is complete subjectivity.

The idea of concentration which includes the whole of oneself as well as the whole of the object raised another question. How exactly does the capacity to make a whole picture in which every part is related connect with the capacity to be a whole person? Is the striving for one at least partly based on the striving for the other? . . . When we look at such a picture do we get a temporary glimpse of what it would be like to be a truly whole person? MARION MILNER, *On Not Being Able to Paint* (1950), Heinemann, London, 1977, p. 111.

Art is the enactment of the imagination; the concentration of imaginative processes through particular materials. This involves special physical skills which can be developed through learning and application. But a certain determination is an essential element in the stimulation of the imagination and in physical application. A relentless dedication requiring all of her concentration and energy allows Cahn's images and ideas to surface.

Miriam Cahn has made works using black chalk for some years. Now she has large blocks of chalk specially manufactured for her. She patiently and mechanically scrapes down the surface of each block with a sharp wide kitchen knife, gradually and ritualistically accumulating a pile of the black chalk dust on the table. This is then transferred to sheets of paper laid flat on another table or on the floor. She works through the dust on the paper, spreading it out and then drawing or marking with her fingers or whole hand, sometimes using a spare piece of chalk from the block. As she works she can hardly see the marks through the dust, the drawing becoming visible only when the dust is cleared away at the end. There is therefore a literal level of unconscious, unviewable creation.

Some works from 1985 are of female figures, animals and children, others are of mask-like, staring faces. They are set at all angles across the sheet, there is no perspective, and they fall in and out of a kind of landscape in which plants and trees are hardly distinct but give a strong sense of place. They are not pictures of people, but act as effigies or surrogates; they stand for people, for humanness, for life.

The figures in my series are actually myself. In a different sense. I see myself as a sieve and they are a kind of mirror image. They are always women. I have also drawn men, but, logically enough, they always turned out fairly classical. It was classic pornography. Whereas the figures which I portray are beings, female beings, which have more to do with feelings. They are definitely meant to be women. What people actually see is another question. I can only portray myself. When I do this with complete subjectivity then this has to happen. They aren't even really other women. It's only me. But I assume that I am a being in a society and, as a result of this, I am able to make many references to particular fields which have perhaps been omitted in art.

The exhibition that brought these works together, *Strategische Orte,** was completed with two books that Cahn made in 1984. They were entitled *2 Sides (of my being), with the children and animals and A and H tests.* One of them, coloured in pastels, shows the mushroom cloud of a nuclear explosion; it was the only coloured image in the exhibition. Cahn sees this as a productive confrontation, deliberately aestheticising something which is totally horrific – naming and confronting the image of the unnamable, the apocalyptic. For her this combination of images was the key to the exhibition.

There is a clarity and specificity to the titling and labelling of all Miriam Cahn's work. Several works are labelled with dates and subtitled with 'Blutungsarbeit', menstrual work. Clear recognition is given to her bodily self at the time they were made, giving some clue to the kind of energy she needs to produce them. She has often described how physically involving and exhausting the works are to make. In this and in her approaches to art, informed in part by feminism, Miriam Cahn tries to mark out a place for her work separate from the dominant traditions of Western art. She cannot see her creativity as contained within a chronology by which one kind of art replaces another; in this sense she is uninterested in aesthetics or style. Without any political posturing or rhetoric, Miriam Cahn quietly proposes another viewpoint, a more direct and intuitive way of seeing and picturing the world.

Staatliche Kunsthalle, Baden-Baden, and Städtische Kunstmuseum, Bonn, 1985–86.

It used to be said that a woman was nervous before her period and nowadays a woman is capable of working with it. It is certainly a form of energy which exists. I really do structure my work in this way. I really do take a break afterwards and date it exactly so that I have a form of control as to what is really happening. It is really something very simple and something of an everyday nature and is concerned with the fact that I really would like women's culture to gain more importance again. At least that it should have equality with men's culture. And as men's culture hasn't proved its worth, it has quite a good chance.

The figures look the way people do. And that is partly terrible and partly funny. They are looking at themselves, they are looking inside themselves, they are looking out of themselves. But it isn't only terrible, it is also funny. But it is primarily a sad history. The history of women in the past two or three thousand years is mainly a history of loss . . . in our culture, black means sad and, as a result of this, the effect tends to be sad, but for me black is rather the colour of life. The things portrayed there —

113

the women and the figures and the animals and also the landscapes – always consist of conflicting contents. They should, at least, always produce a conflict.

It isn't necessarily because of the colour, but this black chalk with its dust has a tremendous number of possibilities, which have nothing to do with either painting or drawing, but which, in themselves, are something special. It has its own material quality, resembling nothing else. It's a closed system. It's a circling around myself in the hope that, in this way, I shall discover a few things about being a woman and, of course, about myself, too. There is a similarity to sport, on the one hand, and on the other hand to Zen people. I do indeed transform myself into a state, but it has nothing to do either with training or directly with absolutely meditative things. These elements are in it. But I make my own mixture.

I hope that the work is so open that it isn't only feminist. But the path leading to this is clearly feminist – the emphasis on physical work, the emphasis on physical cycles, the emphasis on menstruation, ovulation, birth, the gift of child-bearing, children, and all these things.

Miriam Cahn never corrects or removes marks from her pieces. A mark once made must remain with everything around it; there is a constant assessment of when the cumulative marks are complete. There are rational elements to this, but it is largely intuitive. The experience of making the work is primary. Unlike other modern works in which a highly intuitive procedure is evident – late works by Picasso or work by Cy Twombly – Cahn always leaves direct as well as indirect traces of her labour: the handprints or the menstrual dating. Her work challenges the assumptions of a specialised artistic creativity, the traditions of the 'valuable object' and the reverential attitudes to viewing and collecting the work of contemporary artists.

MIRIAM CAHN

I bear responsibility when I take my work outside, when I step into public life. Then I have responsibility. An element then appears which didn't exist before, namely, the public. What is my position towards the public? What is a public? What is a museum? What is an exhibition place? What is money which is paid for my work, etc? What is a collector, what is the so-called person, the average person who looks at my work?

I don't fix my works because I really don't see why I should. The material is what it is. I don't have it framed because I consider that to be classic preservation nonsense; it doesn't interest me in the least. Fixing and framing is a matter of maintaining the work for posterity. I think that's nonsense. The idea is more important to me than maintaining a work. The fact that it's so delicate is connected to the fact that one should be able just to tell by looking at it that time has passed. Some of the dust should fall off it, it should change somewhat, it should be transformed by touching.

* * * * *

IMAGINATION

With a minute brush the conservator is concentratedly repainting part of a large Gainsborough portrait. She sits on a stool, headphones on, bending forward under the bright spotlights, all her attention focused on one square centimetre of canvas. She mixes pigments with a synthetic resin (which ensures that the conservator's work can be removed, though it will be invisible to the spectator's eye). Burnt umber, transparent golden ochre and permanent blue are all laid out on the ceramic mixing palette. Other glass bottles stand on the shelf: vermilion, cadmium red, cobalt blue, verdigris, ceruleum, rose madder, lamp black, lemon cadmium, burnt sienna and Venetian red – the same colours available to Thomas Gainsborough when he painted *The Baillie Family* in 1784. Anna Southall-Searle matches the colours, texture and surface minutely. She has to imitate exactly the effects that Gainsborough sought. Her work is not as an artist, but as if an artist. She compensates for what time and history have made of the work.

Paintings by Howard Hodgkin in the Tate Gallery collection may one day reach the same conservation studio. With luck they will not have suffered the same handling, while on loan, that initially caused the damage (circa 1880) to the Gainsborough painting. Hodgkin's standing in the art world and in Britain, confirmed through his former trusteeships of both the National Gallery and the Tate Gallery, and his victory in the Turner Prize competition in 1985, could not be higher. His paintings are not traditional in subject matter or composition, but they are traditionally made, with oil

87 Conservation studio at the Tate Gallery, London, with *The Baillie Family* by Gainsborough in the background.

paints on wood, over long periods of time. Many writers have seen his knowledge of Western art, together with his interests as a collector of Indian paintings, as confirming his status as a 'traditional artist', as an artist who continues and extends the traditions of British art.

The uniqueness of a work of art is inseparable from its being embedded in the fabric of tradition. This tradition itself is thoroughly alive and extremely changeable. An ancient statue of Venus, for example, stood in a different traditional context with the Greeks, who made it as an object of veneration, than with the clerics of the Middle Ages, who viewed it as an ominous idol. Both of them, however, were equally confronted with its uniqueness, that is, its aura. WALTER BENJAMIN, 'The Work of Art in the Age of Mechanical Reproduction', *Illuminations*, p. 225.

HOWARD HODGKIN

I don't think of myself as part of a tradition at all. It's simply that the nature of moveable painting, paintings to hang on a wall, has hardly changed in the last four or five hundred years, there have been no new developments, there have been hardly any new colours, other than synthetic and therefore more stable versions of the earlier ones. And the functions of tone and colour, and line, have not changed at all.

Nothing has been added to visual language, curiously enough, since the sixteenth century. We think of Picasso, for example, as the archetypal innovative modern artist, which no doubt in many senses is perfectly true, but his means were just the same as everyone else's. Cubist pictures, for example, the classical cubist pictures, really go back to a very refined and specific technique for making forms in space that was developed in the sixteenth century in Venice, by artists such as Titian.

So I don't think that artists can really escape being part of tradition.

The rise of other forms of art has perhaps had a rather different effect, and shown, all the more clearly to the world at large, that painting is still very much the same. When there was this exhibition called A New Spirit in Painting, I was astounded by how incredibly conventional and traditional it looked altogether.

I don't mind my pictures becoming luxury objects; it might mean that people look at them more carefully. I don't think that whether they're cheap or expensive to buy, for the individual who buys them, affects their function in any way.

Paintings are supposed to be self-contained things. Well, as everyone knows, they are and they're not. These well-wrought urns contain ashes guarded by demons. Nothing about them is to be taken for granted. Paintings matter only insofar as you and I matter. They are born in our conditions and pathologies. R. B. KITAJ, 'A Passion', *R. B. Kitaj*, Marlborough Fine Art, London, 1985.

The immediate impact of Hodgkin's paintings centres almost entirely on their aesthetic qualities. The formal compositions are impressive: the exquisite handling of areas both of contrasting vivid colours and of soft hues and tones, for instance mid-blues against light pinks and creams. One or two works have been more or less constructed from the colours of certain late nineteenth-century French paintings. But all of them are formed by a knowledge of the history and traditions of painting. The luxuriance and wealth of visual effects seem to have secured them a place within that history. For Hodgkin, if less for the viewer, these effects are intimately connected to the original subject of each painting.

88 Howard Hodgkin mixing oil paints and medium.

IMAGINATION

89, 90 Howard Hodgkin, *Sad Flowers* and detail, 1979–85.

Hodgkin's works are translations from the original experience of an occasion, a moment, a meeting or a group of people, through another set of experiences involving the activity of painting. The construction of a set of equivalent colours and shapes, the endless reworking of the paint, the constant testing against an emotionally charged personal memory, which itself alters through the process of painting, contradicts the idea of any single creative moment. It is a continuum of imaginative and creative powers being applied with an ambition to make a certain kind of art. That kind of art does not involve the grand scale of the History painting, nor the emotional sweep of a large Abstract Expressionist painting, nor the reflected emotions of a Neo-Expressionist canvas, but the more particular place of the interior, the still life or genre scene. Hodgkin stretches these possibilities well beyond their usual limits.

For a moment it stayed trembling in a painful but exciting ecstasy in the air. Where to begin? – that was the question; at what point to make the first mark? One line placed on the canvas committed her to innumerable risks, to frequent and irrevocable decisions. All that in idea seemed simple became in practice immediately complex . . . Still the risk must be run; the mark made. VIRGINIA WOOLF, *To the Lighthouse* (1927), Penguin, London, 1964, p. 179.

Howard Hodgkin squeezes oil colours onto the flat and clean wooden top of a low trolley. He squeezes two, perhaps three colours on this palette together with a small pool of oil and polymer medium. Grey with light ochre, cadmium scarlet, black with lemon yellow. He dips the brush into the medium and pushes it into the paint, sometimes catching two colours in the same movement. The brush is then applied to the surface of the painting. Finished works take two to three years to emerge from the studio. Paint is applied again and again over different parts of the painting, building up layers, some of which remain visible. More and more work is carried out until Hodgkin is certain that it is right.

HOWARD HODGKIN *There's no image in my mind at all, there's simply the feeling. Feeling does now sound a rather weak and sort of soppy word to use, it is simply the sensation which I wish to retain, or contain at the end. That's the only thing in my mind. If I try and anticipate what a picture looks like, which many years ago I did, I find that a sort of glib empty image appeared. Unfortunately other people liked them very much.*

As a painting evolves, it's necessary to make the marks one uses more and more resonant, or expressive of the feeling that you started out with. There is an element, which I think you find in all kinds of portrait painting, for example, where inevitably the original emotion and feeling begin to look like the picture, as much as the picture itself begins to evoke it from the other side.

The reason why my pictures take so long to paint is that they begin very often with something which is visually representational. They have to go on to turn into something which is visually self-sufficient, physically self-sufficient. Years ago, I was asked by someone, 'Why can't you start at the point you've reached when you've finished the previous picture?' And I can't really find a rational explanation for that, except that it's very difficult for me to give meaning to the very simple language that I

use, unless I go back and look in the most complete way to the subject I started out with. So I have to go out from what is really realism, and can truly be described as a kind of literal realism, to something which is almost the opposite.

I use a very simple language, as I use very few elements, which on the whole is extremely easy to execute, and sometimes very quick to execute; the problem is to give this language meaning. The meaning comes from a very elaborate series of interrelations. In some cases I can repaint one part of the picture again and again and again. Its effect on the other parts of the picture is of course what matters.

I think my pictures were more voyeuristic when I started out, I think it's a fair word to use about them, but I don't feel able to say how far I've got away from that. It's not easy for me to look at my pictures in any historical sense, I'm simply not that kind of artist.

The titles are always precise as to what the paintings are about. What the picture is about is far more important than any formal decisions that I might make while I'm painting the picture. Nevertheless to turn a sensation, a feeling, into a physical object means that you can only do that in formal terms. Formal devices on their own are simply formal devices, and therefore have no meaning. That's why I can't paint a truly abstract picture.

The role of the titles is complicated, in that often they mislead people, and lead them to expect things that they are unable to see in the picture. Nevertheless they are a statement to the spectator of what the picture is about, and presumably that makes some difference. Though I romantically hope that I can look at pictures, as I have often said, at the same distance as the spectator, this in actual fact cannot be the case.

I find it very difficult to think of my activity as an artist in social terms. It's a very lonely occupation indeed, and I wish that when I was doing it, it wasn't so lonely. I don't think when I've done, when I've finished my pictures, when they're out in the world, that they are particularly different to a lot of other things. They certainly seem to me to have a social function. They seem to have an identity in the world outside, that I as an artist certainly do not have.

I think being an artist is much more like being given a life sentence in an open prison – of a very comfortable kind.

Hodgkin's work as an artist is a highly specialised activity producing exquisite and valuable objects of contemplation. He stresses the independence of those objects in the world, and while they *are* physically separate, they are so highly wrought, the labour so evident, that the image invites us to reconstruct some of the making in our minds. Hodgkin has undertaken some work on computer graphics which may change a few expectations about the range of his creativity, but the presentation of his prints and paintings in private galleries or public museums generally relies upon a traditional set of assumptions about his role as an artist. We know little more about the actual subject of a painting by Howard Hodgkin than we do about an Edouard Vuillard from the 1890s, but we are similarly drawn to appreciate the formal values, the colour and composition, while we imagine a 'subject' in the fragmented elements of depiction and the emotive shades and tones before us.

91 Howard Hodgkin, *Mr and Mrs James Kirkman*, 1980–84.

HOWARD HODGKIN *The picture is finished and looks after itself, as it were, when the subject matter has turned into an object; it's really as simple as that. And once that has happened, it is a public thing. It's not private to me anymore, it's become an object; like a table or chair, or any other article of domestic furniture, it should be useful as something to look at and be excited or soothed by. It should work on the spectator in its own manner, and not as an autograph painting by me.*

* * * * *

Susan Hiller has since the late 1960s made installations and photographic, audio, video and painted works which explore the processes of the imagination. She is critical of the many presumptions in 'scientific' descriptions of the world, and sees her work as questioning the 'common-sense' view of creativity as entirely conscious and controllable. A frequent theme has been the ordering and exposure of obscure or unconscious structures that can provide new meanings. A much exhibited work, for example, is Hiller's *Dedicated to the Unknown Artists*, 1976, in which she laid out 305 picture postcards of a 'rough sea'. Every possible variation had been published in the British Isles, but they took on a new significance when structured by the artist.

SUSAN HILLER *I see an artist – dreadful word artist, but anyway, we're stuck with it. I see this person, this cultural worker, with a particular kind of job to do, partially the setting*

IMAGINATION

up of problems to be explored and resolved, beyond that with the job of representing previously unformulated or incoherent shared perceptions. Artists take issues, ideas, thoughts, images that have been internalised by all of us or many of us and they find an outward form for manifesting those things. Art functions as a kind of mirror to show people, including the artist, what they don't know that they know. Now that's an actual job of work.

Several of Hiller's works refer to dreaming, or implicitly question the division between 'rational' waking life and 'irrational' dream life.* As well as dream material, she incorporates automatic writing, messages through mediums, 'voices in the ether' and unexplained messages or transmissions in her works. These are not for her an indication of the existence of extra-terrestrial or non-human spiritual forces. Rather they are a projection outwards of untapped and unexplored areas of human potential or creativity.

Susan Hiller has used automatic writing, marks generated on the page without conscious formation, in a number of pieces. The marks are most often illegible squiggles, but *Sisters of Menon*, 1972 and 1979, is based on some automatic writing which produced coherent words. As Guy Brett put it, the message 'led the artist to reflect that automatism has always been evaluated according to gender: linked with madness and mediumship in women, and in men with science and with art. The message also led her to question the whole notion of "self". What is the "me"? Where are one's edges and limits?'* Automatic writing on photographic paper was incorporated in the installation work *Elan*, 1982, which used the research of Konstantin Raudive, a Latvian psychologist who claimed to have tape-recorded the voices of the dead in empty rooms. More recently the writing has overlaid a number of works generated from photographs taken in automatic photo booths.

These photo works are called after a time and a place, for example, Midnight, Baker Street, *so that the subject represented in the work is defined in time and space rather than in terms of a unified self-presentation. All of those works combine some sort of figural representation of the head and shoulders format taken in a photo booth. I've written quite a lot about the fact that in the photo booth not only do you have a miniature theatre scenario with curtains and so forth, and you're invited to self-enact the self, but there's no intervening photographer either to alter the kind of image that's presented. That the camera operates as a mirror is the key to all those pieces, all of which combine, as I said, the image of the head and shoulders with a kind of contradiction, obliteration, and/or embellishment of the image, either in the form of these gestural marks that I call automatic writing or in some equally transgressive materials like feathers or glitter or something of this sort.*

I don't think anybody believes in some kind of essential self any more, unless they have some vested interest in maintaining that position. We are all multiple beings with many voices and many possibilities – the kind of subtext of the culture which is madness and schizophrenia is a clear demonstration of that. I suppose there's something frightening about giving up the notion of the unified self, but in any case, I start with relinquishing that essentialist definition. So, yes, the marks are made by

She wrote, with David Coxhead, *Dreams: Visions of the Night*, Thames and Hudson, London, 1976.

In 'Singular and Plural', *Susan Hiller 1973–83: The Muse My Sister*, Orchard Gallery, Londonderry/Third Eye Centre, Glasgow/Gimpel Fils, London, 1984.

SUSAN HILLER

me, my hand. As I said in Sisters of Menon, *my 'hand' made these marks, but not in my 'handwriting'; and the issue is a series of paradoxes, like a set of Chinese boxes, one inside the other.*

I don't see any opposition between rational and irrational, this is a completely constructed dichotomy. If you look at the history of science it's full of so-called irrational breakthroughs, people having dreams and winning the Nobel Prize as a result – just as the history of art practice ought to be seen as a history of work, of problems being set, being solved. There's a drift, if you like, across this whole territory of rationality, irrationality; and the two interconnect.

Talking about voices and spirits from the other world, or the tradition of mediumship put forward as an explanation for this phenomenon, is simply a kind of alienation of the source of the material, a personal projection which is located outside us. There's actually nothing any more mysterious or weird about so-called automatic phenomena than there is anything strange or bizarre about our notions of creativity. I pose notions of automatism against notions of creativity in the same way as the surrealists did for a kind of utopian political purpose; that is, to show that there is a level of available strangeness and creativity in the most simple processes, like doodling with a pencil. The issue is to retrieve those kinds of access to unconscious primary processes, to realise that they are a form of energy available to everyone and that there isn't a particularly specialised class of people for whom these phenomena are available.

92 Susan Hiller makes slides of her 'automatic writing', projects the images and paints over the wallpaper.
93 'Daydreams' wallpaper by Coloroll.

Exhibition, *Home Truths: Love, Death and Language*, Gimpel Fils, London, October 1985.

When I placed my head on my pillow, I did not sleep, nor could I be said to think. My imagination, unbidden, possessed and guided me, gifting the successive images that arose in my mind with a vividness far beyond the usual bounds of reverie. I saw – with shut eyes, but acute mental vision. MARY SHELLEY, Introduction to *Frankenstein* (1831), Penguin, London, 1985, pp. 54–5.

A pierrot figure in polka-dot costume, with droopy eyes and wan smile, sits poised on the edge of the white crescent moon. The wallpaper is pinkish and blue. The wallpaper is in a bedroom, the pierrot motif reappears on a white china vase on the dressing table. On one wall is a poster image of the pop star Nik Kershaw, on the other a poster of two fluffy white kittens. There are magazines and shoes strewn across the floor; a handbag, shirt and night-dress hang on the back of the door. On the dressing table is a small collection of make-up, and on the chair a teddy bear is sitting next to a squash racquet.

A section of the same wallpaper is partially obscured, painted over in hard black Ripolin house-paint. Although there are casual brush marks, the paint carefully describes in negative a series of marks, squiggles and calligraphic shapes through which the pattern of the wallpaper is still visible.

Around the pierrot pattern are other wallpaper works by Susan Hiller.* Next to the pierrot is a group of red hearts and beyond is a group of yellow hearts, all partially painted over. Some other wallpapers show alphabet letters and on the far wall of the gallery is a wallpaper showing stylised pictures of commando operations: helicopters, parachutes, a jeep, various explosions and a chunky beret-wearing soldier with an automatic weapon. A further work shows jet fighter aeroplanes and helicopters in endless, repeated conflict, the repetition of the wallpaper crisscrossing the actual depictions. The eye shifts from background wallpaper images to the overlaid

gestures marked out in the hard black paint. There is no resolution between the two kinds of depiction, the wallpaper images and the carefully projected and painted marks. The works are unsettling, putting one deliberately and productively off balance.

The so-called automatic mark in painting is something that has a history at least as old as surrealism, and has existed outside painting on the kind of lunatic fringe where I get a lot of my ideas. In mediumship the idea of automatic texts, messages, is a very prevalent one. It has something to do with the fact that the imagination scans surfaces and so forth and literally reads them. They're represented in some way that we have called automatic because it seems to bypass conscious intention. I do a series of automatic drawings which I then make into slides. The photographic process is important in this work. I project onto the wallpaper surfaces and I then paint, as it were, the background. I'm painting out, I'm not making any marks at all. The marks, the so-called marks are in the negative, they're not there at all, they're spaces, and that has to do with a series of puns around writing in the negative and making the invisible visible which are themes that run through all my work.

For Hiller it is not so much that automatic writing might free us all from the tyranny of our rational waking life, but that its unintelligibility and as such its marginality in our culture, is a potent symbol of female speech. Hiller is not inviting us to *read* her scripts as intelligible. They are not decipherable. On the contrary they are paradoxes. Their marginality is the mark of their metaphoric power. What the work asks is: how is it possible to create a new language for her experience when female experience is always secondary? How is it possible for this work to be seen as a primary cultural act . . .? JOHN ROBERTS, *Susan Hiller*, Orchard Gallery, Londonderry/Third Eye Centre, Glasgow/Gimpel Fils, London, 1984, p. 40.

The dreams of many people, even people who are living in a given historical period, can be expected to represent the full range and variety of human behaviour and experience, from the bizarre to the banal including (in Jung's words) 'ineluctable truths, philosophical pronouncements, illusions, wild fantasies, memories, plans, anticipations, irrational experiences, even telepathic visions'. MARY ANN MATTOON, *Understanding Dreams*, Spring Publications Inc., Dallas, 1984, p. 36.

In 1983 Susan Hiller made the videotape *Belshazzar's Feast*, which was subsequently incorporated into an installation owned by the Tate Gallery, *Belshazzar's Feast/The Writing on Your Wall*. She wrote about the work: 'Nowadays we watch television, fall asleep, and dream in front of the set as people used to by their fireplaces. In this video piece, I'm considering the TV set as a substitute for the ancient hearth and the TV screen as a potential vehicle for reverie replacing the flames. Some modern television reveries are collective. Some are experienced as intrusions, disturbances, messages, even warnings, just as in an old tale like *Belshazzar's Feast*, which tells how a society's transgression of divine law was punished, advance warning of this came in the form of mysterious signs appearing on a wall. My version quotes newspaper reports of "ghost" images appearing on television, reports that invariably locate the source of such images outside the subjects who experience them. These projections thus become "transmissions", messages

94 Susan Hiller, *Midnight, Baker Street*, 1983.

95 Susan Hiller, *Belshazzar's Feast*, 1983. The video was transmitted on Channel Four Television in January 1986.

　　　　　　　IMAGINATION

96 Susan Hiller, *Clair de Lune II*, 1985.

Susan Hiller, *Belshazzar's Feast*,
The Artist's View, Tate Gallery,
London, 1985, p. 5.

that might appear on TV in our own living rooms.'* The videotape with its own flickering fire image, translated from 8mm film through projection, is mesmerising in its own right. The insistent but hushed tone of the voice retelling the reported experiences, with the soothing background song, is gently humorous and yet disturbing. We know they are not true, they do not really happen; but then why should someone invent them?

SUSAN HILLER

The image of the fire in Belshazzar's Feast *relates to the fact that everybody used to sit round fires – not just in their living room but going back to primeval times in the cave; and it relates also, in a sense, to the patterning on wallpapers in the* Home Truths *series, because when you're a kid you lie in bed at night and look up at the shadows and so forth. This notion of 'reading', which is simultaneous with the notion of projection, is what I'm actually trying to hone in on in all of this work. One might derive pictures, stories, even prophecy, from these kinds of phenomena. What often emerges is a kind of text or message.*

I deliberately set out to make a tape that would present to the spectator two sets of options – one, the visualisation process which comes under the heading of imagination; that is, the images on that tape trigger off ideas and pictures in everybody's minds just as gazing into the fire does. Or as Leonardo advised young artists to look at drifting clouds, or at the patterns of moss on rocks, to generate landscape imagery. Then the soundtrack is dealing with the way our culture handles these imaginative capacities by taking them away from us and locating them in a kind of 'other' dimension. Whether, as in this particular case, in flying saucers, or whether it's the notion of the artist as a specialised genius who alone has access to these capacities.

While Hiller uses, and Beuys used, materials for making art which are untraditional, Cahn, Gormley and Hodgkin each employ materials that are conventional and respected. Yet their methods, their own combinations of technical and imaginative skills, are all to some degree unconventional. Beuys emphasised that everyone is an artist because he refused to see the artist as marked off from other people; similarly, Susan Hiller's work points to the possibilities of the untapped creative powers in each of us. On the other hand both see the artist expressing through their work a particular set of concentrated imaginative skills. The complementary technical skills are specific to certain practices in art, but are not different in kind from other trades, such as design, decorating or construction. But when Howard Hodgkin takes oil paint, Gormley his clay and lead and Cahn her blocks of chalk, they transform these materials in ways that are unpredictable, but exactly fulfil their own creative requirements. They make arresting images which acknowledge, but are not dependent on, previous uses of the same material. All five artists do a kind of double work, making imaginative transformations of material and imaginatively extending what sort of worker the artist might be.

IMAGINATION

4 Sexuality, Image and Identity

Sexuality today is . . . a contested zone. It is more than a source of intense pleasure or acute anxiety; it has become a moral and political battlefield. Behind the contending forces . . . lie contrary beliefs, and languages, about the nature of sex: sex as pleasure, sex as sacrament, sex as source of fulfillment, sex as fear and loathing . . . The subject of sex has moved to centre stage in contemporary political and moral discourse. Through it we are expected to express our subjectivity, our sense of intimate self, our 'identity'. JEFFREY WEEKS, *Sexuality and Its Discontents*, Routledge & Kegan Paul, London, 1985, pp. 4–5.

Part of what we call our identity is constructed and reconstructed through gender and through our sexual choices. Girl, boy, woman, man, mother, father, heterosexual, homosexual: all are fundamental terms in our lives. They are essential as categories for organising our own behaviour and interests, and through them we create an idea of others in relation to ourselves. Definitions may have shifted over the last century, the detail may be blurred, but we still think of actions and preferences as 'female' and 'male', as feminine or masculine. This chapter focuses on some of the ways that artists have attempted to question our understanding of those concepts and commented on the roles and attitudes expected of men and women, and in particular on the construction of images of women in a modern consumer society. For feminine and masculine are not terms that correspond evenly or equally. In politics and business, and to some extent in culture and the family, the male is predisposed to act as the more forceful agent. We fulfil positions created for us (and suggested to us from the earliest age) which are themselves restricted by the social, economic and legal structures of the state.

It is essential to realise that the concepts of 'masculine' and 'feminine', whose meaning seems so unambiguous to ordinary people, are among the most confused that occur in science . . . in human beings pure masculinity or femininity is not to be found either in the psychological or biological sense. SIGMUND FREUD (1915), quoted in Juliet Mitchell, *Women: The Longest Revolution*, Virago, London, 1984, p. 266.

The imbalanced patriarchal basis of society is evident in the images of ourselves and of sexual difference that circulate around us. Television, films, newspapers, magazines and advertisements supply a constant stream of images of how we are now and the ways in which we *might* appear, might dress and might behave. While the direct purpose of these images is to sell products and services by playing upon their (claimed) abilities to fill our supposed needs, they indirectly sell us ideas and beliefs. They may be laughable fantasies, but images in the media mask, or make acceptable, the underlying inequalities of power. They reinforce some of the repressive

97 Cindy Sherman, *Untitled #97*,
1982.

SEXUALITY

aspects of the family, such as its division of labour, and constantly intertwine exaggerated images of violence and romance.

There are endless echoes and transmutations between the different media: films replay the scenarios of shampoo advertisements, cowboys and chocolate-eating truck drivers become the same, sporting personalities gain heroic status, and the stars and stories of soap operas become integrated into articles, features and advertisements.

Fine art is frequently co-opted into providing 'meaning' for mass media images. When something is to be marked as historic, timeless or authentic, a famous painting will be brought into view, preferably with famous music as well. Constable's *Haywain* and Da Vinci's *Mona Lisa* have been in constant use both seriously and ironically. A 'modern' work of art will either signify inspiration and taste, or eccentricity and bohemianism, the Jackson Pollock drip type of painting being a favourite. Whatever was intended by the artist is transformed in the usage of the advertiser or art director. Equally, images from the mass media that relate (in the West) to what we wear, what we own, what we eat and where we live have been consistently used by artists. Since the birth of Pop Art in the 1950s there has been a surge in the traffic of images in both directions. Richard Hamilton's refrigerators or Cadillacs and Andy Warhol's Marilyn Monroes and Campbell soup cans inhabit a strand of art which uses both parody and celebration. Pop artists like Allen Jones or Peter Phillips claim, some think spuriously, that they are using what they see around them; that their fetishistic pictures and sculptures of women are no more than a reflection of a sexually glamorised and permissive society.

Just as viewers are not all men, so equally consumers – of meals, clothes, food, cars, insurance, and cigarettes – are not invariably male. Indeed it is women who do the bulk of consuming, and this can only mean that women ignore the address made in these adverts to male sexual desire, or else they slide into somehow participating in the pleasure on offer . . . it demonstrates just how difficult it is to ascertain what female sexuality is. It is everywhere, but for whom? It is you but of course it is not! It rivals, flatters you and degrades you. ANGELA MCROBBIE, 'Dance and Social Fantasy', *Gender and Generation*, Macmillan, London, 1984, p. 138.

Just as women have particular histories, so images of women have a particular history within Western painting, and within the history of the mass media. In art we might think of Titian's *Venus of Urbino*, and in the mass media the elegant women who are used to promote, but not drive, expensive cars. This history sees women as passive and possessed: above all, on display. In the mass media, as in art, we both look for the relations between people which are internal to a picture, and create or imagine (as already imagined by the designer or artist) the relations between ourselves, as viewers, and the person viewed. Desirable woman as signifier of desire, womanly woman as signifier of domesticity and security, and independent woman as signifier of stylish confidence are all well-worn stereotypes. Typecast or not, all women are subject to the conventions of the need to be admired.

In a world ordered by sexual imbalance, pleasure in looking has been split between

98 Selecting images for the January
1986 issue of *Woman's Journal*,
London.

SEXUALITY

active/male and passive/female. The determining male gaze projects its fantasy onto the female figure, which is styled accordingly. In their traditional exhibitionist role women are simultaneously looked at and displayed, with their appearance coded for strong visual and erotic impact so that they can be said to connote to-be-looked-at-ness. LAURA MULVEY, 'Visual Pleasure and Narrative Cinema', *Screen* 16.3, Autumn 1975, reprinted in *Art After Modernism: Rethinking Representation*, p. 366.

* * * *

For women, the gymnasium is the new zone of consumption which replaces the passivity of fashion consumption by the activity of exercise. The passive sexual narcissism which was encouraged by the fashion and cosmetic industries in adopting the latest 'look', has been overtaken by an active fetishistic narcissism. The body-as-machine, which can be controlled and moulded by women's own initiative, acknowledges her own desires on her own terms. ROSETTA BROOKS, 'What's Love Got To Do With It', *Eau de Cologne*, Monika Sprüth Galerie, Cologne, 1985, p. 40.

Jogging, running and aerobic exercises have become fashionable pursuits in the last decade, new sources of pleasure and pain; a 'puritan leisure ethic'. Women and men in the West are under pressure to smoke less, drink less, eat less (and eat better) in order to counter the sedentary nature of urban life. The new pressure calls into question the over-consumption and wastage that have otherwise been regarded as acceptable in post-war society. For women the new fitness movement represents considerable change and goes beyond their participation in sport. It counters the image of the female body as passive, it suggests that women's control over their bodies has moved away from external care towards internal health, against traditional medical practice. In addition it discourages the constraining clothes and dangerous diet plans that formed part of previous regimes for women. Yet this positive new identity is still pulled back into convention. Fitness and body-culture, reinforced through films like *Flashdance* and *Perfect* and television series like *Fame*, become incorporated into the consumerist language of fashion, romantic fiction and cosmetics. A new type of woman is required to sell more products, more magazines. As such, the idea of woman as body is reinforced. The images of women in circulation are often not of whole women but of faces, hands, legs, arms and breasts. However much women have taken control of their health, their clothing styles and their looks, the insidiousness of the desirable body image, and its fetishistic presentation, continues in innumerable variations. A number of different skills are required to create the desirable image.

A group of people gathers behind the camera. The photographer directs the models. The young man must tilt his head back to match the woman's. Both models wear white work-out gear with bare feet, set against a grey canvas backdrop. Both have shortish, slicked-back hair. Their androgynous bodies are being toned up (or pretending to be toned up). The teacher (of the Medau technique developed in Germany in the 1920s) adjusts their balance, corrects their foot positions. They hold plastic balls up to their chests.*

The stylist runs forward to adjust some fallen hair. The beauty editor talks to the art director who then has another word with the photographer. Some

99 Page from *Woman's Journal*, London.

'Method and Movement', *Woman's Journal*, January 1986, p. 54. Health editor, Vicci Bentley; art director, Roger Hart; photographer, Victor Yuan; trainers, Lucy and Lala Jackson; make-up and hair stylist, Sarah Bee.

Polaroid prints are taken to test the pose and the lighting. The models resume their poses, others move back instinctively, lights flash, the shutter clicks and a new image is created.

The contemporary health movement is saturated with the use of real experience as a substitute for fantasy. American advertising has promised us nothing less than if we buy the right things we will be loved. The image of the aerobic body is a way of making this advertising concrete without depending on products. The perfect body becomes a substitute for the fantasy of a perfect love. MICHAEL VENTURA, 'The Walking Billboards of L.A.', *L.A. Weekly*, 19–25 July 1985, p. 12.

* * * * *

This false search for the 'real' her is exactly what the work is about . . . The attempt to find the 'real' Cindy Sherman is so unfulfillable, just as it is for anyone, but what is so interesting is the obsessive drive to find that identity. JUDITH WILLIAMSON, 'Images of "Woman"', *Screen*, London, November/December 1983, p. 105.

Cindy Sherman's first exhibited works were *Untitled Film Stills*. In each black and white photograph a lone female figure is seen at a moment of stasis. Whether reading a letter, looking out of a window, spilling the shopping or leaving the house, something has just happened or seems about to happen. Some scenes appear more 'genuine' than others: the girl waiting for the train at Flagstaff, the woman watering the garden or the girl pausing as she enters an office building. Others appear more contrived: the half-clothed girl on the bed or the woman in the armchair smoking a cigarette. Yet they are all posed, and for each Sherman has created the scene, through clothing, make-up and hairstyle, and for each she has become a different character. The characters are those of 1940s' and 1950s' films, or rather from the sub-genre of the film still, the vignettes that live on long after the memory of the film itself. They are presented not as specific women but as 'types' of women, a series of roles defined within specific but unknown narratives which we can only guess at.

CINDY SHERMAN

When I was in school I was getting disgusted with the attitude of art being so religious or sacred, so I wanted to make something that people could relate to without having to read a book about it first. So that anybody off the street could appreciate it, even if they couldn't fully understand it; they could still get something out of it. That's the reason why I wanted to imitate something out of the culture, and also make fun of the culture as I was doing it.

When I wasn't working I was so obsessed with changing my own identity that I would do it without having a camera set up, and without anybody seeing me, or going anywhere. Sometimes it would be really frustrating, I would dress myself up as Lucille Ball and realise how awkward and stupid this is, that I'm all dressed up and no place to go. So I would go out and watch TV with people at this gallery where I was living in Buffalo.

I found that it got more uncomfortable to do in New York. When you walk on the street you have to deal with a lot of different elements that are tough. Like being ogled

100 Cindy Sherman, *Film Still #10,* 1978.
101 Cindy Sherman, *Film Still #48,* 1979.

at, or whistled at, or made fun of. Whenever I would go out in costume here, it was — even if I was just dressed up as a secretary to go to work at Artists' Space — uncomfortable walking on the streets. Because it was like I was stripped of my own street identity, my own shield. Anyway, I stopped doing it.*

Sherman's pictures force upon the viewer that elision of image and identity which women experience all the time: as if the sexy black dress made you *be* a femme fatale, whereas 'femme fatale' is, precisely, an image; it needs a viewer to function at all. It's also just one splinter of the mirror broken off from, for example, 'nice girl' or 'mother'. JUDITH WILLIAMSON, 'Images of "Woman" ', *Screen*, p. 102.

Sherman's recreations of these women, in some ways more independent than their 1960s' counterparts, ended in 1980 when she changed to colour photography and moved to the studio where she continues to work. This brought a greater concentration on the figure and face, greater control of the lighting, and closer attention to the pose. Her works since 1980 move between associations of films, fashion advertisements or features, and illustrations for romantic fiction. Many of them use the 'little girl' image, the victim, frightened, worried or lost in thought, others the 'boyish girl', self-possessed, confident, but watchful. The colour images of Sherman lying down (first made as a centrefold for *Artforum* magazine), with her eyes away from the camera, play the most ambiguously with pin-up images of women. A series of 1982 used her sitting upright, looking into the camera, with soft lighting and apparently wearing only a bathrobe. These are defiant images, daring the public to admire a vulnerable surface that retaliates with the knowledge that Sherman is image-maker as well as image.

I was trying to make a content that would be alluring, but then as soon as you looked at it, it would kind of bite you back like something that would make you feel guilty for feeling that way, you would feel sorry for this person because they're victimised, or that you were victimising them by looking at them like that. The work I used to do was closely related to parodying cultural roles of women, but I've never really seen myself as a strict feminist. I'm not trying to make any social statement, or I already have and I don't need to go into that again.

It is no wonder that women artists so often deal with sexual imagery, consciously or unconsciously, in abstract and representational and conceptual styles. Even now, if less so than before, we are raised to be aware that our faces and figures will affect our fortunes, and to mould those parts of ourselves, however insecure we may feel about them, into forms that will please the (male) audience. When women use their own bodies in their art work, they are using their selves; a significant psychological factor converts these bodies and faces from object to subject. LUCY R. LIPPARD, *From The Center*, E. P. Dutton, New York, 1976, p. 124.

Cindy Sherman's work relies on this complicity with the audience. You have to know, not the specific poses or styles or fashions that she is referring to, but the generality of the looks, the positions implied and the kinds of narrative situation. It is like a performance, in that Sherman acts to show us what we know: that we can all be parts of different characters and have

An artist-run gallery in New York.

CINDY SHERMAN

102, 103 Cindy Sherman arranging the pose and background of *Untitled #140* before becoming the model herself, New York, 1985.

104 Cindy Sherman, *Untitled #90*,
1981.
105 Cindy Sherman, *Untitled #92*,
1981.

106 Cindy Sherman, *Untitled #140*, 1985.

107 Cindy Sherman, exhibition at Metro Pictures, New York, 1985.

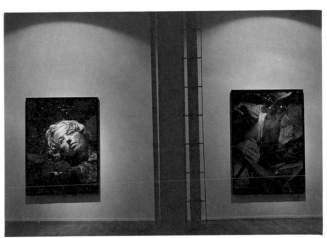

multiple identities, that an image shows little of a person, and that our customary 'readings' of each other through appearances are unconscious, distorting and presumptuous. She allows us the luxury of enjoying the image while making us suspicious of both the image and our enjoyment of it.

In 1983 Sherman enlarged the scope of her images by employing more theatrical costumes, bolder lighting and more extreme gestures. In some the figure appears to be screaming or crying; others are more 'exotic' and parody the lengths to which fashion designers will go to proclaim the 'specialness' of their products. In the following year she was asked by Dorothée Bis to make six new photographs using her designs as advertisements in French *Vogue*.

CINDY SHERMAN *They expected me to do with their clothes what I had done with this other company . . . make kind of cute, funny pictures. From the beginning there was something that didn't work with me, like there was friction. I picked out some clothes that I wanted to use. I was sent completely different clothes that I found boring to use. I really started to make fun of, not really of the clothes, but much more of fashion. I was starting to use scar tissue on my face to become really ugly. This stuff you put on your teeth to make them look rotten. I really liked the idea that this was going to be for French* Vogue, *amongst all these gorgeous women in the magazine I would be these really sick-looking people.*

The collaboration did not work, the clash of different interests was too great, and although the results were published in the February and August issues in 1984, Sherman felt that she had had to compromise. The shift from the innocent girl to more troubling and troubled images has continued, and the more recent photographs use costumes and theatrical make-up in working with mythological and fairy-tale figures. The hag and the crone appear in two photographs, in others there are false buttocks and breasts, and a pig's head and a huge tongue emerge from different faces. The lighting is lurid, and other figures are damaged or injured. The series began from an illustration for a fairy tale commissioned by *Vanity Fair*, but grew with Sherman's imagination into the invention of new fairy tales, in which the victims are no longer just young women, and the identities are more outlandish.

CINDY SHERMAN *I was thinking of some pictures a friend gave me of women in their underwear or their bathing suits, who were missing parts of their body like their hands or arms. So that was the direction I was starting to think of going in.*

I'm trying to give a lot of elements or clues that a viewer can pick up on and, whether they will relate to the lighting, or the costume, or the character, or the mood of the picture, hopefully it will spark something in their subconscious, whether it's from their nightmares, or dreams, or fantasies, or movies, or stories they've read.

I wanted to make it very very clear what my concerns were about, and try to be different and challenging. I've always been so well received publicly that it started to bother me. I wanted to make something that would be hard to be well received publicly. It's still been pretty well received.

Transgressions of fashion codes, cross-dressing and transvestitism are used by subcultural groups wishing to find a distinctive visible identification. Their new costume will be a badge of confidence for themselves and a label to mark them off from others. As Dick Hebdige wrote,* 'It ends in the construction of a style, in a gesture of defiance and contempt, in a smile or a sneer. It signals Refusal. I would like to think that this Refusal is worth making . . . even if, in the final analysis, [it is] . . . just the other side of a set of regulations . . .' Cindy Sherman's 'refusal' is acted out, is a pleasurable and disturbing form of acting up, playing on our anxieties as much as our fantasies. There is an ambivalence in her work, in her success even, that corresponds with the contradictions inherent in the fairy tales and the magazine images that she works with.

Subculture: The Meaning of Style, Methuen, London, 1979, p. 3.

Fantasy is as much a part of Sherman's art as is a theoretical analysis of the roles we play and of the selves we're offered as models . . . She knows that photography is the modern equivalent of the mask and that it offers an opportunity to show all of our selves — except one. This is modern-day kabuki that she's performing. What Cindy Sherman the photographer 'really' looks like would hurt the magic as much as seeing a kabuki star out of costume and in the bank. INGRID SISCHY, 'On Location', *Artforum,* December 1985, p. 4.

* * * * *

Women are arguably closer to bodily processes and transformations than men: their physical cycles are more insistent, and they are used to treating their bodies as raw material for manipulation and display. Women are never acceptable as they *are* . . . at a deeper level, they (we) are somehow inherently disgusting, and have to be deodorised, depilated, polished and painted into the delicacy appropriate to our sex. LISA TICKNER, 'The Body Politic: Female Sexuality and Women Artists since 1970', *Art History,* I.2, London, June 1978, p. 239.

A secretary stops typing, picks up her pencil and sharpens it in a pencil sharpener. The pencil sharpener is in the form of a globe. It splits apart and she cuts her finger. A woman is at a party and finds a razorblade; she cuts herself, and then smears some blood on the white tiles of the bathroom: 'Alone we failed'.

Both these scenes are storyboard narratives made by Alexis Hunter, part of a series started in 1976, some in photographs, some in photocopies.

ALEXIS HUNTER

The reason I used images that were very similar to women's magazines and images in women's magazines was to actually connect to a particular audience, the audience who read women's magazines, because I felt there was so much of political art which didn't engage that sort of audience – they just wouldn't like it, they just wouldn't read it, so I wanted not to seduce them, but to actually not frighten them off – to give them something they were familiar with, and then engage in a dialectic within the form that they were used to, or that made them feel – happier in a way.

I used hands because in a lot of advertising they just do have these hands, disembodied hands clutching at whatever product they sell to give it a tactile reality, so that it makes that object more approachable.

108 Alexis Hunter, *To Silent Women* (detail), 1981.

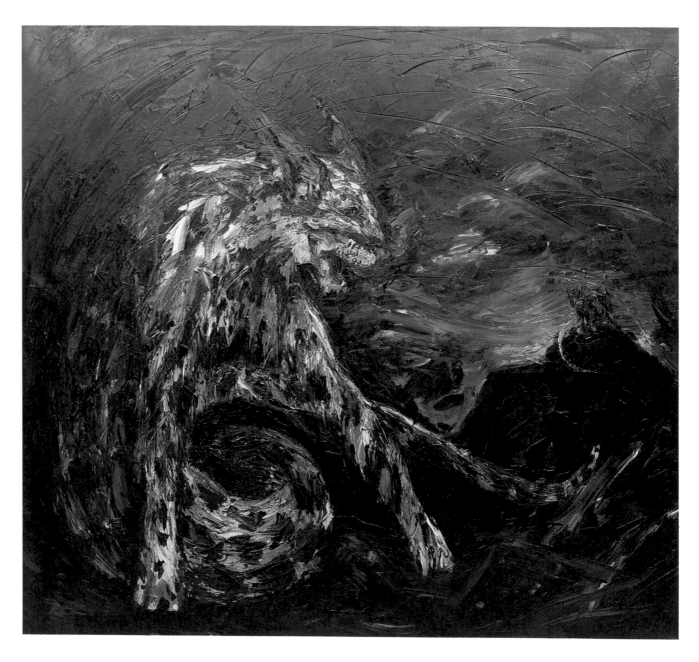

109 Alexis Hunter, *Passionate Instincts VI*, 1983.

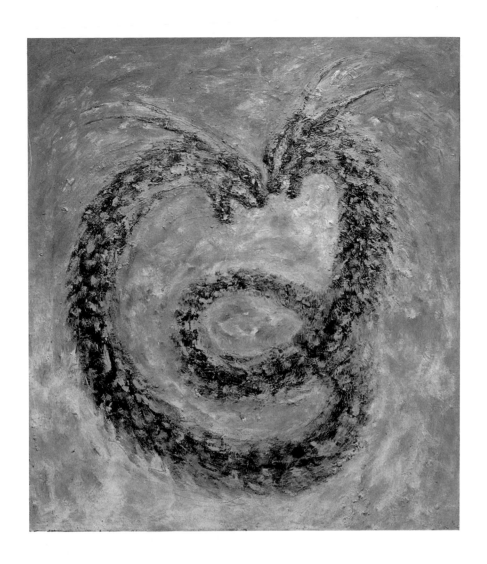

110 Alexis Hunter, *Siamese Separation*, 1985.

Fetishism and a hint of s&m (seduction and mystification) lurk just beneath the surfaces of Hunter's photographs, accompanied by an atmosphere of perversity and frustration. The frustration is that of the woman, who has been manipulated and struggles to free herself from societal conditioning; the perversity is that of the artist, who is in control and enjoying her power . . . Her perversity is really risk-taking – that time-honoured modernist mechanism – thrust into a new framework. LUCY R. LIPPARD, 'Hands On', *Alexis Hunter. Photographic Narrative Sequences*, Edward Totah Gallery, London, 1981.

Alexis Hunter's work in the 1970s was informed by involvement in the women's movement in Britain and the representation and stereotyping that she and many others were contesting.* Her employment on advertising work meant that she was well versed in the typologies and formal arrangements in use. Her narratives were, like Cindy Sherman's images, a counter-play on the dominant images of women in fashion and advertising. They also challenged the accepted idea of what in the 1970s was considered 'good' art. They were not abstract nor were they paintings or sculpture, and they were, even if symbolically, about people's lives.

Alexis Hunter came from Auckland, New Zealand, to London in 1972.

ALEXIS HUNTER

I didn't really get involved until I joined the Artists' Union in 1972. I joined the women's group mainly out of curiosity, really to see what it was like, and then I was very impressed by the level of discussion, and the seriousness of people, and the support, the personal support, people gave each other. In terms of the women's movement as a whole, I've decided to specifically stay with artists' women's groups rather than other groups.

The sort of art that was around then had no passion, no feeling; it was just very formal, very large and expensive to make, and had nothing to do with especially women's lives. So it was a case of if we actually wanted to do it, we had to do it ourselves.

When I started the paintings, I wanted to go back to the biological. The whole physical thing of being a woman works so much on theory. I wanted something more active. The first series of paintings that I did was about women's cycles and very intuitive and very crudely done.

111, 112 Alexis Hunter in her studio, London, 1986.

In 1981 Alexis Hunter re-engaged the language of painting, and this necessitated her getting more involved in the actual physical process of forming the images. She emphasises how crucial this is to the development of both content and image: they are formed together, as in the drawings of Miriam Cahn, in the making of the work. Several groups of work have followed, each with a common set of titles. In these she has been able to follow an emotional expression as well as an intellectual expression.

Nursery fears made flesh and sinew; earliest and most archaic of fears, fear of devourment. The beast and his carnivorous bed of bone and I, white, shaking, raw, approaching him as if offering, in myself, the key to a peaceable kingdom in which his appetite need not be my extinction . . . he dragged himself closer and closer to me, until I felt the harsh velvet of his head against my hand, then a tongue, as abrasive as sandpaper. 'He will lick the skin off me!'
And each stroke of his tongue ripped off skin after successive skin, all the skins of a life in the world, and left behind a nascent patina of shining hairs. ANGELA CARTER, 'The Tiger's Bride', *The Bloody Chamber*, Victor Gollancz, London, 1979, pp. 82–3.

Hunter's *Passionate Instincts* series used animals as symbols to express abstract emotions. They appear to convey the artist's emotional responses, but also have the wider implication of a collective emotional reaction, such as the fear of mutation in a nuclear future. In *Passionate Instincts V*, 1983, a woman with a rat-like face is copulating with a kangaroo-like animal; the 'woman' has a rat attached to her back. This is set in a yellowy-red abstract background and the figures fill the canvas with their apocalyptic movement. In *Passionate Instincts VI* a tall-eared tigerish beast stares out from beneath a stormy sky with a rocky landscape and volcano behind. Hunter's work portrays sexuality, but also fear and anxiety, directly expressing the conflicts that exist around notions of femininity or masculinity, around personal desire and passion.

The Passionate Instincts, *the mutants mating, were about people, things, whatever they are, trying to mate, being frightened of death, and being unable to. And it's just about that, that border between love, sex and violence, which was actually running through all the other work as well.*

 I went into the struggles of the psyche and saw that lack of confidence women had which was one of the most destructive things. Most of those paintings aren't really concerned particularly with women; I think men have those problems as well. If women are seen as passionate and intuitive, it's only because women are put down because those things are considered bad.

ALEXIS HUNTER

 After the *Passionate Instincts* series, Hunter painted a series on the theme of the *Struggle Between . . .*

Those paintings are about seeing conflict as a good thing, a very necessary thing to do with life – I mean, if there's no life there's no conflict – and seeing chaos as inevitable but having to be philosophical enough to deal with continual chaos instead of wanting everything to be cut and dried.

 Of course painting is ambiguous. Everybody is brought up differently, so of course they can't see the same things that I see in them. Hopefully they see different things, and maybe more interesting things than I see. I'm gone once the painting is finished. I've had my enjoyment and then it's up to the power that is between the viewer and the painting.

ALEXIS HUNTER

But men and women are not simply given biologically; they are given in history and culture, in a social practice and representation that includes biological determinations, shaping and defining them in its process. STEPHEN HEATH, *The Sexual Fix*, Macmillan, London, 1982, p. 118.

* * * * *

Eric Fischl's paintings watch people; or we watch people through these paintings. Private moments are frequently portrayed (two women drying themselves in the bathroom, a boy masturbating in a paddling pool at night, a man and boy asleep on a bed); apparent privacy is opened to public gaze.

113 Eric Fischl, *Pizza Eater*, 1982.

SEXUALITY

114 Eric Fischl, *Bad Boy*, 1981.
115, 116 Interior-designed show
houses on Long Island, near New
York City, 1985.

117 Eric Fischl, New York, 1985.

The artist gives intimate, keyhole views of people, often naked or semi-clothed. Awkwardness and unexpectedness abound. The young men are leering. The women seem far from innocent. An air of sensuality pervades, but sex itself is not usually portrayed; as in Sherman's scenarios, something might have happened or be about to happen. These broken narratives are unsettling, but draw us in, force us into the position of the artist taking control of the scene.

Fischl offers us adultomorphic pictures of an adolescent child's point of view, where the child is about to take up adult interests, perhaps already involved in what are usually thought of as adult (sexual) activities, but not fully in charge of their value . . . He engages in them because they seem there to be engaged in, but his estimate of them is unclear. For all his erotic activity, his relationship to eros is still voyeuristic, peculiarly passive if not disengaged. DONALD B. KUSPIT, 'Voyeurism, American-Style: Eric Fischl's Vision of the Perverse', *Eric Fischl Paintings*, Mendel Art Gallery, Saskatoon, 1985, p. 13.

ERIC FISCHL *I was exposed to TV and movies long before I was to paintings. When I was exposed to art, modern art had left 'narrative' behind, and become more formalistic. I was very attracted to TV and film because they had taken that role over. I tried to make paintings in that vein. A photograph gives you that frozen moment but is such a thin slice. The next instant the thing has shifted entirely and the gesture has gone on, so you might not trust the poignancy of it as being other than coincidental. In painting there's always that sense of it* building *to a frozen moment, building to a kind of clarity, and you feel the person behind it.*

Bad Boy, 1981, is one of Fischl's most notorious images. It went through a complicated internal narrative.

ERIC FISCHL *That painting started off with me looking at a blank canvas and deciding that one thing I knew I wanted to paint was a bowl of fruit. I painted a bowl of fruit; and then I was sitting there looking at it. Right, where is this bowl of fruit? Well it's on a table. But with the table in, where's the room? I didn't know the room, but I thought it would be fun to paint bamboo blinds. So I painted bamboo blinds and I thought, this is great, we get like striped light coming into a room. When I painted the blinds in I started to think about that kind of room where it's cool inside but it's really hot outside, maybe it's midday, border towns you know, something like that, south-west border towns, border line, border-line behaviour. So I thought well, I would paint a bedroom in which there were two people having just screwed. So I put them on the bed and I just wasn't interested in it and so the man left, and the woman rolled over, and then I thought that there was definitely another person in this room. There wasn't just this woman. I thought it was a baby so I put a baby next to her and that didn't work out. Then I thought, well, it's an older child, like four or five, and it's sitting on the edge looking out of the blinds. So I put that child in and that didn't work and finally the child gets up and goes over to the table and grows up to about eleven years old as it moves across the room, and on the table I'd had not only the bowl of fruit, which had remained right from the start, but there was a telephone and I kept taking the telephone off the hook, depending on whether I was thinking they were going to get*

disturbed or not. Finally it changed into a woman's purse and as the kid came to where he finally is, and as I was watching him watch, I was saying, well, what is he doing? I thought he was stealing money from her as well. It was completely surprising to me that from a bowl of fruit all of that would take place.

The earlier work was about the transition from innocence to knowledge, from the point of view of a small boy. The figure of the small boy – or even the position of the audience from the point of view of a younger child looking at an older, more grown-up world. That transition is from a state of grace to something where the decisions are more complex, people's exchange is more loaded. Now the sexuality of the work is about relationships, and whether the expectation for fulfilment, and whether the contract between two people, can be satisfied just through sexual stuff.

The viewer is always a complicit voyeur and a revisionist in the face of a realist image which encourages narrativity. These images desire interpretation and not the fixed state of authoritative truth. Fischl continues to insert the reader into paintings as a reminder of this function of text, narrativity and interpretation. BRUCE W. FERGUSON, 'Corrupting Realism: Four Probes Into a Body of Work', *Eric Fischl Paintings*, p. 26.

Fischl insists these paintings are not pornographic or misogynistic and that he is not promoting these attitudes but simply revealing them. But the representation of images and experiences does not by itself encourage critical evaluation. Many of Fischl's paintings simply restate the attitude towards women that is so prevalent in the commercial patriarchal culture he denounces. In this way, Fischl's work succumbs to the culture it attempts to expose. Once purchased, many of these desirable objects are absorbed back into the very culture they critique. JOAN BORSA, 'Eric Fischl. Representations of Culture and Sexuality', *Vanguard*, Vancouver, April 1985, p. 23.

Women, and men, are being observed, looked at, perhaps assessed; some of them return a look to us as observers. These relationships have been knowingly constructed by Fischl. But his position seems far from confident, as the women may be defiant or threatening, and the artist's own anxieties seem to be mixed in with what, and how, he paints. In some paintings, like *Pizza Eater*, 1982, or *Bad Boy*, 1981, the male gaze is unseen by the female; in others it is returned, as in *Dog Days*, 1983, where the dogs in the left panel double the confrontation portrayed in the right panel. In *Master Bedroom*, 1983, and *Untitled (Two Women in Bedroom)*, 1982, the women clearly confront the spectator, reinforcing the discomfort of our implied corroboration of these scenes; questioning *our* presence.

I'm not afraid of the label of 'voyeurism'. The thing I like about France is that the French are incredibly voyeuristic, in the sense that they look, they stare, and they seem very unselfconscious about staring. They simply watch. I like that idea very much. It seems like that's the way you are in the world, and that's the way you learn, is by watching. It's inevitable.

I did a painting that uses that specifically, it's called Master Bedroom, *and what's interesting about it to me is that there are two specific distances away from the painting that you read it, and at either of those things you get the opposite reading.*

ERIC FISCHL

118 Eric Fischl, *Master Bedroom* (detail), 1983.

From about fifteen feet away, the look on the girl's face is a smile, and it's anticipatory in a kind of pleasant way; she's expecting whoever's coming into the room and welcoming them. Then you move to a foot away and you see it's a frozen grimace, it's a smile that has become horrid and anxious, and terrified.

I think I depict women as a huge question mark. I think that their nakedness in my paintings is riddled with confusion about the ambivalence about desiring something, and desiring the pleasure of looking and touching and those kind of things, and also the selfconsciousness of what that means. I always try to make the people in my paintings be people, not objects.

I don't see how a conscious male today can be unselfconscious about his relationship to women, the power structures of that stuff, and not feel drawn to it and be repelled by it. I always thought that I would be letter-bombed by feminists. I was really surprised they didn't. I think that women can recognise the kind of sympathy with which I've portrayed the roles that women have been put in, and I think men can identify the conflicts that they deal with.

If the work raises issues it's because those issues should be raised. It's not because I'm a pervert and I want to see the world only in a certain way. In order to get people thinking about certain things, you have to give them an emotional experience in which that question is raised.

The beach is empty. A few scraps of paper are blown across the sand. The exercise bars stand out on their own. Nearby the motel sign is illuminated. The motel is stuccoed in white; modern and plain, it sticks out from the more obviously suburban houses around it. Its interiors are featureless. There are big picture windows in each room, king-size beds, plain lampshades and plain headboards, a telephone attached in one corner. The bathrooms have dark-coloured tiles which are fixed high up all the walls. In some rooms the windows slide back, revealing the terrace. To one side of the motel is a small, kidney-shaped pool, beside it an abandoned barbecue stained with fat and rust. The houses also have pools; some of them are newly built. They are fitted out to buyers' orders, but they come with venetian blinds, plug-in vacuum system and fitted kitchen. This is where many of Eric Fischl's people seem to live.

ERIC FISCHL

They come from the suburbs, I guess, which is where I come from. What the suburbs are about is a picture-book reality; the way houses are designed, the way objects people surround themselves with are chosen, is through photographs. Advertising feeds the imagination, and feeds the desire, and so people try to make kitchens look like the kitchens they see in photographs. They try to maintain that as an order as well. So what happens is the human experience gets alienated from the environment, because these environments are soundless, airless, smell-less, tasteless. They can't handle emotional disturbances.

I'm dealing with American culture, and that aspect of it that I'm most familiar with – the suburban middle classes. There's been such a heavy denial of those aspects of life which are traumatic, that I find myself looking in those areas and trying to recreate them. I'm thinking about traumas like death, loss, sexual coming of age – large transformations, psychological, emotional, that we don't celebrate because that's

what has been eroded. We don't even know how to bury our dead . . . there's no ceremony around the death anymore, it's just very matter-of-fact.

Eric Fischl has been concerned, like so many of his generation in North America (Cindy Sherman, Laurie Anderson, Robert Longo, Jonathan Borofsky, David Salle or Jeff Wall), to make a commentary on the surroundings of his own life. Their work is filled with mass media images of contemporary urban and suburban life. At times it relates closely to other creative forms: the novel, the rock song, the film, and the television drama. The commentary in this work and its narrative engagement form a sharp contrast to the work of the preceding generations of artists, in which cool Post-Painterly Abstraction and Minimal Art sought either to express personal feelings in symbolic, abstract form or to reflect on art as an autonomous meditative experience. Equally, many of the Pop Artists, like Warhol or Rosenquist, based all their work on popular imagery but had little interest in narrative structure or personal expression. Eric Fischl works through a close emotional identification with what is depicted in each painting, in a manner parallel to Howard Hodgkin, until the subject has become more distanced from his feelings. Then the unease of sexual relations, the selfconsciousness of the male view, can emerge.

This younger generation has inherited many of the opportunities created through the critical clashes of the 1970s in which art was polarised between a prevailing mainstream of abstraction and the incursions of conceptualism and politically based practices, including feminist art. Fischl has been open in acknowledging his debt to the latter strand,* but nevertheless many feminist artists regard his success, and that of David Salle, as partly based on a kind of appropriation of feminist ideas and ideals.

See 'I will not think bad thoughts', interview with Eric Fischl by Gerald Marzorati, *Parkett* 5, Zürich, 1985, p. 15.

Everything that's in my painting ultimately is edited to give you an effect of something taking place, in which meaning is taking place. It is not just that an incident occurs but in that incident – in that set of actions – meaning is revealed. Which is what is essential to making art right now.

 Art is the way that I am in the world, it's the way that I understand the world. I don't think that this is necessary for anyone looking at my art to know, but it's the way that when I've finished the painting, I know how I was feeling.

ERIC FISCHL

* * * * *

Some feminists adopt an anti-theoretical stance. Their argument indicts theory as male-dominated in content and as a generically male occupation. They are right to stress that existing theory is masculinist, be it sociological, biological or artistic . . . No political movement, however, can do without theory. Feminists have therefore had to produce new patterns of understanding a world in which women as much as men are the actors and victims in social history. We have had to draw new maps of a landscape and make new images of the world. GRISELDA POLLOCK, 'Theory and Pleasure', *Sense and Sensibility*, Midland Group, Nottingham, 1982.

147

Also published as *Post-Partum Document*, Routledge & Kegan Paul, London, 1983.

Between 1973 and 1979 Mary Kelly created the *Post-Partum Document* which, in six sections comprising 135 frames, charted her relationship with her infant son.* Stages in the development of mother and child, in feeding patterns, early speech, mark-making, objects of interest and his eventual writing are represented. Alongside the child's explorations is the experience of a mother in diary form, dealing with the practical pressures of parenthood against pressures of work, and the psychological and emotional upsets of watching a child grow. As well as the general commentary, a scientific analysis of the child's separation from the mother is juxtaposed with aspects of debate in current psychoanalytic theory. Extending the framework of theory, Kelly examines the conscious and subconscious struggles over femininity and ideas of motherhood.

Her subsequent work *Interim*, of which the first section *Corpus* was completed in 1985, represents and is 'about' women in the middle of their lives. Based on the experience of friends and colleagues as well as her own, Kelly interrogates the disparity between the expectation and the actuality, between the image and the experience of being a woman in contemporary professional, social and family life.

MARY KELLY *In both* Post-Partum Document *and* Interim, *I was concerned to deal with an area of women's experience that I felt really hadn't been spoken. Historically it became possible to talk about something like the mother/child relationship, or representations of ageing, because we'd become so conscious of those things during the whole process of the women's movement in the late sixties and the seventies.*

What the two have in common is a concern with working in terms of a large project over a number of years. I don't want to produce more objects. My aim is to establish that there might be another postmodernist strategy which doesn't simply have to do with reviving the traditional practices concerned with a specific medium.

It's not a literal notion of ageing; it's simply a preoccupation with that subject which can begin any time, for instance, one of the stories deals with someone who's twenty-five and another who's sixty-five. It's actually an intervening moment when one becomes aware of something that's grating – a dissonance between how one feels and how one appears. It's this experience that I tried to explore on the basis of over 100 conversations that I had logged for a period of three years. When I went back over the material and looked at it, the themes that emerged continually centred on the body, on money in rather a specific sense, on history, which was really a personal as well as a rather wider political history, and on power, in the sense that perhaps women don't have access to it within the institutions where they find themselves.

How I organise the first section around the body is to take that theme, to take these conflicting representations of the body and the so-called crisis of ageing, and in a sense to parody their presentation in the discourses like fashion or popular medicine. I also took up another notion which comes from Charcot's work in the nineteenth century, from his Iconographie, *where he pictured women hysterics in what he called the five passionate attitudes. I chose this not simply because that was considered to be the terminal stage in the hysteric crisis, I could use it rather metaphorically to refer to this crisis of ageing, but also because those poses have become so prevalent.*

It seemed rather appropriate that one would take up these themes and actually rework them in a contemporary setting. I wanted to make the same kind of shift in the piece that Freud made after his work with Charcot; that is, not to look at the visible symptoms necessarily, but to listen to what the patient says. So in the piece, the movement that's being set up is one shifting between image and text, between looking and hearing; and then considering the image of woman again from a new perspective.

Corpus, the first section of *Interim*, has a total of thirty frames arranged in pairs, each with an image of an article of clothing in the left-hand frame and a story in handwritten text in the right. There are five groups, each with one of Charcot's titles, and each with three pairs of frames that employ first the connotations of fashion, then the connotations of popular medicine and lastly the connotations of romantic fiction. These are three 'places' that Kelly considers especially significant in the fixing of ideas of femininity, places where ideas of what is appropriate to the female sex and to female sexuality are defined and contested.

So, in 'Menacé', the first image is of a leather jacket, shown neatly folded with stylish lettering and an insignia, as if in a fashion advertisement. Next to it is a story about a party at which age is being discussed:

prieve, Elizabeth comes over and asks me what I'm working on. I tell her it's another long project and hope she won't pursue it. "On what," she insists. I fumble, knowing it will sound dreadful no matter how I say it, "middle-age, well, that is, I suppose I mean women like us." "I don't feel middle-aged," she snaps, seems offended. I try to explain that it's not so literal, more about the way we represent it to ourselves, almost before the fact. She says she has a phobia about it, tries to change the subject. Sarah interrupts to tell me the leather jacket is lovely but she distinctly remembers that I said I'd never wear one. I confess I finally gave in for professional reasons, that there's so much to think about now besides what to wear, that the older you are the harder it seems to be to get it right and that the uniform makes it a little easier. I look at Maya for confirmation but she

Humour is an important part of Mary Kelly's strategy in *Corpus*. Cartoons and jokes are one of the forms in which stereotypes and images are circulated, but humour is a process through which they can be unfixed. Humour makes the stories enjoyable for the range of audiences that Kelly addresses.

The second pair in the third group, 'Supplication', shows on the left a pair of boots opened out, as if for medical examination, with the style of lettering from a medical dictionary below. The story alongside describes a trip to the beach on a summer's day:

give us pleasure. Yes, the children, they are lovely. See how much they are enjoying this? We smile. Then, "Mum", a small voice shouts, "your legs are fat." Elena laughs and I begin to lecture, "Look," I say, "if you compared my fat legs with all the fat legs over forty, you'd discover..." but he's gone before I finish so I carry on complaining to Elena, asking her what can be done to fight the dreaded flabby thigh". She points in the direction of her beach bag where I see a Sunday paper, take it out and note the supplement devoted to the preservation of the perfect pair of legs : first, you should jog for at least fifteen minutes everyday; follow this with one hour's arduous exercise; then thirty minutes of massage, pedicure recommended, waxing optional but <u>resting</u> absolutely necessary, legs raised, ankles on a cushion for not less than twenty minutes, preferably at midday. "You see," Elena says, "it's very simple, all you have to do is dedicate your whole life to it."

The third pair of the same group shows the boots bound up together by their laces, initialled with titles in 'fancy' lettering. The story here tells of a woman's meeting with a man and her confusions:

lovely person. Thinking is a dangerous practice. Eyes still sparkling he suggests, "Let's go to my place, have a coffee where it's quiet, we can talk..." "I can't." "Why not." "I didn't plan on it." He says he did, for several months. I'm taken by surprise but now inflexible; absurd at my age. I feel flushed and rather foolish, want to stay but say I'm sorry: Call a taxi, comes ten silent minutes later; body painted gold, interior lined with velvet. Odd. I ask the driver who is dressed in purple livery and looks vaguely like a lizard, if there's some mistake. I didn't want a limousine and can't afford it. He assures me it's alright, he's just eccentric. I get in, lean back, spread out my satin skirt across the seat, slip off my silver pumps and think. Should have stayed, no reason not to. It's too late. The radio announces twelve o'clock, the car breaks down, the lizard scurries off and I walk home in rags and wooden shoes.

The other articles of clothing are a bag in 'Appel', a black nightdress in 'Erotisme' and a white embroidered dress in 'Extase'. The image is formed from a photograph of the object which is worked on by Kelly to emphasise the internal shadows, and then enlarged and laminated onto perspex. The perspex is suspended in a frame – the same for both image and text – in such a way as to cast a shadow on the lightly coloured backboards. Certain words are picked out with red overpainting to allow the eye to skip down the text picking up these significant words.

MARY KELLY *I think when we're looking at images of women, for both men and women, we are voyeurs; we're pleasurably involved in that looking, but I think something different happens to the woman. She's in some way also troubled by the kinds of identifications*

that she makes with her image. Am I like that, would I like to be like that, should I be like that, was I like that? I'm really putting that on the surface. I'm just reversing the usual process so that what she identifies with is not the literal figure but that feeling of masquerade, or perhaps you might call it alienation.

I wanted to invoke the same sort of pleasure that's produced in those glossy advertising images, and to do that without actually using the woman's body. You find, in my work, that simply the texture and colour of the background, the black frame, the painting behind the image, all are part of a process that, without reproducing exactly the same kind of image, creates a similar effect.

With the photo laminate it's very important for me that it doesn't invoke primarily the codes of photography. We have something like a skin on the surface [of the perspex] that casts its own shadow. So while the image on the surface does have some iconic properties, the real shadow has an existentialist bond with that object in a way that's much more like an index.

Mary Kelly's unconventional format of writing and image, story and symbol can be contrasted with Cindy Sherman's approach. Whereas Sherman works with single images of women as in advertisements and magazines, providing a disturbing but often attractive portrayal of herself, Kelly is at pains to leave images of women absent. She is wary of using representations of women, even from a critical position, when the stereotypes behind those representations may still be reinforced. The actual images of the clothing are insubstantial, 'floating' on the perspex in the frame, complemented by initials and titles on the one hand and elaborate stories on the other. But we are hooked by these stories, with their sharp descriptions and poignant conversations.

MARY KELLY

In the final panel that notion of romance, as it were, is also one that was perhaps easiest to caricature, just in terms of tying the garment up in knots. In terms of the narrative, it's one that could underline this aspect, and I did this by introducing elements of existing fairy tales. That panel, for me, is absolutely crucial because it's a kind of comic relief, when it's put in play with the other two. I think that's something absolutely necessary for the viewer to get some distance on the subject.

I don't believe in women's culture or women's art, and one thing that I say rather definitely about my pieces is that I'm not trying to excavate some female culture from the past. I'm not trying to valorise the female body. I'm not even trying to say there's some essential feminine experience. I'm trying to look at the way femininity is produced in one specific moment or particular event. Now for me, it's important to use writing to invoke a sense of listening to, rather than looking at, the woman; I don't think this is stylistically identified with women's art. The other thing is that I actually feel I'm treating the text as an image; that is, giving it the same consideration that you would give the painted mark.

One of the things that I had wanted to show in the Document is that there's a moment in a woman's life that seems to be privileged in this society, which revolves around the mother/child relationship. It's the one time that she can be the actively desiring subject, but still remain within a rather conventional and acceptable definition of the woman as mother. In the new work it's not at all the case. We're

Menacé

119, 120 Mary Kelly, *Corpus*
(details), 1984–85. Two of the thirty
frames.

The music is loud, too loud to talk. Sound swells and breaks, rolling over me, through me, funky, dissonant, feels good. I want to dance, smile at Ruth soliciting a partner. We push our way into the center of the room and start to move in what I think is perfect unison, except that from a certain position I can see myself in the cloakroom mirror. The image grates. I keep manoeuvering back to it for a re-play, seems so out of synch with how I feel. The clothes perhaps, not tough enough, too sixties. No, the hair, too severe, should fly across my face when I turn. No, it's more insidious than that, the expression is wrong, too animated, childish even, absurd at my age. Keep the mouth closed and look cynical. To compensate for the double chin. Beware of raising your arms and unleashing untidy ripples of loose flesh that linger thereon. No, the hips, definitely the hips, hardly perceptible but not quite the same, something to do with the feeling of space around the waist. Ruth has gone for a drink and someone is offering me a joint. I feel silly. Everyone I know went back to alcohol years ago. Still, everyone I know is thousands of miles away and everyone here is so Goddamn young. Mostly students. I feel like a chaperone. Aren't there any other lecturers for Chrissake. I spot a post-graduate fellow, greying at the temples, looks promising. I corner him. He says he's a fem-inist so I proceed to ramble on about the beginnings of the women's movement saying, "you remember the first meeting at Oxford, don't you?" "No," he says, "I was fourteen in 1968." I am stunned, can't speak, feel deceived. How can he know so much? Why does he look like that? Thirty-five at the very least, but twenty-seven? It's hopeless. I'm reduced to a voyeur. Besides, he's with someone who looks like less than twenty-one. I hate them. He senses it, hands me another drink. For a moment, I imagine that he is Prince Gold Hand bringing the Old Crone a glass of the Water-that-Makes-Young from the Fourth Well and I croak, "Have you got it, have you got it?" "Yes," he replies and I seize it in my wizened hands, pour it over me and immediately turn into a beautiful maiden. Then, I ask him what he would like as an offering of thanks, but he says he can't think of anything because the Princess is all he desires and she is already standing with her hand in his. At this point, of course, I want to turn them both into frogs and vanish from their sight forever. But instead, I just excuse myself and go to look for Ruth.

talking about a moment that isn't easily assimilated within the social norm, that's full of contradiction, that leaves her with no other choice than to become something other than what she was, that is, to realise, perhaps, that being a woman was only a brief moment in her life. If she's forced to retreat into a rather artificial, precocious notion of femininity, that runs the risk of being self-destructive. So it's important to look for ways that women can signify their presence, their desires, at a time that's sometimes seen as the end of their lives.

[Psychoanalysis] gets us nearer to the roots of our oppression, it brings an articulation of the problem closer, it faces us with the ultimate challenge: how to fight the unconscious structured like a language (formed critically at the moment of arrival of language) while still caught within the language of the patriarchy. There is no way in which we can produce an alternative out of the blue, but we can begin to make a break by examining patriarchy with the tools it provides . . . LAURA MULVEY, 'Visual Pleasure and Narrative Cinema', *Art After Modernism: Rethinking Representation*, p. 362.

Seminar with exhibition of *Interim* at Fruitmarket Gallery, Edinburgh, 8 February 1986.

Mary Kelly was joined by Laura Mulvey, filmmaker and writer, for a seminar on issues raised by *Interim*.* Mulvey outlined the common roots of their thinking, which came from 'a particular strand of the women's movement that was concerned with the politics of representation and the development of a feminine aesthetics . . . [We] were interested in a feminist interpretation of Freudian psychoanalysis and had an objective alliance with the aesthetic strategies of the avant-garde.' Psychoanalysis has been important both in the development of feminist thinking and in issues of representation and sexuality. Indeed psychoanalysis, as Freud intended it, as a scientific investigation into the workings of the mind, is essential to any exposition that intends to relate individual experience to social, economic or political experience. In particular, the work of Freud and Lacan examines how ideas of the masculine and feminine, with their biases and stereotypes, might be replicated *within* each of us.

MARY KELLY

Psychoanalysis has been extremely important in shifting the arguments away from the sociological that led us to believe that if you gave boys dolls, and girls trains, we'd all grow up differently. It was through coming to terms with how the notion of femininity has been internalised, the relation that it had to unconscious processes, and to things like fantasy and desire, that we could rid ourselves in a sense of the terrible moralism of the early seventies. This doesn't mean that we've given up trying to change the way our sexual identities are formed, but we're seeing this within a complexity of other social issues.

The common-sense view, the one which just seems *obvious*, is that we are each born into the world as a little 'self' which is just as much simply *there* psychologically as it is physiologically – a little seed of individuality which over time sprouts to form the adult subject we eventually become; but psychoanalysis has built up a different picture: we become what we are only through the encounter, while growing up, with the multitude of representations of what we *may* become – the various positions that society allocates to us. VICTOR BURGIN, *The End of Art Theory*, Macmillan, London, 1986, p. 41.

121 Mary Kelly highlighting a text in red, London, 1986.

122 Mary Kelly in a seminar with her exhibition at the Fruitmarket Gallery, Edinburgh, February 1986.

155

Mary Kelly was involved in the 1970s, as was Victor Burgin, in debates about theories of photography and film and issues of representation and politics.* In the 1980s such debates have broadened to the fields of art, art history and cultural studies, and as a writer and teacher Kelly uses and contributes to these current theoretical discussions. As an artist she explores the same theoretical ideas, but in a different way. She insists that *Interim* is not autobiographical, but the amalgam of many real reactions to the processes of ageing, many individual responses in the face of common personal, social and institutional pressures. As Kelly says, 'The very subject matter is subversive not necessarily because I make it so, but because it's been expelled from the social, cultural order of things.' While placing that subject matter firmly back into the cultural order, *Interim* asserts that desire is a manipulated but mobile concept, and that masculinity and femininity are attached to particular objects and images through social convention alone. This makes them inherently unstable categories.

MARY KELLY *It's certainly the case that I am trying to provoke a change of attitude: to say that you can't stereotype the feminine as raw experience and the masculine as theorisation or rationalisation. In practice men and women are always involved in both; it's rather important in the* Document *and in* Interim *as well that one should challenge that false notion.*

<p style="text-align:center">* * * * *</p>

We tend to uphold complaints of crude or sadistic advertising, but when we get into the stereotyping of women, we tend not to uphold them. Apart from being a matter of subjectivity, we also believe that advertising must have freedom of expression, within obvious constraints of taste and decency. Lots of women are grossly oversensitive. DIANA BIRD, public relations manager for the Advertising Standards Authority, quoted by Virginia Mathews, 'Sex – is the ad business on a slow learning curve?', *Guardian*, London, 21 April 1986, p. 22.

Two ladders are propped against the billboard. The workmen walk back from their van with rolls of paper under their arms and buckets of paste in their hands. Deftly they start to paste the sheets, twelve for the whole poster, making it ten feet high by twenty feet wide. They work from opposite ends of the billboard and only gradually can the image and the words be read together. A girl with a pigtail and a frock is putting her finger on the flexed bicep of her young male friend or brother. He clenches his teeth and purses his lips. 'We don't need another hero' is blazoned across this image.

Barbara Kruger's images and texts range in scale from the billboard to the matchbook, and appear on T-shirts and postcards as well as in her characteristic red frames in the gallery or museum. She alters the proportions of the image to suit the format and adjusts the scale and placing of the lettering accordingly. From archives of photographs and her own collection of anthologies, books and magazines, Kruger selects images and matches them with the words, sometimes rewriting the text as the work is made. She is best

known for the large gallery works which she has exhibited extensively since 1981, and which have an extraordinary impact against the clean, white, sanctified atmosphere of the museum or private gallery. But her success in the art world has not diminished her desire to reach different audiences in different situations.

I don't think of art per se, I think of how words and pictures – pictures with words – function in culture. If those images on the street are seen as pictures with words on them, that is what they are. Whether they are read as art or not is really not of much meaning to me.

I think we're living in a culture which, if not sophisticated about reading imagery, is certainly very used to being bombarded with incredible amounts of images in very quick sequences. I think that one has to understand how to read those images, what makes them effective, and not to duplicate those images per se, but to reconstruct the machinations that are behind the presentation of those images.

I think public sites being so erratic, the poster works disappear very quickly. Images are covered very quickly. One becomes very fugitive; one's picture, one's messages disappear very quickly. It is good to supplement that public activity with a more art-world market-orientated distribution. It is also a chance to enter an art-historical discourse; there is a need for the voice of others, whether they're women or people of colour, to enter that discourse in some way and that usually happens through the market and through the gallery construct.

I'm interested in dealing with the spectator, and if part of that has to do with monetary exchange, that's fine. It's important because that makes my work more visible, more apparent, more reproduced, and that's good.

There are advantages to working in the art world, because it's a cottage-industry structure, you don't have to hustle for three years, like you do to get enough money to make a movie. Your client relationship is relatively distant, as opposed to being a filmmaker or being an architect.

BARBARA KRUGER

It is not surprising, then, that Kruger uses your representations for her images. Taking your black and white photographs, she reproduces them, with a difference. She may alter the scale, crop the image, and cover portions with her texts, but the result still carries the trace of another. Nevertheless, she does not appropriate images. She is not insisting that we are all children of the mass media but that your media, whether mechanical or otherwise, produce our images, our history. We are your fictions. JANE WEINSTOCK, 'What she means, to you,' *We won't play nature to your culture. Barbara Kruger*, Institute of Contemporary Arts, London, 1983, p. 12.

A series of works made by Kruger in 1985 uses the lenticular format, the prism mechanism that is usually associated with winking key rings and postcards. In each of the four lenticulars, one pairing of image and text is juxtaposed with another pairing on the 'other' side. A close-up image of a micro-chip with 'We are astonishingly life-like' is set against 'HELP! I'm locked inside this picture'. In another, a half-dollar coin with 'Your money or your life', is set against the text: 'God is on your side'. The clash of image with text, the connotations of the pictures against the various meanings of

157

123 Barbara Kruger, *Untitled* (We don't need another hero), 1985, on a billboard at Hammersmith Broadway, London.

SEXUALITY

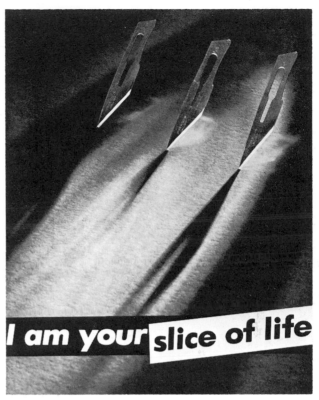

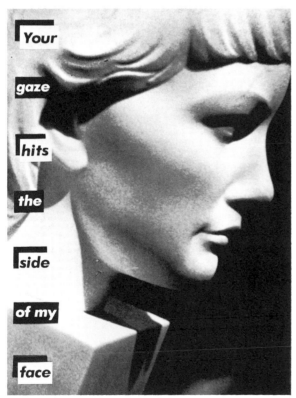

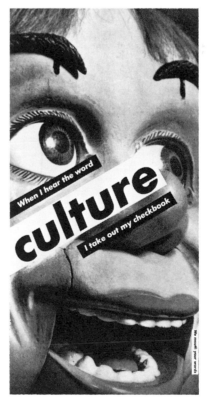

124, 125, 126, 127 Barbara Kruger,
all *Untitled*.

the messages, produces an assertive and resistant tone, heightened by the use of ambiguity and rhetoric.

Thus Kruger produces neither social commentary nor ideological critique – the traditional activities of politically motivated artists (consciousness-raising); her art has no moralistic or didactic ambition. Rather, she *stages* for the viewer the techniques whereby the stereotype produces subjection . . . Against the immobility of the pose, Kruger proposes the *mobilisation* of the spectator. CRAIG OWENS, 'The Medusa Effect or, The Spectacular Ruse', *We won't play nature to your culture. Barbara Kruger*, p. 11.

When 'We won't play nature to your culture' is set across a woman's face whose eyes have been covered with leaves, Kruger is making an implicit objection to the circumscription of women's creative roles as 'natural' while men are given the more significant position of the 'cultural'. Similarly, when the cloud of a nuclear explosion is headlined with 'Your manias become science', Kruger implies a collective resistance. *Your* has become the ruling ideology against which she and others dissent. In other works, the insinuations of the advertisement, all the sly innuendoes of the mass media, are turned back on themselves: 'I will not become what I mean to you', 'We refuse to be your favourite embarrassments' and 'Your comfort is my silence'; others are more accusative: 'You are seduced by the sex appeal of the inorganic', and 'You construct intricate rituals which allow you to touch the skin of other men' set over a picture of a group of suited men laughing and fighting.

BARBARA KRUGER

The whole idea is not to deal with one sort of univocal correct positioning or statement or prescription. There is so much in terms of pictures and words which does that, and I'd rather decline that address. I would like to open it up a little bit and suggest multiple readings and an opening for any number of spectators or subjects.

I don't demand that people look at my work for very long. I don't ask for a Rothko chapel. I don't ask for a Kruger chapel, you know, I'm not interested in having anyone meditate on my work; it doesn't take long to read it. If they want to that's wonderful, and I welcome it, but it's really not necessary.*

The Rothko Chapel is a non-denominational chapel in Houston, hung with a group of large paintings by Mark Rothko.

We have no unmediated access to the real. It is through representations that we know the world. At the same time we cannot say, in a simple sense, that a representation or an image 'reflects' a reality, 'distorts' a reality, 'stands in the place' of an absent reality, or bears no relation to any reality whatsoever. Relations and events do not 'speak themselves' but are *enabled to mean* through the systems of signs organised into discourses on the world. Reality is a matter of representation, as Stephen Heath puts it, and representation is, in turn, a matter of discourse. LISA TICKNER, 'Sexuality And/In Representation: Five British Artists', *Difference*, New Museum of Contemporary Art, New York, 1984, p. 19.

The television column of *Artforum* is written by Barbara Kruger, and she has long had an involvement with new film work and questions of representation in film and cultural studies. Her critiques of the fictions of media, which permeate her work, are sharpened from the first-hand experience she had in

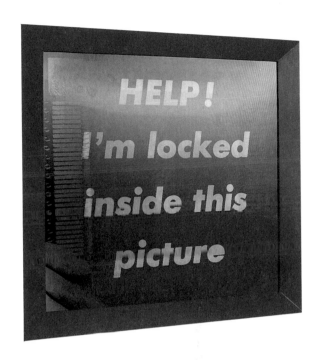

128, 129 Barbara Kruger, *Untitled*,
1985, two images combined in a
lenticular photograph.

the 1970s as an art director working on layouts for Condé Nast women's magazines.

BARBARA KRUGER *It's something I learned when working on magazines for so many years, that you designed a page for someone to look at, for them to look at in a relatively short time; it was important to get people's attention. If you didn't you were fired because you didn't have the competency to construct an object that was seductive enough for people to look at.*

Magazines, and especially fashion magazines, are vehicles for colour advertising, which means that they are about selling particular merchandise and garments, and in order to sell those garments, they are designed to mould that spectator or that subject into the image of perfection from the corporate view. In other words, it is the magazine's duty to make you their image of their own perfection. It's constantly changing because the image of perfection changes monthly; there are different lines, and different items, and different commodities.

It would be very narrow to suggest that fashion is limited to the pages of a magazine or the threads of a garment. One could say that almost everything is subsumed by fashion and its cyclical rhythms and its whims and its dictations, whether that is within the realm of garments, the realm of entertainment or within the realm of art; what is seen, what is celebrated, what is yesterday's papers, what is desired and what is repulsive.

Kruger's use of photographs from old magazines and picture books places her images in a limbo where they are recognisable but not too specific. This floating quality contrasts strongly with the large poster-like formats and the sloganistic texts, and is enhanced by the restrictions of black and white images (though since 1985 Kruger has made a few images in colour); spectators are drawn to examine for themselves the everyday phrases and images she uses. Kruger's work aims to disrupt our reading of stereotypical images, whether of sexuality as such or of the gender divisions of society, work, wealth and power.

I am concerned with who speaks and who is silent. I think about works which address the material conditions of our lives and the oppression of social relations on a global level: in work which recognises the law of the father as the calculator of capital. I want to speak and hear outlandish questions and comments. I want to be on the side of surprise and against the certainties of pictures and property. BARBARA KRUGER, statement in *Ansatzpunkte kritischer Kunst heute*, Kunstverein, Bonn, 1984, p. 68.

The artists considered in this chapter are part of 'high' culture, though Kruger's posters and postcards, and Mary Kelly's book and teaching, spread their works and ideas more widely. It might be argued that they have little power to change the way images and identities in society are formed and displayed. But this is to misunderstand how images in our society circulate. There is considerable exchange between images in the mass media and those in the art world. When Eric Fischl and Alexis Hunter make telling depictions of sexual anxiety and sexual discovery, they are not providing universal new

visions of the world, but images that become part of our culture as much as novels, videos, and television. The high status of the art market and the museum world is such that if an Eric Fischl canvas changes hands at more than $100,000, it has power as an *image* (never mind its power as an original oil painting). His scenes are often uncomfortable, and with their uneasily explicit sexuality, give no automatic support to the visual traditions of women 'to-be-looked-at' by men. Neither Mary Kelly nor Barbara Kruger have any interest in the traditions of oil painting as such. Their stories and slogans help undermine the certainty with which the other great combiners of images and words – the advertisers and magazine editors – go about their work. New concepts of femininity and masculinity develop as new images of women and men are projected.

Differences in the meanings of masculinity and femininity in different contexts make it clear that there is no need to posit any fixed dualistic opposition between men and women . . . If, then, we find something in the relationship of the sexes that seems to resist alteration, this is never so in an absolute sense. We are not dealing with static entities, whether produced by biology or by the social environment. The question would then be: what is it (or what are the areas) which seem most resistant to change? JULIET MITCHELL, Afterword to *Woman's Estate*, Penguin, London, 1986, p. 185.

I think to label something political within culture today is really to disarm it in a way, and I think that it tends to ghettoise particular activity. I think that there is a politic in every conversation we have, every deal we close and every face we kiss, and that sort of ordering and that sort of hierarchy permeates every social construction, and I read that as a political arena. BARBARA KRUGER

5 Politics, Intervention and Representation

A society without power relations can only be an abstraction. Which . . . makes all the more politically necessary the analysis of power relations in a given society, their historical formation, the source of their strength or fragility, the conditions which are necessary to transform some and abolish others. MICHEL FOUCAULT, 'The Subject of Power' (1982), *Art After Modernism: Rethinking Representation*, p. 429.

Art and politics are commonly thought of as separate spheres, with intentions and functions that are diametrically opposed. But for our social system to cohere, for there to be a society that operates without continuous military or police coercion, there must be a consensus which the mass media, the law, education and the arts support. Only through a general cooperation in representing agreed values can the management of society seem naturally to be 'right', to work for the benefit of all. A view of art as entirely separate, transcending the matters of political debate, is itself a political viewpoint. Such a view renders invisible many areas of political debate in the arts, where artists, like teachers, strive to make sense of their work on a day-to-day basis with frequently inadequate resources.

There's a position on the left in which 'art', indeed *any* form of cultural activity, is seen as 'peripheral' to the *real* world of party politics and economic class struggle. There's a position on the right which agrees with this and welcomes it as 'guaranteeing the independence' of artistic creativity. You're then offered a choice as to which square to occupy on a checker-board of positions – any position as long as it's black or white. I think it's important not to accept any games played on this board . . . Artists are *not* independent – socially, economically, ideologically, politically – for all it suits some of them to pretend that they are. But neither are they 'a cog and a screw' in the party machine. VICTOR BURGIN, interview with Rosetta Brooks, *ZG* 1, 1981.

Art in the West is rarely under the direct control of the state; what used to be a service to the aristocracy, royalty, church or government has become more autonomous, a relationship now structured through public funding bodies like the Arts Council of Great Britain and the public galleries and museums. (When the artist Linda Kitson was despatched to the Falklands war – underlining all the contradictions inherent in the aestheticisation of violence at a time of rigorous press restrictions – it was through the auspices of the Imperial War Museum.) Public subsidy is often administered at so-called 'arm's length' from politicians at both national and local level. This ensures a certain continuity for arts support, but when public disputes do occur party political priorities can be very influential.

The connotations of fine art are of middle and upper class life, of a luxury goods market, of selfconscious intellectual enjoyment, of certain kinds of subject matter (including the 'subjectless' areas of geometric or expressive abstraction) and of specialist languages and formats. Art and business can offer mutual support, as discussed in Chapter Two. Artists, curators and critics are not 'employed' by the public relations services of the business

community or the government. They are not servants of either, but the work that they produce (the art, exhibitions, collections and writings) is organised within an economic and social framework.

In the political sphere, broadcasting . . . reproduces with remarkable exactness the forms of parliamentary democracy, and of 'democratic debate', on which other parts of the system . . . are constituted. . . . For though the major political parties sharply disagree about this or that aspect of policy, there are fundamental agreements which bind the opposing positions into a complex unity: all the presuppositions, the limits to the argument, the terms of reference, etc., which those elements within the system must *share* in order to 'disagree'. It is this underlying 'unity' which the media underwrite and reproduce. STUART HALL, 'Culture, the Media and the "Ideological Effect"', *Mass Communication and Society*, Edward Arnold, London, 1977, p. 346.

The artists' drawings sent from sites of interest, colonial outposts and battle zones which filled the pages of nineteenth-century weekly magazines have been transformed into the video images of the contemporary news service, beamed around the world by satellite communication. But for all the technical sophistication with which it is gathered, what is considered newsworthy is still a matter of selection not only by newspaper and television editors, but also by journalists and video crews. Once selected, news images are interpreted differently by different people; to reduce these differences, the meaning is 'fixed' with a caption or commentary. Yet these images, understood against a wider field of images, information and assumptions, are resistant to single meanings (as Barbara Kruger tellingly

demonstrates). They are available, complete or in fragments, to be 'unfixed' and 're-fixed', to be combined with new information by artists and others to make alternative statements with each juxtaposition.

A capitalist society requires a culture based on images. It needs to furnish vast amounts of entertainment in order to stimulate buying and to anaesthetise the injuries of class, race and sex. And it needs to gather unlimited amounts of information, the better to exploit natural resources, increase productivity, keep order, make war, give jobs to bureaucrats . . . The narrowing of free political choice to free economic consumption requires the unlimited production and consumption of images. SUSAN SONTAG, *On Photography*, pp. 178–9.

In their critique of contemporary society, feminist writers have demanded a thorough examination of what is deemed political – the innumerable ways in which groups of people hold power over others, and the way in which social relations are psychologically consolidated 'within' each of us. The feminist emphasis on individual experience and identity reconfirms for art the place it has frequently held as the means of intimate and personal expression, but gives it new purpose. Art may now challenge experience as well as report on it, by questioning the preconceptions through which we express our feelings, disappointments and desires. To demarcate a separate category of political art denies these understandings. But to recognise the political nature of all art does not preclude the examination of work produced by artists who have selfconsciously taken on political issues. Nor does the examination need to be reduced only to those issues; the work's identity as art remains in its specific qualities as painting, as sculpture or as photography. Message and means exist side by side, equally dependent on each other.

I'm always saying that a politically conscious art has to come from lived experience – by which I don't mean you have to be bombed to make art against bombing, but that some part of you has to be able to envision being bombed, rather than just to make pictures of it.

If we can't imagine or image a person out of work, sleeping in the street, shot down resisting eviction, tortured by the police state, what hope have we of providing counter visions? LUCY R. LIPPARD, 'Battle Cries', *Village Voice*, 4 December 1984.

The current range of art engaged selfconsciously with social and political questions is immense. Like the work of Mary Kelly in the previous chapter or of Lubaina Himid, Sutapa Biswas, Sonia Boyce and Donald Rodney in the next chapter, it takes on particular and immediate issues; it explores moral issues to argue against exploitation, national issues to question post-imperial domination, racial issues to challenge discrimination, social issues to reassess what can be cooperative and supportive, sexual issues to question patriarchal values, and economic issues to counter the assumptions of a capitalist system. These artists are not so naive as to think that social and political change can be created simply by exposing these issues in the arena of culture.

The range of their work extends beyond the media of traditional fine art and involves specific interventions; it runs, for example, from public per-

formances to draw attention to double standards in the media reporting of rape (Suzanne Lacey in Los Angeles), to artists working in specific locations with labour and union support (Carole Conde and Karl Beveridge in Toronto), to artists portraying male power-plays (Mike Glier in New York) and to artists working with questions of cultural heritage and discrimination (Rasheed Araeen in London). In Britain, the work of Conrad Atkinson has spanned issues from work and unemployment, Northern Ireland, and industrial disease in his native mining community, to the use of the Royal Warrant on goods made by the producers of thalidomide and an ironic examination of the sloganising aspects of the newspapers. Atkinson, Margaret Harrison and other artists are actively involved with the 'local' political matters of the art world (artists' rights, funding, institutional discrimination, censorship) as well as with wider issues. They address these issues because they are affected as citizens, as members of a local community, as part of a family, as individuals, rather than because of some predetermined idea of being a 'political artist'. Their success is not to be measured like the popularity of a political party. If change comes through the changed consciousness of individuals, then it is art that alters our conscious reading of images, promoting diverse and alternate possibilities.

* * * * *

It should by now have become obvious that the great issues of our day – the militarisation of American life, the Vietnam war, race conflicts, poverty, the decay of cities, the destruction of the natural environment – are not susceptible to rational solutions within the existing system of power relations . . . Poverty on a large scale, like the decay of the cities and the ruination of the natural environment, is a result not of accidental misfortunes but of social and economic policies in whose continuation powerful social groups have a vested interest . . . in brief, the overriding single issue, of which all the others are but specific manifestations, is the distribution of power in American society. HANS MORGENTHAU (1970), quoted by Jon Bird, 'Leon Golub: "Fragments of Public Vision"', *Leon Golub*, Institute of Contemporary Arts, London, 1982, p. 15.

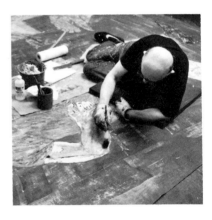

131 Leon Golub in his studio, New York, 1985.

In *Leon Golub*, Institute of Contemporary Arts, London, 1982, p. 6.

Leon Golub believes that the appearance of the Vietnam war on American television every night brought the horror literally 'home' to people, that this helped generate the widespread reaction against continued American involvement. The images made more people understand for themselves. As Golub said in 1982, 'All this atomised chaos, all the controlled and uncontrolled verbal and imagistic garbage jitters in the skulls of the onlookers even as it jitters in the skulls of the media manipulators.'* Golub painted his own large-scale depictions of Vietnam, the soldiers and napalm, unfashionably harsh on the eyes. In 1979 he started two series of paintings, the *Mercenaries* and the *Interrogations*. These scenes of the perpetrations – of victims being tortured – and the perpetrators have in common a picturing of the margins of power. Power is in real, and physical, play, but it is invisible, beyond the normal processes of the state, law enforcement or even warfare. The scenes are, equally, beyond the 'normal' gathering and dissemination of the news, put back into history by these paintings.

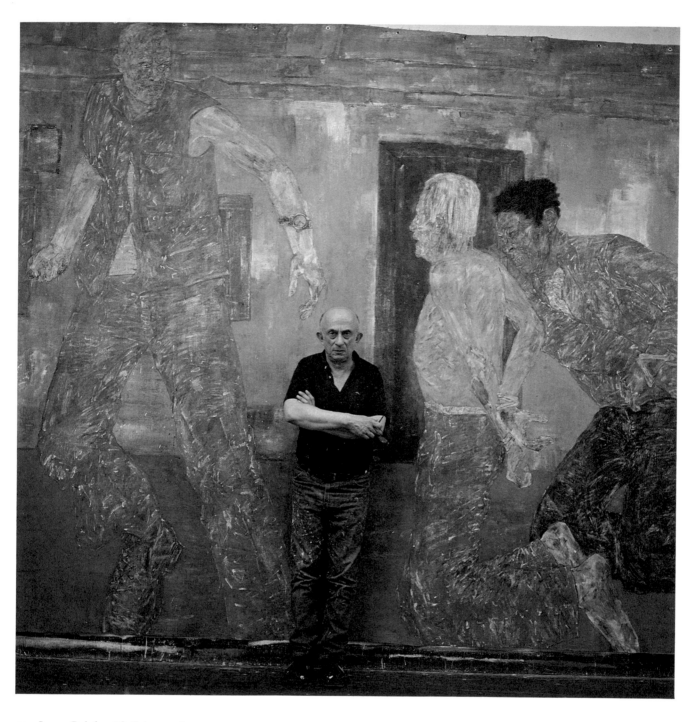

132 Leon Golub with *Prisoners I*, 1985.

POLITICS

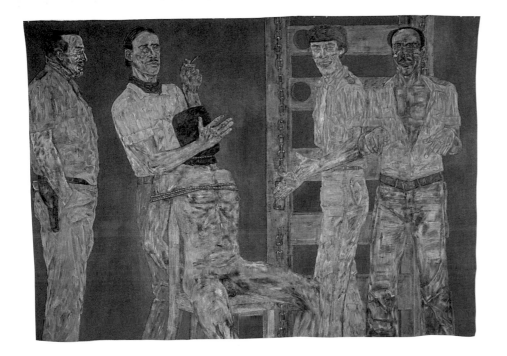

133 Leon Golub, *Interrogation II*, 1981.

135 Leon Golub, *Horsing Around III*, 1983.

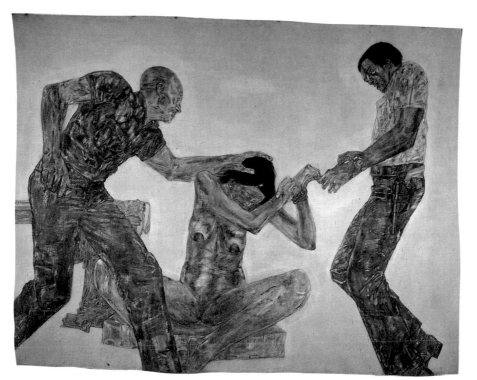

134 Leon Golub, *Interrogation III*, 1981.

LEON GOLUB

Speaking as an American, the Americans are in the middle of El Salvador and Nicaragua. They're right in the middle of it, because our money, our soldiers, our representatives are manipulating the situation every which way they can. We're not seeing it from some distance, we don't have the nineteenth-century distancing that took place because an image had to take two weeks to get from North Africa to metropolitan Paris. So in this retarded medium known as painting, left over, totally left over, the dustbin of history, given all the contemporary media we have – I'm trying to activise it to such an extent that it has some media connections; that it isn't simply a nice item to be revered from a distance in a certain kind of way, protected, framed, encapsulated in amber.

At one level Golub's paintings are intended to shock. To shock us even though we may be saturated with violent imagery from television and film drama, and from the news itself; a shock that is effective because it is in the art gallery and not on the television screen. Golub is aware of the spectator's reactions of disgust and uneasy identification. As Lucy Lippard put it, 'It's simply more imaginable, and thus more depictable, to be doing these things than to be suffering them.'* The paintings are not just a kind of imaginative reportage of an extraordinary 'aesthetic' kind, but prompt a series of questions about ourselves. What is our relation to these events? To violence and the inflicting of pain? To the power of the state and the actions of governments made in our name? What responsibilities do we hold outside our everyday lives?

'Necessary Evils', *Village Voice*, 19 March 1985, p. 92.

LEON GOLUB

We're talking about power, we're talking about resources, we're talking about domination. The United States intends to stay number one regardless. It conceives of itself as number one and intends to stay that way. The United States is in a sense under attack in various kinds of ways. At the same time we have a good name for ourselves, we picture ourselves as being idealistic, we picture ourselves as serving humanity; maybe we do in parts. We disguise from ourselves, which is what the Reagan administration is always doing, our selfishness, by using certain types of language. Meantime at the peripheries, the borders where things shift, where you leave the United States and you enter that part of the world called the Third World, then you permit yourself actions in order to maintain the resources coming into the United States.

Most of these paintings have to do with Latin America, some with South Africa, but by extension they apply to New York or Chicago or London. They can get away with it better in Latin America today, in El Salvador, than they might be able to do in London or New York, but these incidents still occur in major cities through police force or inadvertence, so-called inadvertence. Virtually every country has covert agents. You use a covert agent when you don't want to use the public means of order, so you go to the fringe, you see, and you have people carry out these activities through government agencies.

The US government, in all its claims about terrorism and its victory over the hijackers – that's fine and good at one level, but it's nothing compared to the terrorism that this government has sponsored in Latin America. There's 40–60,000 individuals that have been slaughtered – estimates vary to some degree – over the last four years in

El Salvador, most of whom are teachers, medical workers, peasants, workers in factories; lawyers very often, because they represent civil rights. Our government has given the wherewithal to do this kind of action. So, terrorism at one level, or sadism at another level, depending on how you view it. We see ourselves in noble terms and we see the others as monsters. They may see us as monsters and see themselves in noble terms.

The 'pathos' that Golub has repeatedly said he wants to articulate is the pathos of his own determination to witness . . . but he knows that his record of events no matter how reflective of them it may be . . . will not change them. Hence the pathos. Golub forces that pathos on the spectator by situating him or her both on the periphery of the scene and within it. DONALD B. KUSPIT, *Leon Golub*, Rutgers University Press, New Brunswick, 1985, p. 25.

To contemplate a Golub painting is to confront an object that is both 'beautiful' and repellent. There is an elegance to the figures, sometimes a kind of poise, almost classical, which belies their actions. Golub produces the final surface by relentlessly adding acrylic paint and scraping it back with the broad blade of a small meat cleaver. The paint remains only in the minute spaces between the weave of the canvas and in the fibre itself, producing an etiolated beauty, all the more powerful and disturbing for its appropriateness to both cotton clothing and human skin. There is a confidence in the painting that corresponds with the depicted arrogance of those in control within each picture, who look as though they would gleefully send a picture postcard home showing everything they had been doing.

The *Interrogations* paintings are large-scale and overpowering. The figures are more than life size and are stopped in mid-action; caught in the act. In the *White Squad* series, too, violence has been interrupted: undercover operations, the bundling of a body into the boot of a car, a gun held and another pointed. At any moment the participants could turn on the spectator; in the *Riot* series eye contact is held at a moment of tension, and we have become participants. In less aggressive form we are eyed by the men and women in *Horsing Around* and by the equally cool, 'off duty', *Mercenaries*.

Golub calculates these confrontations precisely. The images are worked up from a large variety of sources, photo files filled with clippings from magazines and newspapers. Fragments of bodies, arms, legs and torsos are ordered by their position or their stance, so that any figure can be assembled. Figures are not always readily available from their original source, so some are worked up through sketches and others are transferred from equivalent situations.

There are interrogations in pornographic magazines. People play out sadistic, masochistic roles, so if I want to do a figure hanging by his heels, which I've done, I don't have photographs that have come from Latin America on this because their archives are carefully protected. I'm sure these photographs exist but they're not for public consumption. However, in play-acting which is called sadism and masochism, in that category one can find all sorts of photographs which are very close to the events

LEON GOLUB

themselves. And we also find it in religious representations, the Christian religion, the crucifixion, the martyrdom of St Peter, the martyrdom of all the saints and the history of heretics.

I visualise the canvas as a kind of skin, the pores of the canvas are the equivalent of the pores of say a face, or hand. By treating it in a certain way I get a kind of drastic visualisation of how light falls on skin. When I put the paint on it's opaque, as it is in certain preliminary stages of painting. If I scrape it through, then the paint gets scraped off and small touches of colour, literally tens of thousands of them, exist in the interstices of the canvas, in the pores of the canvas. This catches the light in a way that I think of as getting an equivalence which carries an emotive quality that in its tension and vulnerability reflects this kind of condition.

One way would be to say they're us and we are them, not in a sense that we carry out such things, but that our representatives at various levels do carry out such things through these figures. At another level we are *them, because given certain circumstances we might have turned out that way, that is to say that people in Latin American countries offered a job of being a policeman or a spy, a police spy, a police agent of some kind, find it often an improvement in their standard of living.*

If these paintings incite pleasure, then this is an impossible desire that is continually frustrated through the contradictions in subject position, caused by the oscillation between identification and anguish. The voyeuristic fascination that is offered at one level is, on another, subverted by the deliberate confusing of internally and externally directed gazes, and the spatial proximity of spectator to image, that suggests a fetishistic mode of representation, interpellating the spectator as *male* in order to question the construction of *masculinity.* JON BIRD, 'Leon Golub: "Fragments of Public Vision"', *Leon Golub*, p. 17.

Leon Golub worked for many years, building a significant reputation in Chicago, in Paris and subsequently in New York, without achieving a wide international following. At one time in the 1970s Golub was on the point of abandoning painting and restricting himself to his career as a university teacher. In 1982, the purchase of *Mercenaries IV* by Charles and Doris Saatchi for their collection in London coincided with a sudden leap forward in Golub's critical standing; they have bought several other paintings since, which has, in turn, enhanced his reputation. This new success and fashionableness, brought about through his new work and the changed critical climate, raised questions about the distribution of the work. Would the work still provoke the same thoughts and reactions in all locations? Might it be subsumed into the general category of fine art as the object of collection and speculation, so that its meanings would be drained away?

LEON GOLUB *I can't put a means test on anybody that might purchase a painting. You can say Saatchi or anybody else who buys a work owns me, takes possession of my mind, so to speak, of my art. But then I enter his home or his situation or his environment. I put my mercenaries there. Not just Saatchi, but anybody else, including myself, has to deal with the presence of these mercenaries and interrogators. I wouldn't object if the French Foreign Legion bought the work. I don't think they would, but I would have no objection to it because they would have to read this thing for what it is. Even if they*

136 Hans Haacke, *Taking Stock (unfinished)*, 1983–84. Charles and Maurice Saatchi are portrayed on cracked plates in the background.

would glamorise it and even if they would give it a special aspect temporarily, I think the message is sufficiently clear that the violence in the work, the vulnerability in the work will have its effect.

Being a professor gives one time to work, it's part of the surplus that we operate with in Western society. I am privileged in being permitted to be a painter. I can get the materials, things of this kind, I have this large studio; in a sense I work for the system. The system glamorises my position; at least in the last few years I'm being made into some strange hero. There are a lot of ambiguities about this. More money is paid for a painting of mine than a lot of people in Africa, maybe hundreds of people, will see in a year's time. Anybody dealing with the arts in any way whatsoever, as a critic, museum people, artists, collectors, all exist in this privileged world. To what extent when you're within the system, can you critique the system, to what extent is your work subversive enough to make people challenge or at least feel uneasy with the circumstances in which they exist? I have guilt feelings about a lot of the circumstances under which I'm operating. Yet I don't know how to get out from under them. The main thing I've always wanted was to go public, I wanted to have some sort of historical role, not just so that I'm a famous artist. It's reporting on circumstances. If nobody sees the work it makes no kind of report.

Leon Golub's paintings show disturbing scenes, or show people (perhaps ourselves?) as vulnerable and as capable of being inhuman. They question, or they suggest that we might question, the degree to which we shift responsibility elsewhere, always thinking of the world as formed by others, not ourselves. And this coincides with the way that conventional party politics would have it; each of us passive and ready to delegate all authority to our representatives. As Raymond Williams puts it, 'There is a widespread complacency of subordination, supported by cheap flattery of ourselves as voters, just waiting to be wooed, by a still better offer, for our precious cross. This has to be seen as contemptible. For it is this style of the whole culture, initially promoted by the techniques and relationships of modern corporate selling, which has reduced the only widely available form of positive thinking about the future, in the programmes of the political parties, to a discredited game.'*

Towards 2000, Pelican, London, 1985, p. 9.

* * * * *

The Thatcher portrait is a pomp-heavy icon of a modern monster, who not long ago was transformed from lowering dowdiness into royal rigor mortis by the image-brilliant Saatchi firm. It ran her election campaigns of 1979 and 1983, softened the shrillness of her voice, crowned her with a less terrifying hairdo, and taught her to carry herself like a queen – rather like *the* queen. GARY INDIANA, 'Art Objects', *Village Voice*, 21 May 1985, p. 109.

The picture is bounded by an elaborate gilt frame, with fluted capitals at each side, and a pedestal base. She sits in the foreground and looks sternly upward and out of the frame. She is poised on the edge of a decorated chair, which is next to a side table on which stands a small version of Harry Bates's *Pandora* of 1891. The scene is a nineteenth-century study, and in the carved

POLITICS

bookcases at the back of the room are some heavily bound books with titles including: Allied-Lyons, Black & Decker, British Airways, Arts Council, Central Office of Information, Conservatives European Elections; IBM, Procter & Gamble, Rank Organisation, TV-am, Victoria & Albert Museum, Wrangler . . . On the top shelf two cracked plates show painted likenesses of the Saatchi Brothers, Maurice and Charles. The book titles are some of the accounts held by the Saatchi and Saatchi advertising agency, now the largest in the world. Mrs Thatcher is the political leader that the agency helped to election victory in 1979 and 1983.

The leftist argument . . . continues[:] . . . the private collector is, in this scheme of things, an accomplice in the ongoing repression of a critical view of economic and human reality. Indeed, it would seem the case is put particularly in the instance of a collector whose profession is precisely the management of image and of cultural illusion to specific, predetermined ends. From this viewpoint, the Saatchi museum's emphasis on the autonomy of the work of art is only the latest effort to prevent art from becoming a vehicle of critical thought that might ultimately threaten the order of things from which Saatchi himself has so far benefited enormously. KENNETH BAKER, 'The Saatchi Museum Opens', *Art in America*, July 1985, p. 27.

Hans Haacke painted *Taking Stock (unfinished)* for a one-person exhibition at the Tate Gallery in 1985. As with most of his work, the piece was prompted by that particular invitation, and by connections between the Tate Gallery, the collectors Charles and Doris Saatchi, and recent political tendencies as he perceived them. In the painting, sheets of paper give accounts of Saatchi and Saatchi holdings of 'furniture, equipment, works of art', the broken plates are a reference to the work of Julian Schnabel, whose Tate Gallery exhibition the previous year was almost entirely made up of works from the Saatchi Collection. Background notes with the work give more information about Charles and Doris Saatchi and their collection. The opening of their museum in 1985 brought extensive appreciation and comment.

Andy Warhol's Chairman Mao is a 20-foot-tall painting which hangs alone, at the end of the room, in deliberate imitation of an altarpiece. What are we to assume from this? That Charles Saatchi and Andy Warhol have seen the error of their capitalist ways? On the contrary, we can safely assume that they haven't, and that the only reason Warhol painted it and Saatchi bought it is that they found the idea of millions of slant-eyed little men in boiler suits being subjected to giant images of Chairman Mao worthy of mockery on a heroic scale. WALDEMAR JANUSZCZAK, 'Diary', *London Review of Books*, 21 March 1985, p. 21.

Hans Haacke's painting makes available information that is no secret but is otherwise scattered. The image becomes a concentrated network of the threads that connect the cultural, the political and the corporate. Haacke's homework becomes active, as his arrangement of information counters the usually flattering presentation of the position of private patrons. Collectors and benefactors are fêted in our culture because of a tradition of private patronage, recently encouraged by cuts in arts subsidy that have forced all arts organisations toward the private sector. No one would deny how exceptional the Saatchi Collection is, and that its impact on London (and the

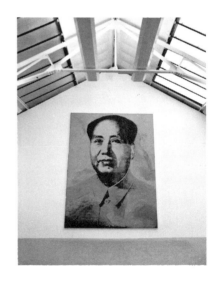

137 Andy Warhol, *Chairman Mao*, 1973, in the gallery of the Saatchi Collection, London, 1986.

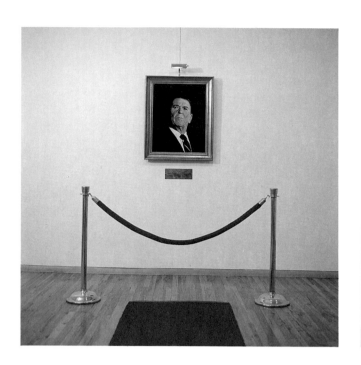

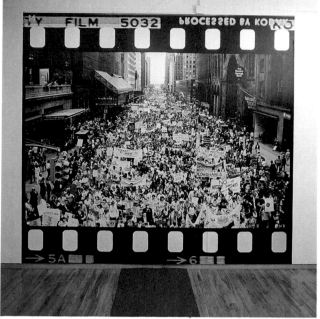

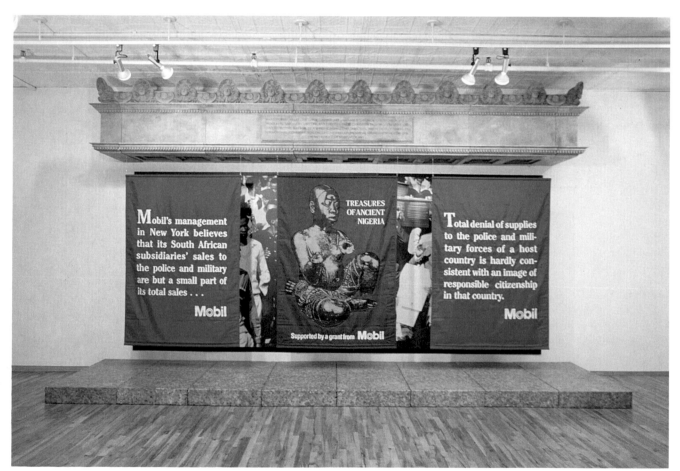

138, 139 Hans Haacke, *Oil Painting, Hommage à Marcel Broodthaers*, 1982–83. The two images face each other with the red carpet running between them.

140 Hans Haacke, *MetroMobiltan*, 1985.

international art world) is very considerable. Haacke's work provokes and promotes a critical engagement with this information.

HANS HAACKE

In the Thatcher piece I wanted to do something, in one way or another, that incorporated the Victorian attitudes and therefore also the Victorian styles that the policies of Margaret Thatcher exemplified. I picked up on the things that are in the Tate Gallery itself, and learned a little bit about the Victorian period. So the frame, the furniture in the painting and the statue are quotes from the Victorian period. The style of painting is part of the message that I wanted to encode.

When we think of Margaret Thatcher or Ronald Reagan, we have these people as persons, but at the same time they represent a particular ideological inclination. And we also know these ideologies that they personify are actually implemented, put into action, and society feels the result of it.

That Haacke makes a particular work for a particular location, and paints or uses texts and photographs as he deems appropriate, need not limit the meanings for other viewers on other occasions. Although drawn from a certain set of references, the ideas are more widely applicable. Haacke's work in the 1960s involved physical processes of change and renewal, and in the 1970s he made works that investigated social systems, including audiences to exhibitions and the ownership of city blocks in New York City. It was such a work which precipitated Thomas Messer, the Director of the Guggenheim Museum, to cancel Haacke's scheduled individual exhibition six weeks before its opening in 1971. The relations between museums (public facilities even when privately owned) and corporate culture have been of continuing interest to Haacke.

Haacke questions the behaviour of museums by examining whether the actual motives of companies are the same as those they declare; and whether the arts should be associated so closely with companies whose actions and policies may embody quite different priorities and values. *MetroMobiltan*, 1985, revolves around a banner reproducing the poster for an exhibition, *The Treasures of Ancient Nigeria*, held at the Metropolitan Museum of Art in New York in 1980. On each side are quotations from the Mobil Corporation's response to a group of shareholders who, in 1981, had proposed a resolution to prohibit sales of fuel to the South African police and military. Mobil is one of the largest American investors in South Africa, and one of the top fifty economic units in the world.* The thinking behind these statements ('Total denial of supplies to the police and military forces of a host country is hardly consistent with an image of responsible citizenship . . .') has been reiterated more recently in advertisements in the *New York Times*. 'Those who would pressure American companies to withdraw from South Africa are doing a disservice to the objective they share with both the American and the South African business communities – an end to apartheid, as peacefully and quickly as possible. Their actions are unproductive and unfairly punitive.'* Behind the banners is a photomural taken from a photograph by SYGMA photographer Alan Tannenbaum of a funeral procession for blacks shot by the police at Crossroads on 16 March 1985. Across the top of the work, on a

See Thomas Grennes, *International Economics*, Prentice-Hall, New Jersey, 1984, pp. 308–9.

New York Times, 24 October 1985.

fibreglass reproduction of the pediment of the Metropolitan Museum, runs a text from the Museum: 'Many public relations opportunities are available through the sponsorship of programs, special exhibitions and services. These can often provide a creative and cost-effective answer to a specific marketing objective, particularly where international, governmental or consumer relations may be a fundamental concern.'

Two weeks before the South Africa advertisement in the *New York Times*, Mobil placed an ad entitled 'Art, for the sake of business', to support the Business Committee for the Arts: '. . . the arts can be your partner in the pursuit of excellence. They can help you meet your business objectives. And they can shape the public's view of your company.'

HANS HAACKE

Mobil is the company that is most aggressively moving into the world of culture, and makes it known to everybody that they do. Differently perhaps from some other companies, Mobil has a very clear sense of why it is doing this, and speaks about it, sometimes even publicly. Indeed for Mobil, culture is an instrument to gain access to what it calls 'the movers and shakers' – politicians, legislature, the press – in order to bring about legislation that is favourable for the company and the industry at large. And for that matter even for business in general, not exclusively for the oil industry. And they have coined this beautiful term that the support of culture serves as 'a goodwill umbrella'. And with the protection of this 'goodwill umbrella' they say, again in their terms, 'We can get tough on substantive issues,' which means public policy issues, not culture. Culture is the instrument to get there.

The image Mobil tries to project as a friend of the arts and culture, of course, is not matched by its actions.

Soon after Haacke's exhibition at the Tate Gallery, Mobil's lawyers wrote to the gallery drawing its attention to alleged copyright violation committed by Haacke and reproduced in the catalogue. They said that they had followed his work over the years with 'interest, amusement, raised eyebrows and concern'. The Tate Gallery withdrew the catalogue from circulation while consulting with a government solicitor who evaluated Mobil's claims as 'frivolous and insubstantial'. The catalogue went back on sale at the end of 1985. The object of Mobil's letter was to put pressure on the Gallery and Haacke to stay in line. The Tate Gallery had not recently received funds from Mobil, but it continues to depend on sponsorship for some of its special exhibitions. The support of United Technologies, who produce parts for the Cruise missile, for the 1986 Oscar Kokoschka retrospective exhibition among others, has brought the greatest criticism.* Most galleries complain that sponsorship is unpredictable and of limited availability given the reductions in public funding in America and Britain. Funding, public or private, never comes without some strings attached, and gallery directors are aware of the danger of sponsorship being available only for certain exhibitions; as the Director of the Metropolitan Museum, Philippe de Montebello, put it, such funds force a 'hidden censorship' of programmes.*

See David Coombs (ed.), *What Price Arts Sponsorship?*, Tate Gallery, London, 1986.

Quoted in Brian Wallis, 'The Art of Big Business', *Art In America*, New York, June 1986, p. 28.

Clearly my views of the world and the way in which society should be structured differ from the way a company, like Mobil, likes to see the world set up. A public institution like the Tate Gallery is in certain ways the battleground where we meet. Mobil is trying to use museums to improve its image and to influence the press, society, and politicians to come around to their point of view, which I believe is not in the public interest. I in turn am not only interested in keeping business interest out of the arts, but also in making sure that public institutions remain truly public institutions. Museums are accountable to the public, they are set up by the public, are paid for by the public in order to make art works available to that public. I think it is not only fair but it is necessary for a democratic society that its institutions are scrutinised and reminded of their responsibilities.

Two of Haacke's works concentrate on the activities of the German businessman and collector Peter Ludwig. While training as an art historian Ludwig met his wife Irene, and subsequently joined her father's company, Leonard Monheim AG, in Aachen. Monheim produce chocolates under a large number of labels, and at a number of different sites.* Over recent years they have helped with technical expertise and management on a franchise arrangement to produce chocolate in East Berlin. The first of these works, *Der Pralinenmeister* (*The Chocolate Master*), 1981, detailed through fourteen panels the range of Ludwig's activities as a collector, and the various galleries, museums and institutes he has founded. He is perhaps most famous for his early championship of American Pop Art, and he has subsequently purchased large numbers of so-called Neo-Expressionist works. More recently, he has acquired a considerable number of contemporary works from officially blessed artists in Russia and Eastern bloc countries. In particular, he has established the Ludwig Institute for Art of the GDR at Oberhausen, assembled in collaboration with the State Art Trading Agency of the GDR (East Germany).

Haacke's second work about Ludwig is entitled *Broadness and Diversity of the Ludwig Brigade*; it depicts Ludwig in the pose of German photographer August Sander's rotund 'confectioner' of 1928. Behind him his wife Irene holds a placard saying 'Solidarity with our fellow workers in the capitalist part of Berlin'; and on the right Erica Steinführer, an East German 'labour heroine', holds a placard saying, '9DM/hour is not enough. Stop the job cuts at Trumpf.' Opposite the painting, but separated by a wooden 'wall', is a billboard with an advertisement for Trumpf (one of Ludwig's chocolate companies) with the words, '. . . there must be time for this'.

There are many other collectors who play a role in the art world, but what distinguishes Ludwig is that he is not satisfied with collecting art and making it available to the public. He has demonstrated over the years that his lending of art, and his donating of art works, serves for him to gain power in public art institutions. There are quite a number of museums in West Germany and elsewhere who have received, or hope to receive, works from him, and they all know that if at any time they make a move that would displease him they would be struck off the list as possible receivers of his goodies.

Ludwig contracted his operations in 1986, selling Leonard Monheim AG to Jacobs Suchard GrubH and returning to Lindt his concession to produce their brand of chocolate. He still holds the Trumpf, Mauxion and Novesia brands.

141 Hans Haacke, *The Chocolate Master* (detail), 1981.

142 Ludwig Museum in construction, Cologne, 1985.

143, 144 Hans Haacke, *Broadness and Diversity of the Ludwig Brigade* (details), 1984. The work was installed in Berlin with a high wooden wall between the painting and the poster.

It matters because the programmes of the institutions who receive works from him are very clearly influenced by him. The exhibition of contemporary Soviet art in Cologne, works that would generally be received with very low esteem by the public and the critics, was one could say 'foisted' on the museum.

For years there was no knowledge or recognition that Mr Ludwig had business interests in East Germany [his chocolate business]. It only became clear later on, and then one recognised that he was trying to push East German art. The same suspicions surround his art expansion into Bulgaria. Nobody in the Western world, I believe, finds anything of interest in contemporary Bulgarian art. He has bought a large bulk of Bulgarian art recently. It was a government-to-industrialist deal, and again I'm not the only one who has these suspicions that he wants to be, and maybe is already, the prime chocolate man in the Eastern bloc.

In Cologne, the Ludwig Collection of contemporary art has been housed until recently in the Wallraf–Richartz Museum. The new Ludwig Museum in Cologne, built next to the cathedral at the considerable expense of the city of Cologne and the region of Nordrhein–Westfalia, houses mostly Western contemporary art with some from the East alongside. Before the Wallraf–Richartz closed, Ludwig was interviewed in the galleries.

We have a large collection of Bulgarian and Soviet art, but we have no business links with Bulgaria or the Soviet Union. In Austria I have endowed a foundation and I have neither private property nor significant business interests in Austria. We export to practically every country in the world, including Austria, and probably also to Bulgaria, but it really makes no difference to us. We have had business links with the German Democratic Republic for decades: they haven't increased nor have they been reduced after we became involved on the cultural level. We haven't had a sort of exchange trade combining economic interests with cultural ones. In principle we do not combine economic interests with our activities in the cultural field but keep the two separate. The only connection which exists is that I always make use of the many business trips which I, as a businessman, have to make around the whole world, to see exhibitions and museums.

I wouldn't like to become the herald of art from only socialist countries. I want to show world art, that is, American art, Soviet art, art from the Federal Republic of Germany and from the German Democratic Republic, West European art and Central European art, art from the Balkans and art from Scandinavia. That is precisely my mission.

PETER LUDWIG

145 Peter Ludwig being interviewed, Cologne, 1985.

Naturally, museums work in the vineyards of consciousness. To state the obvious is not an accusation of devious conduct. The institutions' intellectual and moral position becomes tenuous only if it claims to be free of ideological bias. HANS HAACKE, 'Museums, Managers of Consciousness', *Hans Haacke*, p. 107.

Haacke challenges assumptions about who can or should say what to whom. He is often questioned about biting the hand that feeds him, but it is clear that he needs to work in private and public galleries precisely in order to stretch the limits of what is 'acceptable' and to 'argue' with the art world

on its own ground. Haacke counters the disinformation of culture as a form of public relations. He has said: 'In order to reach a public, in order to insert one's ideas into the public discourse, one has to enter the institutions where this discourse takes place. Under present circumstances that is easier if an exchange value comes along with use value.'* Haacke's works combine critical acuity with formal inventiveness and accessibility.

'A Conversation with Hans Haacke', *October* 30, New York, Fall 1984, p. 42.

HANS HAACKE

In any argument that you make, it matters a great deal that you articulate it well. What I'm doing is not writing a newspaper column. As you look at my work, 'artistic' – it's always awkward to use that term – considerations come into play: the styles in which I operate, which vary from piece to piece, the materials that I employ, the colours, the textures, varying typefaces, the connotations that all of these have, the history that is part of these materials – all of this plays a role. Formal considerations play a very very important role. There is no conflict between the form and the content.

I'm an artist, I'm not a journalist, I'm not a TV person. Access to these media is very difficult and has its own problems. I think that each professional sphere should make sure that its own house is in order.

* * * * *

All significant social *movements* of the last thirty years have started outside the organised class interests and institutions. The peace movement, the ecology movement, the women's movement, solidarity with the third world, human rights agencies, campaigns against poverty and homelessness, campaigns against cultural poverty and distortion: all have this character, that they sprang from needs and perceptions which the interest-based organisations had no room or time for, or which they had simply failed to notice. RAYMOND WILLIAMS, *Towards 2000*, Pelican, London, 1985, p. 172.

As the vast complex of land and waterways which is Docklands throbs with new life a fresh challenge is posed, that of Creative Management of Change. Achieving the right balance between housing and industry and facilities for leisure, ensuring that the new landscape matches the quality of the waterscape – all the pieces which fit into the jigsaw of the 'exceptional place' . . . REG WARD, 'The Pace of Change', London Docklands Development Corporation, 1984/5, Annual Report and Accounts, p. 16.

WHY MOVE TO TH

146 London Docklands Development Corporation advertisement (detail), 1985.

The other project workers are Sandra Buchanan, Sonia Boyce, Roberta Evans and Sarah McGuinness.

If it is 'breathing life' into Docklands, [it] has a breath heavily laden with the gin and tonics of the ad-men, the public relations consultants, and their friends in the press. TED JOHNS, quoted in 'A Battle For The Docklands', *Labour Herald*, London, 27 August 1982.

Property development takes place the world over. The instability of the need for many products and services, and therefore industrial plant and jobs, is one of the features of industrialised Western economies. London Docklands is exceptional only in the scale of land and productive resources involved, and their proximity to the financial districts in the centre of London. Peter Dunn and Loraine Leeson set up the Docklands Community Poster Project in 1980.* Their aim was to 'express the views – desires, misgivings and aspirations – of local people in response to the London Docklands

POLITICS

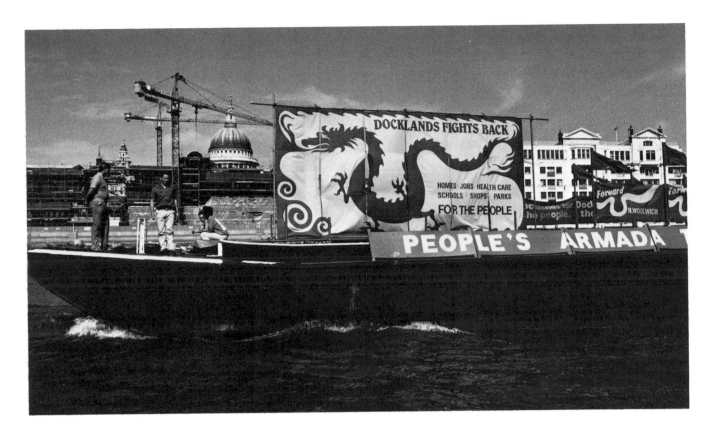

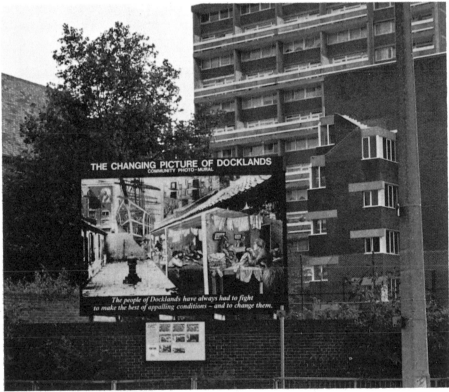

147 Peter Dunn and Loraine Leeson, Docklands Community Poster Project, People's Armada to Parliament, September 1985. The flotilla of barges passes St Paul's Cathedral on its way up the Thames to Westminster.

148 Peter Dunn and Loraine Leeson, Docklands Community Poster Project, *The Changing Picture of Docklands*, Wapping, London, 1985.

redevelopment programme'. Their work is integrated with these local responses through a steering committee made up of representatives from various community groups (the Association of Island Communities, the Association of Wapping Organisations, the Joint Docklands Action Group and others). They and their co-workers on the Community Poster Project sit on the committees of these groups to gather opinions and test strategies.

The project is funded by the local Borough Councils and by Greater London Arts, and was funded by the Greater London Council until this top tier of the local authority structure was abolished by the Conservative government in April 1986. The GLC, in its last administration, altered the norm of arts policies by increasing the overall budget dramatically and making community-based groups, women's groups, gay and black arts a priority. Their policies gave resources to many groups which had previously struggled for survival, allowing them to develop; and they provoked exceptional levels of debate in London and beyond.

In the last fifteen years . . . consciousness of the art world's power structures and how they are used has radicalized many artists. Alternative spaces, objectless art, street and community art . . . all variously represent increasingly sophisticated assaults on the still unchanged battlefield. LUCY R. LIPPARD, 'Power/Control', *Village Voice.*

In 1980 the London Docklands Development Corporation was set up by the government to replace the Docklands Joint Committee (organised between the five boroughs of Docklands). The new Corporation was given sweeping powers, particularly with regard to planning consent, thus removing control from the elected boroughs. More than anything it is the lack of any democratic accountability that has united local people against the Corporation; theirs is not an opposition to development in principle, but to it being imposed without local consultation and consideration. The work of the Docklands Community Poster Project divides into four main areas: a series of changing photo-murals, posters and artwork to assist local groups, an archive of photographs for use in the community and travelling exhibitions.

LORAINE LEESON *When we set up the project we did a feasibility study and we visited a lot of the tenants' organisations. We talked about what people actually wanted in order to get the message across and nearly everybody said, 'Look, we want posters, but we want big ones.' We need to get the message across in a big way. We want to make our statement very clearly. We didn't conceive of them as a changing image in the way that they are now, in the sense that they unroll in a sort of slow animation film. It was partly through working out the process by which we could actually make the things that big that gave us the idea for a changing image.*

Each of those photo-mural images comes out of months and months of discussion. The housing sequence took about eighteen months to evolve before we even had the first image. We've already gone through a process whereby the ideas have been talked about before we get from our steering committee a particular kind of feedback. We show the photo-mural images as well as the exhibitions and the campaign work at festivals and at public meetings, so we're getting feedback that way. When we first set

up the project we put a marquee on the Green opposite where we had our first photo-mural image up. We had all the future images for that particular sequence in an exhibition and people just came. We live close to Docklands as well as working in Docklands and there is sometimes a debate in the local press around the issues – that's on an informal level. But it's most important that we actually have that formal base to go back to in our steering committee.

Because you have people who are very involved, absolutely committed to what they are doing, what happens is that it's a very exciting way of coming up with ideas, because they actually speak in visual images. What we do is simply pick up on what these images are, and go away and visualise them in some form, come back and have a discussion about them. We don't make an image as a committee. We try to talk all the time about what the fundamental issues are, and how far the image is meeting those issues. It's a very stimulating way of working for us. It's also a very long process to develop an image. When we go along to the meetings of all the different groups in the area, we are there not only to contribute as a Docklands group ourselves, but to keep in touch with what's going on, and to report on what we are doing. And to take back images we feed in. The 'Big Money' image for example came when someone literally said, 'The city is marching eastward.'

The first cycle of images on the photo-murals, *The Changing Picture of Docklands*, starts by representing the planning attempts of many years in 'What's Going On Behind Our Backs?'; it then depicts 'Big Money Is Moving In', with office blocks made of coins marching forward. People attempt to hold them back but are relentlessly forced towards the 'Scrap Heap'. At the end of the first cycle an image of 'bursting through' the developers' illusions is worked in relief with the image on the surface of the photo-mural physically split open.

The cycle of images – different sections of the whole picture are gradually changed to effect the transformation from image to image – moves beyond the simple polarisation of visual propositions characteristic of most political posters. The different parts of the picture are drawn on a small scale, then enlarged photographically onto separate wooden panels and worked on again with coloured dyes and paint, before being weather-sealed and screwed into position on the billboard. The images change on each billboard through changes in the panels, which circulate from one of the six billboard sites to the next, the 'story' developing on each. The method is specifically designed to encourage local people who walk by to read and react to the images.

The second cycle of images followed up on the theme of housing and living conditions. This cycle develops historically, showing how present-day housing has been fought for, the links between housing and work, and between men's and women's work in the Docklands area. The format for the cycle is a series of scenes of different periods, which are then shown as both interior and exterior, describing, literally, two sides to change. Part of the impact of the photo-murals comes from the contrast they form with current billboard advertising, which tends to use single slick images and slogans, and more particularly with the advertisements commissioned by the

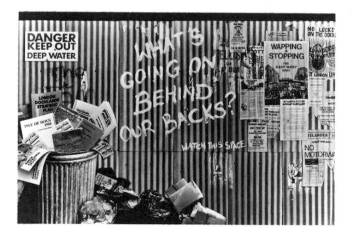

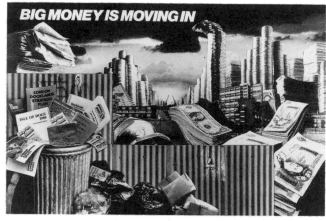

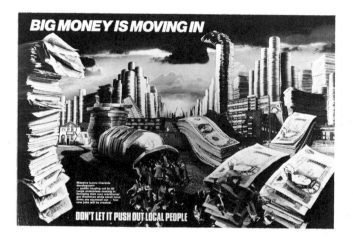

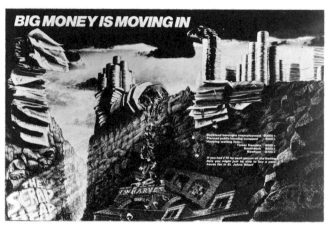

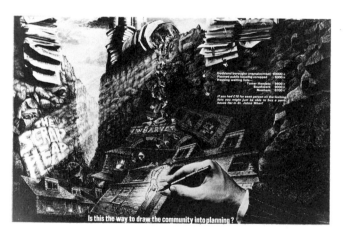

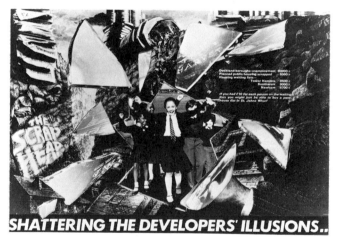

149, 150, 151, 152, 153, 154 Peter Dunn and Loraine Leeson, Docklands Community Poster Project, *The Changing Picture of Docklands*, 1981–84. Six images from the first cycle.

London Docklands Development Corporation itself. The corporation has covered parts of London, at huge expense, with a series of posters about the glories of Docklands development, stressing 'communications', satellites, inducements to new business ventures and the new short-take-off airport to be built in the Royal Docks.

The photo-murals have a different function to advertising. They are designed to get across complex issues and to reveal the underlying structure of what's going on, whereas advertisements are generally designed to obscure the underlying structure and get across a product name. Advertisements do that by relying on people picking up an image quickly – most can be picked up by a passing motorist. Our photo-murals are sited in places where there will be people passing by. They're on the housing estates or near shopping centres and health centres where people will see them over a period of time, probably at least once a week. The photo-murals are designed to represent the community and the community's point of view, from its own point of view, not to put a point of view or a representation on to the community.

LORAINE LEESON

Society is a battlefield of representations, on which the limits and the coherence of any set are constantly being fought for and regularly spoilt T. J. CLARK, *The Painting of Modern Life*, Thames and Hudson, London, 1985, p. 6.

Two principal criticisms are raised against art that is actively engaged with politics. It is condemned as propaganda, and so ruled to be not art. And it is condemned, conversely, for its dependence on the state funding chain, by which its critics see it gaining a spurious recognition as art which it does not merit. But the boundaries of art are not marked out by those who would constrict art to dealing with 'eternal' questions in the safety of the gallery. 'Art' involves a number of specific practices and the poster is as valid a *form* of art as any other. The conventional hierarchies that place oil painting and bronze sculpture at the top of a pyramid of practices, with photography and printed works lower down, relate predominantly to histories of market values, connoisseurship and a reassuring stress on the authentic touch of the artist's hand. When art is made to convey particular meanings, principally to carry a political message, and not for sale in the market, then *different* criteria of effectiveness are in operation. This does not remove the work from the general category of art, or negate the use of the same techniques of colour composition, balance of design and appropriateness of surface and texture. The art–propaganda divide is itself propaganda on behalf of a certain view of art. In presupposing a total division between them, it labels art as an inherently aesthetic and ennobling concern, with propaganda on the other side of an imagined and hallowed line as didactic, brash and debased. This serves only to emphasise, as discussed in Chapter Two, that various aesthetic criteria in society are employed simultaneously. The highly political and specific nature of some of the images of Hogarth, Picasso, Kollwitz and Heartfield enhances their status in any history of art. In Poland the poster is regarded as one of the most significant of art forms and merits its own department in universities.

The images and texts utilised by Peter Dunn and Loraine Leeson are very

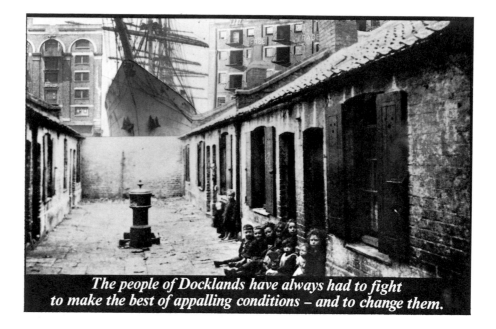

155 Peter Dunn and Loraine Leeson, Docklands Community Poster Project, 1985 and continuing. An image from the second cycle.

The people of Docklands have always had to fight to make the best of appalling conditions – and to change them.

different from those used by the Docklands Corporation (whose advertising agency, Gold Greenless Trott, invented a wild-looking crow as their protagonist). In drawing on historical photographs, contemporary scenes and current phrases in use, Dunn and Leeson transfer 'meanings' that already exist. Images like theirs that present an oppositional view need to be extracted from current debates and actions but not limited by them. The best art dealing with specific issues will also speak beyond them. The disruption of property development is a worldwide issue, but even were it not, the Project's work would have artistic value as an outstanding example of the inventive use of posters. This is borne out by their participation in exhibitions in America and Canada, and the publication of their work in international magazines.

PETER DUNN *We make our work about the things that we're passionate about. It's very important to us that we find focus in our work for the things that are affecting us all the time, like when they're closing hospitals, when they're depriving people of jobs, things that are affecting us personally. These are things that we want to make our images about. The art world exists and is the main distribution system for art. It can't be ignored and clearly we see at least some parts of our work actually intervening in that system as well and raising questions within it.*

In the short term a lot of the battles are about winning small victories and we have won those victories. In the long term it's about a shifting of consciousness and building up the campaign. When the Development Corporation was set up, that was seen as a sort of defeat for the community that campaigned against it. The next round came when we began to shift the notion of the Development Corporation, after the Development Corporation had been seen as this great white hope. It then became the controversial Development Corporation.

The Labour Party was opposing the Development Corporation, but in certain ways they were not that convinced that it was such a bad idea. We're talking about actually creating democracy in Docklands, not just reproducing a Development Corporation in another form; so part of the campaign might be aimed towards the next government.

Someone could say that the Sistine Chapel was propaganda for the Catholic Church. There is a sense in which it is propaganda. The original concept of the word is the propagation of ideas and it has taken on all these connotations of the thirties and the Nazi period. I have a very old-fashioned notion of the word, so that if you do it well enough then it can be conceived as art. I don't really have a problem about people calling it propaganda because it is about the propagation of ideas. I would argue about whether that is a sinister notion.

I think that at least 70 per cent of our work is invisible, it's about the process of trying to build and sustain a context for the practice . . . Trades unions, tenants and action groups are not model socialist organisations with enlightened policies on culture there are struggles there. You [also] have to keep plugging at the art world to resist marginalisation of socialist practices there. PETER DUNN and LORAINE LEESON, 'The Changing Picture', interview with Carole Conde. *Photography/Politics* 2, London, 1986.

At Heron Quays, for instance. Prestige and prime new space in a quayside, media village atmosphere . . . Interesting? If it all sounds too good, don't assume there's a catch. There isn't. *London Docklands for Communications*, LDDC brochure, 1985.

There is a significant irony that many of the disused Docklands warehouses, which members of the art community used temporarily, have now been refurbished and sold off as 'studio' accommodation. New York's SoHo has seen a similar process; the district was taken up by studios and galleries and is now full of boutiques and wine bars. In Docklands, artists have taken their own position in a clash of images and views about the future. The importance of their place as artists (not just as citizens or householders or employees) is determined by the efficacy of their work. The artists in the Poster Project are striving to widen the imagination of the community into thinking about the past and the future, to counteract the influences on that thinking which are weighted in the developers' favour. They concentrate on particular types of intervention: the photo-murals, the People's Armada to Parliament (a day-long water-borne carnival with music, banners and decorated barges), the exhibitions and posters, making art one of the vehicles of the collective imagination.

We are consolidating our forces for the next stage of the campaign. We don't see it as a romantic notion of struggling against all the odds. There are spaces that we can open up and where we can win things, and we're not interested in romantic failure. PETER DUNN

* * * * *

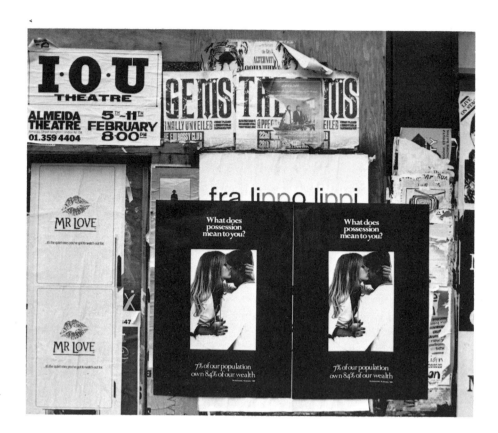

156 Victor Burgin, poster, 1976. The posters were originally flyposted around Newcastle-upon-Tyne.

A statistic made famous by John McGrath's theatre company, 7.84.

A poster is on the hoarding. There are several copies on the same hoarding, and they are surrounded by an assortment of film and rock concert posters. Colours and lettering clash, competing for attention. The poster is photographic and shows a couple embracing. The image has a wide black border and carefully proportioned text: 'What does possession mean to you?' and below in smaller type: '7% of our population own 84% of our wealth'.*

The poster is a work by Victor Burgin and was flyposted in Newcastle in July 1976 as part of the Newcastle Festival. The work had been originally commissioned for an exhibition collaboration between the Robert Self Gallery and the Fruitmarket Gallery in Edinburgh. It was a continuation of a group of works, started by Burgin in the early 1970s, which juxtaposed found text and image to make, as does the more recent work of Barbara Kruger, a confrontation of meanings, to produce a new meaning through irony. In the series *UK 76*, for example, Burgin overlaid a photograph of a woman working, concentrating hard at an industrial sewing machine, with the text of an advertisement, 'St. Laurent demands a whole new lifestyle'. The appropriation of images and texts and their strategic association in these works had a certain sardonic humour, a satirical play on the elisions and ellipses of advertising. Burgin trained as a painter but took up making photoworks in the late 1960s. He made very few works for the street and after the Newcastle poster a number of *vox pop* radio interviews convinced him that the street was not a space that had any special advantage for works which contested the assumptions of meaning and language.

It's practically impossible to go through any day, in contemporary Western society, without seeing a photograph: in a magazine, in a newspaper, on a hoarding; or you might carry a photograph around with you. Whereas with painting you have to make a special trip. No one needs a special training to feel that they can look at photographs. Whereas to feel that you have the right to look at paintings, that you understand paintings, this marks you out as somehow belonging to the select. So I wanted to do photography because it didn't put people off, they didn't feel intimidated by it. I wanted to use language with photography because photographs can mean more or less anything until you start to anchor the meanings a little with language.

I no longer see politics as a matter of making statements; I mean not in art. Politics is certainly a matter of making statements, persuasive and articulate, arguments supported by fact. I don't think art is a particularly good way of doing that; I think we have many other channels open to us. The media in general is obviously one such channel. I don't see art as being in any way privileged in the field of making political statements.

To make statements in art is to do something which, in a sense, is not expected or is resisted. It is resented because people to a certain extent come to art to get away from being preached at; to allow themselves a little play; to indulge in forms of mental activity which in most walks of life, in a gross-national-product-orientated culture, would be condemned as a waste of time.

157 Victor Burgin, London, 1986.

In the late 1970s and early 1980s Burgin continued to make works combining text and image – but whereas they had previously been grouped around a country, as in *US 77*, Burgin moved to a more metaphoric grouping with *Zoo*, 1978, made in, and in part about, Berlin. The scenarios became more intricate, with narratives or cross-references and more subtle uses of language that indicated a change in his political interests. They became concerned with the points at which the individual is produced, or reproduced, within a social framework. These shifts emphasised Burgin's interests in the 'politics of representation rather than the representation of politics', as he put it, and his concern with the politics of the individual, subject to fantasies, desires and wishes – a politics developed during the 1970s through feminist critiques and theory and the extensions of psychoanalytic theory. Burgin consolidated his position as a worker in the visual arts with three different jobs: artist, writer and teacher.

It wasn't that you struggled for the glorious day of the revolution, and then when the morning breaks, the blood coursing in the gutters, capitalists swinging from the lamp-posts, then you have a New Art for a brave new world; it's rather that you struggle for change within the institutions that you're in every day. Althusser saw the school as primary; the university, the polytechnic, as primary. So working in education seemed to be quite a legitimate sphere of activity, and in a sense more realistic than my occasional difficult excursions into the street with my handful of posters. I tend to see art, in fact, as a branch of the education institution; I think effectively that's more or less what it's become today.

There would be no point in changing that image on the gallery wall, or that poster in the street, if you didn't simultaneously change the discourses within which it was

implicated. The meanings are not there locked in the image like peas in a can on a supermarket shelf, which you simply have to open. It's a much more complex process. Looking at the complexity of this process, in fact, became part of the academic work I was doing. Again, there was an interest in shifting what art criticism had been, towards something which was actually useful, something which was about the social world.

Many art critics seem to think, negatively, it's somehow their business to find a fault. But in the more positive sense, in which criticism is concerned with what is truly critical in society, criticism becomes a form of play, a form of thinking otherwise, 'how could things be different?' Anything which encourages that sort of mental activity, that positive critical intervention in the work, that production of the work, rather than simply the consumption of that work as just another statement, or as a 'success', or a 'failure', anything which encourages viewer participation, I think, is good. The art world has become the ghetto of creativity. If you're not an artist you're not a creative person. That is to say, 'Let's not have any creativity in the office, let's not have any creativity on the factory floor, let's not screw up, you know, just do as you're told, if you want to be creative go and be an artist.'

It's necessary for me to work across that ideological division between the artist's concern with the 'purely visual', with the 'spirit' and emotion, and the writer's concern with the intellect, with words. That's a profoundly ideological division, and, in a sense, it's part of the politics of representation to dismantle that division, to show it as ideological, to show we haven't got two completely different types of people.

Along with all other men in this society at this time my relation to representation is fundamentally certain (where the woman's is always precarious), and fundamentally fetishistic. That's the bad news; the good news is that I know it, and may therefore be able to do something about it. We can't dispense with the phantasmatic relation to representation, but we should be able to rework it, restructure it. VICTOR BURGIN (1979), interview in 'Sex, Text, Politics', *Block* 7, 1982, p. 25.

There are narrative fragments but there is no linear coherence. We are encouraged to read vertically, through association, across the relations of text to image . . . No longer consumers at the margin of the finished work, we are drawn onto the site and into the process of meaning itself. LISA TICKNER, 'Sexuality And/In Representation: Five British Artists', *Difference*, p. 24.

Olympia is a work in six panels, in two groups of three. The images show: the head of the reclining nude in Edouard Manet's painting *Olympia*, a swimming-pool changing room with Burgin reflected in the mirror, an image of James Stewart in Alfred Hitchcock's film *Rear Window*, Sigmund Freud's study in Vienna, a bouquet of flowers held by the maid in the Manet painting and a friend reclining in the pose of Olympia. One text in the work draws upon E. T. A. Hoffmann's story 'The Sandman', the source of the ballet *Coppelia*, in which a young student falls in love with Olympia, a mechanical doll. The second text is derived from the case history of Anna O by Freud and Breuer, one of whose complaints was that whenever she looked at flowers she could not see the whole bunch, but only single flowers. The work weaves a number of threads: men looking at women, the construction and the power relations of masculinity and femininity, the private and

158, 159, 160 Victor Burgin,
Olympia (details), 1982. Three of the
six photographs.

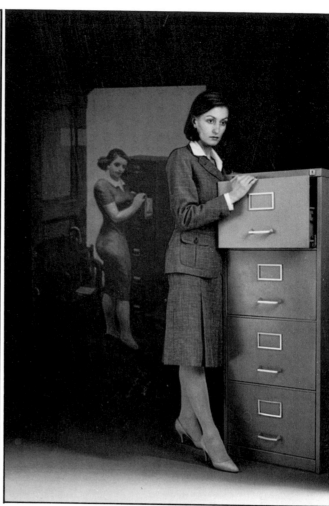

161 Victor Burgin, *Office at Night*,
1985–86.
162 Victor Burgin and Francette
Pacteau working on *Office at Night*,
London, 1986.

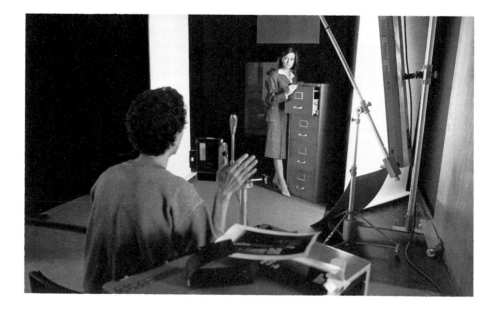

public ideas of outward appearance and its relation to sexual desire, and high art and psychoanalysis. There is a potent mix of reality, fantasy and memory in which words and images have an equal part to play. Burgin's interest in theories of representation, particularly those developed from psychoanalysis, informs his art so that references to a variety of sources provide many levels of reading in the work. The texts are placed within the work in such a way as to make the references clear, but not so as to restrict the viewing of the work to those with a prior knowledge of them.

VICTOR BURGIN

In the Hoffmann story Olympia is a mechanical doll made by a brilliant professor, made so convincingly that he's able to pass her off as his own daughter. To the point that one of his students falls in love with her, and spies on her. Effectively Anna O is the first psychoanalytic patient, the classic patient in Breuer's and Freud's study, in both senses. So Anna O in so far as she's a narrated figure, as none of us know her in the flesh or whether she even existed, is a fictional character also. So she too, to an extent, is the invention of a brilliant professor.

I am examining that unconscious level of motivation, or trying to represent *it, let's put it that way, and particularly the authoritarian, masculine personality. Certainly the women's movement and feminist theory were a great influence on me. I thought, then, the proper response for me as a man was not to try and make feminist art, not to address women's issues, but rather to find the counterpoint to those issues in the sphere of the 'masculine'; 'those who find themselves male without knowing quite what to do about it' [Jacques Lacan]. If it makes sense to say, as I believe it does, that we are oppressed by the structures of patriarchal society, that is to say authoritarian masculine forms of society, then I think that anything which can undermine that authoritarian male personality is probably a good thing – anything which can take it apart, anything which can start to examine that which was previously presented as being punctual, atomic, indivisible, taken for granted.*

So you don't confront, as I think many political artists do, *the authoritarian patriarchal principle (here in England, incidentally, under Thatcher, we understand quite well that you don't have to be a man to be a patriarch), you don't confront that with another act of aggressive masculinity, by making aggressive, punishing, tough, macho political art, because that is precisely to miss the point.*

A woman is being photographed in the studio. She wears a formal suit with knee-length skirt and white blouse. She is standing next to a tall filing cabinet and has the top drawer slightly open. Behind her, at the back of the studio, an image of a woman in an office suit is projected from a slide. She too looks strained and posed. Victor Burgin gets up and discusses the image with the woman.* She suggests a different position for the feet, and maybe for the hands. In *Office at Night*, Burgin starts with images sparked by an Edward Hopper painting in which a woman stands behind and to one side of a male, and more senior, colleague. Everything is suggested and nothing is certain. Alongside the Hopper-related images are large isotype images,* indicating 'male' and 'female', 'people in a room', 'keyhole'; in this reduced and restricted form of communication, seeing and understanding is in its most condensed format.

Francette Pacteau.

The isotype (an acronym for International System of Typographic Picture Education) system was developed by Otto Neurath in Vienna in the 1920s.

In a text produced alongside the work, Victor Burgin writes:

Office at Night may be read as an expression of the *general* political problem of the organisation of Desire within the Law, and in terms of the *particular* problem of the organisation of sexuality within capitalism – the organisation of sexuality *for* capitalism. Patriarchy has traditionally consigned women to supportive roles in the running of the economy, subject to the authority of men. The 'secretary/boss' couple in Hopper's painting is at once a picture of a particular, albeit fictional, couple and an emblem, 'iconogram', serving to metonymically represent all such couples – all such links in the chains of organisation of the (re)production of wealth.

In the *Office at Night* series the bold juxtapositions of the coloured isotype images and the black and white photographs create concentrated relationships. This density, and the large scale of the works, makes them all the more evocative of 'an office', 'a woman' and a set of questions about power. Burgin's politics have developed through his art, his writings and his teaching; each is a specific practice, but they are united through his view of individual consciousness, the nature of ideology, and the nature of political change. In developing those specific practices he rejects the need to take on more conventional or 'acceptable' media. He makes some of his work available through a New York gallery anyway.

VICTOR BURGIN *I see the return to painting as a failure of nerve, rather than a return to pleasure. I see it as a part of neo-conservatism. To move out of didacticism is not necessarily to return to previous forms of pleasure. After all I don't think that any image is free of either the capacity to offer pleasure or the didactic dimension. I think that painting is heavily didactic. What does it teach us? Nothing's changed; nothing must change.*

We tend to believe, even such a long time after the inauguration of psychoanalysis, that we can make an absolute *division between mental normality and abnormality; that psychically disturbed people, 'abnormal' people, cannot see reality 'the way it is', but* we *see reality the way it is. The political is presented as being supremely rational even in the face of the fact that political processes are often quite clearly profoundly irrational. Yet no one addresses that dimension of irrationality, which I think is the basis, the unconscious motivation, of very important political, as well as personal decisions – decisions which affect us all.*

The fact that I do not see in contemporary events the portents of the imminent collapse of capitalism and the guarantee of the inevitable triumph of the proletariat does not mean that I have forgotten the experiences of my working-class childhood, it does not erase my sense of what social injustice is, and it does not change my social and political allegiances. Of course memory cannot be conclusively disentangled from fantasy; of course my strongly-felt moral sensibility has roots in irrationality and internalised policemen whose influence over my actions is far from benign; of course allegiances may be betrayed as easily as affirmed, and ideology and political affiliations cannot simply be 'read off' from social class. Of course moralities and histories are 'relative', but this does not mean that they do not exist – at the very least as components of the 'psychic reality' which is the ground of my actions. VICTOR BURGIN, *The End of Art Theory*, p. 198.

* * * * *

Terry Atkinson teaches on the Fine Art course at Leeds University, a four-year degree course that is unusual in having equal parts of studio and theoretical work, whereas most are heavily biased to the studio. Atkinson has taught for many years and has been concerned with the didactic capabilities of works of art as well as with the need to guide students in how they might make effective works of art themselves. A founding member of Art & Language, with Michael Baldwin, Harold Hurrell and David Bainbridge, Atkinson participated in the earliest of the group's discussions in the mid-1960s while teaching at Lanchester Polytechnic. Art & Language were, and continue to be, one of the most influential groups of artists, basing their art and writing on a continual examination of the concept and role of art and criticism. Although Atkinson left Art & Language in 1975, an involvement with philosophy and an interrogative aspect to his work has remained. 'The Art & Language project was a project, is a project, increasingly to make aware that art is didactic . . . increasingly to make it clear that art is didactic as opposed to transcendental.'[1]

In discussion with Jon Bird, *Audio Arts* supplement, London, 1985.

TERRY ATKINSON

That's the old tradition with Art & Language, and I think this is why I always find their work so engaging, that it presupposes not only an active spectator, but an active artist trying to be as selfconscious as possible about a given set of exchanges, opinions and information. That may sound trite but that's very important because it runs contrary to what we might see as the generally accepted ideologies of teaching in art schools. Spontaneity is seen as somehow more authentic than reflection or contemplation or theory.

I see art as strategic, as a strategy for doing certain things and trying to achieve certain aims. That implies that it is also strategically aimed at an audience – the audience I particularly aim at is the one which is in one way or another centred round the art schools, people who've been through art schools or are in some way aware of that milieu. It presupposes a minimal amount of training and a consciousness of certain kinds of issues. Having said that, one does see and has seen numerous attempts to get art into a more public arena.

The issues of a modern developed society are so complex that the left-wing heavy-booting, kind of thumping, operation I just can't take seriously. I don't think it takes on board the basic day-to-day contradictions of experience. The last exhibition was set up with the idea of exemplifying contradiction and exemplifying the complexities that come from contradiction. Maybe there will be artists that will come along and sort it out in a much more direct fashion, but I can't see it myself.

163 Terry Atkinson, studio teaching in the Fine Art Department of Leeds University, 1986.

You've probably got to *do* History painting – hot, not to say torrid, contemporary history painting. You ought to do it without so great a leaven of irony, I think. Some kind of direct & staccato 'expressive' way of painting is probably the way; though presumably a large part of your nervousness – justified nervousness, I think – has to do with wanting that way of painting without its current ridiculous neo-Nolde connotations. T. J. CLARK, letter to Terry Atkinson, 6 June 1983.

In the exhibition *Art for the Bunker*, which included several cycles of Atkinson's work, warfare is present throughout.* In both the *Stone Touchers* and the *Happy Snap* series, conflict seems close; the remembrance of the dead

Art for the Bunker, Gimpel Fils, London, April 1985, and tour in Britain and Ireland.

164 Terry Atkinson, *The Stone Touchers 1*, 1984–85.

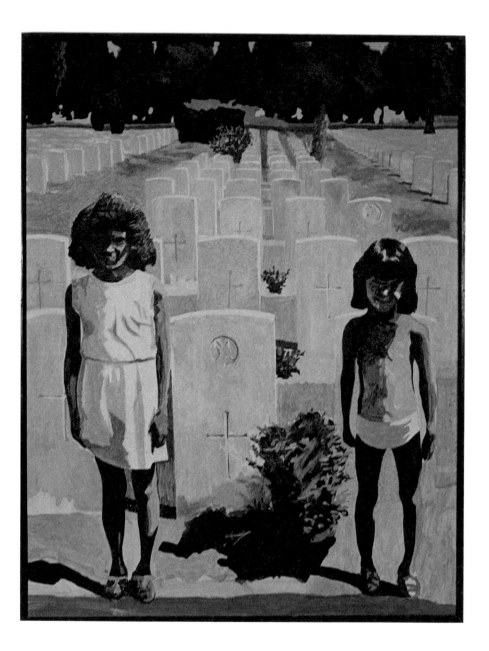

THE STONE TOUCHERS 1

Ruby and Amber In The Gardens of their old Empire history-dressed men.

Dear Ruby and Amber,
Do you think God is a person?
If he is, is he a he?
If he is, is he black or white, or brown or yellow,
or pink or orange or blue or red, or green or purple. ?
What if he's a she?

Do you think God is a dissident? Or is he a South African,
Or an Argentinian, or an Anglo-Saxon, etc. ?

Do you think he's the best knower?

If he is a she do you think all the he's would admit
she's the best knower?

MAP–KEY

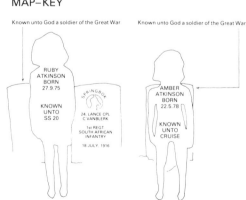

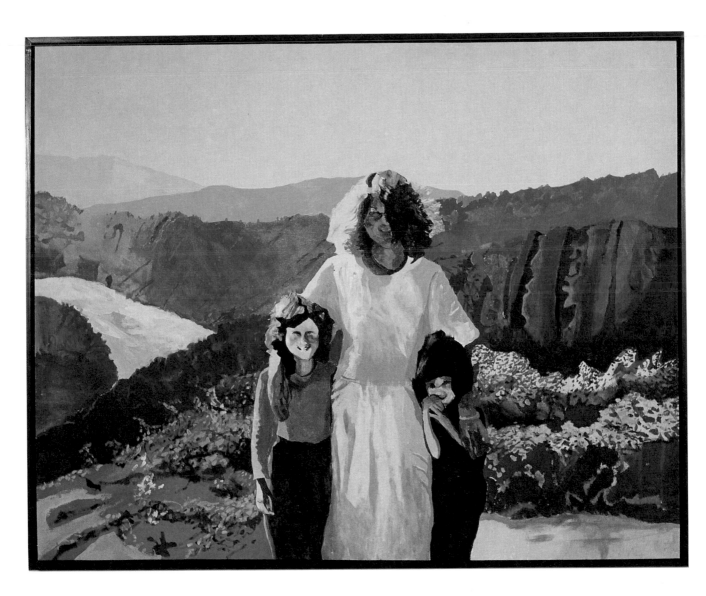

165 Terry Atkinson, *Happy Snap 4 1984.*

Part of a nuclear family; Sue, Ruby and Amber above the Dordogne river near Souillac on Hiroshima Day, August 7, 1983.

from the First War and Hiroshima is set against the dread of a nuclear disaster today. Atkinson's family, his wife Sue and children Ruby and Amber, are present in all the pictures. History is recalled only through the eyes of a personal present, redrawn from the past as it is perceived intellectually and emotionally, not just as remaindered in books and photographs. Unlike the processes of broadcasting and the construction of the news, where events unfold one after the other, time has become circular; the capacity to repeat seems all too obvious in Atkinson's presentations. Pathos and irony are the principal mechanisms in these works, and they run through the paintings and the extended captions.

As for other artists in this book (Susan Hiller, Mary Kelly, Peter Dunn and Loraine Leeson, Victor Burgin, Lubaina Himid and Donald Rodney) the text, here in this extended caption form, contributes crucially to the work. The text is not just an addition, but helps elucidate the meaning of the whole work. Although this is common in art now, it seems unusual against a background of modern art which presupposed the primacy of the sensory experience of looking at the painting or sculpture. In eighteenth-century painting it was usual to have texts, or more often poems, set into the frame of the work, or painted onto a border. Many nineteenth-century paintings referred to such well-known stories, either classical or modern, that a 'text' was almost assumed by both artist and public. Only the modern demand for the autonomy of artistic experience made the painting such an isolated object. Contemporary artists using text as part of their works recognise that we think and communicate concepts through words, and the presence of words enriches, rather than invalidates, the significances of colour, line, tone, design and texture in conveying emotional and intellectual content.

The Stone Touchers 2
RUBY AND AMBER AMONGST THE IDEOLOGIES
'I shall lead you' she said, 'Along the path of graves from Moscow to Calais with many detours, touching the shores of six seas. Those huddled in pits, in unmarked forest graves or in white fields of multiple crucifixion. They are our people too. Released from nationality they are fraternal in the hoax of the afterlife snug among the alluvials in the Republic of Europe, as, equal at last, they drain into Vistula and Rhine and a thousand rivers, the republic of wedding-clothes, too many citizens to be cause of morbidity or grief, their lapsed literacies singing in earth and water in all our languages listen. They are male-made reality.
(Nearly Douglas Dunn)
HISTORY HAS A PERMANENT STUTTER,
It says
W-W-W-WATCH OUT!
(ANON.)

TERRY ATKINSON The Stone Touchers *took the autobiographical input of the kids, but took the other aspect of what it is to be a family in the West. Some of the consumer habits, the holiday, tourism. These are pictures of kids in the graveyards of northern France. One should point out anecdotally here that this was unrehearsed, we went to the graveyards because we happened to be driving through and the kids said, 'What are they? Why are there so many of them?'*

By accident the first graveyard we went to was a South African one. There are obvious links, the link forward to apartheid and the whole business of uranium mining. The next one we went to was a German graveyard, much more deliberate, they wanted to see a German one. They're flanking a Jewish gravestone. A German Jew sits next to a Christian. Again one's projecting forward the two big wars of the West, trying to suggest some kind of link to our present-day nuclear issues by virtue of the fact that these Stone Touchers *were shown in the same exhibition as the* History Snap *and* Happy Snap *groups of work.*

A lot of our artists deal with politics not selfconsciously; that is, they make certain images without really knowing what tradition, what relations of production, what relations of distribution produce them and their objects. In that sense I think history is just impossible to get round.

Top bureaucrats keep close control over all programmes dealing with Ireland. Reporters and producers, overwhelmingly white, male and middle-class (and, in the BBC, vetted by M15 to weed out progressives), are normally trusted to make the 'right decisions'. But when it comes to Ireland no one is trusted . . .
The 'reference upwards' procedure, and the knowledge that Ireland spells trouble, also acts as a deterrent to career-conscious TV journalists, many of whom are especially vulnerable because they are employed on short-term contracts. As has been said, for every programme that gets banned, there are probably twenty that never get made in the first place. LIZ CURTIS, 'British Broadcasting and Ireland', *Screen*, March/April 1986, pp. 48–9.

Since 1984 Atkinson has continued the *Art for the Bunker* theme with work on the subject of Northern Ireland or, as he stresses, work about British attitudes to Ireland. Ireland remains prominent in the news in Britain as a problem of violence, of justice, of prejudice and history. But the government influence on the media and a pervasive self-censorship make it hard for a well-informed general view to exist in Britain. Atkinson's work points to some of the cross-currents, playing images of a rural, green and idyllic Ireland against the sophisticated weaponry and surveillance equipment in use by the British troops and the Royal Ulster Constabulary. The militarisation of the British police force – in its dealings with riots, the miners' strike of 1984–85 and most picket-line disturbances – is something Atkinson points to as being a direct effect of the methods in use in Ireland. When Atkinson draws on the history of Anglo-Irish relations, and uses the imagery of war, he exposes, like Anselm Kiefer, images that many would prefer to forget, to leave buried.

The motif of the unmastered past is for example applied particularly to the Germans in relation to the holocaust, but it's occurred to me particularly over the last four or five years that Britain itself has an unmastered past. Ireland is perhaps only one aspect of it, but it's a very important aspect because Ireland is the issue that gets an enormous amount of media coverage. Many of what I take to be the structural myths about Ireland, that colour the British perception of Ireland, are made in the media on a more or less unselfconscious level. I think there are direct effects that Ireland is having on Britain, not just on British political life but on British life in general. It's generally

TERRY ATKINSON

201

166 Terry Atkinson, *Bunker in Armagh 15*, 1985.

A miniature wheelbarrow bomb disposal robot guided onto a makeshift altar suspected of being booby trapped in an apparently derelict bunker in Armagh.

167 Terry Atkinson, *Bunker in Armagh 14*, 1985.

Left
Vase of History-fireworks flowers
Right
Two ancient Gaelic ghosts in British ideology-proof suits passing through a de-contamination shower after completing a tour haunting the border.

contributing towards what I'd call the brutalisation of British life.

On the one hand is the straightforward British racist view of the old Fenians, bomb throwers, etc. There's a whole history of imagery attached to that; the Irish bog peasant usually portrayed as some sort of semi-ape-like character, that's one aspect. But another aspect which is strangely kind of translucent, is that the British tend to see this abstract Ireland, this idea of Ireland being an emerald isle, a sort of idyllic, gentle, rain-soaked country.

It goes under various names in the media, Catholic versus Protestant, Loyalist versus Republican; so the 'ideological bunker' I see as in some ways metaphorically resonating around that idea of first, the British view of Ireland being fairly fixed, and then the British incomprehension of the two apparently fixed ideologies.

I produced the first Irish sketchbook very quickly after the Whitechapel show; I went out to Derry and I was there for a few days at the Orchard Gallery. I began to collect quite a few images. One for example would be that British fort in the middle of Derry, Fort George, which is like a huge Don Judd sculpture with video cameras. When I went to Belfast, it was the morning after thirty-eight [men] got out of the Maze so the city was jumping, and for a couple of days the helicopters seemed to be very active.

Well, I support republicanism. Irish republicanism I mean, but I think on the whole I'd support republicanism anyway. It would be historically stupid to say you could support Irish republicanism and at some point to say that it doesn't have links with the provisional IRA – since it's clearly the military wing of Sinn Fein.

Obviously it's very uncomfortable and it involves me in all sorts of contradictions, on a wider basis, like that with the peace movement. One of the ideas of the Gimpel Fils show was to sit those family pictures in there alongside the Irish pictures; the whole idea of the bunker was a metaphor for my own fixed positions. I don't obviously overtly support the provisional IRA.

Atkinson's work as a painter, lecturer, writer and activist crosses the boundaries of different kinds of political activity. The survival of the West is set against the faces of his children, the beauty of a night sky is disrupted by the rumble of heavy armaments lorries, the heron fishing on the riverbank is unaware of the ultrasonic listening equipment being tested nearby. These elisions and disruptions are characteristic of an art that offers, like his teaching, not direct protest but the possibility of an active contemplation; mechanisms to break the hold of the 'ideological bunker' of the status quo.

Terry and Sue Atkinson were closely involved with the miners' strike, and with the support groups that were formed during the year-long struggle. Art and activism were inseparable at the moment of the auction of artists' work which they organised in aid of the welfare of families and dependants.*

23 July 1984 at the Greater London Council.

TERRY ATKINSON

One of the characteristics of multinational capitalism, despite its apparent ability to spread this homogeneous cultural patina across the societies of the West, is that it is really quite unstable and obviously more unstable at some junctures than others. One of the really powerful things about the miners' strike was that it was a strike about culture in a sense.

My father was a miner, he was killed on the coal face in 1951. My mother told me about a month ago that she gets 52 pence a week for him. That last little anecdote's

colour obviously happened since the miners' strike but it is details like that which have colour obviously happened since the miners' strike but it is details like that which have coloured my view of what miners are. In the fifties, as I came through school and college, the villages were being systematically run down; then, coming from that class it seemed perfectly real to me that I could feel the heel of somebody on my neck. Those communities struck back in the early seventies through Scargill, and his picketing strategy which took the Heath government completely by surprise. The reflexes go back a long way to the 1926 strike. The view of the South Yorkshire miners, the way the South Yorkshire miners view the Nottinghamshire miners, is not simply about this strike; they are absolutely suspicious of the Nottinghamshire miners because of what happened in 1926. I thought the miners were maybe being absorbed into present-day society; they were mortgaged, they had cars, but they still went on strike for twelve months which is very uncharacteristic.

I remain partial to culture that leads us not into the valley of thoughtlessness but to the moving of mountains. I first heard of *empowerment* through feminism and grass roots culture. This often gets misinterpreted. People think I'm saying art alone can change the world. It can't. But it can become part of the world that's changing. LUCY R. LIPPARD, 'Power/Control', *Village Voice*.

Artists who contribute to the excavation and dissemination of information, to the recognition of the double standards of national and individual behaviour, who argue for democratic procedures and freedom of expression and explore the mechanisms of personal relations of power, must dodge the labels that will be thrown at them in the attempt to defuse and devalue their work. Leon Golub exploits the fashionableness of his work in the art world to gain it a wider viewing in exhibitions and museums, and indirectly through books and magazine articles. The work of Peter Dunn and Loraine Leeson is in danger of neglect by the art world, because its concerns and location seem distant, but they argue convincingly the usefulness of their work in questioning the assumptions of that world. Like Victor Burgin – though they differ about the effectiveness of the street as a location for political art – they want to create active viewers, an audience of participants. 'I see what you mean' is a common phrase that catches the deep-rooted connection between understanding and image-making, for visual images are a vital factor in social and political change. As artists' images circulate they contribute, like news images, cartoons and caricatures, to a resistance to power as much as to its enactment. Art that makes a political critique – both of the arrangements of society, and of the limiting conventions of what is political – will emphasise the *conflict* of images and issues rather than their resolution.

6 Identity, Culture and Power

The starting-point of critical elaboration is the consciousness of what one really is, and is 'knowing thyself' as a product of the historical process to date, which has deposited in you an infinity of traces, without leaving an inventory; therefore it is imperative at the outset to compile such an inventory. ANTONIO GRAMSCI, quoted in Edward W. Said, *Orientalism*, Routledge & Kegan Paul, London, 1978, p. 25.

Culture is the vital, but rarely acknowledged ingredient for a lucrative tourist industry, for profitable business entertainment and ultimately for a successful foreign policy. RAYMOND WILLIAMS, quoted by Roland Miller, 'International Exhibitions. Quality or Prestige', *Circa*, Belfast, 1985, p. 7.

Wherever we travel we seem to be in the same place. The cities we might fly to have a similar appearance, with their shining glass and overhead walkways. The corporate logos on the tallest buildings are identical, and each shopping mall sells the same ice creams, the same hamburgers and the same sweatshirts. Other places beyond the timetables of the airlines seem to be not just somewhere else, somewhere different, but somehow less relevant, less central to our culture. For this 'common culture' is international, or rather supra-national; it has no centre of its own but is dispersed across many city centres. Its dominance, its ubiquity, is based on the logic of multinational corporations, providing the same products, the same financial services, the same technical expertise and the same values all over the world. This international 'culture' is Western, largely English-speaking, and is disseminated through, and built on, fashion, magazines, television programmes, architecture and much of the arts. This culture is an integral part of what has been described as the social formation of Late Capitalism.* Less easily defined and less homogeneous than any specific language, it has nevertheless become a common reference point of communication between individuals, between peoples, between nations. But what is this culture built upon? What has been covered up, or covered over, in its construction? What is missing?

See Ernest Mandel, *Late Capitalism*, New Left Books, London, 1975; and Fredric Jameson, 'Postmodernism, or The Cultural Logic of Late Capitalism'.

The driving forces of global economics and trade keep this common culture in constant flux, creating and recreating a set of dominant values and ideas, incorporating elements from different localities, promoting compatible viewpoints and suppressing contrary and incompatible opinions. The international art world is enmeshed with these forces. Contemporary Western art is often given the label of 'international'. This is a modern conception and is both the representation of an idea (a humanist assertion that it is 'natural' that a universal modern art should encircle the globe – available for everyone, from whatever background) and of a certain truth, that modern art can be a commodity like all others, to be packaged, promoted and sold everywhere. Art fairs, Biennales, international exhibitions, are all based on the assumption that art can transcend its maker or place. Of course there are

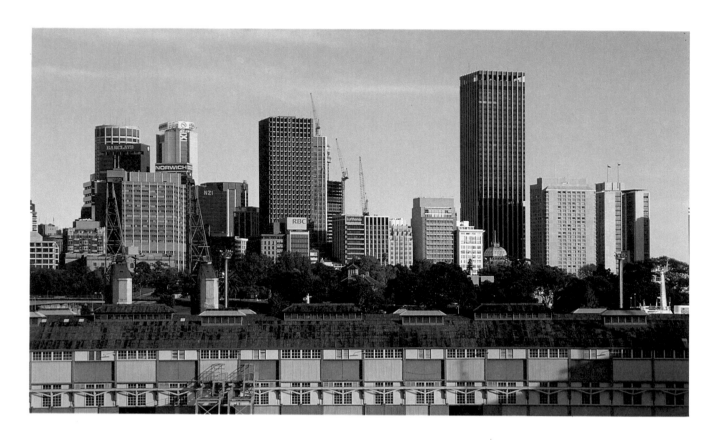

168 Skyline, Sydney.
169 Performance by Bruce McLean
at the *Sydney Biennale,* on the steps
of the Art Gallery of New South
Wales, 1986.

IDENTITY

170 Landscape near Alice Springs.
171 Michael Nelson Tjakamarra,
Possum Dreaming, 1985.

aspects of art that may be intelligible to, or appreciated by, the least likely viewers. But inevitably the art that is considered in a trans-regional, trans-national context will have an enhanced significance to those who know the 'rules' by which it qualified for inclusion. The rules, which are never overt and change constantly, can be observed in action in the key art magazines where the opinions of artists, curators, collectors and dealers are reflected and formed. A false impression is often given that these criteria define the visual arts; rather, a struggle continues between different *sets* of rules, between different interest groups, different cultures and different histories, each with its own ideas and priorities.

Every exhibition is a map. As such, it not only separates, defines and describes a certain terrain, marking out its salient features and significant points, omitting and simplifying others, but it also depicts this ground according to a *method of projection*: a set of conventions and rules under which the map is constructed . . . With exhibitions it is the concept of history and the position in the present from which that history is written which correspond to the method of projection. The problem is, however, that, in exhibitions as in maps, the conventional nature of the representation tends to be hidden in use. The laws of projection become invisible. We forget that the world is not rectangular and Australia is not in the bottom right hand corner. JOHN TAGG, 'A Socialist Perspective on Photographic Practice', *Three Perspectives on Photography*, Arts Council of Great Britain, London, 1979, p. 70.

The Biennale of Sydney is an 'international' event in the calendar of the art world. 1986 marked the sixth; work was exhibited both at the Art Gallery of New South Wales and at Pier 2/3, a vast and austere disused wooden loading shed near the Sydney Harbour Bridge. Like most international events, the Biennale exhibits a considerable proportion of art that has been, or will be, endorsed by the art magazines, the galleries and the other Biennales in Europe and America. To this degree it fits into and contributes to the system established outside Australia. But contrary to this it also has a number of particular and local considerations. A large number of artists from Australia and New Zealand are invited, and in 1986 art from Cuba, Poland, Argentina and New Guinea was exhibited, marking out the Biennale from presentations in Venice or Paris. This in itself would make it a stimulating event, but the addition of performances, ancillary exhibitions and seminars with visiting artists and critics encourages considerable and fruitful discussion and debate.

There was no dominance of an 'approved' style in the sixth Biennale. No single *stylistic* fashion was in vogue, other than a general acceptance of figurative and expressive images, and a sprinkling of abstract works that came from New York under the 'neo-conceptual' label. In one sense everything seemed equal, but this equality remained an illusion. The parade of images encouraged a 'global culture' view where individual, regional and national inflections were set against some indeterminable norm or standard; the actual circumstances of the production of the works remained unknown. The diverse values and intentions that were important to each artist or group may have survived the hectic encounter, but they often seemed submerged in the general pell-mell. Nevertheless, for the viewer in Sydney juxtaposi-

tions appeared which would never otherwise be available: the American Eric Fischl between the Chilean Carlos Leppe and the Australian Julie Brown-Rrap, each with a very different examination of the sexual. So too the Russian emigré pair Komar and Melamid placed provocatively next to the Australian Richard Dunn, each showing a reworked idea of 'History' painting. An installed work by the Yugoslav Braco Dimitrijević (who lives in London), which included a painting from the permanent collection of the Art Gallery of New South Wales, could be viewed between the work of two Americans, Agnes Martin and Nancy Spero. The British artist Bruce McLean used the portico and steps of the Gallery itself to poke fun at overly formalist attitudes in art. Perhaps the oddest and most contradictory of conjunctions was that of the bark paintings and performances of the Ramingining Performance Group with the videos of producer and 'artist' Malcolm McLaren, whose Duck Rock album appropriated Third World and tribal music. McLaren dominated much of the media coverage of the opening of the Biennale, confirming to everyone who asked that artists are indeed the rock stars of the 1980s, and that they, like everyone else, are only interested in fame and money.

* * * * *

The theme of the 1986 Biennale was 'Origins, Originality and Beyond', questioning originality and reproposing the possibility of a new authenticity.* In the words of a press release: 'Today appropriation of images from any number of sources including other artists' work is accepted as legitimate practice. The works themselves cover a wide range of subjects from myth, magic and alchemy to images from the Stone Age through to today's electronic era.' This theme exposed questions of the legitimacy of different practices and subjects, and with it questions of cultural identity. Any Biennale – and this one is considered as a case study – but particularly one in Sydney will bring forward questions of national power and authority. Is this Biennale the same as all others, but on the other side of the globe? What does it mean for this event to be in Sydney rather than in New York? Does it propose a new map of the art world where Sydney might be more centrally located? Does it give hopeful indications for a resistance to 'global culture'? The expectations and reactions of visiting artists, critics and curators were not surprisingly varied and conflicting.

The director of the sixth Biennale was Nick Waterlow.

I expected something a bit more different than how it looks in the Biennale. It is too unified, too levelled out. It is like any normal big exhibition in Paris or London or America, or anywhere . . . There are some good pieces of work, as always in large exhibitions, and some good installations, but there is nothing that is specifically Australian. I don't think that anything is changed by including a few Aborigines. That's because of bad conscience more than anything else.

MIRIAM CAHN

172 Work by Agnes Martin, Braco
Dimitrijević and Nancy Spero in the
Sydney Biennale, 1986.

173 Work by Braco Dimitrijević in
the *Sydney Biennale*, Pier 2/3, 1986,
with the Sydney Harbour Bridge.

I think it makes perfect sense that living tribal rituals of Aboriginal origins might make their entry through this particular diffusion channel of performance art into the world stream.

THOMAS MCEVILLEY

I imagine political, military and business figures are at the centre of power. But in terms of the fine arts, New York is still the centre, though somewhat decentred in comparison with a generation ago. There are now all kinds of terribly powerful regional centres, the cities of Germany and North Italy, and Sydney for that matter is one.

We have much contact with different nations, economically and financially. World art, news and information pour into Japan, but we have not had the opportunity to meet with foreign artists to exchange views on works of art. So I took the opportunity to come here and get involved in such discussions.

NABUO NAKAMURA

We are already much influenced by world events through economic exchange. For me it is not possible to forget our culture completely in order to communicate with Western people, but it is also difficult to communicate with them whilst retaining our culture.

In Japan we have had two dramatic events in our history; first we opened up the country to the outside, and second, after the World War II American occupation, which led to a confused situation in Japan. I feel Japan has not yet emerged from the effects of occupation.

I feel like an 'outsider' because I come from Chile, a country where the military control implies censorship and repression; a country also inscribed within the problematic of Latin American colonialism. This double circumstance makes the appearance of Chile in an international event rather special: it must capture the attention of a spectator who may be rather inattentive or prejudiced. This presence must also attempt to recreate the context within which the works – and their strategies of power and opposition – must be read. It must also argue for the right to a 'difference' against the uniformity of the market and of international criticism.

NELLY RICHARD

It is now conventional for feminist essays to begin by questioning the place from which one speaks; it has also long been customary for Australian essays to pose the question of speaking of place. To speak about Australia in other countries is, usually, to start with stories and descriptions; to speak about Australia in Australia is to begin half-deafened by the din of conflicting and variously invested discourses on place, space, movement, distance, identity and difference – wild histories of the mapping of a terra incognita. MEAGHAN MORRIS, 'Identity Anecdotes', *Camera Obscura* 12, Los Angeles, 1984, p. 42.

For the Australian art world the Biennale of Sydney provokes arguments about the relationship between art in Australia and in the rest of the world. These arguments are suffused with the wider question of Australian-ness and Australian national identity. The Biennale also has a history which has occasioned the fight for better recognition of women artists and the recognition of certain artists' rights; in these demands artists intervened and won. The right of Aboriginal artists to participate has also been recognised. It is an important but anxious event. For an Australian artist interested in a

conventional career, inclusion in the Biennale is one way to begin to achieve recognition abroad, to gain critical attention in the international art press and perhaps find a route to exhibitions and sales overseas. For any artist working with these goals (and there are many significant artists in Australia who do not), the possibility of sales abroad is important as the market in Australia is limited. The generation of Sidney Nolan, Arthur Boyd and John Perceval looked to London in the 1950s and 1960s, but now the principal focus of attention is New York, its critics, galleries and collectors. Australian critics and art historians also have differing views of the Biennale.

PAUL TAYLOR *When it comes to Australian art, the information about it will travel faster than the actual objects, and that might be the case with what is happening now. Over the last few years a number of people have talked about what is going on in Australia. We have to be more active in developing a profile of what Australian art is and then carefully placing that in different contexts.*

There are so many different kinds of Australian art that it is like any other country, I don't think there is a quintessentially Australian or British or German art. But given that, there is a body of work that has been made in Australia over the last ten years which does try and address itself to what is Australian, what is particular to this context and to the issue of representation.

TERRY SMITH *The Sydney Biennale is to plug us into the international art system. It's as simple as that.*

The Biennale as a form has to make everything that goes into it into a kind of blancmange. It makes artists who would otherwise be very specific and concrete and accurate in their work produce overblown statements. Most international art shows do that and they are tedious beyond belief for that very reason.

This one is about 'Origins'. There's some bizarre notion that there is an essential origin to artistic creativity that has always been there. That modernism and postmodernism have somehow got away from it, and therefore we have to go back to the art of Aborigines and women and people who are really in touch with the central core of things . . . it's totally crass. It has no sense that people live in societies, women live in societies, Aborigines live in societies. Human relationships are socially formed. The rest of it is really rhetoric and our best artists know this and they operate with this, they know it's a contradictory situation, they know there is no guarantee about identity or nationality . . .

Marginalisation is a productive space, it's a space which you can use. You can fight back and also step away and step aside and you can construct other things as well. Being Australian is like being someone from a sort of partially marginal culture, or partially third world – second world. It's obviously a productive space to be in at the moment.

The way [global culture] works now is by diversifying. It has to work by making regional differences active, making them recognisable but not really disturbing. It has to keep the structures in play and change the details. So regionality is really absolutely essential news for global capital at the moment, absolutely essential.

Like the Biennales, every presentation of contemporary Australian art in Europe and America has brought out the questions of an imagined nationality, of a shared identity, or the disparity of different artists from different cultures and backgrounds.* Of the artists in the *Eureka!* exhibition in London in 1982, a quarter were born outside Australia, and by that time more than half of Australians were not of British families. The first exhibition abroad to present Western and Aboriginal contemporary work side by side was entitled *From Another Continent: The Dream is Real*. A group of the Warlpiri travelled to Paris to present a large sand painting, and there was a day of seminar discussions with the exhibition. If white Australian artists were worried about being exhibited as decontextualised exotica from the 'margins' of the art world, their fears were increased when the French press and public gave most of their attention to the 'natives'. For the French here was the 'true' exotic; as Richard Dunn, one of the artists, wrote, 'White Australia was to be characterised as a dream; interlopers of others' imaginary space, colonisers of the Real place (the unFrench and the Aboriginal) *and* as purloiners of European art. Forty thousand years of the Real in the form of the Warlpiri ground painting was to be set against the two hundred year dream. No contest!'*

Australian artists have again and again had to deal with other people's stereotypes of what the characteristics of an Australian art might be. At its crudest the landscape, the 'outback', the imagined rawness of the huge 'uncharted' continent, and now Aboriginality, have all become threads in this stereotype, a stereotype made all the more ironic by the fact that the vast majority of Australians live in cities.

Propositions that there are artists who 'appropriate' the material on which their work is based, or artists who are style importers as *opposed to* those whose practice is 'true', 'serious' and 'authentic' and thus in need of protection is a false dichotomy. Equally false is an inherent Australian cultural identity (to be uncovered) as *opposed to* that which has arisen in Australia's interactions in the world and its representation there. SUZANNE DAVIES, 'Repressed/Memory', *The Biennale of Sydney*, Sydney, 1986, p. 63.

* * * * *

Our treatment of the natives may be deemed unjustifiable by some. Naturally they may say that it was their country, and ask what business we had there? Quite so; but the same argument may be used in all new countries. It will not hold water, however, nor can we change the unalterable law of Nature. For untold centuries the Aborigines have had the use of the country, but in the march of time they, like the extinct fossil, must make way. THOMAS MAJOR (1900), quoted in Richard White, *Inventing Australia*, George Allen & Unwin, Sydney, 1981, p. 70.

If the West has produced anthropologists it is because it was tormented by remorse. CLAUDE LÉVI-STRAUSS, quoted in Hal Foster, *Recodings*, Bay Press, Port Washington, 1985, p. 198.

People are looking down from the balconies, others are crowded around the space of the gallery itself. Three film crews wait for the action; members of

Exhibitions include *Eureka!*, Institute of Contemporary Arts and Serpentine Gallery, London, 1982; *From Another Continent: The Dream is Real*, ARC and Musée d'Art Moderne de la Ville de Paris, 1983; *Australian Visions*, Guggenheim Museum, New York, 1984; *An Australian Accent*, P.S.1, New York, 1984; *Anzart*, Richard Demarco Gallery, Edinburgh International Festival, 1984; *5/5*, Daadgalerie, Berlin, 1985.

'Other than What', *Art-Network* 13, Sydney, 1984, p. 52.

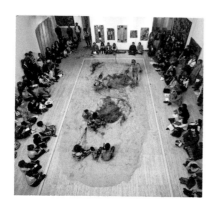

174 Ramingining Performance Group at the *Sydney Biennale*, Art Gallery of New South Wales, 1986.

The Biennale of Sydney, 1986, p. 236.

Sydney Biennale, 1979, and *Australian Perspecta*, Art Gallery of New South Wales, 1981, were among the first.

the audience balance cameras on their knees or hold them poised. The centre of the space is cleared of people and filled with sand, some of it roughly shaped to form two nest-like circles, with grass scattered over the rims. One crew and some individual photographers are peering behind a screen where the performers are preparing their face and body paint; two little boys scamper about, white paint glaring against their dark skins. The 'performance' begins, the five women are clapping and singing, two men sing and drum, the other two approach the nests/waterholes, dancing, with two small boys behind them. They approach and retreat several times; the chanting continues, and after some minutes water is brought for the 'washing' of one of the men. The performance is casually interrupted for discussion among the participants. The cameras click incessantly, more people join the back of the crowd. At the end they clap while John Mundine, the Art Advisor from Ramingining, announces the names of the performers.

The leader of the performance is George Milpurrurru, and his bark paintings are hung on one wall of the gallery. The performers all come from Central Arnhemland, but some are members of the Ganalbingu Group, some from the Marrangu, some from the Djenba and one from the Wagilak. The 'performance' is a post-funereal cleansing ceremony, and takes place in a 'sculpture', by Milpurrurru, representing a series of waterholes made by the Wangarr Wunggan (sacred dog). As Mundine writes, 'In north-eastern Arnhemland all present-day Aboriginals originate from specific Wangarr (Creative Beings) and Wänga (Land). These Creative Spirits in different physical forms set in motion climatic patterns, shaped the land and created the original members of the present-day family groups, giving them land, language and social laws. In their journeys they left "footprints" in the landscape: part of their spiritual self embedded in rocks, waterholes and other topographical features . . . These "footprints" are reproduced today as paintings on the body, on sacred representations of the Wangarr and other objects used in rites of passage, and as ground sculptures used in mortuary and other ceremonies.'* It is hard to imagine any other contemporary art performance that could feel as contradictory as this: relaxed, and yet fraught with political and cultural tension; loaded with such specific meanings and significances, and those meanings so distant from the audience. It was inherently intriguing, and affecting, as much with a sense of irony as with any multi-cultural rapprochement. Yet the performers were there by their own choice, several with previous experience of working in museums and Western institutions. They know that participating raises the Aboriginal social profile, and that is valuable in keeping up the pressure in the Land Rights campaign. Other exhibitions in Australia have included Aboriginal and non-Aboriginal work together,* but not without considerable debate. Museums and art galleries have only recently begun to rethink the relation between their sections of 'European and Western' art and their sections of 'tribal' art. Some related issues surrounding historical material in present-day cultural attitudes emerged at the 1984 exhibition at the Museum of Modern Art, New York, titled *Primitivism in Twentieth Century Art*, which provoked ferocious debate in the art press. Someone who has dealt with the

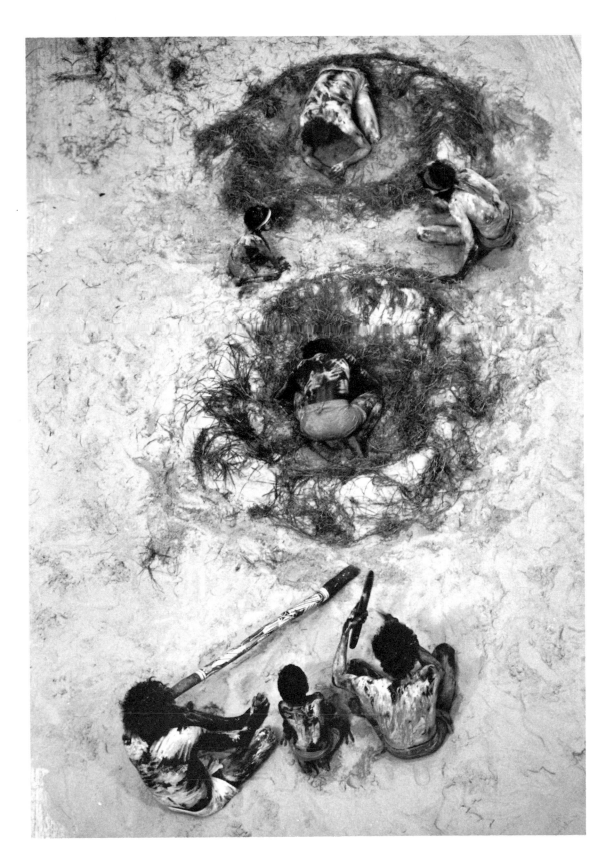

175 Ramingining Performance
Group at the *Sydney Biennale*,
Art Gallery of New South
Wales, 1986.

issues in Australia for some years is Gary Foley, Director of the Aboriginal Arts Board of the Australia Council.

GARY FOLEY *The Biennale is irrelevant to me personally and to a certain extent professionally. The inclusion this year of some Aboriginal artists as well as some Aboriginal speakers in a forum two years ago is in my opinion largely a tokenistic gesture. It's interesting that the organisers of these sorts of events usually do feel impelled to include Aboriginal people because there is an inherent recognition that to ignore what must, and can only, be regarded as the true cultural heritage of this country would be a pretty major mistake on their part.*

I believe that any expression of Aboriginal art, be it traditional or contemporary, is an act of political defiance. So much time and effort, two hundred years of very concerted effort to destroy Aboriginality and Aboriginal culture, has gone into this country. The fact that Aboriginal culture does remain a living thing is in itself an extraordinary political statement about their resilience, their adaptability and their tremendous willpower.

On one hand you've got Western society which is essentially very competitive, individualistic and materialistic, whose basic unit is the nuclear family. Aboriginal society is diametrically opposite on virtually all counts: it is very anti-materialistic, the concept of private property is a concept which doesn't exist. Individualism is regarded as counter-revolutionary, for want of a better term.

That's why Aboriginal art and culture and the political struggle for Land Rights are inextricably linked. Because in many of these communities the only way people can resist the attempt at invasion from an alien culture is through having a strong community themselves. The way in which they can achieve that is to have the knowledge of the security of their land.

Cultural colonialism does not massacre and imprison and institutionalise a subservient people, but, more gently, it absorbs the values of a peripheral cultural system into the larger system of the dominant one. Ranged against this, however, are other factors that are central to the present revival of Aboriginal life and culture . . . Quite clearly, for a people who have been long considered officially subhuman, to be suddenly doing something that elicits broad respect, that gains the admiration, not merely of a spectrum of the white liberal middle class . . . is evidence itself of a renaissance in Aboriginal identity . . . KENNETH COUTTS-SMITH, 'Australian Aboriginal Art', *Art-Network* 7, Sydney, Spring 1982, p. 55.

There are thought to be about 100 surviving Aboriginal languages. The Aboriginal population is around 300,000 out of a total Australian population of 11 million. At the time of European contact there were some 300 different tribal groupings, with languages as different in themselves as Russian and English. The diversity of language points to the longevity of different groups and reinforces the radio-carbon evidence from early settlement sites, where the wall markings and designs indicate that Aboriginal society has existed in Australia for at least 40,000 years. Only in 1967 were the Aboriginal people given full rights as citizens, and it is only in the last ten years that the policy of assimilation has changed to that of multi-culturalism. This applies to all racial and national groups in Australia. In the case of the Aborigines it has meant gradual recognition of Land Rights (though far from the full protec-

tion from mining interests that they desire), support for the outstation movement which encourages tribal groups to continue traditional patterns of life, and certain symbolic acts like the return of Uluru (Ayers Rock) to the Anangu people who live there.

Michael Nelson Tjakamarra had three paintings included in the 1986 Biennale. He works at Papunya, a settlement about 270 kilometres west of Alice Springs, where a number of artists (members of the Pintubi, the Luritja, the Anmatjera/Aranda and the Warlpiri) are producing work which is sold and exhibited through the Papunya Tula Company. 'Papunya Painting' started in 1971 when art and craft teacher Geoff Bardon encouraged the children, and more significantly the adults, to transfer their traditional ceremonial designs to the modern materials of canvas and canvasboard, using oil and then acrylic paint. Within a few years, an energetic 'movement' had started, with successful sales of the work across Australia and abroad, and an increasing number of members of the community joining in, including a number of women. The community at Papunya is smaller now than in the mid-1970s, as many have moved to outstations. There are also a significant number of artists at Kintore, on the edge of the Western Desert.

Papunya itself, named after the 'Honey Ant Dreaming' hill nearby, is based around a water bore. It was established as a government settlement in the 1960s to help tribal, nomadic desert people who were suffering from a drought, and many of whom were incorporated into the welfare system with health care and Western schooling. Only a few years ago, a group of Aborigines appeared from the desert, claiming that they had never seen white people before.* Today much of the settlement looks like a ruin, with burnt-out houses, broken buildings and facilities, wrecked cars and metal and plastic litter strewn along every line of jumbled fencing. Alongside the family houses in use are the 'humpys', lean-tos made of corrugated metal and propped-up pieces of cloth and board.

Michael Nelson Tjakamarra's house is half-filled with canvases and paints, though he takes these outside to work. Painting earns money and is still regarded as an important cultural activity within the community.

You must appreciate that we, my generation, were brought up in the bush, in our own country in the desert. We were instructed by the old people. We did go to school and learned something of the European way, but only to a limited extent. We were primarily brought up within our own Law. We became well versed in our own culture. Our culture was very much alive. We had our dreaming places, our sacred sites, our song cycles and traditional dances and ceremonial regalia, like shields and so on.

We hadn't lost all of that; not like those people living here in Sydney. They've lost all their culture, they just follow the European way. But we still hold fast to our culture. North of us, south of us, west of us, our language and culture is still intact, right there in the middle of the desert, among the spinifex and sand dunes. I still remember when we lived in bush shelters and travelled constantly, from Ngangaritja to Papunya to Yuendumu, and then back again.

Such accounts are sometimes disputed, but some Aborigines do still live in virtual isolation in Central Australia.

MICHAEL NELSON TJAKAMARRA

176 Michael Nelson Tjakamarra and Malcolm McLaren at the opening of the *Sydney Biennale*, Pier 2/3, 1986.
177 Michael Nelson Tjakamarra working at Papunya, 1986.

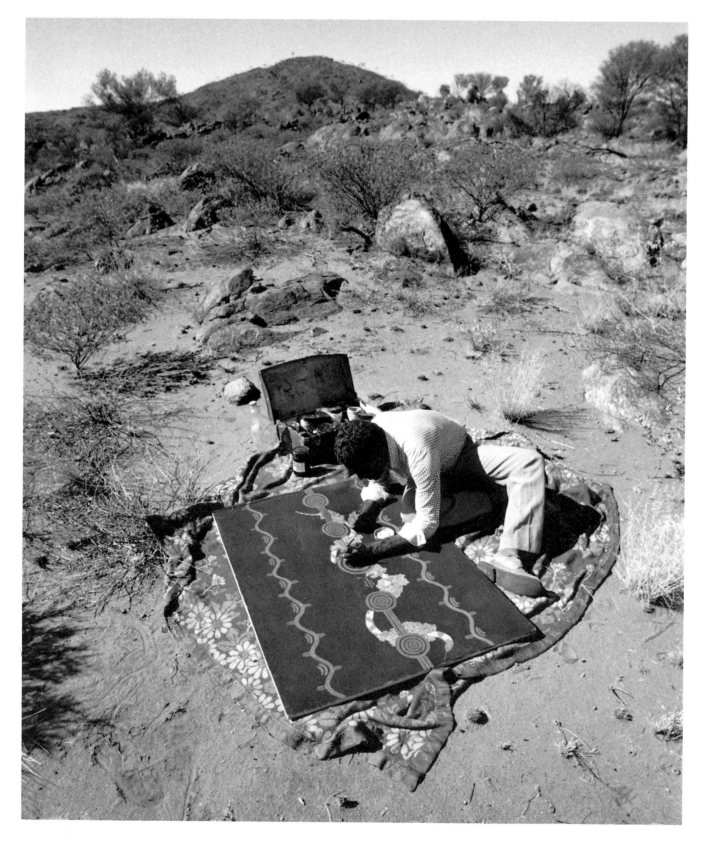

178 Michael Nelson Tjakamarra
working near the honey ant
dreaming hill at Papunya, 1986.

IDENTITY

The designs I had learned from corroborees and from traditional ceremonial regalia I had been taught by my uncle, my father and my grandfather. All of us – the young, the old and the middle-aged – we all knew this way. The designs were also painted on shields, usually little shields, sometimes big ones. The designs were derived from those we created in the sand. Now that we paint these designs on canvas, white people and other Aboriginal people can see them and appreciate them. They can be seen all the time, whereas the traditional forms of our art could only be seen at ceremonies. Those shields that we painted we only used them at certain times; for corroborees or related rituals. The designs we made in the sand were also only seen occasionally. We use these designs still in corroborees and other ritual practices. I still participate in ceremonies. It's embedded in my heart. Others may have lost it all but at Kintore, Papunya and Yuendumu we still retain our culture. We cherish our traditions.*

Traditional Aboriginal dance, song or ceremony.

The appreciation of painting from Papunya, with its superficially semi-abstract appearance, was qualified by some who saw it, because of its modern materials and formats, as in some way impure, as a hybrid form of Aboriginal art. The subtle modulations of colour, the intricate patterns, similar to the ritual sand paintings in which the designs originated, and the dreaming stories, deprived of any sacred content for non-Aboriginal viewing, were dismissed as 'inauthentic'.

From the first, Aboriginal 'artists' had developed 'art' that could be traded with the Europeans. Even bark painting, which is usually regarded as the oldest and most 'authentic' of Aboriginal arts, is now thought to have been developed post-contact. The symbols and designs existed, but they had been adapted for the changed circumstances. This type of adaptation is parallel to 'development' in Western art. Because the Western concept of art does not exist as such within Aboriginal society, 'difference' or 'otherness' is sometimes used to deny full artistic recognition to Aboriginal painting. It is somehow seen as less important because the activities of painting, carving or decorating are part of the ceremonial aspect of life.

The ceremonial is at the core of the Aborigines' close relationship with the land, a land which to Western eyes seems totally inhospitable for thousands of miles. It supports a society which appears to be in the middle of nowhere, the furthest point from the urban, 'global', culture of the city. (Though as you fly from Alice Springs to Papunya you see an American military listening station and the cleared 'lines' where seismological tests have been conducted by the mining companies.) A conceptual 'mapping' of the landscape and its features is important to Papunya painting. The pictures have a resemblance to the views across these scrub plains, but depiction of the land is interlaced with depiction of the dream stories, the principal repository of Aboriginal history and lore.

Well, it is good that you people can get the chance to see our paintings. You can see our dreamings that follow the tracks of our dreamtime heroes, the kangaroo track, the possum track or the snake track. They are all beautiful designs that you can see. We've always used these designs but now you can see them too. Maybe you'll even understand and learn from these designs; learn from these dreaming tracks that are so

MICHAEL NELSON TJAKAMARRA

179 Sculpture of Truganini, the last Tasmanian who died in 1876, and her husband, in the Art Gallery of New South Wales.

180 Aboriginal painted funerary poles in the Tribal Art section of the Art Gallery of New South Wales.

IDENTITY

much a part of us. I'm very proud of these paintings. I love to see them, I came here to see them because they remain in my heart; all the paintings that I work on.

We only paint designs that people may view; they are not too sacred for the public to see. We paint the possum dreaming. That's fine. The possum ran away with a woman, everyone is allowed to know that. We can also paint about the rock wallaby crossing that dreaming track. Other parts of the story we would not expose. The honey ant dreaming, that's all right too. And the water dreaming. The woman dreaming, wild banana too, all of these suitable for public exposure. Others, we would never touch.

White people don't really fully appreciate these dreamings that we paint. These dreamings are part of this country that we all live in. Europeans don't understand this sacred ground and the Law that constrains our interaction with it. They are ignorant, they still don't understand. We've been trying to explain it to them, to explain what it means to us, for the sake of all Australians. We try to show them that this is our land. We try to show them our dreamings. But white people don't even recognise our ownership of it. Today we paint all these pictures and white people want these too. They still can't understand. They want them as souvenirs to hang on their walls but they don't realise paintings represent the country, all of the vast land.

In other countries they're all right; the land belongs to them, it's their country. We belong to this country; that's why we keep saying that we want our land back.

The understanding and appreciation of Aboriginal culture has altered immeasurably in recent years; the success of the Papunya Tula Company is one example of that recognition. But even if museum curators have given up the idea of studying a 'frozen' culture, the construction of Aboriginal history is still embedded in European institutions, and the market for contemporary work is likely to be a restraining rather than a progressive force. To resist the dominant culture still involves changing stereotypes and altering assumptions about cultural domination.

The history of white settlement in Australia in relation to the Aborigines is a story of homicide, rape, the forcible abduction of children from their parents and the methodical dispossession of the lands upon which their well-being, self-respect and survival have depended. 'Cultural convergence' is attractive as an *idea* because it offers a painless way to expiate our collective guilt of this history while simultaneously suggesting an easy solution to the more mundane but nevertheless pressing problem of finding a uniquely Australian content to our art in an international climate sympathetic to the notion of 'regional' art. IMANTS TILLERS, 'Locality Fails', *Art & Text* 6, Melbourne, 1982, p. 53.

You seek to say that because you are Australians you have the right to study and explore our heritage, because it is a heritage to be shared by all Australians, white and black. From our point of view, we say you have come as invaders. You have destroyed our culture. You have built your futures upon the lands and bodies of our people. And now, having said sorry, you share out a picking of the bones of what you regard as a dead past. We say that it is our past, our culture and heritage, and forms part of our present life; as such it is ours to control. It is ours to share on our terms. That is the central issue in this debate. ROS LANGFORD, address to the Australian Archaeological Association, quoted by Adrian Marrie, Adelaide Artists Week, March 1986.

* * * * *

Who today is unaware of those things called Australian films or the Australian music industry and, as the hopefuls in the Australian art bureaucracy are waiting to add, the new Australian art? While particularly the Australian music that is celebrated in America is far from the best produced in the country, the image of a nation having come of age assaults us every time we open a fashion or music magazine, survey exhibition catalogue and film journal. Australian culture hasn't necessarily 'come of age'; rather, it is the beneficiary of a worldwide loss of confidence and nostalgic yearning for lost utopias. PAUL TAYLOR, 'A Culture of Temporary Culture', *Art & Text* 16, 1984, p. 95.

An image of 'Australia' has been created by Australian artists in part to satisfy an idea held by the rest of the world. But the idea changes in response to the changing image, transmitted through emigration connections, family photographs, films, books and tourist promotions as well as art. Changing patterns of work and leisure cause individuals, groups and generations to redefine the 'place'. In the imaginations of people, a place does not exist until it is experienced and described. The play, the to-and-fro between truth and fantasy, forms stereotype images.

In 1985 the Australian Imants Tillers exhibited *THE NINE SHOTS*, a work on ninety-one canvasboard panels, at the Bess Cutler Gallery in New York. The work combines an image from a 1960s' painting by Georg Baselitz, *Following Wind*, with the *Possum Dreaming* painting by Michael Nelson Tjakamarra. Tillers has been using this process since 1981, creating his art entirely from the images of other artists. These are not just images from the mass media in the tradition of Andy Warhol, or re-photographed versions of famous paintings or photographs from the early twentieth century in the style of Sherrie Levine, but images found through and worked from reproductions in catalogues and art magazines. The reproduction is gridded up and the rectangles on the grid correspond to canvasboard panels. Each of these is worked on separately on Tillers's desk, using oilstick and acrylic, making *his* version of the original image or combination of images. Tillers goes much further than simply reproducing the fashionable *styles* of other artists, though their fashionableness is part of what is useful to him. He copies and reworks the image, leaving it in 'quotation'. The particularity of another artist's image is normally considered to be inviolable. Against all the expectations of the artist's assumed creativity and individuality, with the connotations of forgery and the weight of copyright legislation against him, Tillers throws caution to the winds and makes a virtue out of the second-hand.

In some works, like *THE NINE SHOTS*, an image is taken from an artist who not only has little power to use Tillers's image in return, but who lives in a society that has regarded the 'ownership' of images as precious, both at a tribal and an individual level. This use of Aboriginal images came about only after careful consideration and discussion with, among others, Tim and Vivien Johnson, white artists and critics who have spent time working and living at Papunya. They, and Tillers, are aware of the power relations, but consider collaboration and rapprochement to be essential. Tim Johnson argues that the more Papunya 'style' is circulated in the Western art world,

181 Imants Tillers in his studio, Mosman, Sydney, 1986.

the more it will be taken seriously as a part of contemporary art, and not mere ethnography.

I was interested in those Baselitz figures he painted in the sixties because they're heroic figures and yet they are decrepit, they're ruins in a sense, and have some sort of relationship to Australia's origins. It was a convict settlement. I was interested in them for that reason. I was also interested in them formally because they're painted in little sections that sometimes are coherent and other times are like little fragments. The figures look like they're falling apart on a formal level. I was interested that if I painted an image like that onto canvas boards, there would be a relationship between the structure of the painting and the image on top of it. The link with Papunya, with the Michael Nelson painting, was that Papunya painting too has this fragmented surface, not just with the dots but with colour areas, and I thought by juxtaposing the two it would be like the fabric of his clothing and his body becoming this Aboriginal painting. I had been interested to put them together in that way for quite a long time, but it was a matter of finding the appropriate combination. The figure has its arms outstretched, it's almost sort of being crucified. It was like the circles of the Michael Nelson painting became like targets sort of penetrating his body. I saw that as being like a metaphor for how Australian culture could be seen from one viewpoint.

I'm interested in what people's preconceptions are in particular places. What interests me now is that artists like Philip Taaffe and optical and neo-conceptual painting is starting to be interesting for people in New York. In terms of what is happening here in Australia the Papunya artists make the kind of work that with only slight adjustments would fit into that kind of sensibility, not just the optical aspect of it but the conceptual aspect of it because their work is probably the most highly conceptualised work that's around; their images are dealing with very specific content.

I expect people to recognise someone else's image there but I'm interested in going beyond that stage, and then saying what does it mean that someone is repainting that, or what have they added to it? The structure of my images is quite different to those originals. Anselm Kiefer's painting is dense with material, you know, and material surface. When I paint a Kiefer I'm painting a very flattened image and in my process of painting it's transferred onto separate little panels. It starts to have a different kind of aura and surface than Kiefer's work. The only thing that's in common between our works, Kiefer's and mine, is that reproduction, but in their physical attributes they're quite different.

The work in the Sydney Biennale LOST, LOST, LOST *consists of three separate images; on the left-hand side it's a Walter Dahn and Jiři Georg Dokoupil collaboration of a sort of swastika man ploughing through the forest with his truckload of swastikas. The middle images are a Kiefer painting out of Mondrian, of a tree being transformed into Mondrian's vertical and horizontal stripes, and on the far side is a Kiefer forest. I was interested in that painting setting up a dialogue between two opposing positions within German art, Kiefer on the one hand and then the sort of ironic attitude of Dokoupil and Dahn against that perceived seriousness.*

I decided that working on canvasboard units, while it had a certain aesthetic importance, was also extremely practical. For an artist to be producing Kiefer-size canvases and expecting them to be shown outside Australia, it's absolutely ludicrous.

182 Imants Tillers in his studio, Mosman, Sydney, 1986.

There isn't the artistic economy to support that kind of transport cost. It had to be something small that I could really organise myself and do cheaply.

This process means that I can re-use parts of images that I no longer want to keep and they form the sort of sub-structure for new works. Even when I obliterate an image completely, in my mind there will be some kind of dialogue between what was there before and what I paint over it. They also form a cumulative whole which is like one huge painting. The panels began with number one and they're now up to almost 9,600.

There are different issues at work, say in America or Australia, although we're all subject to the same bombardment of images. In Australia I still feel a sense of isolation, whether it's real or not, and a feeling of marginality and provincialism. I use second-hand images to try and reverse that, in that there is a sort of irony, but also an attempt at reversing that power relationship between the centre and the provinces, particularly now that I'm showing in America.

There is no 'real' Australia waiting to be uncovered. A national identity is an invention. There is no point asking whether one version of this essential Australia is truer than another because they are all intellectual constructs, neat, tidy, comprehensible and necessarily false. They have all been artificially imposed upon a diverse landscape and population, and a variety of untidy social relationships, attitudes and emotions. When we look at ideas about national identity, we need to ask, not whether they are true or false, but what their function is, whose creation they are, and whose interests they serve. RICHARD WHITE, *Inventing Australia*, p. viii.

The questions of nationality and identity implicit in all of Tillers's recent work are intensified in a large mosaic he is making for the cupola of the new Federation Pavilion in Centennial Park in Sydney, the prizewinning design of architect Alexander Tzannes. The pavilion provides a permanent structure over the stone which marked the declaration of the Federation of the six states of Australia in 1901. It is a place celebrating the symbolic unity of nationhood. Tillers is incorporating the image of a Baselitz 'heroic' wanderer with a reworked Aboriginal design. The fragments of the mosaic will magnify his metaphor still further, a reworking of others' images and of his own.

The panel works incorporate a hectic pluralism of different images, a postmodern allegory of nationhood no longer able to be unified through the 'imagined communities', extant only in fragments of images, each with its own partial history. One work is built on the combination of part of a painting by Lord Leighton with a late de' Chirico, which also includes a reference to German painter Sigmar Polke and the work of New Zealand artist Colin McCahon, entitled THE HYPERBOREAN AND THE SPELUNCAR. An image by Julian Schnabel and part of a Sandro Chia combine in PSYCHIC (for Yves Klein). Both these images were taken from glossy advertisements in *Artforum* placed by a Japanese gallery, and Tillers added to them another reference to Polke. Another work is a reworking of a painting from the 1860s of Mount Kosciusko, the highest mountain in Australia, by Eugene von Guerard. The painting was 'rediscovered' in South America and is now in the National Gallery of Australia. Here the theme of discovery, of a 'real' Australia is heightened and parodied at the same time.

It is inescapably obvious that most artists the world over live in art communities that are formed by a relentless provincialism. Their worlds are replete with tensions between two antithetical terms: a defiant urge to localism (a claim for the possibility and validity of 'making good, original art right here') and a reluctant recognition that the generative innovations in art, and the criteria for standards of 'quality', 'originality', 'interest', 'forcefulness', etc., are determined externally. Far from encouraging innocent art of naive purity, untainted by 'too much history and too much thinking', provincialism, in fact, produces highly self-conscious art 'obsessed with the problem of what its identity ought to be'. TERRY SMITH, 'The Provincialism Problem', *Artforum*, September 1974, p. 56.

The concern with the construction of national identity, with the position of what might be an 'Australian' art, which Tillers and other artists have turned on its head, mirrors the uncertainties Tillers feels about his own 'identity' as an Australian subject. His experience is increasingly common (Melbourne is the second largest Greek city in the world), and increasingly characteristic of an Australia that is now transformed since the partial severing of its links with its original colonising country. A heritage of social egalitarianism and a strong trade union history were seen in the Whitlam Years of the 1970s as a ballast for questioning the relationship both with British culture and with the influence and power of the American multinational corporations and the arts they fostered. That period was brought to an abrupt end with the dismissal of the government on 11 November 1975 by Her Majesty's Governor General of Australia, Sir John Kerr. This act seriously undermined the reality of 'independence'. It questioned the degree to which Australia, and by implication Britain and other Western countries, could be separate from external – now American – political, economic and cultural interests.

IMANTS TILLERS

My parents being Latvian, they come from a marginalised sort of country as well. Latvia has always been under the domination of other cultures, Germany, Russia, Sweden. I think there's a similarity with Australia. I don't really belong to my parents' culture and even though I went to school not speaking any English, speaking Latvian, now I can't speak any Latvian at all. I guess there is a sort of detachment both from Australian culture and from my parents' culture. I'm in a sort of zone where I don't feel that I particularly fit into either.

I think everyone is subject to those systems – political, economic, social systems – and in a sense those forces are so overwhelming that the individual feels quite powerless to do anything. One has to believe in one's own individuality and my feeling about that is that when I'm painting these sort of pre-existent images, it's as though I feel my individuality is there but it's submerged; in a sense it's almost a metaphor for how the individual feels within society at large. You can do these little alterations, you can have these private thoughts, private desires, but you know your actual actions, or the images that you produce in a generalised sense, are fairly anonymous and merely reflect those power structures.

The strange thing about seeing these magazines was that all the art that was covered there, none of it actually existed in Australia, and Australia was in fact never mentioned. It was as though it didn't exist; as an artist one felt that anything that you did wouldn't really register. For ten or fifteen years I had this sort of sense of

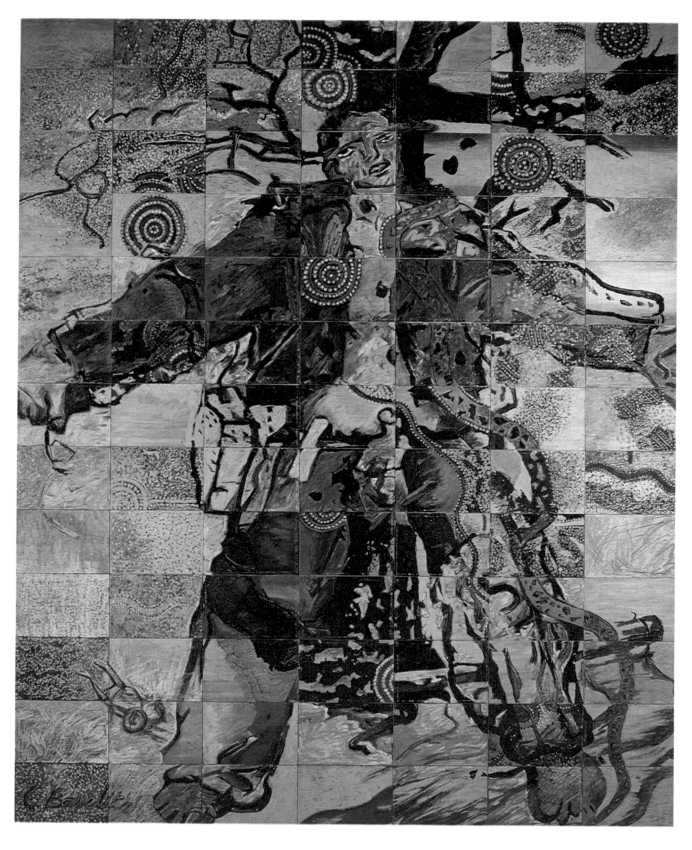

183 Imants Tillers, *THE NINE SHOTS*, 1985.

IDENTITY

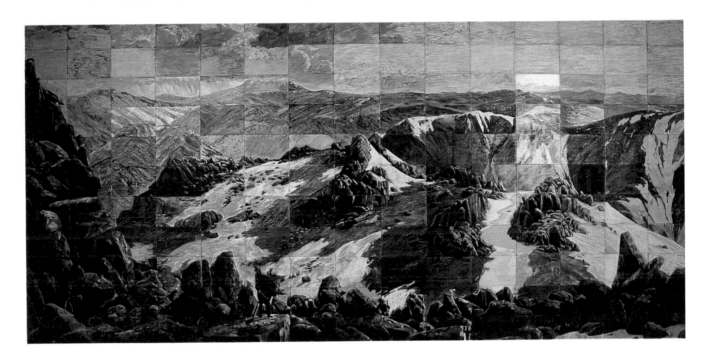

184, 185 Imants Tillers, *MOUNT ANALOGUE* and detail, 1985. The work is made up of 165 individual panels.

powerlessness and irrelevancy, but by showing in New York – my shows there are reviewed – my images are starting to appear in these magazines that I felt were so important.

* * * * *

There were those who would not admit it – even perhaps some here today – people who would have strenuously denied the suggestion but – in their heart of hearts – they too had their fears that it was true: that Britain was no longer the nation that had built an Empire and ruled a quarter of the world.

Well they were wrong. The lesson of the Falklands is that Britain has not changed and that this nation still has those sterling qualities which shine through our history. MARGARET THATCHER (Cheltenham, 3 July 1982), quoted in Anthony Barnett, *Iron Britannia*, Allison & Busby, London, 1982, p. 150.

The message that European culture and whiteness itself represented 'civilisation', while African culture and blackness represented the primitive and the barbaric, was transmitted around the world through the white man's religion, literature, music and art. The myth served to detract attention from the decadence of his own culture, an extension of which was the savage and barbaric way he asserted his own superiority over the 'inferior' races. White men have always known the value and richness of the peoples and cultures they have sought to dominate. BEVERLEY BRYAN, STELLA DADZIE and SUZANNE SCAFE, *The Heart of the Race*, Virago, London, 1985, p. 191.

Four artists are working in different parts of the same hall. Each has a number of eight-foot by four-foot panels in front of them. Sketched-out designs cover most of the panels, while others are partially painted in bright colours. Faces, arms, musical instruments, legs and video cameras emerge from the backgrounds and the clothing. Chila Kumari Burman, Lubaina Himid, Tam Joseph and Shanti Panchal are working on the murals for the reopening of The Roundhouse in London, a 'new and independent base for the arts of the worldwide black community', supported by Camden Borough Council and the Greater London Council.* Although limited to a twelve-day festival for its initial opening in 1986, The Roundhouse will become, in the words of its Coordinator, Remi Kapo, 'London's first high-profile mainstream arts centre where we can witness and enjoy the black community's contribution to the arts. Things are changing. For the first time the artists of Asia, the Caribbean and Africa – custodians and creators of the world's most vibrant and vigorous art forms – are to be given a major venue in Britain.' Tam Joseph paints a jazz club scene, Burman a mixture of Japanese and Chinese motifs, Panchal a group of traditional Asian singers, musicians and dancers, while Lubaina Himid paints a drummer next to a reworked version of Picasso's famous *Three Musicians*.

LUBAINA HIMID *The Picasso* Three Musicians *are about several things: they're about Africans today not using traditional music, but a mixture of Western music and traditional music. The reason why I used Picasso's* Three Musicians, *is that I wanted to say that Picasso has taken some things from the traditional African visual arts and used them himself, to inspire him.*

The demise of the GLC has threatened the future of The Roundhouse, now also funded by Greater London Arts and the Arts Council of Great Britain.

A lot of my work has been about how European masters took African artefacts. I was also trying to say something about contemporary African music, as well as about jazz music, and how that was appropriated from black origins. I'm trying to say a lot about the kind of swapping of culture; how both sides, how everybody is taking from everyone else, to make a better art.

The woman with the TV on her head is just someone I happened to see in Dalston Junction. It's also about women using television, I mean using the media, and not having the media use them. That's why there's a woman photographer.

Ideas, cultures, and histories cannot seriously be understood or studied without their force, or more precisely their configurations of power, also being studied. EDWARD W. SAID, *Orientalism*, p. 5.

Lubaina Himid has reworked Picasso before. A large work on cloth, *Freedom and Change*, shows two running black women, dresses streaming behind; it echoes Picasso's post cubist paintings of the early 1920s of women running on the beach. In Himid's work they are led on by some small dogs, and two white men are left behind, stuck in the sand up to their necks. Picasso's appropriations of African tribal masks and ceremonial figures, and the early modernist interest in 'primitive' sculptures and objects, is challenged and reversed. Another cut-out shows a man fondling his enormous penis, which has become a dog's head. On the two columns which support an image of a heaped table there is a painted inventory: 'Women turn your full energies on the restoration of the planet / War / Money / Cruise / Armies / Uranium / Pershing / Nuclear Waste / Pornography / Poison / Wine-Lake / Battle / Police Brutality / Missiles / Gold / Guns / Tanks / Meat Mountains / Murdered Languages / Poverty / Unjust Laws / Hatred / Misery / Disordered Leaders . . .' A standing figure in eighteenth-century military regalia is *Toussaint L'Ouverture* who led the successful slave revolt in St Dominique (now Haiti); his epaulettes are made of shiny drawing pins. Current news clippings cover his legs and boots, reporting on racial discrimination, the increasing powers of the police and the rebelliousness of the black communities in Britain today. A painted slogan runs: 'This news wouldn't be news if *you* had heard of Toussaint L'Ouverture'. A traditionally robed African woman has a gun slung across her front, poised for use.

LUBAINA HIMID

The figure is Yaa Asantewa, who at the turn of the century kept British troops out of her land, not for very long; the British troops obviously outnumbered her and her men. One of the British governors had stolen her Ashanti stool, which is a very important part of life, and then thought that he could take the land. She's a warrior queen, and whether she single-handedly kept them at bay or not, the fact that a woman is part of that myth is very important. She's a key person.

It's much more about using the past to change the future, rather than to examine how now is. I feel I can see how now is. I've tried to make pieces about things that happen to us, as black women, as black women artists.

All those pieces are about personal things, either personal realisations, or actual happenings, or things that kept repeating themselves. In the end, instead of trying to

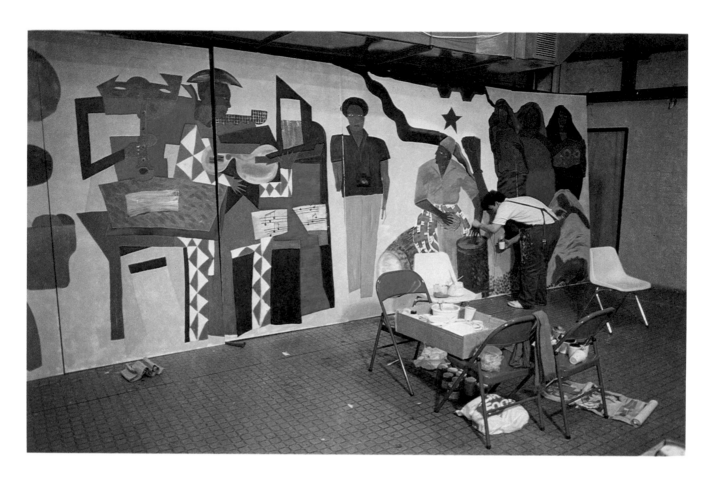

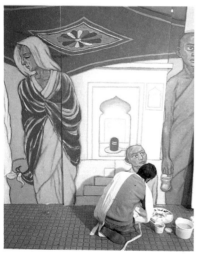

186 Lubaina Himid working on mural for The Roundhouse, Yaa Asantewa Centre, London, 1986.
187 Shanti Panchal working on the mural for The Roundhouse.
188 Chila Kumari Burman and Tam Joseph working on the mural for The Roundhouse.

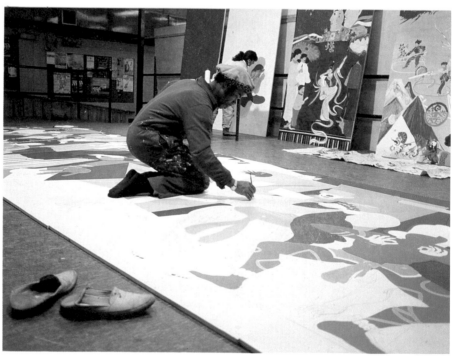

IDENTITY

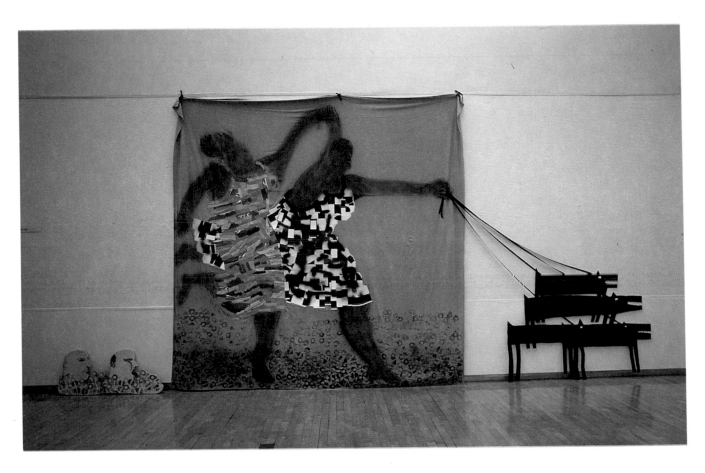

189 Lubaina Himid, *Freedom and Change*, 1984.

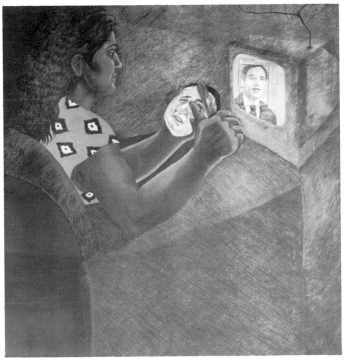

190 Sutapa Biswas, *The Only Good Indian . . .* , 1985.

write a strong letter, or make a phone call, or jump on something, I've made a piece of work . . .

I am speaking very much to an audience, to a black audience. I don't want to appear like a magician to that audience, so I do want them to understand what I am saying, which doesn't mean I have to make it different, but I have to think I am not just talking to art academics. I am talking to people about what I think life is about and how I want to change it, and do they agree?

It is black artists alone who determine the form, functioning and future of black art, for better or for worse. EDDIE CHAMBERS, 'The Marginalisation of Black Art', *The Race Today Review*, London, 1986, pp. 32–3.

The artists are recording black woman's spirituality and consciousness with a wealth of artistic expression: satire, storytelling, vengeance, analysis, the dismantling of stereotypes and an unjust, hierarchical system which attempts to smother black women at the bottom of the social pile. It is a moving, inspiring, hopeful cry. LORRAINE GRIFFITHS, 'A Thin Black Line', *Blackboard*, Birmingham, Spring 1986, p. 32.

The work of a number of black artists came to prominence in London during the 1970s, including that of Frank Bowling, Gavin Jantjes, Aubrey Williams and Rasheed Araeen. Araeen founded the magazine *Black Phoenix* in 1978, and his writings and work have encouraged a large number of art school graduates to see themselves as 'black artists'. The Black-Art Gallery was opened in 1983; together with the Africa Centre and, more recently, the Brixton Art Gallery, it raises the profile of black artists in London. Eddie Chambers and Keith Piper formed *The Pan-Afrikan Connection*, a series of group shows in public museums around Britain between 1982 and 1984. They are committed, like Araeen, to a critical art that will express the shared oppression and racism suffered by black people in Britain. Lubaina Himid is one among a number of black artists in Britain who have been organising their own exhibitions. She trained in theatre design, and began by making exhibition programmes for several restaurants in London. She organised the exhibitions *Five Black Women* at the Africa Centre, *Black Woman Time Now* and, in 1985, *The Thin Black Line* at the Institute of Contemporary Arts. Beginning in 1982 she spent two years at the Royal College of Art, taking an MA by thesis on the subject of 'Young Black Artists in Britain'. To counter the almost complete lack of black tutors in art schools, Himid and other artists have built an informal network of support to help other black art students. Wherever possible they try and formalise this into official day-lecturing. In 1986 she opened her own gallery in south London, the Elbow Room; the first show she curated was of work by black artists, entitled *Unrecorded Truths*.

LUBAINA HIMID *I tried to take slides of my work and knock on the door – 'Can you look at these slides, I'd like a show here' – and they'd look up at the fluorescent lighting at them and say, 'I don't think so.' I would encourage other people to send their slides to galleries, and they got nowhere, and so I tried to find out why it was. I mean it's very naive of me, this was about five years ago; I couldn't understand it.*

One got the impression that the art world was 'liberal' and so would see everything fairly. I discovered that art galleries are like the greengrocers or the dole queue; it's the same people, only they're arty people. So I tried to find out how galleries worked, and how they thought, and so I wrote a thesis on young black artists.

I got involved with Greater London Arts and got to know many more people who ran galleries. I discovered that in order to get a show, you did have to know a little bit more about the workings. The people who ran them would have to know your work, or know you, or know someone who knew you.

I discovered that black art was not a priority. They didn't know any black artists, they never went to any exhibitions that black artists took part in, in little places like St Matthews Meeting Place in Brixton, or the Africa Centre. I just kept thinking to myself, well, blimey, I could do this. I know a lot of black artists, and I know people who don't 'know people', who are not taught by such and such an artist, and can therefore get an introduction, who have a great deal of talent, a great deal to say, but don't have the 'ins'.

There'll be a lot of black women's work. I'm very interested in feminist work. What's been happening is that although there have been shows where black artists, for instance, black men and women, have been asked to be in mixed exhibitions, what they have never got is room to actually expand an idea, often because there isn't the space in other galleries. I want to be able to give black artists, men and women, and white women artists, a real chance to expand their ideas, to take risks really.

The key thing in this gallery is to get as many people as possible in there to see the work. Selling I think is important for all sorts of reasons, but it certainly isn't going to be anywhere near the top of the priority list.

What I'm really interested in is the thinking about it, the making it, the showing it, the talking about it, and the documenting it.

Yuh hear bout di people dem arres
Fi bun dung di Asian people dem house?
Yuh hear bout di policeman dem lock up
Fi beat up di black bwoy widout a cause?
Yuh hear bout di M.P. dem sack because im refuse fi help
im coloured constituents in a dem fight 'gainst deportation?
Yuh noh hear bout dem?
Me neida.
VALERIE BLOOM, 'Yuh Hear Bout?', *News for Babylon*, ed. James Berry, Chatto & Windus, London, 1984, p. 105.

Unrecorded Truths included the work of Brenda Agard, Simone Alexander, David Bailey, Sutapa Biswas, Sonia Boyce, Allan deSouza, Keith Piper, Donald Rodney and Marlene Smith. These artists come from a variety of family histories and cultural backgrounds, and use a range of techniques. Their work employs the symbolic, the allegorical, the documentary, the mythic and the personal to resist the omissions of dominant histories and accepted truths, and play upon the theme of 'hidden histories'.

Donald Rodney's installation, *The Lords of Humankind*, on the 'subject' of slavery, used large printed and charred sheets as the backdrop. Images and texts were painted on these, and a 'history' book recorded some of the order

191 Donald Rodney, *The Lords of Humankind* (detail), 1986, at the Elbow Room, London.

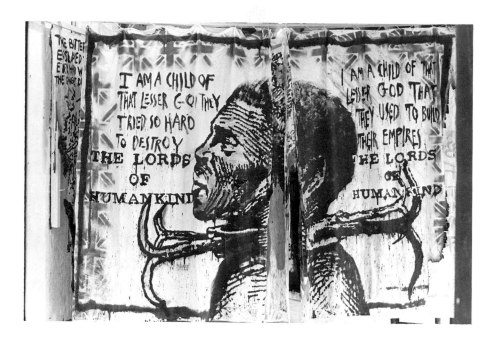

192 Sonia Boyce, *She ain't Holding them Up, She's Holding On (some English Rose)*, 1986.

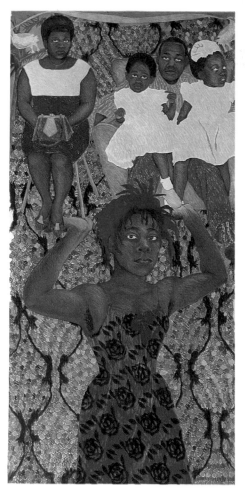

of events. Rodney had intended to use a sugar-coated model boat on a stand, and to place X-rays along the top of the sheets.

DONALD RODNEY

The X-rays are a metaphor. X-rays are when you look beneath the surface of something. The show is about 'histories' and I'm going into something deeply actually looking beneath the surface, trying to find out about the system and how it works . . . the actual structure of slavery. That's what that's about. That's why I use X-rays. There's a few of me.

When I went to Trent [Polytechnic] I had been brought up in the tradition of painting; I knew how to paint. I knew the history of painting, I knew my Picassos and everything . . . I wanted to be a black Picasso, not because I thought being black was important, but because I wanted to be famous. When I got to Trent I met Keith [Piper] and he introduced me to Eddie [Chambers] and their work was about the experience of being black. Up until that time, I had been painting flowers, really pretty flower paintings . . . then I thought I should start doing things about me. I suddenly became aware of what I wanted to say and who I wanted to say it to. I no longer had to use the language given to me by Western art traditions.

Sonia Boyce included a highly worked pastel of herself placed beneath her family, arms reaching up to them. Titled *She ain't Holding them Up, She's Holding On (some English Rose)*, it shows Boyce wearing a dress of bright pink tissue paper stencilled with black roses. Adeola Solanke has written: 'Sonia Boyce and Lubaina Himid are two black women artists who are concerned in their work with the reality behind the distortions that pretend to portray how it is to be black and female in a white, male-dominated society . . . Sonia Boyce presents close-up examinations of various realities black women undergo and sustain. The whimsical head-on gaze of her subjects usually dominates the piece and draws us into the epicentre of troubled or burdensome situations. Her work has a lingering poignancy that lends it enormous power . . .'* A number of Boyce's works have been of domestic scenes, some with her as a child.

From Two Worlds, Whitechapel Art Gallery, London, 1986, p. 12.

SONIA BOYCE

I was thinking about when I was a child and how my mother used to take us to all her friends and the houses used to be really full, and kids running up and down the house, and people being in the kitchen baking bread and someone else being in the living room talking about back home and stuff like that. And I was thinking about how I was always sort of tagging on to my mum's skirt and listening to all these conversations, getting all the juicy bits of who did what, when. What I felt was a sort of safe time for me, like being hidden in a corner but being very secure. So I started thinking about conversations my mother used to have . . . and this came from . . . this was just like a second of it, rather than encapsulating a whole story. That whole time, that whole culture that you don't see anywhere else. I felt I had to talk about it. Somehow, without regard for anybody else, it was just very important to me. Surfaces and colours, they were just a device for me.

I'm talking about the stories and the tales that our parents brought with them when they came from the Caribbean, that whole lifestyle; it's like cutting short a continuity. They left everything and they came here, and what that means for us here. Like the

thought of seeing old people, old black people is really a strange thought for me, or even knowing how they live from day to day; and keeping hold of those tales is really important to me, it gives me a sense of knowing what I am about. I'm from here, but I'm also from there as well . . .

An Asian woman is sitting watching the television, quietly peeling a potato. The potato grasped in her hand and submitted to the peeler is actually the head of the former Home Secretary, Leon Brittan. Sutapa Biswas's work, titled *The Only Good Indian . . .*, is hardly softened by its humour. Many of her works use satire, as she says: 'So many things are so ironic, they can be quite funny . . . that is something I try to incorporate.' In *Unrecorded Truths* she exhibited *Blind Man's Bluff*, a work that originated from an experience on a train hearing a blind South African white man swearing about blacks to the acute embarrassment of a woman sitting near to Biswas. The pastel includes a text across it:

Storm trooping eyes of a dazed cornflake eating Mr Harry sitting opposite kneecaps not twitching or bouncing. Noticed he was blind in the eyes and thought for a minute and yes. Oh what a calamity said the woman squirming like a jelly. In tinfoil crisps pressed evenly on the top of my tongue. Fuck the bastards he grunted. I bit the vinegar pass the salt. This face the colour of dandruff spit tongue devil anecdote I smile passing grin exchanging air crossing legs and swallowing crisps sweet smile of reason blossoms and cornflakes recedes.

Blind Man's Bluff.

SUTAPA BISWAS

In most of my work I've tried to trace certain elements within my own cultural history . . . to use ideas of myth and to rework those ideas to signify, in very crude ways, imperialism. To try and make the viewer aware of the fact that a particular cultural history existed and to try and encourage the viewer to question what happened to that culture. How was it inverted? Where does it fit into the present-day existence of, for instance, black people, whether they're Afro-Caribbean or Asian people living within Britain? I try to link everyday events to things that perhaps are not everyday events like the idea of myth, story, heroes and heroines . . . to say that we are all goddesses, we are all heroines, we are all gods. And our histories can be within our own hands.

Whether our statement is conscious or instinctive, whether it is expressed super-ficially, through outward appearance, or through fundamental changes in outlook and lifestyle, it will serve to reaffirm our rejection of the dominant culture and its attempted negation of our way of life. So any act of cultural defiance or ideological independence – whether it be through song, dance, our use of language, the way we style our hair, our dress, our view of the world, a painting or a poem – testifies to our existence *outside* the roles in which British society has cast us. BEVERLEY BRYAN, STELLA DADZIE and SUZANNE SCAFE, *The Heart of the Race*, p. 212.

The dilemma of belonging and not belonging to this society is the reality these artists are addressing themselves to, not through a mythical level or some phoney spiritual stance derived from their own traditional cultures. They are fully aware of their place and responsibility in the present world. They know that our present predicament is not the result of a natural process or a conflict between our traditional cultures and the modern world. It is in fact a dire consequence of a global economic system, with a highly complex and sophisticated superstructure of ideas, values and attitudes; and this superstructure is commonly known as Western civilisation. RASHEED ARAEEN,

193 Sutapa Biswas, *Blind Man's Bluff*, 1986.

'Art For Uhuru' (1982), review of the work of Eddie Chambers, Dominic Dawes, Claudette Johnson, Wenda Leslie and Keith Piper, *Making Myself Visible*, Kala Press, London, 1984, p. 149.

The awareness and funding of black arts increased in Britain between the mid-1970s and the mid-1980s. Certain priority funding was made available, a few 'ethnic arts' programmes were launched by local authorities and the regional arts associations, and a few specialist officers in black arts were appointed. Most notably, the Greater London Council made considerable impact in the early 1980s with an Ethnic Minorities Unit and a Race Equality Unit. The museum and gallery field remains largely unmoved, responding in an inadequate and piecemeal manner to the energetic work of the artists themselves. As the limited new funding was distributed, it became apparent to many black artists that this too could be an insidious form of institutionalisation and containment.

They oppress you, they don't want to give you the opportunity to explode. People say to you, you're from Africa, you have to do 'ethnic arts' and you can't escape from it because they've already made you. HOURIA NIATI, quoted in Kwesi Owusu, *The Struggle For Black Arts in Britain*, Comedia, London, 1986, p. 51.

Naseem Khan's report to the Gulbenkian Foundation of 1976, *The Arts Britain Ignores*, had argued for increased funding for 'ethnic arts', implying that harmonisation might be achieved by recognising the different communities as culturally separate. Many artists and cultural workers have subsequently argued against this as another form of stereotyping and ghettoisation, Rasheed Araeen among them: 'But to base the development of a multi-racial culture only on this difference does not look right, particularly when there is evidence that this difference has not been fundamental to most black artists in their attempts to come to terms with and express their own priorities *within* the contemporary art practice . . . Besides providing this white society with an exotic entertainment, this will impose a specific cultural role upon the black community, the result of which could limit its ability to express its reality in a contemporary context.'*

Making Myself Visible, p. 103.

Black artists are arguing for the recognition of what *they* choose to make, for the democratisation of decision-making in the arts, for the allocation of funds to be made on the basis of knowledge and not assumption. Their criticisms of white cultural institutions are not answered by slight alterations in the balance of funded programmes, but they have had to start with demands for recognition.

First of all, you have to understand what it means being invisible. It is quite a difficult thing to be. You're invisible to a whole set of people, the people that supposedly matter, not invisible to other black artists.

LUBAINA HIMID

For a long time the stock answer was that there aren't any black artists, black people don't make pictures. We've all come from all sorts of different directions and been working up and down the country. A lot of us have managed to disprove that, but you know, fancy having got to 1986 and managing to prove that you exist.

194 Jean-Michel Basquiat and Andy Warhol, *Untitled*, 1984.

195 Jean-Michel Basquiat, *Trunk*, 1982.

196 Jean-Michel Basquiat and Andy Warhol at the Tony Shafrazi Gallery, New York, October 1985. Behind them is one of their collaborative paintings.

197 Page of *Brutus* magazine, Tokyo.

That was the first hurdle, and then the second hurdle is that it then gets put into categories – oh, black art is all about blood and hand grenades, or black art is all about market scenes in Trinidad and Jamaica.

If you realise you're invisible, that does tend to make you more of an activist than if you think you're in with a fair chance like everybody else. I've always said that I think it's the duty of a black artist to be an activist. But I'm not that strict about that, when I'm either talking to artists or showing them. That's what I believe and that's how I try to work; but I think imposing narrow forms of creating on artists is ludicrous whether it's saying you've got to paint on five-by-five canvases and if you don't do that you're not an artist, or whether it's saying unless the work is very hard-hitting in a very obvious way, it's not black art.

Racism defines the translation of prejudicial ideas and myths into practices which through the exercise of institutional power and cultural authority, favour certain groups at the expense of others. The economy plays a fundamental role in determining racism, since the positions people occupy in the social relations of production determine whether they have the social and political power to translate ideas into institutional social practices. KWESI OWUSU, *The Struggle For Black Arts in Britain*, p. 35.

We are reminded how English racism is not a discourse but the inter-discursive space of several discourses working together: of race, and colour, and sexuality, and patriarchy and 'Englishness' itself. STUART HALL, 'Reconstruction Work', *Ten.8* 16, Birmingham, 1984, p. 9.

Much of the work of black artists in Britain frames questions of personal identity in questions of cultural identity. However diverse the histories – individual, familial and collective – that feed that cultural identity, it will be at odds with the imagined collective history. There is a widespread forgetfulness that much of British history is still written with positive connotations to its lost empire, which creates a gulf between the national identity and history as black people experience it. The expression of this awareness helps to expose and remove the often unconscious discrimination embedded in the media world and the art world equally. Black art is essential to the formation of a renewed British culture which is neither bound to the ruined associations of the old nor subservient to the transatlantic culture which constantly assails it.

LUBAINA HIMID

You can always accept the money and use it. The money is ours, it's not white money, the money is black people's taxes, it's not just white people's. White people are in charge of giving it out, but it's our money too. One should never have problems about accepting money, one should accept it, know the direction it has come from, and use it to change things.

It really is difficult for me to say that the white art world is racist. It's difficult to say that because there's a sort of unchangeability about that. I have to look at the art world as something that can be changed. If I just decide in my head something that I know, and everybody knows, that white people are racist when it comes to making decisions about sharing things, what do you do – you could end up doing nothing. In order to

IDENTITY

work, you have to slightly change your attitude to those people, and just keep calling their bluff again and again and again. I mean, that's my approach. If something's got by a methodical – in my terms, logical – method, then it can't be taken away, or be out of fashion as fast as if you broke down the door and stuck the picture on the wall.

Success for me would be to see my work in five different kinds of venues at any one time, rather than seeing it as a progression from showing work in an eating space at the bottom and Cork Street or the Tate at the top. There isn't a singular place that I see as the pinnacle of success.

If we acknowledge the complex make-up of our culture and history and recognise equally the complexity of creative thought and artistic praxis then possibilities other than vagueness and dogma can be found. If we are to act as verbs, then, with a truer knowledge of our cultural and historic grammar and with the awareness that art is not a simple part, but the complex heart of our cultural body. GAVIN JANTJES, 'Critical Perspectives', Edward Totah Gallery and *Artrage* 2, London, February 1983.

* * * * *

I will not make myself the man of any past. I do not want to exalt the past at the expense of my present and my future. . . . If the question of practical solidarity with a given past ever arose for me, it did so only to the extent to which I was committed to myself and to my neighbour to fight for all my life and with all my strength so that never again would a people on the earth be subjugated. It was not the black world that laid down my course of conduct. My black skin is not the wrapping of specific values. FRANTZ FANON, *Black Skin, White Masks*, trans. Charles Lam Markmann, Pluto Press, London, 1986, pp. 229–30.

But merely being in New York, one among 40,000 artists in the city, doesn't guarantee anything. It just opens up the possibility of access to the art world's power structure. In this way, provincialism pervades New York, precisely in that the overwhelming majority of artists here exist in a satellite relationship to a few artists, galleries, critics, collectors, museums, and magazines like this one. TERRY SMITH, 'The Provincialism Problem', *Artforum*, p. 58.

The artist is bent over the paper, he pulls and pushes, scratches the pencils across the sheet. The sound on the video is up high, the image on the large monitor is black and white, figures run back and forth, melodramatic music is heard. The screen is no more than three feet from the paper. Letters and heads, black-faced with sprouting locks, appear; other words – 'snake, pig, rooster, eclipse, animals, men' – emerge. Behind the video is a wall of cassettes, hundreds shelved like books; and a few books littered next to the bed, something on Chinese philosophy next to photographs of jazz musicians. The soundtrack gets more anxious, the priest has been shot; this is Roberto Rossellini's *Rome Open City*. Jean-Michel Basquiat concentrates on his drawing.

I'm not really sure whether the stories of the artists in the studio quietly working are really true anymore. There's always photographers coming to the studio, and stuff like this. It's a life that is documented and put out there. You go to a restaurant and they write about it in the Post *on page six.*

198 Cover of *New York Times Magazine*, 10 February 1985.

JEAN-MICHEL BASQUIAT

Basquiat's studio and apartment is on the edge of the Lower East Side of New York. He has had it for a few years, since the success of his paintings has given him an income. In the studio downstairs he lines up a row of house doors. Some of them he has already started to paint. He nails a wooden cut-out of a lamb to one of them, jabs at it with a big wax crayon, giving it an immediate devilish look. He returns with a large palette and paints an area of grey, concentrating his attention on the light green door in the centre. He hammers some more on another cut-out, switches to the paint, and another door, letting silver paint bleed down the front. In staccato fashion the images change and gradually build on the doors. The doors are facing a portrait of Basquiat by Andy Warhol, hung high over the kitchen area.

JEAN-MICHEL BASQUIAT

I tried to paint like the Lower East Side and what it was like to live there . . . and Spanish things from the neighbourhood.

I was trying to communicate an idea, I was trying to paint a very urban landscape and I was trying to make paintings different from the paintings that I saw a lot of at the time, which were mostly Minimal and they were highbrow and alienating. I wanted to make very direct paintings where most people would feel the emotion behind them when they saw them.

People expect you not to really change; they want you to be the same as you were when you were nineteen. I think my mind affects my work more now than it used to, I used to work more heart to hand . . . I think that as you get older you can't help it, the mind just pulls into it. I hope it doesn't have too much effect on it. But in some ways I think that it's been good.

I just look at the words I like, and copy them over and over again, or use diagrams. I like to have information, rather than just have a brush stroke. Just to have these words to put in these feelings underneath, you know.

Most of Basquiat's paintings have words strung across them. Others have medical diagrams or terminology. The black head recurs. The outlines are harshly painted against garish coloured grounds. Parts of bodies, legs or arms drawn in perspective, oppose the diagrammatic and schematic elements. Some words and letters are cancelled out. Sketches are xeroxed and repeatedly pasted onto other parts of the same painting. Outline shapes and silhouettes predominate. Within the chaos of different marks and references, there are occasionally biting symbols and associations. As Mark Francis has written, 'it would be a mistake to think these paintings are only a bid for fame and immortality in an art world which thrives on novelty. In fact, many of them are morbid reflections on death and paradise lost.'* Basquiat is certainly clear himself about some of his meaning.

'Black Magic Marker', *Jean Michel Basquiat*, Fruitmarket Gallery, Edinburgh, 1984.

JEAN-MICHEL BASQUIAT

A lot of them are self-portraits and some of them are just my friends and stuff.

I use the black as the protagonist because I am black, and that's why I use it as the main character in all the paintings. Black people are never portrayed realistically, not even portrayed, in modern art, and I'm glad that I do that.

Black people are glad to be represented and recognised in my paintings; that's the feeling I get when we talk about it.

Jean-Michel Basquiat's work came to prominence in the early 1980s following the 'new wave' that broke in fashion, styling, music and graffiti in New York in the late 1970s. The most famous of the graffitists of the New York subway, artists like Lee Quinones, Daze, A-One, Crash, Futura 2000, gave up their battle with the New York Transit Authority and started to make sponsored works in school yards, parking lots and on saleable canvases. Keith Haring made his notorious subway drawings, white chalk figures and animals drawn over the 'blanks' awaiting new posters; Jenny Holzer had her slogan stickers in telephone boxes, and fly-posted 'essays'; in 1982 Richard Hambleton painted more than 400 silhouettes around the back of empty lots and gas stations. Stefan Eins established Fashion Moda in the South Bronx, Tim Rollins formed Group Material working with the community in the Lower East Side, and Collaborative Projects organised a number of theme shows including *The Times Square Show* and *The Real Estate Show*, eventually starting a gallery called ABC No Rio. John Ahearn was working in the Bronx making portrait casts and busts of the residents. A film by his brother Charlie Ahearn, the 1982 *Wild Style*, documented the whole rap and hip-hop, music and dance scene of the South Bronx and the Lower East Side, featuring figures in music like Grandmaster Flash and Afrika Bambaataa, and the gallery owner Patti Astor. Out of this milieu Basquiat and Keith Haring became the overnight successes of the New York art world, as art and fashion, the nightclub and the gallery, music and dancing, coalesced in hectic confusion.

In one week Jean-Michel Basquiat opened his first solo show at Mary Boone, appeared in the MOMA survey, received a rave review from the *Times*, and proved himself in an even more concrete way. A 1982 painting by the twenty-four-year-old artist, who began his life as graffitist Samo, was offered for sale at a contemporary paintings auction at Christie's in the distinguished company of modern masters like Diebenkorn, Lindner, and Guston . . . Including the 10 per cent commission, Basquiat's first major painting at auction brought $20,900 . . . In only two years then, this new artist's work has appreciated 500 per cent. ELLEN LUBELL, 'New Kid on the (Auction) Block', *Village Voice*, 29 May 1984, p. 45.

Basquiat first became famous as Samo. That was his tag around SoHo where he, and collaborator Al Diaz, left cryptic messages and crude drawings on public walls. They often included a stylised crown, and always the name accompanied by the copyright mark, ©. Sometime in 1980 Samo was killed off, but Basquiat had already started showing drawings at clubs, partly through his connections with Keith Haring. Basquiat's work was included in the *New York/New Wave* exhibition at P.S.1. curated by Diego Cortez in January 1981. In September he joined Annina Nosei's gallery and was given money, materials and a place to paint in the basement. At the time of his exhibition in March 1982 the arrangement had become notorious, and it was referred to by Jeffrey Deitch in his review of the exhibition in *Flash Art*: 'Basquiat is likened to the wild boy raised by wolves . . . A child of the streets gawked at by the intelligentsia. But Basquiat is hardly a primitive. He's more like a rock star . . .'* In the same year he had a total of eight one-person

Quoted in Cathleen McGuigan, 'New Art, New Money', *New York Times Magazine*, 10 February 1985, p. 32.

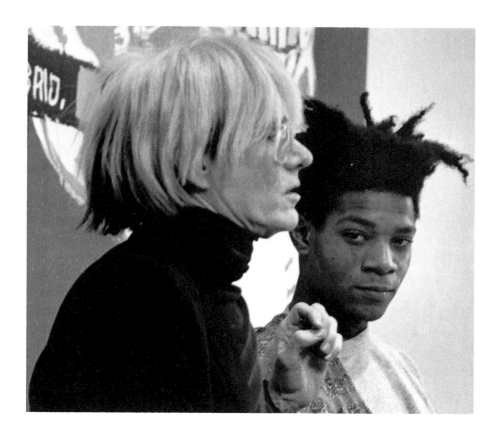

199 Jean-Michel Basquiat and Andy Warhol at the Tony Shafrazi Gallery, New York, October 1985.

exhibitions, including the Galerie Bruno Bischofberger in Zurich and Patti Astor's Fun Gallery in New York. He also started selling his work in Los Angeles through the Larry Gagosian Gallery. Equally flamboyantly he quit the Annina Nosei Gallery, destroying the unfinished works in her basement. He later joined the Mary Boone Gallery.

Warhol and Basquiat have made art out of what few others would dare – a defacement of each other's painting. In each of these enormous neo-pop epics Warhol begins with his choice corporate logos writ large. Enter Basquiat who blocks out the boss's images or scribbles all over them. PAUL TAYLOR, 'Question', *The Face*, October 1985, p. 17.

Recognising that the declaration of a renewed faith in painting could use a sacrificial child to enliven it, and further recognising that if he were to officiate, some of the spilled blood might revive his own standing, Warhol found a miracle in Basquiat. Here was a young artist who already had mythic status, street-smart with the touch of a natural, a graffitist who had attempted to free himself from the early burnout of the street artist by publicly killing off his tag, an untutored talent who had been captured by rapacious art dealers and forced to work and work and work until he finally ran away, a rebel looking for the security of an understanding surrogate father. Warhol realised that Basquiat, as a wild child in an expensive suit, could provide a much more unsettling image of the uses of money and leisure than either the older artist's lost superstars or the relatively accessible decadence of Studio 54. THOMAS LAWSON, 'Toward Another Laocoon or, The Snake Pit', *Artforum*, March 1986, p. 105.

The gallery was filled with large paintings. The magazine photograph records the artists standing on chairs, Basquiat with his arm around Warhol, smiling gawkily. The image is on a double spread surrounded by other notices of fashionable events, new consumer items, and fashionable titbits. Keith Haring's opening at both Tony Shafrazi's and Leo Castelli's galleries is featured; Haring grins from the top of one of his ($90,000) metal sculptures. This is *Brutus* magazine, a monthly published in Tokyo. Basquiat was forty-five minutes late for the photo session, Warhol came an hour late. Basquiat arrived on a bicycle, and sucked a lolly. Warhol was wearing fluorescent pink glasses and his white wig, his face looking as plastic as ever. His presence quickly filled the gallery with onlookers. Warhol said that the two had worked every afternoon from two until six for a year to do the collaborative paintings. It doesn't look quite that long. They smile for the cameras: the magazine photographer and the film camera.

Jean-Michel Basquiat is an equivocal figure. The darling of the art world for his 'fifteen minutes', launched to fame and fortune at an alarming speed, he has had the self-assurance to position himself at the centre of the art world. Whatever his early defiance on the street, like many before him Basquiat has been absorbed by a system that needs increasing amounts of 'new' work to sustain it and frequently removes all that was significant from the work which opposed it. But even when purchased by corporations, banks and museums, his images, with their tough black faces and ironic use of 'primitive' and fetishistic elements, are not entirely accommodated. They speak in fragmented form of other experiences, and of a subversive, but contained, power.

A moment of fashionable currency soon falls away into the local past. The art world in New York is local, but with global effects. Jean-Michel Basquiat's work has already been seen across America and Europe, in numerous capital cities. The view from New York becomes the museum and gallery view in cities around the world. The size of the market, the number of galleries and collectors (including the banks and corporations), the number of artists and critics, the circulation of its magazines and the prestige of the museums combine to give New York this influence.

The interaction between 'margin' and 'centre', between the local and global culture, is not simply one of dominance and subordination, but of continual tension. Artists are caught between the two polarities in the search for their own cultural identities; the expression of that tension is what, in part, gives such significance to the work considered in this chapter. For national and racial identities are mythical as well as real. They offer no guarantee of cultural authenticity or 'true' origins, yet they are a record of actual events and a position from which to struggle. In the end all art is political in its resistance to the global culture, which is intent on suppressing views and values that resist its spreading and monotonous patina. As artists challenge the assumptions of conventional history in the making, they create the fragments of a resistance, working to discover not simply who they are, but how we all might be.

Obviously there's going to be things that are charming, old things that we lose in it, but this is in the nature of change. We don't really have to call it homogenisation, let's call it the process of cultural diffusion. It has to go on at an increasingly accelerated rate, and inevitably will in the next generation. In the deepest valley of the Amazon, they've got the transistor radio and maybe the Watchman. THOMAS MCEVILLEY

I don't need to remind you that the problem of liberation is also one of culture. In the beginning it's culture and in the end it's also culture. The colonialists have a habit of telling us that when they arrived in Africa they put us into history. You are well aware that it's the contrary – when they arrived they took us out of our own history. Liberation for us is to take back our destiny and our history. AMILCAR CABRAL, quoted in Gavin Jantjes, 'Critical Perspectives'.

The point is not to eliminate the productive tension between the political and the aesthetic, between history and the text, between engagement and the mission of art. The point is to heighten that tension, even to rediscover it and bring it back into focus in the arts as well as in criticism. No matter how troubling it may be, the landscape of the postmodern surrounds us. It simultaneously delimits and opens our horizons. It's our problem and our hope. ANDREAS HUYSSEN, 'Mapping the Postmodern', *After the Great Divide: Modernism, Mass Culture, Postmodernism.*

Notes on artists

Selected references to biography, exhibitions and bibliography. The exhibitions are cited with solo exhibitions first, commencing with private galleries. Where possible recent group exhibitions have been cited, especially those having catalogue essays.

TERRY ATKINSON Born Thurnscoe, near Barnsley, 1939. Barnsley School of Art, 1959–60; Slade School of Fine Art, London, 1960–64. Teaching: Birmingham College of Art, 1965–67; Lanchester Polytechnic, 1966–73; Leeds University since 1977. Founding member, Art & Language, 1967; leaves 1975. Exhibitions: Gimpel Fils, London; *Terry Atkinson: Work 1977–83*, Whitechapel Art Gallery, London, 1983; *Art for the Bunker*, Gimpel Fils and tour, 1985/6. *Sydney Biennale*, 1984; 'Aperto '84', *Venice Biennale*; *The British Art Show*, Arts Council of Great Britain, 1984; *Images of War*, Chapter Art Centre, Cardiff, 1985; *John Moores Liverpool Exhibition 14*, Walker Art Gallery, Liverpool, 1985. Cf. In discussion with Jon Bird, *Audio Arts* supplement, London, 1985. Lives and works in Leamington Spa and Leeds.

JEAN-MICHEL BASQUIAT Born New York, 1960. Worked as graffitist Samo, New York, c. 1978–80. Exhibitions: Annina Nosei Gallery, New York, 1981–82; Mary Boone Gallery, New York; Galerie Bruno Biscofberger, Zürich; *Jean Michel Basquiat. Paintings 1981–1984*, Fruitmarket Gallery, Edinburgh. *New York/New Wave*, P.S.1, New York, 1981; *Documenta VII*, Kassel, 1982; *Five Americans*, Museo Civico, Modena, 1982; *New York Now*, Kestner–Gesellschaft, Hanover, 1983; *New Art*, Tate Gallery, London, 1983; *Whitney Biennial*, New York, 1983; *Back to the USA*, Kunstmuseum, Lucerne, 1983; *An International Survey of Recent Painting and Sculpture*, Museum of Modern Art, New York, 1984; *Paris Biennale*, 1985. Lives and works in New York.

JOSEPH BEUYS Born Krefeld, 1921. Radio operator and pilot, World War II. State Academy of Art, Düsseldorf, 1947–54. Teaching: State Academy of Art, Düsseldorf, 1961–72. Fluxus events, 1963–65. Exhibitions: Galerie Schmela, Düsseldorf, 1965 and numerous others; Anthony d'Offay Gallery, London. *Westkunst*, Cologne, 1981; *Documenta VII*, Kassel, 1982; *Zeitgeist*, Berlin, 1982; ROSC '84, Dublin; *Von hier aus*, Düsseldorf, 1984; *German Art in the 20th Century*, Royal Academy, London, 1985. Founded German Students Party, 1967; Organisation of Non-Voters, Free Plebiscite, 1970; Organisation for Direct Democracy, 1971; Free International University for Creativity and Interdisciplinary Research, 1973. Lehmbruck Prize, 1985. Numerous publications. Cf. Caroline Tisdall, *Joseph Beuys*, Thames & Hudson, London, 1979; Götz Adriani, Winfried Konnertz and Karin Thomas, *Joseph Beuys – Life and Works*, Barron's, New York, 1979. Worked in Düsseldorf. Died January 1986.

SUTAPA BISWAS Born Bolpur, India, 1962. Moved to Britain, 1966. Leeds University, 1981–85. Teaching: Department of Adult and Continuing Education, Leeds University, 1985. Exhibitions: Guildhall, London, 1981–82; *The Thin Black Line*, ICA, London, 1985; *The Third World Within*, Brixton Art Gallery, 1986; *Unrecorded Truths*, Elbow Room, London, 1986; *The Issue of Painting*, Rochdale Art Gallery and AIR, London, 1986. Artist in Residence, City Museum and Art Gallery, Stoke-on-Trent, 1986. Lives and works in Leeds.

JONATHAN BOROFSKY Born Boston, 1942. Carnegie Mellon University, 1964; Yale School of Art and Architecture, 1966. Teaching: School of Visual Arts, New York, 1969–77; California Institute of the Arts, 1977–80. Exhibitions: Paula Cooper Gallery, New York; ICA, London and Kunsthalle, Basel, 1981; Philadelphia Museum of Art and tour, 1984/5. *Westkunst*, Cologne, 1981; *Documenta VII*, Kassel, 1982; *Zeitgeist*, Berlin, 1982; *New Art*, Tate Gallery, London, 1983; *An International Survey of Recent Painting and Sculpture*, Museum of Modern Art, New York, 1984; *Space Invaders*, Norman Mackenzie Art Gallery, Regina, 1985; *Carnegie International*, Pittsburgh, 1985. Cf. Mark Rosenthal and Richard Marshall, *Jonathan Borofsky*, Harry N. Abrams, New York, 1984. Lives and works in Venice, California.

SONIA BOYCE Born London, 1962. East Ham College of Art and Technology, 1979; Stourbridge College of Technology and Art, 1980–83. Exhibitions: Black-Art Gallery, London, 1986. *Five Black Women Artists*, Africa Centre, London, 1983; *Black Woman Time Now*, Battersea Arts Centre, London, 1983; *Strip Language*, Gimpel Fils, London, 1984; *Into the Open*, Mappin Gallery, Sheffield, 1984; *Heroes and Heroines*, Black-Art Gallery, 1984; *Room at the Top*, Nicola Jacobs Gallery, London, 1985; *Black Skin/Bluecoat*, Bluecoat Gallery, Liverpool, 1985; *Celebration and Demonstration*, St Matthews Meeting Place, London, 1985; *The Thin Black Line*, ICA, London, 1985; *Unrecorded Truths*, Elbow Room, London, 1986; *Some of us are Brave*, Black-Art Gallery, 1986; *From Two Worlds*, Whitechapel Art Gallery, London, 1986. Artist in Residence, Skinners Company's Girls School, London, 1985. Lives and works in London.

VICTOR BURGIN Born Sheffield, 1941. Royal College of Art, London, 1962–65; Yale University, 1965–67. Teaching: Trent Polytechnic, Nottingham, 1967–73; Polytechnic of Central London, since 1973. DAAD award, Berlin, 1978–79. Exhibitions: John Weber Gallery, New York; ICA, London, 1986; MIT, Boston, 1986; Kettle's Yard Gallery, Cambridge, 1986. *New Art*, Tate Gallery, London, 1983; *The British Art Show*, Arts Council of Great Britain, 1984; *The Critical Eye/1*, Yale Center for British Art, New Haven, 1984; *Difference*, New Museum of Contemporary Art, New York, 1984; *Turner Prize Shortlist*, Tate Gallery, 1986. Cf. Victor Burgin, *Thinking Photography*, Macmillan, London, 1982; *The End of Art Theory*, Macmillan, London, 1986; *Between*, Basil Blackwell/ICA, London, 1986. Lives and works in London.

MIRIAM CAHN Born Basel, 1949. Gewerbeschule, Basel, 1968–73; Atelier de Stadt Basel, Paris, 1978–79. Exhibitions: Galerie Stampa, Basel; *Das Klassische Lieben*, Kunsthalle, Basel, 1983; *Venice Biennale*, 1984. *Documenta VII*, Kassel, 1982; *Szene Schweiz*, Kölnischer Kunstverein, Cologne, 1983; *An International Survey of Recent Painting and Sculpture*, Museum of Modern Art, New York, 1984; *Cross-Currents in Swiss Art*, Serpentine Gallery, London, 1985; DAAD Galerie, Berlin, 1986; *Sydney Biennale*, 1986. Lives and works in West Berlin.

PETER DUNN Born Liverpool, 1946. Reading University, 1971–75; Slade School of Art, London, 1975–77. Collaborating with Loraine Leeson on: 'The Present Day Creates History', Ruislip/Peterlee; Bethnal Green Hospital Campaign; East London Health Project; Docklands Community Poster Project since 1980. Local exhibitions of Project material. Exhibitions: *Future of the Metropolises*, Technische

Universitat, Berlin, 1984; Banff Center, Alberta, 1984; Anna Leonowens Gallery, Halifax, 1985; *Kunst mit Eigen-Sinn*, Museum Moderna, Vienna, 1985; A Space, Toronto and tour, 1986; *War of Images*, Mackintosh Museum and Transmission Gallery, Glasgow, 1986. Cf. *Cultures in Contention*, Real Comet Press, Seattle, 1985; *Photography/Politics 2*, London, 1986. Lives and works in London.

ERIC FISCHL Born New York, 1948. California Institute of the Arts, 1969–72. Teaching: Nova Scotia College of Art and Design, Halifax, 1974–78. Exhibitions: Edward Thorp Gallery, New York, 1978–82; Sable–Castelli Gallery, Toronto; Nigel Greenwood Gallery, London; Mary Boone Gallery, New York; Mendel Art Gallery, Saskatoon, 1985 and tour including Whitney Museum, New York, 1986. *Whitney Biennial*, 1983 and 1985; *An International Survey of Recent Painting and Sculpture*, Museum of Modern Art, New York, 1984; *The Human Condition*, San Francisco Museum of Art, 1984; *Venice Biennale*, 1984; *Paris Biennale*, 1985; *Carnegie International*, Pittsburgh, 1985. Cf. *Eric Fischl Paintings*, Mendel Art Gallery, 1985; *Parkett 5*, Zürich, 1985. Lives and works in New York.

LEON GOLUB Born Chicago, 1922. Art Institute of Chicago, 1946–50. Lived in Paris, 1959–64. Teaching: Rutgers University since 1970. Exhibitions: Susan Caldwell, New York, 1982–84; Barbara Gladstone Gallery, New York; *Mercenaries and Interrogations*, ICA, London, 1982; New Museum of Contemporary Art, New York, 1984 and tour. *Whitney Biennial*, 1983; *New York Painting Today*, Carnegie Mellon Institute, Pittsburgh, 1983; *The Human Condition*, San Francisco Museum of Modern Art, 1984; ROSC '84, Dublin; *Paris Biennale*, 1985. Cf. Donald Kuspit, *Leon Golub. Existential/Activist Power*, Rutgers University Press, New Brunswick, 1985. Lives and works in New York.

ANTONY GORMLEY Born London, 1950. Anthropology, Cambridge University, 1968–70; Central School of Art, London, 1973–74; Goldsmith's College, London, 1975–77; Slade School of Fine Art, London, 1977–79. Teaching: Brighton College of Art, 1982–84. Exhibitions: Salvatore Ala, Milan and New York; Städtische Galerie, Regensburg, 1985. *British Sculpture in the 20th Century*, Whitechapel Art Gallery, London, 1981; *Objects and Sculpture*, ICA, London/Arnolfini, Bristol, 1981; 'Aperto '82', *Venice Biennale*; *New Art*, Tate Gallery, London, 1983; *The Sculpture Show*, Hayward Gallery, London, 1983; *An International Survey of Recent Painting and Sculpture*, Museum of Modern Art, New York, 1984; *The British Show*, British Council, Art Gallery of New South Wales, Sydney, 1985; 'Art and Alchemy', *Venice Biennale*, 1986; *Between Object and Image*, British Council, Palacio de Velázquez, Madrid, 1986. Cf. Lynne Cooke, *Antony Gormley*, Salvatore Ala, 1984. Lives and works in London.

HANS HAACKE Born Cologne, 1936. State Art Academy, Kassel, 1956–60. Teaching: Professor of Art, Cooper Union, New York since 1967. Exhibitions: Galerie Paul Maenz, Cologne; John Weber Gallery, New York; Tate Gallery, London, 1984; Neue Gesellschaft für Bildende Kunst, Berlin, 1984; Centre d'Art Contemporain, Dijon, 1986. *Documenta VII*, Kassel, 1982; *Von hier aus*, Düsseldorf, 1984; *Sydney Biennale*, 1984. Cf. *Hans Haacke*, Vol. II, Tate Gallery/Van Abbemuseum, Eindhoven, 1984; *October 30*, New York, Fall 1984. Lives and works in New York.

SUSAN HILLER Born New York, 1942. Smith College and Tulane University. After anthropological fieldwork in Central America, moved to Europe at end of 1960s. Exhibitions: Hester van Royen Gallery, London, 1976–78; Gimpel Fils, London, 1980–85; Interim Art, London; ICA, London, 1986. *Sense and Sensibility*, Midland Group, Nottingham, 1982; *Sydney Biennale*, 1982; *New Media*,

Malmo, Sweden, 1984; *New Pluralism*, Tate Gallery, London, 1984; *Psychic TV*, Waterfront Gallery, Toronto, 1984; *The British Art Show*, Arts Council of Great Britain, 1984; *Kunst mit Eigen-Sinn*, Museum Moderna, Vienna, 1984; *The British Show*, British Council, Art Gallery of New South Wales, Sydney, 1985; *Hand Signals*, Ikon Gallery, Birmingham, 1986. *Belshazzar's Feast* broadcast Channel Four Television, January 1986. Cf. Susan Hiller, *Sisters of Menon*, Gimpel Fils/Coracle Press, London, 1983; *Susan Hiller 1979–83: The Muse My Sister*, Orchard Gallery, Londonderry/Third Eye Centre, Glasgow/Gimpel Fils, London, 1984. Lives and works in London.

LUBAINA HIMID Born Zanzibar, 1954. Moved to Britain, 1954. Theatre design, Wimbledon School of Art, 1972–77; Royal College of Art, London, 1982–83. Organised gallery at Tutton's restaurant, Covent Garden, 1977. Curates: *Five Black Women*, Africa Centre, London, 1983; *Black Woman Time Now*, Battersea Art Centre, London, 1983; *The Thin Black Line*, ICA, London, 1985. Exhibitions: Blond Fine Art, London and all above; *Into the Open* (co-curated), Mappin Art Gallery, Sheffield, 1984; *Heroes and Heroines*, Black-Art Gallery, London, 1984; *New Horizons*, Royal Festival Hall, London, 1985; *Celebration and Demonstration*, St Matthews Meeting Place, London, 1985; *Some of us are Brave*, Black-Art Gallery, 1986; *From Two Worlds*, Whitechapel Art Gallery, London, 1986. Opened The Elbow Room, London, 1986. Lives and works in London.

HOWARD HODGKIN Born London, 1932. Camberwell School of Art, London, 1949–50; Bath Academy of Art, Corsham, 1950–54. Teaching: Bath Academy of Art, 1955–66; Chelsea School of Art, London, 1966–72. Trustee of the Tate Gallery, London, 1970–76 and National Gallery, London, 1978–85. Exhibitions: Arthur Tooth & Sons, London, 1962–67; Kasmin Gallery, London, 1969 and 1971; M. Knoedler & Co., New York; 'Howard Hodgkin: Forty Paintings: 1973–84', *Venice Biennale*, 1984 and Whitechapel Art Gallery, London, 1985. *A New Spirit in Painting*, Royal Academy, London, 1981; *An International Survey of Recent Painting and Sculpture*, Museum of Modern Art, New York, 1984; *The British Art Show*, Arts Council of Great Britain, 1984; *Carnegie International*, Pittsburgh, 1985. CBE, 1977; Turner Prize, 1985. Cf. In conversation, *Art Monthly*, London, July/August 1984. Lives and works in London and Wiltshire.

ALEXIS HUNTER Born Auckland, 1948. Elam School of Fine Art, Auckland, 1965–69. Teaching diploma in art and art history, 1971. Moved to London, 1972; freelance work for commercial film companies. Exhibitions: Edward Totah Gallery, London and New York; RKS Gallery, Auckland, 1982. *Sense and Sensibility*, Midland Group, Nottingham, 1982; *Sydney Biennale*, 1982; *The New Europeans*, Germans Van Eck Gallery, New York, 1985; *Hand Signals*, Ikon Gallery, Birmingham, 1986. Cf. Lucy R. Lippard and Margaret Richards, *Photographic Narrative Sequences*, Edward Totah Gallery, 1981; interview with Caroline Osborne, *Artscribe 45*, London, February/April 1984, p. 48. Lives and works in London.

JÖRG IMMENDORFF Born Bleckede, West Germany, 1945. Stage design, 1963–64; with Joseph Beuys, State Academy of Art, Düsseldorf, 1964. LIDL activities, 1968–70. Teaching: secondary school, Düsseldorf, 1968–80. Exhibitions: Galerie Michael Werner, Cologne; Sonnabend Gallery, New York; Nigel Greenwood Gallery, London; *Café Deutschland Adlerhalfte*, Kunsthalle, Düsseldorf, 1982; Museum of Modern Art, Oxford, 1984; Maison de la Culture, Saint-Etienne, 1985. *Westkunst*, Cologne, 1981; *Documenta VII*, Kassel, 1982; *Zeitgeist*, Berlin, 1982; *Expressions: New Art from Germany*, St Louis Art Museum, 1983; *New Art*, Tate Gallery, London, 1983; *Sydney Biennale*, 1984; *An International Survey of Recent Painting and Sculp-*

ture, Museum of Modern Art, New York, 1984; *Von hier aus*, Düsseldorf, 1984; *German Art in the 20th Century*, Royal Academy, London, 1985; *Carnegie International*, Pittsburgh, 1985. Cf. Jörg Immendorff, *Das tun, was zu tun ist*, König, Cologne, 1973; *Café Deutschland Gut*, Wittrock, Düsseldorf, 1983. Lives and works in Düsseldorf.

MARY KELLY Born Minnesota, 1941. Pius XII Institute, Florence, 1963–65; St Martin's School of Art, London, 1968–70. Teaching: American University, Beirut, 1965–68; Goldsmith's College, University of London. Exhibitions: *Interim*, Fruitmarket Gallery, Edinburgh, 1985; A Space, Toronto, 1986; Riverside Studios, London, 1986; Kettle's Yard Gallery, Cambridge. *Typisch Frau*, Kunstverein, Bonn, 1981; *Sydney Biennale*, 1982; *Sense and Sensibility*, Midland Group, Nottingham, 1982; *The Revolutionary Power of Women's Laughter*, Protetch McNeil, New York, 1983; *The Critical Eye/1*, Yale Center for British Art, New Haven, 1984; *The British Art Show*, Arts Council of Great Britain, 1984; *Difference*, New Museum of Contemporary Art, New York, 1984. Cf. Mary Kelly, *Post-Partum Document*, Routledge & Kegan Paul, London, 1983; *Corpus*, Kettle's Yard, Cambridge/Fruitmarket Gallery, Edinburgh/Riverside Studios, London, 1986. Lives and works in London.

ANSELM KIEFER Born Donaueschingen, West Germany, 1945. State Academy of Arts, Karlsruhe, 1968–69; with Joseph Beuys, State Academy of Art, Düsseldorf, 1970–72. Exhibitions: Galerie Helen van der Meij, Amsterdam, 1977–80; Marian Goodman Gallery, New York; Anthony d'Offay Gallery, London; Galerie Paul Maenz, Cologne; Städtische Kunsthalle, Düsseldorf, 1984; Saatchi Collection, London, 1986. *A New Spirit in Painting*, Royal Academy, London, 1981; *Westkunst*, Cologne, 1981; *Documenta VII*, Kassel, 1982; *Zeitgeist*, Berlin, 1982; *Expressions: New Art from Germany*, St Louis Art Museum, 1983; *An International Survey of Recent Painting and Sculpture*, Museum of Modern Art, New York, 1984; *Von hier aus*, Düsseldorf, 1984; *Sydney Biennale*, 1984; *Paris Biennale*, 1985; *German Art in the 20th Century*, Royal Academy, London, 1985; *Carnegie International*, Pittsburgh, 1985. Cf. Gudrun Inboden, *Anselm Kiefer*, Galerie Paul Maenz, 1986. Lives and works in Hornbach and Buchen.

BARBARA KRUGER Born Newark, New Jersey, 1945. Syracuse University, New York, 1966–68; Parsons School of Design, New York, 1968–69; School of Visual Arts, New York, 1968–69. Teaching: School of the Art Institute of Chicago, 1975, 1977 and 1979; California Institute of the Arts, 1980–81. Exhibitions: Annina Nosei Gallery, New York; Galerie Chantal Crousel, Paris; ICA, London, 1983. *Documenta VII*, Kassel, 1982; *Image Scavengers: Photography*, Institute of Contemporary Art, Philadelphia, 1982; *Whitney Biennial*, New York, 1983 and 1985; *The Revolutionary Power of Women's Laughter*, Protetch McNeil, New York, 1983; *Sydney Biennale*, 1984; *Ansatzpunkte kritischer Kunst heute*, Kunstverein, Bonn, 1984; *The Human Condition*, San Francisco Museum of Modern Art, 1984; *Difference*, New Museum of Contemporary Art, New York, 1984. Television critic for *Artforum*. *We don't need another hero*, public billboard, Artangel Trust, London, 1987. Cf. Barbara Kruger, *No Progress in Pleasure*, New York, 1982. Lives and works in New York.

LORAINE LEESON Born London, 1951. St Martin's School of Art, London, 1970; University of Reading, 1971–75; Hochscule der Kunste, Berlin, 1976. Collaborating with Peter Dunn on: 'The Present Day Creates History', Ruislip/Peterlee; Bethnal Green Hospital Campaign; East London Health Project; Docklands Community Poster Project since 1980. Exhibitions: see under Peter Dunn. Cf. *Cultures in Contention*, Real Comet Press, Seattle, 1985; *Photography/Politics 2*, London, 1986. Lives and works in London.

CARLO MARIA MARIANI Born Rome, 1931. Accademia di Belle Arti, Rome, 1951. Exhibitions: Galleria Gian Enzo Sperone, Rome; Galerie Paul Maenz, Cologne; Sperone Westwater, New York; Edward Totah Gallery, London. *Documenta VII*, Kassel, 1982; *An International Survey of Recent Painting and Sculpture*, Museum of Modern Art, New York, 1984; *A New Romanticism*, Hirshhorn Museum, Washington, 1985; *Sydney Biennale*, 1986. Cf. Michael Kohn in *Flash Art*, Milan, April/May 1984. Lives and works in Rome.

MARY MISS Born New York, 1944. University of California at Santa Barbara, 1962–65; Maryland Art Institute, 1966–68. Teaching: Sarah Lawrence College, New York, 1976–83; School of Visual Arts since 1983. Began work on outdoor structures, 1967. Films using outdoor constructions, 1973 and 1977. Projects: *Study for a Courtyard: Approach to a Stepped Pool*, ICA, London, 1983; *Laumeier Project*, St Louis, 1985; Gementesmuseum, The Hague, 1985; Battery Park City, New York, 1985; Hayden Square, Tempe, Arizona, 1985; Thomas P. O'Neill Building, Boston, 1985; San Diego State University, 1985. Exhibitions: *Beyond the Monument*, Hayden Gallery, MIT, Cambridge (Mass.), 1983; *Connections: Bridges/Ladders/Staircases/Tunnels*, Institute of Contemporary Art, Philadelphia, 1983; *Sitings*, Museum of Contemporary Art, La Jolla, California, 1986. Cf. Mary Miss, 'On a Redefinition of Public Sculpture', *Perspecta 21: Yale Architectural Journal*, 1984, pp. 52–70. Lives and works in New York.

DONALD RODNEY Born Birmingham, 1961. Bournville School of Art, Birmingham, 1980–81; Trent Polytechnic, Nottingham, 1981–85; Slade School of Fine Art, London, 1985–86. Exhibitions: Saltley Print and Media, Birmingham, 1985; *The Atrocity Exhibition & Other Empire Stories*, Black-Art Gallery, London, 1986. *Heroes and Heroines*, Black-Art Gallery, 1984; *Unrecorded Truths*, Elbow Room, London, 1986. Member, Black Art Group. Lives and works in London.

CINDY SHERMAN Born New Jersey, 1954. State University College, Buffalo, 1974–76. Exhibitions: Metro Pictures, New York; Stedelijk Museum, Amsterdam, 1982; Akron Art Museum, 1984. *The Image Scavengers: Photography*, Institute of Contemporary Art, Philadelphia, 1982; *Venice Biennale*, 1982; *Documenta VII*, Kassel, 1982; *Urban Kisses*, ICA, London, 1982; *The Heroic Figure*, Contemporary Arts Museum, Houston, 1984; *Whitney Biennial*, New York, 1985; *Carnegie International*, Pittsburgh, 1985; *The Mirror and the Lamp*, Fruitmarket Gallery, Edinburgh, 1986. Cf. Peter Schjeldahl and Michael Danoff, *Cindy Sherman*, Pantheon, New York, 1984. Lives and works in New York.

IMANTS TILLERS Born Sydney, 1950. Architecture, University of Sydney, 1969–73. Exhibitions: Yuill/Crowley Gallery, Sydney; Bess Cutler Gallery, New York; Matt's Gallery, London, 1983; Australian representative, *Venice Biennale*, 1986. *Eureka!*, Serpentine Gallery, London, 1982; *POPISM*, National Gallery of Victoria, Melbourne, 1982; *Documenta VII*, Kassel, 1982; *Tall Poppies*, Melbourne University Gallery, 1983; *An Australian Accent: Three Artists*, P.S.1, New York, 1984; *Two Worlds Collide*, Artspace, Sydney, 1985; *Sydney Biennale*, 1986. Cf. Imants Tillers, 'In Perpetual Mourning', *ZG/Art & Text*, New York, Summer 1984; Eleanor Heartney, 'Imants Tillers', *Artnews*, New York, January 1986. Lives and works in Sydney.

MICHAEL NELSON TJAKAMARRA Born 1949, Vaughan Springs, Northern Territory. Worked in the Northern Territory as a stockman, truck driver and buffalo shooter before settling back at Yuendumu, the Aboriginal community where he was raised. Moved to Papunya, west of Alice Springs, and took up painting, 1981. National Aboriginal Art Award, 1984. Exhibitions: *The Face of the Centre: Papunya Tula Paintings 1971–1984*, National Gallery of Victoria, Melbourne, 1985; *Sydney Biennale*, 1986. Lives and works in Papunya.

Further reading

A select list of books and catalogues not already cited in the text or in the Notes on artists.

Lawrence Alloway, Donald B. Kuspit, Martha Rosler and Jan van der Marck, *The Idea of the Post-Modern*, Henry Art Gallery, University of Washington, Seattle, 1981

Anzart, essays by Denise Robinson and others, Richard Demarco Gallery, Edinburgh, 1984

Lisa Appignanesi (ed.), *Desire*, essays by Victor Burgin, Mary Kelly, Julia Kristeva, Laura Mulvey, Kathy Myers and others, ICA Documents, ICA, London, 1984

– (ed.), *Postmodernism*, essays by Jean-François Lyotard and others, ICA Documents 4 & 5, ICA, London, 1986

Art & Ideology, essays by Benjamin H. D. Buchloch, Donald B. Kuspit, Lucy R. Lippard and others, New Museum of Contemporary Art, New York, 1984

Art of Our Time: The Saatchi Collection, four volumes, Rizzoli, New York, 1984

Michèle Barrett, *Women's Oppression Today*, Verso, London, 1980

Roland Barthes, *The Fashion System*, trans. Matthew Ward and Richard Howard, Hill and Wang, New York, 1983

– *Image–Music–Text*, trans. Stephen Heath, Fontana/Collins, London, 1977

Krim Benterrak, Stephen Muecke and Paddy Roe, *Reading the Country*, Fremantle Arts Centre Press, Western Australia, 1984

John Berger, *Selected Essays and Articles*, Penguin, London, 1972

– *Ways of Seeing*, BBC and Penguin, London, 1972

Andrew Brighton and Lynda Morris (eds.), *Towards Another Picture*, Midland Group, Nottingham, 1977

Benjamin H. D. Buchloch, Serge Guilbaut and David Solkin (eds.), *Modernism and Modernity*, Press of the Nova Scotia College of Art and Design, Halifax, 1983

Noam Chomsky, 'Disinformation', *Disinformation. The Manufacture of Consent*, Alternative Museum, New York, 1985

Richard Cork, *The Social Role of Art*, Gordon Fraser, London, 1979

Rosalind Coward, *Female Desire*, Paladin, London, 1984

Jo-Anne Birnie Danzker, *Mannersm. A Theory of Culture*, Vancouver Art Gallery, Vancouver, 1982

Wolfgang Max Faust, 'Hunger for Images and Longing for Life: Contemporary German Art', *Wild visionary spectral*, Art Gallery of South Australia, Adelaide, 1986

Formations of Nation and People, essays by Alan O'Shea and others, Routledge & Kegan Paul, London, 1984

Hal Foster, *Recodings. Art, Spectacle, Cultural Politics*, Bay Press, Port Townsend, 1985

Peter Fuller, *Art and Psychoanalysis*, Writers and Readers, London, 1980

– *Images of God*, Chatto & Windus, London, 1985

Suzi Gablik, *Has Modernism Failed?*, Thames and Hudson, London, 1984

Glasgow Media Group, *Bad News*, 1976 and *More Bad News*, 1980, Routledge & Kegan Paul, London

Tony Godfrey, *The New Image. Painting in the 1980s*, Phaidon, Oxford, 1986

André Gorz, *Farewell to the Working Class*, trans. Michael Sonenscher, Pluto Press, London, 1980

Stuart Hall, Dorothy Hobson, Andrew Lowe and Paul Willis (eds.), *Culture, Media, Language*, Hutchinson, London, 1980

Stuart Hall and Martin Jacques (eds.), *The Politics of Thatcherism*, Lawrence and Wishart, London, 1983

Charles Harrison, 'The late sixties in London and elsewhere', *1965 to 1972 – when attitudes became form*, Kettle's Yard Gallery, Cambridge, 1984

Stuart Hood, *On Television*, Pluto Press, London, 1980

Donald Horne, *The Great Museum. The Re-Presentation of History*, Pluto Press, London, 1984

Robert Hutchison, *The Politics of the Arts Council*, Sinclair Browne Ltd., London, 1982

Owen Kelly, *Community, Art and the State: Storming the Citadels*, Comedia, London, 1984

Jean-François Lyotard and collaborators, *Les Immateriaux*, Centre Georges Pompidou, Paris, 1985

Phil Mariani and Brian Wallis (eds.), *Wedge. The Imperialism of Representation. The Representation of Imperialism*, texts by Gary Indiana, Barbara Kruger, Allan McCollum, Edward Said and others, New York, Winter/Spring 1985

Alan Moore and Marc Miller (eds.), *ABC No Rio Dinero: The Story of a Lower East Side Gallery*, ABC No Rio/Collaborative Projects, New York, 1985

Achille Bonito Oliva, *The International Trans-avantgarde*, Giancarlo Politi Editore, Milan, 1982

Rozsika Parker and Griselda Pollock, *Old Mistresses. Women, Art and Ideology*, Routledge & Kegan Paul, London, 1981

Robert Pincus-Witten, *Entries (Maximalism)*, Out of London Press, New York, 1983

Corinne Robins, *The Pluralist Era. American Art, 1968–1981*, Harper & Row, New York, 1984

Susan Sontag, *Against Interpretation*, Eyre & Spottiswoode, London, 1966

John A. Walker, *Art in the Age of the Mass Media*, Pluto Press, London, 1983

Jeffrey Weeks, *Sex, Politics and Society*, Longman, London, 1981

Raymond Williams, *Problems in Materialism and Culture*, Verso, London, 1980

Judith Williamson, *Decoding Advertisements*, Marion Boyars, London, 1978

Janet Wolff, *Aesthetics and the Sociology of Art*, George Allen & Unwin, London, 1983

Kathleen Woodward (ed.), *The Myths of Information: Technology and Postindustrial Culture*, essays by Andreas Huyssen and others, Coda Press, Madison, Wisconsin, 1980

Patrick Wright, *On Living in an Old Country*, Verso, London, 1985

List of illustrations

Index